LA

MW01088261

The Plays of Don Nigro

Jim McGhee

For Charles Fee —

With respect + admiration —

3/24/04

University Press of America,® Inc.
Dallas · Lanham · Boulder · New York · Oxford

Copyright © 2004 by
University Press of America,® Inc.
4501 Forbes Boulevard
Suite 200
Lanham, Maryland 20706
UPA Acquisitions Department (301) 459-3366

PO Box 317
Oxford
OX2 9RU, UK

Library of Congress Control Number: 2003114668
ISBN 0-7618-2752-8 (paperback : alk. ppr.)

⊖™ The paper used in this publication meets the minimum
requirements of American National Standard for Information
Sciences—Permanence of Paper for Printed Library Materials,
ANSI Z39.48—1984

Table of Contents

Publication of this book was facilitated in part by a grant from the Research and Publications Committee of the York College Faculty Senate.

Permission to quote from his work has been given by Don Nigro.

Preface

This book is about the work of a man who may be regarded in the future as one of America's greatest dramatists. We are all familiar with the stereotype of the struggling artist, unknown and unrewarded in his lifetime, who comes to be esteemed by later generations as the finest craftsman of his era. I never expected, however, to meet such a writer or to be anle to produce his work, particularly a world premiere with the author attending. But I have had these experiences, and I am writing this survey to inform actors and directors, particularly artistic directors, of the breadth and depth of Nigro's work (pronounce the name to rhyme with high-grow) so that perhaps in his case the stereotype may be broken and we may honor this artist in his own time.

Laurence Harbison, senior editor at Samuel French, Inc., and the man responsible for French printing Nigro's early work, feels that two factors have contributed to the lack of a national reputation: (a) no Nigro work has yet had a major New York production, one of the advantages of which would be that the playwrights's name would be associated with a title that people could identify; and (b) Nigro does not live and work in New York City and thus is not available as a recognizable personality.

This is not to suggest that Nigro's work is unknown. Productions of his plays are going on all the time—in colleges and universities, in off-off-Broadway venues, in community theatres in this country as well as in professional theatres in Europe and Canada. Samuel French, Inc. has published over 25 playbooks and the 20-odd plays in the Pendragon cycle are in the process of being printed, making Nigro the most published American playwright ever. (To distinguish published from unpublished work, I have asterisked those plays available in manuscript from Samuel French, Inc.) Writing in rural eastern Ohio, he has completed over 200 scripts and has over 60 in progress, making this study out-of-date already. Information about plays completed after 2001 may be found on the internet: goose.ycp.edu//~jmcghee/dnigro.

Chapter One: Monologues

By January, 2002, Nigro had completed 35 individual monologue plays for women, from the 447 words of *Animal Salvation* to the hour-long *Cincinnati*. The characters range from Eve, Ariadne, Medusa, and the Sibyl to contemporary housewives, actresses, and schoolteachers.

In *Winchelsea Dround*, written in a line pattern resembling free verse that Nigro uses to indicate rhythm to the actors, Elizabeth, in a white dress, sits on a wooden chair, imagining herself as a denizen of a city long ago covered by the waters of the English Channel. Elizabeth explains that she is attracted to that lost place because she herself is lost, that madness was a possibility she chose quite naturally. The piece is hauntingly lyrical and lingers in the memory long after performance. I should note, too, that many of the characters in these monologue plays appear in other scripts.

The title character in *Madeleine Nude in the Rain Perhaps* is not mad, although she tells us of her encounter on a bus trip with a man sitting next to her who talked to himself in a French accent, each of his hands representing a voice as if the hands were puppets. Eventually, she tells us, the police took the man off the bus. This piece requires a talented actress who can speak in several different voices as she recreates for us the Frenchman's imaginary conversation.

In *Frankenstein*, Meredith, a very pretty 25-year-old in a low-cut dress, tells us that she is obsessed by Mary Shelley, her novel, and the Boris Karloff movie. She says that she does not care if she is locked up as a mad person because she lives in an imaginary world of her choosing. She concludes by smilingly telling "you" that she has decided not to have sex tonight.

Another in this gallery of madwomen, Beatrice of *Animal Salvation*, calls herself the goddess of the moon. Her vision is that at some future time the human race will allow itself to be consumed by the animals who, having taken upon themselves the guilt of the humans, will

become vegetarians. (Nigro is an omnivore.) But the animals eventually hear the plants screaming and, as an act of penance for the massacre of the plants, the animals sacrifice themselves. The plants take on the guilt, then rocks, then dust, then wind, and finally God, who will create a garden and people it with animals, and the whole process will begin again. But, she wonders, what will they eat?

A character who presents herself not as a goddess but as the moon itself tells us in *The Drowned Moon** of her desire to explore the world of darkness. She is trapped in a bog, and a man lost in the bog sees light coming from a strand of her hair. When her hood falls off and the light streams out, the man sees his way out of the swamp and leaves. But the moon is trapped and pulled under the water and a large stone is placed on top of her so that she cannot return to the sky. When the man realizes the source of the light that saved him, he returns to the bog and lifts the stone from the moon and raises her from the water. The light almost blinds him but he holds her in his arms to warm her and kisses her gently on the lips. The moon, fearing the return of the dark things, goes to the sky, leaving the man forever lost in the labyrinth of the bog.

Another story of a man lost is told in *Darkness Like a Dream*. A young actress, Desdemona, explains how a man she had not seen for seven years came to a production of *A Midsummer Night's Dream* in which she was playing a tree fairy. The character is described as sitting in dim light with lights occasionally passing across her as if she is driving late at night, but she does not mime driving. It is as if she is describing a past event that is occurring for us as she tells it. Meeting the man after the show, she suggests they go somewhere to talk. She starts off in her truck, the man following in the same truck he had seven years ago. There is no moon and they drive, she leading, he following, into the enchanted woods. She likes the feeling of control this gives her, and she develops possible ways that the ride could end: they crash, or run out of gas at the same time but still stay in their cars, or she runs out of gas and the bumper of his vehicle touches hers and she will be lost; or he will run out of gas first and she will keep driving, leaving him alone in the forest, weeping for her. This outcome, she decides, is the one she will remember: the only man who never disappointed her, who never betrayed her. He will be hers forever.

Another actress, Rose, explains the dangers of touching in *The Irish Girl Kissed in the Rain**. Again, a man drives a long distance in the dark to see her perform, but she has less and less time for him as the

weeks go by. And though she knows he loves her, she must escape from that love. As a girl in Dublin, she tells us, she played the Virgin Mary and no one was allowed to touch her.

Dulcy in *Madrigals* is "a small, pretty girl of perhaps twenty, in her slip, sitting on a chair, painting her toenails . . . some time in the 1920's in a room in a house in Terre Haute, Indiana." She tells us she has moved from a mental insitution in another state to Mrs. Sarcey's Palace (a bordello), but her musings are of birds and painting toenails.

In *Centipedes**, Minnie, a woman in her twenties, tells us about an encounter with a centipede. Her husband Mac collects theatrical moustaches, and Minnie has come to identify herself with Kafka and the centipedes.

Hazel in *Squirrels* also has trouble with creatures and tells us in her first sentence that she has just given birth to a family of squirrels. She sees herself as the nut goddess, a squirrel diety. But all the squirrels run away and leave her waiting for another visitation from the animal world, perhaps raccoons.

Also expecting an incredible birth is Grushenka of *The Weird Sisters*. From a pool of light on a stage bare except for two chairs, she informs us that she has stopped reading Dostoevsky and has begun to listen to a "dripping" inside her head. She complains of severe headaches and of hearing a voice which she believes is that of her unborn sister, waiting, fetus-like, inside her skull to be born. Grushenka imagines that she herself is inside someone else's skull, and while she waits to be born from her prison by brain surgery, she reads Dostoevsky.

Three monologues that might be characterized as cautionary tales are *German China**, *The Garden**, and *A Discoverie of Witchcraft**. *German China* is about secrets and a lesson that Heidi, the narrator, learned from her grandmother. The old woman kept the key to a locked cabinet on a string around her neck. Fascinated by this never-to-be-opened secret place, Heidi finally gets the key after her grandmother's death, opens the cabinet, and sees that the china in it is old and worthless. But she understands the curse the old woman warned her of: that the glory of a secret is not telling it. This wisdom, Heidi tells us, she is passing on to her cousin's little girl.

The story told by Mrs. Quilch, an old woman, in *The Garden*, begins like a fairy tale and seems addressed not to the audience but to a little girl about another little girl who got lost in the forest and made her way to a grotto where she found and picked some beautiful yellow flowers. She hears the voice of an old woman who tells her a story

about a witch who cuts off and plants the heads of little girls who steal her flowers. In the places where she plants the heads, beautiful yellow flowers grow. Saying that the little girl is next, Mrs. Quilch smiles as the lights go out.

The witch in *A Discoverie of Witchcraft* describes how she discovered her powers and how she paid back a boy from her village who had taunted her for being ugly. She narrates how she learned her craft from an old witch and took over her house when the old witch died. People pay her for love potions and for misfortunes cast upon their enemies. The sexual vengeance she inflicts upon the hapless boy is hilarious and, ultimately, fatal.

Occasionally, Nigro will deal dramatically with an issue of public concern. Ellen, 29, in *Sudden Acceleration*, says she has no pity for the corporate and government officials who refused to believe that some defect in her car caused the death of her five-year-old son, crushed against the back wall of her garage because the car shot forward as she applied the brakes. She expresses the rage of those who have been victimized and from whom legal recourse has been taken. She plans to wait outside the corporate headquarters of the automobile manufacturer and smash the top executive into the wall, explaining that this will be just another case of sudden acceleration for which no one can be blamed.

*Wind Chimes**and *Higgss Field* deal with inexplicable situations. In the first play, Diane describes how she played with her girlhood friend, Shelly, in a labyrinth of streets in Phoenix, where they would wander until they got lost and then try to find their way home again. They began to ring the doorbells of strange houses, then hide in the bushes to watch whoever answered look around for the culprit. One day they heard wind chimes. Fascinated by the sound, they went to the door of the house and rang the bell, then ran. They fell, and Diane got up and ran until she was exhausted, terrified. Shelly was not with her. In fact, Shelly had disappeared for good. Years later, on a stop-over at the Phoenix airport, Diane searches again for the little pink house with the wind chimes. Just as she is about to give up, she hears the chimes, finds the house, and rings the bell. Again she hears the sound of something shuffling toward the door. But as she tells us that she is listening to the wind chimes, the lights go to black.

A similar suspenseful ending distinguishes *Higgs Field*, but the imagery and sentence patterns create a bizarre impression of quantum electrodynamics in an hilarious if gargoyle world. Andromeda, the

young narrator, speaks of herself in the third person, describing how she got out of bed and climbed down a rainspout to run to Higgs Field in search of Mrs. Schroedinger's cat. Andromeda lost her friend Marie who wandered into the ancient burial ground one night and disappeared. Another friend, Berenice, whose father was eaten by dachshunds, is in a coma in a madhouse. Next to Higgs Field is Mr. Gott's house, and, if we don't know we are in a strange new world, the Quarks live across the field. (There are six members of the family, but four of them are seldom seen; and when Mrs. Quark is very happy, Mr. Quark is very sad.) Near Higgs Field, too, is an old house once owned by Maxwell, and, close by, Isaac's apple orchard. There is fog over the Heisenberg woods and old Mr. Hubble uses his spyglass to peek at Miss Mobius, who is training to be a metaphysical ecdysiast. Times and places coalesce as Andromeda goes to the shop of Mr. Gott, the blind watchmaker, and finds that he has died and is decomposing. She knows that soon she must go (like the Andromeda of legend) to be chained to her rock. Lost and in tears, Andromeda pets Mrs. Schoedinger's cat which has appeared from under the piano. She tells us that something is moving toward her in the rain across Higgs Field, and the light on her fades and goes out.

Another figure from Greek mythology, Ariadne in *Labyrinth**, describes a conversation she had with Theseus about the labyrinth and the Minotaur. She tells the Greek hero all that she has learned about the labyrinth and her half-brother, the bull-man who lives in the center of the maze.. Ariadne's mother, Pasiphae, warns her against Theseus, her father refuses to help, and her sister, Phaedre, tells her that men are sewage. After making love to Ariadne, Theseus urges her to get as much information as she can from Daedalus, and while she is talking to Daedalus, Theseus steals the wings that Daedalus had built years earlier. As Melissa, a Greek captive, is sent in as a sacrifice to the Minotaur, Ariadne ties one end of a ball of yarn about her waist and hands the ball (which of course is magical and without end) to her mother. Inside the reeking labyrinth, littered with parts of dead and mangled bodies, she finds Melissa, about to be ravished and then killed and eaten by her half-brother. As she talks with him, Theseus, held aloft by the wings, pours oil on top of the Minotaur and drops a lit torch, setting him on fire. Ariadne and Melissa follow the yarn back to the daylight world and find that Theseus has run off with Phaedre. Ariadne explains that the labyrinth to her is the path she makes as she moves through it, that she herself is the labyrinth.

In *The Sybil**, another modern retelling of an ancient myth from the point of view of the protagonist, a young girl in a white dress reminisces about how she could tell what adults were thinking when she was a child. Now, mad, she lives in a cave, writing the future on leaves that she scatters about for fools to read.

The actress in *Medusa** wears a "simple and elegant gown" with long gloves and a covering on her head that hides her hair. Her face is covered with a white mask and she wears dark glasses. She tells us that in the evening she walks through a forest of statues, the men she has turned to stone. One day, she says, as she lay naked on the beach, a hideous shaggy creature rose from the depths of the ocean and raped her. After this visitation by the god Poseidon she noticed her appearance gradually changing into something horrible. She dreams of a man with a sickle cutting off her head and a winged horse, her stallion child, emerging from the stump of her neck. She speaks of her death and her belief that beauty is "the perfect coldness of the inanimate, in the blind kingdom of the stones."

In *Cassandra Proteus**, the young prophetess of Greek legend speaks to the audience from a stage "littered with fragments of broken statuary," and her discourse is also fragmentary, filled with wildly anachronistic images, in part a jumble of images from Nigro's plays. She says that her gift of being able to see the future is also a curse. She sees all times and places, but only in technicolor fragments, and is thought to be insane. Her visions are like seeing "interlocking plays, deeply intertwined universes," but she sees only in flashes. She tells us she can feel the place on her neck where Clytemnestra will cut off her head, and she sees the murder of Agamemnon and her own murder over and over. She is doomed to try to communicate her visions, knowing that no one will believe her. The future she sees is worse than the past but everything is jumbled together and she can never escape.

Eve in *Genesis* is "a beautiful young woman not yet thirty" wearing a simple brown dress. She tells us of her memories of the garden, of her fear and certainty that one of her sons will kill the other, and of the Creator-God who will kill her for pitying him for his eternal loneliness and anger and guilt.

* * * * * *

In addition to giving voice to characters from myth and legend, Nigro investigates some characters from fiction and fairy tales. In *Nutcracker**, Maria, in a white nightgown, explains her problems in the Marzipan Castle with her huge-jawed husband who keeps her awake half the night cracking walnuts with his teeth. When she can sleep, she

dreams of mice. The world of chaos and constant warfare in Toyland is driving her mad, and she prays to be rescued from it. She wants to be real, to go home to a place she never was.

The title charcter in *Wife to the Headless Horseman**, Katrina, explains how, on a midnight walk through the haunted woods, she was swept up by a horseman with a head that he carried around like a pumpkin. Ecstatic for the first few months of their marriage, Katrina admits to some difficulty in getting used to talking to her husband's head while his body was doing things to her from behind, and she has great trouble with the horse, who goes everywhere with her husband, even into the bedroom. She begins to miss her former life, even thinking fondly of her former suitor, Ichabod Crane. One night when Brom, her former lover, comes to rescue her, she accepts his offer and marries him. After all, she reasons, her former headless husband was already dead. But life with Brom has become deadly dull, and she misses her old husband. She decides that if she can't bear it any longer, she can always cut off her new husband's head.

Johanna, the character who tells the story of *The Well of the World's End**, begins with the traditional "Once upon a time . . .", commenting as she continues that time is a terrible thing and that all stories are lies. A girl very much like her, she says, had a mother who died, and the father remarried and the stepmother hated the girl because she was beautiful and sent her out to go to the Well of the World's End and fill up a bucket with a hole in it and bring it home full of water. A "great, ugly, goggly-eyed frog" says he can solve the bucket problem if she will do whatever he tells her for the whole night. The girl agrees and the frog pounds a cork into the hole in the bucket. But the girl doesn't keep her word and goes home with the bucket. Late that night the frog knocks on her door and, at the stepmother's insistence, the girl does everything the frog asks, taking it into her lap and then into her bed. Just before dawn the frog asks her to cut off his head. Deep in the eyes of the frog she sees the same strange girl she saw reflected in the deep water of the Well, but she closes her eyes and chops off the frog's head. When she opens her eyes the frog has disappeared and a handsome prince has taken his place. Together they chop off the stepmother's head, make soup of her, and live happily ever after. Or perhaps, she says, there is some other ending, and she narrates some other ways in which the story could end. Sometimes she dreams of the girl in the Well and wonders what her story is, or will be, once upon a time.

* * * * * *

There are six monolgue plays for women that investigate historical figures. Nigro prefaces the script of *Joan of Arc in the Autumn* with a note saying that after her death rumours circulated that the real Joan had not been executed by the English, and that in 1436 Joan's brothers announced that she was still alive and three years later brought a woman they claimed was Joan to Orleans. It is this Joan who tells us that the power she has comes from St. Catherine and St. Michael, but later she remarks that her voices are older than saints. She talks of her execution, and she feels that she must have died because she can still feel the burning inside her skin. She speaks of the Dauphin, the carnage of battle, and of being wounded in the thigh by an arrow, then escaping from the Burgundians by leaping from a tower, only to be handed over to the English. She describes how her naked corpse was shown to the 10,000 people who came to watch, and then her flesh was burned to ashes which were thrown into the Seine. She thinks she must be who her brothers say she is, because there is always burning in her head. It is autumn; the leaves are burning, and in her dreams everything is burning.

In *Captain Cook*, Elizabeth, the widow of the explorer of the Pacific, sits alone on a bare stage with four wooden chairs. She enumerates the contents of a trunk containing mementos of her husband's explorations. She describes events in his life, trying to make sense of it. She has nightmares about his death at the hands of cannibals in the Hawaiian Islands.

Nigro prefaces the script of *Narragansett** with the information that Ada Shephard was hired by Nathaniel Hawthorne and his wife to be governess for their three children—Una, Julian, and Rosebud—during the family's extended tour of Italy in the late 1850s. "Some years later she was drowned off the coast of Narragansett." In the monologue, Ada speaks to the audience from a boat, telling us of her dreams and her recollections of her time in Italy with the Hawthornes. She is speaking in 1874 of events that occurred much earlier, but she uses both the present and the past tenses as her narrative jumps from image to image. She speaks of Una being very pale and thinks she will die young. She speaks of her fiancé in Yellow Springs, Ohio. She talks of hearing the Hawthornes copulating at night in the room next to hers, thinks that a succubus is kneading her flesh, and dreams of a huge badger entering her at night. She talks of the people she encountered and of her experiences with the Hawthornes in Europe, but her recollections are mixed with images of death and copulation. Towards

the end she decides that this will be the day that she drowns herself to redeem everyone from the madness of unholy conjugation.

In *Cauldron of Unholy Loves*, Claire Clairmont, "a handsome old woman of eighty . . . speaks from the study of her home in Florence, Italy, in the year 1878. Night, a lamp, a sense of old books and papers everywhere, darkness all around her." Claire describes how a boarder in her home, Captain Silabee, is waiting for her to die so he can claim all her papers and correspondence. In her youth, she tells us, she had a child by Lord Byron and an affair with Shelley during the spring and summer of 1816. The child later died and Byron married Claire's sister. The papers that Silabee covets are love letters and fragments of poems by both Shelley and Byron. She decides that her present for Silabee will be to burn the papers as Shelley's body was burned on the shore of Lake Geneva by Trelawny.

Mrs. Winchester, in *Within the Ghostly Mansion's Labyrinth*, is a "well-dressed old woman, who speaks from within her dark, strange house in the year 1919." Mrs. Winchesster tells the story of the great house she built at the direction of a medium who told her that the spirit of her dead husband, the heir to the Winchester rifle fortune, wanted to build a house for all who had been killed by Winchester rifles. In the beginning, she thought that the spirits were harmless, but she has learned to fear them. In an interesting aside, she mentions the Pendragon house in eastern Ohio that she has heard of, giving evidence, if any were needed, that in the labyrinth of the author's mind all things are somehow connected. Mrs. Winchester tells us that she has tried to hide from the ghosts in the labyrinth of her house, but she knows they will get her eventually.

A story that the playwright insists came to him in a dream is told by Minna, an old woman, of *Sophie Brancasse**, a beautiful nineteen-year-old girl that Minna met on the boat that was carrying them from Bremen to New York. Minna describes a faded yellow postcard she has with a photograph of nine people: Minna and Sophie, Andreas, the Freudenbergs (a young couple), Albert Schumaker (or his brother), Sebastian, Fraulein Rittensohn, and Belary. The fourteen-year-old Sebastian was in love with Sophie as was Andreas, whom Minna loved. Belary made no secret of his physical desire for Sophie and for Frau Rittensohn. Minna tells us that she worried about Sophie who had a bad heart and was often confined to her bunk because of dizziness. Sophie and Minna hear Frau Rittensohn and Belary copulating in the bunk next door and the next night Minna and Andreas discover Belary

copulating with Sophie. Minna goes on deck and later returns to see
Andreas smothering Sophie with a pillow. After testifying to the
Captain that Sophie had a bad heart, Minna announces to the group of
mourners that she and Andreas are going to be married. Minna says
that the Captain married them the day before the ship docked in New
York and that Andreas was a good husband for fifty-two years. They
had three children, one a girl named Sophie, but Andreas would not go
near her. Minna says that she thinks she saw Belary as an old man
selling rags from a filthy cart but she isn't certain. Nor can she
remember how she came to have the postcard with the photograph.

 Two more contemporary monologues deal with animal visitations.
In *Balloon Rat**, Anna, 30, tells us about seeing balloons from her
daughter's birthday party moving at night on the kitchen floor. Anna
says she noticed during the next few days that the floor seemed to be
slanting and the windows were unusually difficult to open and close.
As she lay in her bed at night she felt something was watching her with
beady rodent eyes, but she could never see it. When Anna goes to
make tea in the dark kitchen, she sees what she thinks are the two red
eyes of the rat staring at her, but discovers that the lights are from the
stove that she forgot to turn off. The next day, returning from a trip to
a museum with her daughter, Anna hears something rustling on the
other side of the door. She raises her closed umbrella and opens the
door, only to be surprised by friends who have been waiting in the dark
to begin a birthday party. After the friends leave, Anna puts the last
piece of birthday cake on the table for the balloon rat. In the morning,
after a refreshing sleep, Anna finds the cake gone but a rose made of
icing is in the center of the plate. She says she is very pleased.

 The story of *Wild Turkeys** is told by Miranda, a sixteen-year-old in
t-shirt and panties who sits in a circle of light on a bare stage. She tells
us that "this morning" she saw seven wild turkeys cross her yard in the
early fog and then climb up the wooded hillside behind her house.
She wonders if they have come for her or the child inside her. She
describes the lingering memory of a dream in which she sees the
turkeys standing around a little corpse in the woods. When she looks in
the eyes of the turkeys she realizes that they are telling her to make a
wish "on behalf of the darkly wattled gobbling/ black carnivorous god."
But Miranda sits holding her stomach tenderly, telling the birds that
they cannot have her child. "She's mine. She's mine," she says as the
light fades and goes out.

 In two monologues, Nigro uses the relation of performer to audience
as a way to tell stories about a teacher and a student. In the longest of

the monologues, *Cincinnati*, the teacher, Susan, speaking to the audience as if they were her class, announces that the subject for the day is pain and other people. As she describes her conversation with the Chair of her department, a young male colleague, and an older man with sad, wise eyes, we learn that she is tormented by the death by fire of her baby daughter and that she is mentally unsure of what is real. While she describes her pain and her experiences with the three others, the lights narrow until there is only a bright spot on her face. When she finishes her lecture, the light goes out. Class is over and we realize we have experienced a tour de force of a mind desperately trying to stay sane in a world of unbearable pain.

The student in *Normalcy** is giving a class report on Warren G. Harding. Her name is given as Madison and she speaks in the delightful run-on sentences of a typical scatter-brained student who has some facts at her disposal but gets the story of Harding and his infidelities mixed up with her recollections of her father, a beer-truck driver whose wife followed him around on his route. She explains that people who criticize Harding for "looting the treasury blind and/ humping everything in sight" are taking the short-sighted view of things that her mother took when she found her father in bed with the Pottorf sisters and shot herself through the right temple. Madison tells us how her father's beer truck crashed into a Mayflower moving van at the bottom of a hill because something was wrong with the brake lines. The truck burst into flames and exploded, and as she watched the blaze she thought of how she could now love her father forever, although she admits to being sorry about not having marshmallows. But, her report concludes, Harding should be an inspiration to everyone because his life proves that absolutely anybody can become President.

There are fourteen other monologues for women, four related to the Pendragon cycle, three in a group of interconnected plays called *The Zoar Plays**, five in *The Girlhood of Shakespeare's Heroines*, and two in another set of interconnected one-acts, *Pictures at an Exhibition**. These will be discussed later. Of the monologue plays I have described, the archetypal patterns that remain in the mind are those of white-clad, usually pretty women in their twenties, most of them victims, many of them either admittedly mad or teetering on the brink. Their stories are poignant, told with poetic imagery and rhythms, as they exhibit courage, acceptance, and, sometimes, a hilarious appreciation of the ludicrous.

The monologue plays for men offer a more diverse range of character types, ages, and situations. In the category of figures from history, the range is from Diogenes to Saint Anthony to Al Capone to Naz, a modern-day Christ. In *Diogenes the Dog*, the Greek Cynic philosopher is described as "a filthy old man in rags," dressed so that it is difficult to establish a time period. Coughing terribly before acknowledging the audience, he announces with glee that his body has begun to putrefy and explains his philosophy of reducing his needs to a minimum. He consistently insults the audience, does routines reminiscent of Groucho Marx, enumerates his rules to live by, and demonstrates how he exposes himself to fat women. He concludes with a series of statements, some philosophical, some ludicrous, some ludicrously philosophical, and then tells us that he has made a mistake, that we are not what he thought we were, and that he is not who he is, but somebody else entirely.

As a setting for *The Temptation of Saint Anthony**, Nigro suggests a tomb in the Egyptian desert by which Saint Anthony sits and tells us of the various torments that Satan has inflicted on him because of his extreme piety. He describes particularly the torments of lust, of apparitions of beautiful young women who visit him nightly. One appears to him as he is talking to us, but he sends the invisible (to us) temptress away. Towards the end of his litany of tortures, he reflects on the possibility that he has misinterpreted God's message, that perhaps it is not Satan who is sending the naked women but the Lord; and by rejecting God's bounty the saint is wallowing in the vainglory of misguided purity. He decides that he has indeed been too proud, and he calls to his visions, asking that they come to him so that they may rejoice together. But no one responds, and he is left looking out into the darkness as the light on him fades.

Ritson, the fifty-year-old antiquarian in *Border Minstrelsy*, curses Sir Walter Scott, who, it seems, has referred to Ritson's book on the extant poems, songs, and ballads relating to Robin Hood as a work of "superstitious scrupulosity." Ritson expresses his scorn for Samuel Johnson, for Warton's *History of English Poesy*, and for Percy's *Reliques*. Railing against those who do not check their sources, who twist evidence to prove a thesis, he defines his view of scholarly investigation and his love for Jennie, his "sweet scullery maid."

Mr. Arbuthnot in *Nightmare with Clocks* winds clocks in an antique store as he admits to us his obsession with the image of a very young

girl he saw bathing when he was five years old. His attempt to sublimate his obsession by concentrating on antiques has not worked and he has been experiencing a recurring nightmare. He desribes the grandfather clock about to strike 2:00 a.m., the door next to the clock that opens to reveal a lovely eighteen-year-old girl asleep in a canopied bed. As he approaches her, the clock strikes two, and he wakes up in his own bed. An elderly man asked him to examine a collection of old clocks. Arbuthnot went to the house and realized that it was the house in his dream. And the old man has a grand-daughter. Arbuthnot makes a more-than-generous offer for the clocks, but the old man rejects it. Arbuthnot then tries to enter the house late at night to find out how his dream ends. He fails, but he promises us that he will try again.

The Cubist painter Georges Braque speaks in *Picasso* of his friend and fellow painter who noticed a squirrel in one of Braque's paintings. Standing next to an easel (with painting facing upstage), Braque tells us that although he had not intended to paint a squirrel, his friend Picasso assured him that there was a squirrel in his painting. Braque swears he will get rid of the squirrel and works very hard to do so. Unfortunately, he has begun to see the squirrel peering out at him from all parts of the canvas. While Picasso paints and sells his work for a fortune, Braque works on the single painting, neglecting his other paintings and his mistress, who moves in with Picasso. At last he calls Picasso back. The squirrel is gone; but, says Picasso, "I liked it better with the squirrel." Braque tells us he gave the painting to a beggar, describing it as a painting of a squirrel. He then states the importance of this lesson he learned from his friend Picasso.

The painter Vermeer speaks to us in *Dutch Interiors**, of a perspective box he bought from his rival van Hoogstraten, a box with two peepholes that, when looked into, create the illusion of the interior of a house in three dimensions. One day he saw a girl with a pearl earring in the box and became "utterly lost" when he looked into her eyes. He wants to touch the girl who, he learns, is pregnant by a soldier who has deserted her. He dreams of hearing water and of reaching to open the door to the bathroom where the girl is bathing, but he wakes.up. At the darkest point of his despair he dreams he is again inside the perspective box, but many years have passed and the box has sat forgotten in a storage room of a museum. He goes through the rooms of the box looking for the girl, but he cannot find her until, on a table in one of the back rooms, he finds another perspective box. Looking into it, he sees the girl looking back at him—or perhaps turning away.

A famous American figure, Al Capone, in *Capone*, speaks to us in bathrobe and slippers from his house at Palm Island, Florida in "perhaps" 1946. In a modified-stream-of-consciousness narration, Capone complains of something (syphilis) eating at his brain. One memory interrupts another but the picture of a man more sinned against than sinning gives a depth to the famous gangster that other treatments miss, or don't even attempt. We learn how Capone got his facial scars, how his early life started him on the path he could never escape, how his friends and allies were brutally murdered, how he brutally retaliated and eventually was imprisoned. In Nigro's version, Capone ends his days playing on the floor with his grandchildren. He remembers a young blond girl, so perfect he almost didn't want to touch her.

In *Jezebel**, James Prophet, a theatre critic of the 1930s, explains, from a bar in New York City, the series of events that led to his writing a review of a dance program that he had never seen. As Prophet explains it, Rhys Pendragon bet him he could not write a review of a dance program without going to it, although years ago Prophet had seen the same dancer perform the same program. Prophet drank too much and missed the entire show but nonetheless went to his office and wrote the review. As events turned out, the woman dancer never performed at all, her place being taken by two male dancers who performed a different program. As Prophet describes in hilarious fashion his editor's reaction to his gaff, he tells us that the newspaper union not only prevented him from being fired permanently but also got him back pay and a raise. In fact, he now reviews all shows without seeing them.

In *Broadway Macabre**, the character Old Producer (based on an historical figure) sits in an armchair on a bare stage. He is white-haired, pale, "skeletal, very unhealthy looking, very well dressed." As the monologue begins, Old Producer repeats the question a playwright (to whom he is speaking) has just asked about how he liked working with Peter Brook. Quite angrily, Old Producer berates the young playwright who apparently has refused to change his script as Old Producer and the director had wanted. Old Producer tells the playwright that the theatre is not about money, but about the fight, about winning, cutting the other guy's throat with "a smile on your face, a shine on your shoes and a fucking melody in your heart." He rails against artistic integrity, telling the writer that he is destroying the best chance for success he will ever have and that he will regret the decision he made today for the rest of his life. He concludes his tirade by telling the writer that an actress, whom he had locked in her dressing room at intermission, sued him and Peter Brook and Old Producer went

bankrupt. But five years later he was the "wealthiest son of a bitch in the history of the fucking American theatre." He won; and that's how he liked working with Peter Brook.

Neff, in *Childe Rowland to the Dark Tower Came*, is a man in his forties, the chair of a university theatre department. He tells the audience that he thinks he has done a good job running the department, bolting down the seats in the experimental theatre space, getting rid of the undergraduate acting major and most of the acting classes, limiting rehearsal time to the daylight hours, and encouraging a concentration in deconstructive hermeneutics. He wonders if someone in the audience is one of those who have threatened to blow up the new Fine Arts Center. Or perhaps out in the audience is the person who has been tap dancing in the hallway at 3:00 a.m., or the one who puts up drawings of the Chair having intercourse with Popeye, or the "enormously pregnant Greek exotic dancer who refused to drop out of her acting classes." Neff explains the difference between those who create, the adjudicatees, and those who, being persons of taste and discrimination, become the ruthless adjudicators. The theatre, he concludes, would be a wonderful place if only there were no people in it. And, like Old Producer describing himself as a "little bloody-clawed cock" crowing on top of a "mountain of stinking corpses," Neff says there is nothing more glorious in the universe than to stand on top of a hillock made from the corpses of one's enemies (he would first kill the actors and then the audience) and shriek out his final adjudication "into the heart of an immense and impenetrable darkness."

A fourth monologue dealing with theatre is *Horse Farce*, probably Nigro's funniest monologue, in which an old French actor, Larue, tells us of his moments of triumph and hilarity during his long career. His memory is failing as he tries to relate to us the performance of one particular play, the "famous" title of which he can't remember, a farce involving a horse that eats a straw hat. As he tries to tell the story he gets confused and talks about another play, or an actor, or a performance venue, and we never hear the entire story. But we do get a moving portrait of a not-so-successful life in the theatre and an attempt, at the end, to justify that life

Perhaps the most shocking and imaginative conflation of times, places, and characters occurs in *Golgotha*, in which Naz, in his early thirties, dressed in jeans and a flannel shirt, speaks from a stage bare except for three wooden chairs. He is the Christ come back to modern Pittsburgh, and he speaks of the two thieves crucified with him, Moe

and Mac, one from Brooklyn, the other from Scotland. Naz talks about Lazarus, Mary Magdalene, his brother Satan, and his creator father, the cannibal who is eating his brain. Naz describes eating a peach in London in the seventeenth century, of talking with Pontius Pilate, and of how Mac and Moe ate body parts in the garbage dump outside Herod's palace. Because of his rapid-fire narration of events from different times and places, the effects of this monologue include humor, pathos, shock, and a sense of madness.

The setting for *Lovecraft** is an old house in Providence, RI, in 1936, although Nigro might say that a dim candlelight effect on a bare stage would be adequate. We hear the sound of an approaching thunderstorm as we see the tall, cadaverous Lovecraft walking, trying to compose. He breaks off his writing to tell us of his childhood as an ugly youngster, too hideous to go out in the daylight, according to his mother. He occasionally becomes energized by a story he has already written, expressed by a "My God, Eliot, it was . . ." refrain and tells us of his parents, his wife, his ghost writing for a Colonel Bush, a well-known motivational speaker of the time. He says that gigantic crabs whisper in his ears, and that the sounds he hears in the basement are sea monsters that will eat his brain and guts. He imitates pigeons cooing, sings and dances, tries to imitate Caruso and then a dog. He is terribly lonely and knows that he is the monster in the labyrinthine maelstrom

In *The Necromancer's Puppet Theatre **, Dr. Faustus speaks from "the prison of his study in Hell." He remembers and yearns for the demoness, Mephistopheles, and talks of authors and characters from literature—Giordano Bruno, Rider Haggard, Henry Miller, Teiresias, Tennyson and the Lady of Shalott, Pyecroft, Thomas Mann, God, Satan, Shakespeare, Marlowe, and Giapetto. Almost all the major themes that Nigro deals with in his plays are at least mentioned by Faustus, who is outraged that he has been turned into a puppet theare and is no longer a major figure in literature. But his left hand rises up "like a snake" and speaks to him in a "high, squeaky voice," insisting that he is indeed a puppet show. The left hand then bites Faustus' nose and won't let go. Faustus finally forces the left hand into his pocket and talks again about imagination, salvation, and damnation until the left hand bites him in the crotch. He pulls the left hand from his pocket and speaks of God, Satan, illusion, writing, and magic. Image crowds on image as he tries to give voice to his torment, saying that to endure he has created his own little repertory company of puppets. He invites the audience to watch the show; the admission fee is "merely" their souls and bodies.

In *Caliban**, the title character speaks of his unending suffering, describing his life before the events dramatized in *The Tempest*—of Ariel (a girl) being stuffed in a tree, of the death of his mother Sycorax, of the hideous loneliness he feels after her death, of his father Setebos, and of the arrival of Prospero and Miranda. He describes his growing sexual attraction to Miranda, of being near to copulation with her when Prospero discovered them. What Caliban then relates is a reprise of what he says in Shakespeare's play, but his thoughts are developed beyond the play and we learn that he now sees love as an illusion, that the Miranda he loved was his own creation, bearing little resemblance to the actual girl. But Caliban cannot stop thinking of her and tells us he has tried to commit suicide. He knows as he curses all the gods, no one, real or imaginary, is paying or will pay the slightest attention. He will play the role of the unloved and loving monster forever.

The last character from literature investigated in the monologues is Marley in *Marley's Ghost**, who drags a heavy chain onstage as he howls and moans. "He is grey and rotting, covered in cobwebs." After describing some of his torment (which "gets old after awhile"), Marley tells the audience that they shouldn't snicker at him, that if they think being a dead person is easy, they should go and hang themselves from the nearest lamppost. He admits to getting "a crumb of twisted satisfaction" from scaring Scrooge, and, though he is a ghost of a character in a book, so too are the members of the audience, "merry corpses." For Marley, the worst punishments of all are the many incarnations he is forced to endure, although he hopes to find some purpose, some beauty, in his fate. He sees his part, with all its howling and moaning and torment, as, in a strange way, his salvation, that, as "a perpetual theatrical performance" he is a kind of triumph over Death. His purpose is to make a kind of resurrection in the souls of the audience, "those poor wretched cobwebbed dead who sit and watch in darkness." Urging his fellow ghosts to celebrate while they can, he reminds us that he has another performance on the quarter hour.

A curious investigation from popular culture occurs in JACK IN THE BOX*, in which Jack, "a hideous . . . jester figure, with the big nose, red cheeks, hump and leer of Mr. Punch, and a jester's hat," pops out of his box at the penultimate phrase of the tune, 'Pop Goes the Weasel.' Lolling grotesquely, Jack tells us he hates the song that always signals his appearance. Trapped in his box, he thinks of "the lost eyes and sweet soft/boobies of dear sweet Madge/the milkmaid, lost, lost." Then the child turns the crank, the tune plays, and bang he goes into the light. But he begins to ponder the lyrics of the song,

singing the verses, growing more excited as the words seem to provide clues to his former life. When the child approaches to close the lid of the box, Jack recognizes her as Madge. He pleads, but the lid is closed on him. In the darkness we hear the crank being turned and the song playing. "When it gets to Pop, there's a loud bang. Then silence."

An imaginary character from the twentieth century, Uncle Fritz in *Wolfsbane**, sits at a table in a tropical country with a red drink before him. The convention in this monologue is that he is talking to a single individual, addressed as "my dear," probably a young woman. Fritz talks of werewolves and the Furher ("a kind man, much misunderstood"), and the nature of jealousy. He says that in the death camps of the Holocaust he was the one who chose who would live and die. He has no regrets and says that he whistled tunes from Puccini as he sent people to the left or the right and now always associates Puccini with the smell of burning flesh. He tells his auditor that he is very pleased with his work and feels no guilt because there is no punishment, no law. God, the King of the Wolves, is always kind to those who look with clear eyes.

In *Mink Ties*, Lester, a paunchy middle-aged salesman in a rumpled suit with a garish plaid tie, explains why he stopped wearing ties made of real mink fur. Lester is wealthy from his ventures in peat moss and fan belts, and he says that he used to wear mink ties as conversation starters with his clients. As a collector who buys and sells things, Lester relates how he went to Arkansas to buy a 1914 Republic truck. Thinking that the farmers who owned the truck didn't know its real value, Lester offered them five hundred dollars. But the farmers knew the blue book value of the vehicle, sixty-two thousand dollars, and wanted every penny of it. Lester agreed, but while he was waiting for them to get the papers from the house, a strange teen-aged girl sitting in the hayloft of the barn told Lester that if he betrayed another living creature in his life he would be similarly punished in hell. On his way home, Lester slept at a motel where he had a nightmare about being caught in a trap, thrown into a cage, and about to be skinned alive. He woke up before the skinning, but as soon as he got home he gave all nineteen of his mink ties to the Salvation Army. Later, while attending an opera with his wife, he was sure that the fox fur on the coat of the lady sitting in front of him was saying the same words as the girl in the barn, and he rushed in panic from the auditiorium. In closing his story, Lester offers to sell us his 1914 Republic truck.

The monologue plays for men present a wider array of ages, types, and historical periods than the monologue plays for women. The men

on average are older, more inclined to philosophical musings, more capable of generating laughter, and, perhaps as a corollary, more conversant with horror. In addition to the ones discussed, there are six monologues in the Pendragon cycle, one monologue in *Pictures at an Exhibition**, and one for Ruffing, the English detective. These will be covered later. But in the monologues for both sexes, Nigro achieves a commingling of emotional effects that fulfills the Dylan Thomas definition of poetry , that "poetry is what in a poem makes you laugh, cry, prickle, be silent . . . lets you know that your suffering is forever shared and forever all your own." Many of the monologues are printed as if they were free verse (as a way of indicating speed and rhythm to the actors), and Nigro is insistent that a play is first a work of literature and then a script that is performed. In his view, the sad state of American theatre is directly attributable to the devaluing of plays as literature.

Some of the monologues require, others invite, the actor to use different voices. Larue in *Horse Farce*, for example, must use several voices to tell the story of the plays and women he has experienced. But in most of the scripts there is no authorial indication of how and when an actor might use different vocal interpretations. Nigro is content to leave decisions of this kind to the directors and actors involved, although he hopes that he has, through the rhythm of the pieces, given some information about how he hears the lines being performed.

A great advantage of the monologue is that it is easy to rehearse and stage. An evening of Nigro monologues might require no more than a wooden chair or two, some informal clothing, bird and clock noises perhaps, and lighting. Even though some scripts specify a particular location, the effect needed can be achieved with minimal set pieces and props, no walls or doors. In some monologues, a specific costume is necessary to indicate time period and character. Everything else depends on the actor, and with such a breadth of quality scripts, I expect that actors will find Nigro's monologues a treasure trove of possibilities that may move them to explore his longer scripts.

Chapter Two: Short(er) Plays

Of Nigro's two-character scripts, five are connected with the Pendragon cycle and will be discussed later as will the dyadic encounters in *The Zoar Plays** and *Pictures at an Exhibition**. Of the eighteen other plays for two characters, five are about authors and/or stories and one features the painter Van Gogh. In *The Red King's Dream*, the set requires a "large old comfortable round-backed arm chair" in front of which is a white oval rug. The chair is flanked by two wooden tables on one of which is a chess board with pieces of a game in progress. The chair is lit by "the flames of an invisible downstage fireplace," an effect Nigro calls for in other scripts. In the chair, wearing a white dress, is Mabel, curled up asleep. We hear the sound of a ticking clock and then of a door opening. Alice, slightly older, in a white nightgown, enters, wonders who the strange girl in her chair is, and wakens Mabel. The girls try to figure out who they are and where they are, becoming increasingly confused until they agree that they are in a looking-glass room and are, perhaps, mirror images of each other, neither knowing who or what is real. They decide that they are dreaming each other and that perhaps the Red King is dreaming them. At the end of the play they exchange places, Alice curling up in the chair to go to sleep. When she wakes up, she says, she will have gone back through the looking glass. Mabel says that she will see her there, in the looking glass. Mabel says good-night to "Mabel" and Alice says good-night to "Alice;" the light fades out and we hear the ticking clock.

The Argentinian writer, Jorge Luis Borges, appears in *The Babel of Circular Labyrinths*. We are to imagine we are in a vast library at night, an illusion created by "a table, a chair, a green shaded lamp which makes a circle of light, and darkness all around." The blind writer sits holding an open book which he tells us is an English translation of *Don Quixote*. He hears the sound of a footstep and smells the perfume of what he assumes is a very beautiful woman. Beatriz, dressed "in the fashion of 1929," steps into the light and expresses surprise that Borges doesn't recognize her He says that she smells like Beatriz Viterbo, a character he created in a story, but she cannot be that

Beatriz because that woman is dead, or at least the real woman that
Borges loved is dead, and the woman in the story is somebody else.
Beatriz responds that she has come from "deep within the labyrinth of
mirrors" to give him a gift. When she places a knife on the table,
Borges tells her what she has done, and when she asks how a blind man
can see a knife on the table, he asks her a riddle: "Why is a raven like a
writing desk?" Her first response is that they are both stained with
blackness. Borges asks why she has come to put a knife on his table
and repeats the riddle. She responds that the raven and the desk are
similar because the bird sits on a dead man and the dead man sits at the
desk. Borges says that if he picks up the knife he will die. She then
asks him the riddle; Borges says that neither one is her yet both are her
because (parodying Nicholas of Cusa) her circumference is nowhere
and her center is everywhere. He invokes Zeno's paradox about half-
way points to prove that he will never be able to pick up the knife.
Beatriz remembers that she was looking into a mirror, the mirror of
infinite regress, before she was sent to give Borges the knife. Borges
asks for a kiss; she refuses, and again he asks her the raven/desk riddle.
She answers that it is because she loves him. Borges replies that a
raven is like a writing desk because a "dead man/who is now a
book/has written that it is." He picks up the knife; she asks him what
he sees. The light fades out and we hear the ticking of the clock.

In *Ringrose the Pirate*, Henry James lies in his bed dying, dictating
to the last. His secretary, Miss Bosquanet, sits at a small desk with an
old typewriter. James has suffered a stroke and his attempts to dictate
are nonsensical, ludicrous, and pathetic. Gradually, though, he begins
to make coherent statements, and when he starts dictating a play about
Ringrose the Pirate even the secretary can follow what he is saying,
asking him to slow down so that she may type his words accurately.
James laments that he has never had sexual intercourse and asks Miss
Bosquanet if she will grant a dying man's last request. James thinks
that Maupassant was a better writer because he had frequent intercourse
with shopgirls, but Miss Bosquanet refuses, although she does agree to
lie down next to him. She is just about to kiss him when James shouts,
"EUREKA!" and begins madly dictating more about Ringrose. She
moves to her typewriter to take down his words, but as she waits for
more, James dies.

An eerier and less funny play about an author, *The Death of Von
Horvath*, takes place on a bare stage with two wooden chairs. The
author is talking with a gypsy, "a thin dark girl of nineteen in an old
dress." Instead of visiting a brothel in Amsterdam (their location), Von

Horvath, fleeing the Nazis in 1938, has spent his last bit of money to have the gypsy tell him his fortune. Although he is skeptical of what she tells him, he admits to being superstitious and concedes that the girl has accurately described one of his dreams. She predicts that he will die on June 1st, the day that Von Horvath has feared since he was a child. Her prediction is very specific: he will be struck during a thunderstorm by a branch from a tree on the Champs-Elysees. She urges him to stay with her, but Von Horvath says he has an engagement in Paris. As the lights go to black we hear the sound of rain.

In *The Bohemian Seacoast**, set near Shakespeare's tomb in 1856—actually a darkened stage with a bench to suggest a pew—Delia Bacon comes to verify her long-held belief that Shakespeare did not write the plays attributed to him. She has a brief conversation with a Curate, who leaves her to her explorations. Shakespeare's Ghost, played by the actor who plays the Curate, appears, asks what she is doing, shows her how to react properly on stage to a sudden shock, and assures her that he did in fact write every blood-soaked word of his plays. A rooster crows, the ghost leaves, and although very addled at first, the redoubtable Delia tells the Curate, when he reappears with an invitation to a rasher of bacon for breakfast, that she has no need of evidence to convince her of the truth: Shakespeare did not write the plays. She has had a revelation and no facts will ever disturb her certainty.

The last of the two-character plays to deal with an artist, *Netherlands** presents Van Gogh and a Dutch Girl complete with wooden shoes and a pail of clabber. The painter sits on a park bench over which the shadow of the arm of an enormous turning windmill passes slowly. The opening conversation between the two characters is even more bizarre than that between Von Horvath and the gypsy. Van Gogh shows the girl his ear, kept in a little coffin box, and the girl says it looks like a dried apricot. Van Gogh muses about what goes on in the brain of a man who has just shot himself, saying that perhaps the man envisions one last painting, a landscape in the rain with crows. When the girl says she is hungry, Van Gogh again offers her the ear; she accepts and, using the clabber as a dip, finds it surprisingly tasty. She says it is beginning to rain, and Van Gogh hears crows coming. The girl holds his hand as the lights dim and we hear the creaking of the windmill and the sounds of crows getting louder. We see the shadows of birds, then darkness and the sound of the crows.

* * * * * *

A very different time period, 1175 England, is evoked in *Fair Rosamund and Her Murderer*. Nigro's description of the imaginary

setting for the play is "a cobwebbed rose bower somewhere in a labyrinth." But, he adds, "In fact, two stools on an otherwise bare stage will do." Rosamund and the Murderer (who does not follow his orders to kill her) speak to us but not to each other. They comment on each other's lines, givng us two different perspectives. After he decides he cannot kill Rosamund, the Murderer becomes her lover in the labyrinth. When the king heard of their liason, he sent troops in to find them, forcing them to flee the labyrinth. Eventually each returned to the maze alone and ever since they have been searching for each other, archetypal lovers separated by a thin wall, able to perhaps hear each other but never to see or touch.

A similar convention of spirits of the dead speaking to us informs *Major Weir*, set in a "dark, empty, haunted mansion in Edinburgh, Scotland." The time span of the play is from 1670 to 1830 and the setting is a bit more complicated. In addition to the stool used by Jean, the Major's sister, Nigro asks for old spinning wheels, without thread, that make a whirring noise. Downstage hangs a string with a noose. The Major is as he was in 1670, but Jean is as she was in 1629 when she was nineteen. The tale that the Major and his mad sister tell is filled with images of devil-worship, incest, and assorted crimes to which the Major tells us he confessed. For these crimes both he and Jean, with whom he acknowledged an affair, were hanged, even though many at the trial did not believe his raving recital of evil. But his sister substantiates his story. Dresed in a white nightgown—yet another Ophelia archetype—she is vulnerable, poetic, beautiful, and passionate. As the spinning wheels turn, she whirls wildly around the stage. Even the doll that she holds early in the play is eventually put in the noose of string, spinning. As in the previous play, the two characters never look at each other—until the end, when, as the lights dim, the Major turns to look at Jean, who is watching the doll.

In addition to *The Red King's Dream*, there are two other short plays for two women. *Binnorie* is a poetic re-creation of a tragic tale of two sisters in love with the same man. The women tell their story seated on chairs, one using a language of fantasy and romance, the other more realistic, down-to-earth. Although what happened is left deliberately ambiguous, it seems that the poetic sister watched the other drown and did nothing to save her. Later that night the wet cold body of the dead sister visited the bed of the poetic sister, driving her insane.

In *The Dead Wife*, a play perhaps instigated by the O. J. Simpson murder trial, a woman who was stabbed to death by her famous husband appears to the husband's new wife, warning her that she is in

danger and giving her a knife, the weapon used to murder her, suggesting that the new wife use it on her husband. The play requires a bed, a white nightgown for Laura, the new wife, with a black nightgown for Maud, the dead wife. We hear the ticking of a clock and, as the lights go down, the sound of heavy footsteps approaching.

In *Donkey Baseball**, Lefty, a pitcher, and Bart, a catcher, sit on a bench that represents the bullpen. As they watch the minor league game occurring as if behind the audience, they describe what is going on during the game and what their lives are like. As the inning progresses, the opposing team loads the bases; Pottdorf walks in a run and, after a number of foul balls, serves up a grand slam home run. In the course of their commentary, Bart describes the difficulties of playing donkey baseball (regular baseball except that everyone is riding donkeys) and suggests that life is donkey baseball, an analogy that Lefty recognizes as pertinent.

In another play for two men, *The Tale of the Johnson Boys**, Henry and John, in their late teens, are illuminated as if by the light of a campfire down center. In a prefatory note, Nigro tells us that these boys are relatives from the past (over 200 years ago) and that their story has survived since then. The boys speak of a past event, of being surprised in the woods and held captive by two Indians. When the Indians fall asleep, John convinces Henry that they have to kill the Indians. Henry shoots one Indian and John bashes out the brains of the other with a tomahawk. The boys get back to their cabin at breakfast time and John insists that the men come back with him to verify their story of killing the Indians. They find the Indian that Henry shot still alive, his lower jaw blown away, and leave him to die.

Three of the two-character plays—*Lurker, Specter,* and *Something in the Basement*—deal with a threat from a real if mysterious source. In *Lurker*, a man and a woman sit on two wooden chairs, speak of the same events, but do not look at each other. Marston is dressed in a rumpled suit and describes his growing obsession with the woman, Lil, who is wearing an open shirt over a bikini. Bird sounds suggest a garden. Marston relates how, on a midnight walk, he saw Lil undressing in her upstairs bedroom. Like Arbuthnot in *Nightmare with Clocks*, Marston moves closer and closer to her as the days and nights go by. He develops a hatred for her cat and dreams of killing it. He stops going to work: he can think of nothing but his need to see and touch the woman. He discovers a hole in her backyard fence through which he can see her sunning herself in her garden. One night, in desperation, he finds an open window, enters the house, climbs the

stairs to the bathroom where he can hear water running, opens the door, and is stabbed to death by the waiting Lil. She has been commenting on her need for habit and ritual and the lessons she learned from her father. She discloses that at night she digs in her garden by her three rose bushes. Marston, speaking as if mouldering in the soil of the garden, accepts his fate, while Lil, like the Old Woman in *The Garden*, waits in front of her (now) four rose bushes. She is aware that another candidate, a fifteen-year-old boy with a bicycle, is peering at her through the hole in the fence..

In *Specter*, two wooden chairs are placed side by side to represent the front seat of a car. We hear the sound of thunder after a flash of lightning. No costume description is given for the man, Norris, but the woman, Marla, wears a white dress. They speak directly to each other and from their dialogue we learn that Norris has put his car in a ditch trying to avoid Marla, who was standing on the road in the rain. He has given her shelter in his car while they wait for someone, possibly Marla's boyfriend, who had earlier let her out of his car at her request. Norris discloses that he teaches English at Princeton, but he has trouble getting a truthful answer from her. He gives her his coat to help her stay warm, and as they talk the dialogue escalates slowly into a contest over who has done the wildest thing, a contest made more imaginative, perhaps, by the liquor flask that Norris produces and shares with Marla. She tells him that the wildest thing she has done is to allow herself to be picked up by strange men on stormy nights, engaging them in conversation, possibly even making love with them, while she waits for her boyfriend to appear. He then holds the stranger while she cuts the unfortunate man's throat with the boyfriend's hunting knife. She kisses Norris as, she says, she kisses the strange men just before she kills them. Norris pretends to start forcing her to have sex, telling her that it is not a good idea to deceive people or to trust strangers. But he puts his coat around her shoulders and they enjoy the "illusion" of safety and company until blinding headlights shine on them from the darkness. They can't see who it is, but Marla thinks it is probably her boyfriend. Norris and Marla look at each other as the stage goes dark, leaving us to ponder their fate.

The longest of the two-character plays, *Something in the Basement*, requires a more elaborate, but still minimal, set. Two rooms are suggested, a bedroom (a usable bed) and a kitchen with "some suggestion of cabinets and sink with window above." In the imaginary upstage wall of the kitchen is a door to the basement. The door must be practical and very sturdy, but "a detailed realistic environment, beyond

what is actually used in the play itself, is not desirable." The play has eight numbered scenes: night, morning, day, night, morning, night, day, and night, but the action is continuous. The play begins with Philip and Mary in bed, reading. Mary tells him that she doesn't want him to bother her, to even touch her. She thinks that since she cannot get pregnant sex is ridiculous and obscene. Philip argues, but Mary thinks she hears a sound coming from the basement. He goes down to look and returns with a round-bottomed green bottle but says he saw nothing in the basement. Mary insists that he did not look long enough and says that she is frightened and cold and now wants Philip to make love to her, but he has fallen asleep. Although Nigro gives no indication of how transitions between scenes are to occur, dimming the lights and bringing them up again would suffice to indicate the next scene: morning. We hear bird sounds as Philip and Mary dress. He thinks there is a rational explanation for Mary's fear of basements, but she relates a sexual experience she had with a young man she barely knew. Philip leaves without responding. As the scenes progress, Mary does go into the basement and while she is there we (and Philip) hear the sounds of tinkling glass, Mary laughting and, eventually, moaning and groaning as if in a sexual frenzy. Philip thinks the noise she hears is caused by cats or squirrels and he boards up the windows in the basement, telling her she must choose between returning to the basement or living upstairs with him. He plans to board up the basement door, closing it forever. Mary promises that she will just go down to have a look and that she will be right back. Hearing Mary laughing in the basement, Philip picks up a hammer and begins boarding up the door to the basement, slowly at first then more and more frantically. Mary asks to be let out, but the lights fade to black.

Ragnarok depends for its chilling effect on the audience's gradual realization of the identify of the two characters, called in the script Yg (a serious young man in a white suit with vest) and An (a pretty twenty-five-year-old woman in a white dress), although their names would only be known to the audience through the program since, like other Nigro characters in these plays, they do not call each other by name. As the play begins, An, sitting in a wooden chair downstage of Yg, seems disturbed, and Yg questions her about her emotional state. She explains that, although she knows the work, apparently scientific, that she and Yg are doing is necessary, it still bothers her. Yg points out that this, their life's work, is what they have been trained to do, that they have learned many important things. An says that she has become attached to their subjects and thinks that they are suffering "like us."

She says that their subjects are intelligent, that they live in cities. For Yg (and for Nigro) this fact demonstrates that the creatures are an entirely different species. When An insists that the creatures possess languange, Yg derides their noises and scratches. That the creatures have traveled to the moon is only an indication of how vastly inferior their intelligence is. He and An need to continue their experiments for the good of their species, a race of superior beings from Andromeda, who are treating humans exactly as humans treat rats, and monkeys, and rabbits. Yg's clinching argument is that the humans are not worth a moments's concern because they kill other animals for sport, for fun, and put the heads up on walls as trophies. An is horrified and agrees with Yg to carry on their experiments, fetching babies to see the effects of drops of acid in their eyes.

In *Necropolis*, Post, a 35-year-old American, and Anna, an East European woman of 24, are in the bedroom of a hotel. Anna is wearing Post's shirt as she sits on the edge of the bed wondering why she has just had intercourse with a stranger. Post, a journalist, tells her that he volunteered to come to the war-torn city because it was his job. Anna tells him that she is a sniper, the best shot in the city, an Olympic-class marksman with a rifle. She shoots those she believes are enemies. From two blocks away and four stories up, she makes their heads explode, and she never misses. No one pays her; it is her job. Post wonders how she can make life-or-death judgments without remorse. She asks what it is like for him to be a watcher, but he says that they are both watchers: he watches and writes, she watches and shoots. Post thinks that their making love was more than a casual release of tension and asks her if she would like to help him in his job by translating and taking him to places in the city he could never get to on his own. He doesn't want her to go back into the street, hiding in bombed-out buildings, doing what she does. Anna says that she is caught in the waste land and must play out her part in the story. She asks Post if he would marry her to save her from her fate. When he hesitates, she tells him that he can keep her panties and she will keep his shirt. Someday, she says, she may find him in her sights and perhaps blow his head off. She tells him that if she sees him looking over his shoulder she'll know he's thinking of her

* * * * * *

The nominal setting for *Wonders of the Invisible World Revealed* is "A parlor at the Coach and Horses, an inn in Sussex, towards the end of the nineteenth century." But, Nigro's description continues, "just an armchair for Griffin will do." Griffin is an invisible man, every part of

his body concealed "by clothing, gloves, bandages, or glasses." He is talking to Millie, a young housemaid, confusing her, giving her a difficult time, accusing her of staring at him, of fidgeting, of wondering why he is covered in bandages. He insists that she guess why he is swathed in bandages, but she remarks that he must be very unhappy to waste his time bullying a poor servant girl. She thinks he must have a secret, and he offers to trade secrets with her. He tells her that he is invisible and, when she insists that she can see him, argues that he must not be confused with the clothing wrapped around him, just as she is not defined by her flesh. Griffin points out some of the advantages of being invisible, one of which is the ability to go where others can not, to see what others are forbidden to see, like a beautiful young girl bathing. When she is incredulous, he describes her attic bedroom, her breasts, her pubic hair which he has seen because he was in her room, naked and thus invisible, not only as she bathed but as she later pleasured herself. He describes her masturbation in great detail, calling his experience watching her "the most profound and possibly the only true religious experience" of his life. Millie calls him a monster and demands that he take off the bandages so that she can see him. Griffin explains that he is like God, that she must take it on faith that he exists, because if he takes off his coverings he would be revealed as nothing. When she says that she believes that he is nothing, he starts to dismiss her, but then asks what her secret is. She says that she thought he already knew her secret: that she, too, is invisible. "Yes," Griffin says, "I can see that." And with this stunning anagnorisis/peripeteia, the lights fade and we hear the clock ticking in the darkness.

In *Wormwood*, two characters, Cline and Sheila, are sitting on a rug in front of an invisible fireplace down center. A wine bottle and two glasses are behind them and we learn that it is about three in the morning and they are in Cline's mansion deep in the woods. Sheila explains that she doesn't ordinarily accept invitations from strangers but that Cline impressed her with his expensive clolthes, good manners, and Mercedes. They begin to kiss but Sheila wants to know how Cline got his money, and, when he tells her that he is a self-made man, she presses him for more information. Cline says that he is the most successful maggot farmer in America. Realizing the source of the strange smell she has been experiencing, Sheila wants to leave. Although he offers her the keys to his Mercedes, Cline refuses to drive her home because he is sick of the prejudice and loneliness he endures because of his maggots. He explains enthusiastically how he discovered that maggot excrement makes "wonderful" fertilizer. The

maggots eat any and all refuse and the more maggots, the more fertilizer. He employs over six hundred people on his acres and acres of maggots that are "perfectly happy to live in huge piles in vats and bins." Maggots, he tells her, are excellent sources of protein and he has developed over fifty delicious recipes. Maggots can solve the world's waste and hunger problems. Maggots are the secret of life; in fact, God, salvation and resurrection into eternal life are the maggots. When Sheila says she is not feeling well and wants to leave, Cline offers her another hors d'oeuvre. Realizing that the hors d'oeuvre are made from maggots, Sheila runs out holding her mouth. Cline calls after her, telling her that she has gone into the maggots vats area and warning her about falling in. We hear Sheila screaming as Cline munches on an hors d'oeuvre and says that interpersonal relationships are getting too complicated. He thinks that perhaps he should get a dog.

A very recent two-character play, *Memoirs**, takes place on "an American front porch in the Gilded Age," and concerns a series of conversations between Mark Twain and Ulysses S. Grant. The two smoke cigars, agreeing that it is a ridiculous habit but that they are too old to give up smoking. Twain tells Grant that he should write his memoirs of the Civil War and his time as President. Grant rejects the idea but asks Twain to stay. The lights fade, we hear the sound of birds, and the lights come up as Grant looks at a contract. Grant says that he is almost out of money and that a publisher has sent him the contract for his memoirs. Twain looks at the contract and offers to publish the memoirs himself, giving Grant seventy per cent of the returns and paying for publication out of the remaining thirty per cent. Grant agrees and the lights fade and them come up as Twain whistles while Grant writes. He complains about the difficulty of writing, saying that he prefers the company of horses to people. But he has to finish the book before the thing growing in his mouth (cancer) kills him. Twain says he cannot write like Grant, starting at the beginning and working through towards the end. Twain then tells Grant how he killed a man in the war, or at least fired at a lone horseman. Grant says that while Twain sees one face he sees thousands and thousands. The light fades and comes up on a twilight scene with Grant still scribbling with a shawl wrapped around him. He must communicate with Twain by writing notes because he is unable to speak. Twain reads aloud a note saying that the battles at Shiloh and The Wilderness were nightmares. Twain reads other notes from Grant saying that when he finishes the book he will die. Twain says the same is true of him and

smokes his cigar as Grant writes, the crickets chirp, and the light fades and goes out.

Short(er) Plays: 3 Actors

While five of the two-character plays dramatize parts of the Pendragon cycle, none of the three-character plays does so. And while there are four plays for three women, there are no plays for three men. In *Lost Girl*, for three women, Nigro uses a repetitive structure in which one girl lost in a foreign country is replaced by another. The setting is a park bench and we hear birds singing as Mala, wearing a backpack and carrying a huge map, approaches Lara who is seated on the bench reading a black-covered book. Both women are in their early twenties and wear blue jeans and tee shirts. Lara's first word, in response to Mala's, "Excuse me," is "Futhorc?" the name of a rune. Lara's vocabulary is meant to elicit laughter along with a sense of a foreign country. She speaks in a humorous gallimaufry of Latin, English, German, and morphemes that resemble English but are not. Mala is looking for Yggdrasil, a mythical/literary allusion that Nigro does not explain. In the course of their conversation, Lara takes Mala's map and backpack and goes off to find Yggdrasil. Mala picks up the black book and starts reading it upside down as a third woman, Nola, enters, and the initial dialogue of the play is repeated, as one lost girl frees another to continue the search for the magic oak tree.

In *Ballerinas*, three dancers, Petroushkas, Scheherazade, and Giselle, appear in the set of a backstage dressing room. They are "delicate, graceful, exquisitely beautiful creatures." Since the play opens with music from *Swan Lake*, we may assume that it is intermission and the dancers are attired as members of the corps de ballet. The contrast Nigro highlights in this play is between the earthy, vulgar realism of the girls' language and the beauty they create with their disciplined art. Petroushka drinks from a flask and Scheherazade lights up a fat cigar. Giselle holds her head oddly to one side and complains that she is turning into a bird, a swan that is dying. All three lament their physical problems, the conditions under which they have to work, and the fact that they haven't been paid in a long time. Giselle decides that she will not go back on stage and curls up into a ball on the floor. Petroushka agrees that support for the arts has been eaten by pigs, that the world will soon be inhabited only by vultures, snakes, and pigs, and there will be no more swans. Scheherazade insists that they, the dancers, have always existed and will always exist, that the universe is the dance of Shiva, and that pigs cannot kill the dance because stories

will always be told and performers will always enact them. We hear again the music from *Swan Lake* as she looks at a large feather she has found in her cleavage, and the lights go to black.

Another play for three women, *Ida Lupino in the Dark**, is set in a room illuminated by the "eerie glow" of a downstage television screen. Minnie is surrounded by sound-making devices which she uses to punctuate her narrative of a movie with stars of the thirties and forties. She uses an overturned bicycle with a horn and a playing card in the spokes of the back wheel to create the sound of an old movie projector. A tape recorder plays violin music and she herself plays "dramatic and ominous" chords on a battery-operate keyboard. When she blows the fog horn twice, her younger sister, Sherry, opens the upstage door to the room, asking if everything is all right. Minnie tells her to close the door becaue she is letting the dark out. She then tells her sister that Minnie is her *nom de plume*, that she is really Ida Lupino directing a movie that takes place in New York in the 1940s. When Minnie blows a "loud racetrack fanfare" on a trumpet, her older sister, Caitlin, bursts through the door. She turns on the lights and Minnie starts screaming, long and loud, until Sherry turns off the lights and closes the door. Minnie continues narrating her movie (with sound effects) and when Caitlin tries to interrupt, asking where Mac, Minnie's husband, is, Sherry says that Mac has gone to New Jersey to look for manikin parts. Minnie tells her sisters the plot of her movie: an older sister is smothering a younger sister with loving concern and the youngest of the three sisters is sleeping with the middle sister's husband. Minnie says that "they" wanted her to play the betrayed sister but that she decided to direct instead. She calls for places and Sherry sits on the couch next to her and Caitlin sits on the other side as Minnie narrates the story of fog creeping in. One, she says, is a murderess, one is doomed, and one can only watch helplessly as the hands of the clock move toward midnight, when gigantic worms and humongous rats will come to devour them. Without warning, she says, they are engulfed in darkness. Caitlin blows the foghorn. Blackout.

In the last play for three women, *Barefoot in Nightgown by Candlelight**, three girls in white nightgowns—Cath, Alicia, and Belle—huddle together barefoot on a bare stage as if illuminated by candlelight. Cath, a recent arrival at Miss Evesham's boarding school, is selected by Alicia and Belle to be the third member of their group that plays a game called Mistress and Slave. Cards from a deck are dealt until one girl gets the Queen of Spades and one girl the Queen of Hearts. The girl with the Queen of Spades demands that the girl with

the Queen of Hearts perform one act, and the act must be performed no matter what it is. The third girl is a silent witness. The first game—they only play one night a month when the moon is full—requires Cath, the Slave, to kiss Belle, the Mistress, long and tenderly on the lips. In the next game, Belle demands that Alicia dance naked in front of the fire in the parlor. Then Alicia demands that Cath steal something from Miss Evesham's night stand while the woman is sleeping. Cath takes a picture of a young man from the night stand. The next time, Alicia, who knows that Belle is afraid of heights, demands that she stand on the edge of the roof and count slowly to one hundred. Cath pleads that the game be stopped. But Belle fulfills the task, saying, "that's the game." As Mistress the next month, Belle orders Cath to strangle Miss Evesham's canary. Alicia and Belle tell Cath that a girl who quit playing the game just before Cath arrived died suddenly and unexpectedly. Cath strangles the bird, but when it is her turn to be Mistress she orders Alicia to go in her nightgown to the barn where the gardener's one-eyed son sleeps and give herself to him. A month later, Miss Evesham finds the missing picture of the young man under Cath's mattress, calls her a thief in front of the whole school, slaps her, and tells her that she will be sent home in the morning. Alicia says they must play the game one more time. Cath deals and Alicia as Mistress orders Belle to burn Miss Evesham in her bed. The girls describe the dropping of the lit candle on the bed and how they ran down the stairs and out of the house until they got to the top of the hill, where they watched the fire destroy the house and its inhabitants. But, they conclude, all they have done is play the game.

* * * * * *

Two early plays, *God's Spies* and *Crossing the Bar*, call for one man and two women. In *Crossing the Bar*, two old women, Gretchen and Margaret, are sitting on folding chairs before an open coffin while organ music plays. The women remark on how good the corpse looks, and what a great tragedy ("like King Lear") the man's death was, how God works in mysterious ways, and how nice, as a little boy, the dead man was. They begin to sniffle as they wonder how they will be able to go on without the man visiting them every Friday night and playing his saxophone in church. They note that the man looks amazingly similar to his appearance when he was alive, even to his facial twitch, realize that the man is alive, and get him to sit up, but the body falls back down. They prop it up with an umbrella and Margaret sings the opening lines of 'Indian Love Call' as Gretchen slaps the man, shouting at him to wake up. The man emits a violent sneeze; the women scream;

the body falls back in the coffin and starts singing 'Indian Love Call.'
The man mentions the name of Betty and speaks of her as a former
passionate lover. Ranting of Betty's beauty, he tries to get out of the
coffin but the women push him back down. Gretchen beats him
violently with the umbrella and slams the coffin lid shut. As the lights
fade we hear the voice of the man singing "quite beautifully," the
closing lines of the song.

 God's Spies is set in a Christian television station, but there are only
three chairs on the bare stage. Dale, a woman of 25 with too much
jewelry and makeup, sits in the middle chair; on one side sits Calvin,
22, "gangly and intense;" on the other is Wendy, 19, "small and thin,
no makeup, in a clean but faded Goodwill dress." Dale speaks to the
invisible camera down front, introducing her guests as Calvin, who will
be speaking about devil worship in modern music, and Wendy, who
spoke to God in a belfry. In a not totally literate Midwestern dialect,
Calvin tells us that the pictures on tarot cards (he rhymes the word with
carrot) are sold in subversive locations like bookstores and universities.
Wendy then relates a childhood experience when she was looking for
God. Although her mother had warned her to stay in the house because
a bad man who wasn't nice to little girls had escaped from the state
hospital, Wendy disobeyed and went into an unfamiliar church with a
steeple. In the basement of the church she found a skinny old man with
dirty clothing hammering nails into a little wooden box. The old man,
who cannot speak except for an AAAAAAA sound in his throat, shows
her the wooden animals he has carved. Hearing a church bell ringing,
Wendy ran upstairs and saw in the belfry the fat, red-faced pastor
ringing the bell. Although beaten and sent to bed without supper,
Wendy thought the old man must be very hungry and put some grape
juice and crackers in a bag to take to him. She found no one in the
basement of the church and climbed the stairs to the belfry, feeling that
there was someone behind her. She heard a voice saying what a soft
body and fine hair she had and turned to see the red face of the fat
pastor and knew that in her search for God she had found the Devil.
But as the man reached out to molest her, someone pulled the bell rope,
the bell started ringing, and the fat pastor fell from the bell tower to his
death. Wendy gives Dale a carved wooden pony she found in the
church basement, saying that it's a gift and won't cost fifty-eight
dollars (like the Bibles that Dale has been hawking). Dale closes the
program by telling her audience that if they want a Bible, she will see
that they get it for free.

Another Nigro investigation of religious beliefs, *Bible*, is hilarious as it answers the question of what happens when the words of the Bible are taken literally. Mama is a beautiful young woman in "neo-Victorian finery," sitting on a park bench with her children—Annabel (a petite adult actress dressed as a young girl) and Harry (a boy played by an adult actor). Mama explains that Papa cannot be with them because he is hard at work, as a Christian censor, burning books, throwing writers in jail, and destroying all pictures of those "in a state of undress." Letting the Holy Spirit guide her fingers, she picks a passage at random from the Bible to read to the children. She reads from Genesis about Judah going in unto Shuah who bore a son named Er. She reads that Shuah had another son, Onan, and another, Shelah. Harry remarks that people must have spent a lot of time in their tents conceiving and, when told that Judah took Tamar as a wife for Er, wonders how Er grew up so quickly. Mama tells him it was because he ate all his vegetables and Harry asks if he will grow up quickly and begin conceiving if he eats all his vegetables. Mama says that only women can conceive and reads that the Lord slew Er. Annabel is perplexed: Er was just conceived and now the Lord has slain him. Mama explains that the Lord slew Er because he stopped eating his vegetables. At this point, Mama needs a drink and takes a swig from a little bottle in her purse. She continues reading the story of Judah giving Tamar to Onan, who spills his seed on the ground, and the children's questions—simple, logical, child-like—force her to supply answers that are ludicrously funny. Harry and Annabel start arguing and calling each other names and, when Mama scolds them and tells them to make up, Harry kisses Annabel on the cheek and then on the lips, bending her to the ground. Mama separates them and reads how Tamar put on a disguise and went to see Judah. When she comes to the passage about Judah thinking thatTamar was a harlot, Mama closes the book and says that they all lived happily ever after. When the children urge her to continue reading and take more of her medicine, she does, forcing the children to drink from her bottle. She reads how Tamar conceived by Judah and was condemned by him to be burned for whoredom. With all three feeling the effects of the "medicine," Annabel, wanting to be as pure as Adam and Eve in the garden, runs off stage and proclaims that she is naked. Harry runs off to be naked and not ashamed with her, and, after reading a passage from the Song of Solomon, Mama leaves to do likewise, saying what a surprise it will be for Papa when he comes home.

Another very funny play, *Come into the Garden, Maud**, develops out of a phone call from a woman who says that there is a cat ("your cat") in her garden. The stage is divided by light into two areas, Phoebe's and John's, each with a chair, a lamp, and a small table on which is a telephone. After Phoebe tells John that his cat is in her garden, John tells her she has dialed the wrong number. Phoebe insists that she has the right Murphy, even though John says there are a hundred Murphys in the phone book. He hangs up; she calls again. He says he doesn't have a cat, that it's four in the morning, and asks her to stop calling. He yells at her, hangs up, and turns out the light, but she calls back, asking John why he is being so rude to her. They talk at cross purposes, each misunderstanding the other. Phoebe tells John her name, and Jill, wearing the top half of pajamas (John is wearing the bottom half), enters, learns that John is talking with Phoebe, assumes that he is seeing her romantically, and wants to go home. To clarify the situation, John asks Phoebe to talk with Jill and explain why she called. Phoebe is convinced that there is a Mrs. Murphy, even though John has told her he is not married, and she and Jill talk about sleeping with married men (they don't) and being allergic to cats (they are). They decide that John must have thrown the cat out when Jill arrived and that is how the animal got into Phoebe's garden. Convinced of John's treachery, Jill slams down the phone and leaves to get dressed and go home. Phoebe calls again to tell John that perhaps she was mistaken about the cat, that some "very large object" is in her garden moving closer to the house. John says he can't come over because he doesn't know where she lives, that there are woods on one side of his house and an empty house on the other side;. Phoebe says "the thing" is banging on her window and we hear the sound of glass shattering as Phoebe pleads for John's help. The lights go out on Phoebe and we hear the sound of a dial tone. John hangs up, the phone rings, and he asks for Phoebe, but there is only silence as the lights on him fade and go out.

A combination of Groucho Marx-like stichomythic dialogue, mistaken identity, and a repeated statement occurs also in *Creamery**, but without the sense of menacing threat from a mysterious source. In our imaginations, helped by a program notation of location, we are in "an ancient, falling apart little train station somewhere in Arizona," but there is only an old wooden bench on stage. Maureen and Will, both 27, stand by their bags; Tammy, an "enormously pregnant" 19-year-old, is sitting on the bench. Maureen is angry with Will because his car has broken down, stranding them in the middle of nowhere. She complains about the people at the station, including the pregnant girl,

and leaves Will with the bags while she goes to get more information. Tammy, addressing Will as "Bobby," tells him that she is dying, that God is eating her nose. She pulls him onto the bench and tells him that she is going to tell him how to cure hiccups. He starts to hiccup, tries to leave, and in the struggle they fall to the floor, ending up with Tammy sitting downstage, her legs spread, and Will sitting behind her, her back against his chest. In a hilarious sequence, Tammy blames Will for giving her the hiccups, claims that she can do anything (except cure herself of hiccups), and asserts that the secret of life is the secret of curing hiccups which she is about to reveal to him. She starts crying and says she has no idea where she is going to have the baby, feels that she has become a great "Zeppelin Creamery," but knows a peace she has not known for perhaps nine years. We hear the sound of a train whistle and Maureen returns, sees Will and Tammy together, enumerates Will's disgusting personality traits, takes her bag and leaves. Will tells Tammy that he has to go, but she points out that his hiccups are gone, although she doesn't know how she cured him. She says it's all a matter of chance, of destiny. Although Will repeats that he has to go, neither of them moves as we hear the sound of the train coming into the station. The lights fade as she snuggles up to him.

Warburton's Cook, is based on a recorded event in the life of the antiquarian John Warburton (1682-1759), a number of whose rare manuscripts from the Elizbethan-Jacobean period were either used by his cook to start a fire in the oven she used to bake pies or scorched beyond repair when put under the pie bottoms. Dorry Roach, the housemaid, is sitting at the table in the kitchen eating a pie, an experience she says is almost better than kissing. Betsy Baker, the cook, tells her that the pie is the secret of life, the way to a man's heart, the great leveler. The women comment on the great mess of rubbish in Warburton's study, which Dorry has been forbidden to enter, but which Betsy straightens up when the master is out at a coffee house. Betsy loves him, but since he won't look in her eyes, she expresses her love with pies and fire to keep the house warm. Warburton wants to know what Betsy has done with his manuscripts, explaining that he had sixty-five handwritten copies of plays from the Elizabethan-Jacobean period, some nearly a hundred and fifty years old. When he asks her if she has thrown the manuscripts out, she tells him that she used them to get the fire going and to line pie bottoms. Furious, Warburton explains that among the manuscripts she destroyed were handwritten copies of plays by William Shakespeare, unpublished and unknown until he found them in a bookseller's trunk. Betsy asks why he needs dusty old copies

of plays when he can go the Drury Lane and see Shakespeare performed. Trying unsuccessfully to describe the enormity of the loss she has caused, he tries to scrape out the crust and contents of a pie, burning his fingers and pulling out "utterly illegible" strips of old manuscripts. When he calls Betsy a "cretin," she reminds him of how she cared for him during his serious illness and berates him for what he has done to her "beautiful" pie. She begins to cry and he looks at her for "a long moment" before asking Dorry to bring him some milk and a bowl. He puts the broken pieces of pie in the bowl, pours milk over them, and begins to eat, asking if the cherries are from a neighbor's garden. Dorry says that Betsy got up early in the morning to pick them herself. Warburton describes the pie as "wonderful," "extraordinary," the "finest pie" he's ever had. Betsy asks if he really thinks so, and she smiles as he says he is very happy with the pie, that it is a work of art.

Charity and forgiveness play a central role in *The Sin-eater*, a play set in Wales "in another time." As the lights come up we see a girl in white lying on a bed, at the foot of which stands her sister, mourning, in black. The Sin-eater, a ragged young man, describes in a monologue how his task of symbolically eating the sins of the recently deceased was part of his family's heritage. Because of their "dark privilege," he and his family lived on the outskirts of the village in abject poverty, shunned until someone died. But this time, he says, is different. He has known the sisters since they were young. The older, darker sister sometimes would take pity on him and leave food out for him, while the younger, livelier sister would make fun of him. He loved the younger sister and now must enter her house to eat her sins. The older sister urges him to get started and leaves to get bread, cheese, and wine for the ceremony. The young man, saying that the beautiful younger sister looks as if she were still alive, falls to his knees at the foot of the bed. The younger sister speaks, telling us that she is not dead, that she can hear and smell and feel touch, but that she cannot move nor open her eyes. She thinks she may have had an epileptic fit like her grandfather who once interrupted his own funeral by sitting up and announcing that he wanted some crackers. She hopes they won't bury her alive, tries unsuccessfully to pee, and wonders what the boy is doing at the foot of her bed. The older sister returns with the food, places the plate on her sister's breast and tells the young man to get on with his job of eating the food and thus symbolically taking into himself the sins of the dead woman. The younger sister says she would like some crackers, setting up an hilariously funny counterpoint: the convention is that we in the audience can hear her, but her sister and the

young man cannot. When the older sister leaves, the young man expresses his undying love for the girl he believes dead. She responds by calling him a "lip-diddling imbecile" and asking for a piece of the cheese. The young man says to himself that he is having evil thoughts and the girl in the bed shouts, "Necrophilia. Necrophilia," but the young man kisses her, twice, "long, reverential, and very erotic." The older sister returns, curses him as a monster, and orders him to leave, saying that the men of the village will tear him to pieces. The young man moves downstage to the edge of the light as the younger sister sits up in bed and tells her sister that she must not be mean to the Sin-eater because he saved her life. The Sin-eater lies down on the stage as if lying back in water, accepting death. When the older sister tells the younger that the Sin-eater has drowned himself, the younger sister takes the plate of food to where the young man is lying and puts the plate on his chest, preparing to eat his sins. She kneels and kisses him "long and tenderly" as the older sister watches and the lights go out.

In *The Sin-eater* Nigro offers a possible physical explanation for the apparent death and resurrection of the younger sister. But the labyrinth has many paths and as way leads on to way different forces make their appearance. In *Asmodeus**, the demonic takes the stage. Sitting on a bed framed by pulled-back mosquito netting, Sarah, a woman in her twenties wearing a "lovely Victorian lace nightgown" speaks to someone in the darkness, asking if "it" has been killed. Gabriel, a man in his twenties wearing "red long underwear, a pith helmet and boots, carrying a valise in one hand and a tennis racket in the other," walks into the light saying that he can't find any bats. Sarah insists that there are bats and wants to move to another room in the hotel, but Gabriel says there are no more rooms; they have explored them all. Sarah says she doesn't like the room because she doesn't like mirrors, that as a young girl in Bombay she used to stare into mirrors for hours, believing that she could see somebody else in the mirror. She tells Gabriel that since they are now married she must tell him a secret. She has been married before, not just once but six times, making Gabriel her seventh husband. She says that when she drinks, she gets married, and Gabriel hopes that she has at last found the right man. She tells him that Asmodeus, who killed her previous husbands, is going to strangle him. We hear a creaking noise growing louder and louder until Asmodeus, a young man in a white suit with a red flower in his lapel, enters pushing an "old cobwebbed Victorian baby buggy." Gabriel notes that the pram is full of snakes and wonders why Asmodeus must strangle Sarah's husbands on their wedding night. Asmodeus says it is because he fell

in love with her beauty and allowed her to see him in the mirror. His punishment for loving a mortal is that he must kill her husbands because, while sex is encouraged in Hell, love is forbidden. Gabriel announces that he is, in fact, the Archangel Gabriel, takes a trumpet from his valise and blows two "incredibly loud, hideous" notes, then asks Asmodeus the name of the bridegroom on the marriage license. Asmodeus protests that Gabriel has forged his signature but eventually kisses Sarah and then "madly and violently" strangles himself. Sarah wonders if she might now have a proper wedding night, perhaps even achieving something like an orgasm, but Gabriel tells her that if she does if will be without his participation, since archangels are not permitted to have sexual intercourse. When she accuses him of lying, he says that he was just playing a part, puts the horn in his valise, shakes hands with her and leaves. Sarah gets into the bed with Asmodeus and pulls the mosquito netting down. Calling Asmodeus her lover, her husband, she wonders if he is only sleeping, if there is a spell for raising demons from the dead. She kneels on the bed holding his head in her arms as the lights fade and go out.

A mysterious and perhaps otherworldly power has, in *The Revenant**, caused two Victorian gentlemen to meet at a park bench late at night. (A revenant is explained in the dialogue as one who returns after a long absence, especially one who returns from the dead.) Again we find the mixing of menace with hilariously funny dialogue as Haggard and Leaf try to figure out why they have been summoned to the park in the dead of night. They soon decide that some mysterious third party has brought them there for some kind of retribution. Perhaps, they reason, their enemy is holding a rifle trained on them as they speak, making escape a bad idea. As they ponder who their mutual enemy might be, we hear an owl repeating their question in humorous counterpoint. Haggard insists that he did not lure Leaf to the park since he would much rather be home in bed with Lucille, the chambermaid. Leaf remarks that he, too, has often admired Lucille and can't stop thinking about her "titties." Haggard begins strangling him but lets go, apologizing. Leaf replies that the activity realigned his spine and suggests that they are dreaming. Then Haggard suggests that Lucille sent them both notes so she could sleep with someone else. His note, he remembers, smelled of perfume. After Leaf remembers that his note also smelled of perfume, they smell something else and discover a hedgehog in a satchel under the bench. There is also a note in the satchel: "Memento mori from a Revenant." The men deduce that a woman has come back from the dead to remind them of their

mortality and give them a dead hedgehog. Then a woman with a black dress and veil appears; she seems about to faint and the men rush to seat her on the bench. The woman says that she was a hedgehog once, explaining that her lover called her his "little hedgehog." When the lover abandoned her, she drowned herself. Leaf calls the woman an imposter, posing as his girl friend Sophy, who drowned herself. The woman has no knowledge of Sophy, nor of Grace, a former love of Haggard's. The Revenant tells the men that the identity of the victim does not matter, because all betrayals are the same betrayal. Leaf understands, but Haggard does not, insisting that the woman is talking gibberish and has probably escaped from Bedlam. Haggard says that he and Leaf will one day tell this story to Kipling and Henley at their club, but Leaf tells him that all betrayals lead to the same place, where they now are. Admitting that he and Leaf have acted badly in the past, Haggard asks the woman ("Grace? Sophy? Lucille?") if there is any possibility of redemption, concluding that there is not.

A dead woman appears (or does she?) in another three-character play set in the Victorian period, *Seance*. One light shines over a green baize table around which are three chairs. The room is dark but a wooden cabinet is just visible upstage. At the table, Florence Cook, a pretty young woman, sits drinking, speaking of apparitions, of ectoplasm, of "spook flubdubbery done with mirrors." She summons Katie, a "shameless little slut," to appear with her "spook and tit show." We hear the sound of a door creaking open, then footsteps as Florence wonders if it is Death arriving to pick up his laundry. Sir William Crookes, "a respected physicist," enters and is appalled by Florence's intoxication, saying that he cares for her as a father for a daughter. Florence tells him that he really loves a "dead imaginary girl named Katie King," but that she and Katie King are the same person. She says that when Crookes thought he was touching Katie King he was really touching Florence. Crookes replies that he escorts her to the cabinet, ties her up, and, after each manifestation, checks her bonds which are always secure and sealed with wax. Florence explains that after the cabinet door is closed, she slips her bonds, gets out of her dress, and emerges in white underwear as the dead girl Katie King, "the girl men love to touch." She tells Crookes that she has decided to stop deceiving him because she cannot let another creature create reality for him. As we hear the sound of a clock ticking, she kisses him on the lips, and Katie King, "a pretty woman who looks remarkably like Florence in her underwear," steps out of the cabinet door. Katie tells the bewildered Crookes that Florence is right, that she, Katie, is dead, or,

rather, never was alive. The women insist that they are one and the same, but Crookes says they are both present. Crookes thinks he is going mad, but Florence, in a very funny speech, describes having visions during her "excruciatingly morbid adolescence." One day Katie King appeared and suddenly Florence was being wined and dined by royalty and very wealthy men. While she might at one time have believed that there really was such a person as Katie King, she soon knew that truth was a lie. After Katie reminds the baffled scientist of the fun they had during the séances, Florence announces that she is leaving and walks into the cabinet, closing the door. Crookes tries to speak with Florence through the closed door, but Katie tells him that she is the one he has always wanted. Crookes opens the cabinet door; the cabinet is empty. Katie urges Crookes to make love to her on the green baize table, telling him that Florence has escaped into the mirrors but that she is his forever. Closing the cabinet door, she places Crookes' hand between her breasts, saying that she is "that most seductive and yet most unsatisfying of all human objects . . . a work of art." Florence is heard pounding on the door, pleading with him to let her out, promising to be anyone he wants, but Crookes reaches out both hands to touch Katie's breasts as the lights go out and the pounding on the door continues in the darkness.

Another investigation, this time of magic, occurs in *The Mystical Egyptian Cabinet**, with predictably ambiguous results. Magus, the magician, is "the wreckage of a once charismatic performer," with a voice "somewhat reminiscent of John Carradine in an old horror movie." His assistant, Lilly, dressed in the 'somewhat revealing costume of a magician's assistant," is sitting on one of several trunks on the stage, drinking from a bottle of bourbon and petting a stuffed rabbit. She decribes the setting, the magician, the doves cooing in the rafter of the "ratty old theatre in a ratty old town," the rabbits who are breeding, and the coffin in which she is ritually sawed in half, three times a night, six nights a week. Magus sticks his head out of the trunk next to her and tries to snap his fingers to create a transformation, but fails, being too hung-over. He reaches for the bottle Lilly is drinking from, but she eludes him, telling him that she wants more out of life than being assistant to "the crappiest magician on the face of the planet." Magus finally falls out of the trunk, dives for the bottle, misses, and articulates a theme we have heard before: truth is a lie. Monica, whose job Lilly describes as being scrunched up in the coffin and sticking her feet out the other end so that the audience believes they are seeing Lilly's feet, emerges from the trunk that Lilly had been

sitting on. After grabbing the bottle from Lilly and giving it to Magus, Monica babbles about rabbits and French fries until an exasperated Lilly grabs her by the front of her bath robe, shaking her "like a rag doll." Magus separates them and, as they continue to snipe at each other, remarks that their complex philosophical arguments are sexually arousing. Monica says that she likes her life, sleeping with rabbits on her face, making love with the great magician, dreaming that they move back and forth through time, that when she is in the coffin (the Mystical Egyptian Cabinet) "all times and places are the same time and place, which is now, and which is forever." After Monica moves off into the darkness to help a rabbit that Magus has hit with the empty bourbon bottle, Lilly tells the audience that she has been dreaming of killing the magician, dragging him to the Mystical Egyptian Cabinet, giving him a bottle to keep him still, and then putting his head in the slot of the box and closing the lid. As she describes using the hacksaw she has been sharpening for months, Magus suggests that perhaps she is not his assistant at all, that perhaps he chose her from the audience and hypnotized her into believing that she is his assistant and has sawed him in half. Lilly remembers that she had been in the audience and had volunteered to be hypnotized and Magus says that when he snaps his fingers she will wake up and remember nothing of what has happened. Monica returns with a stuffed rabbit, Magus snaps his fingers, Lilly turns her head to look at him, and the lights go to black, leaving us once again, pleasurably perplexed, in the dark.

In *Lucy and the Mystery of the Vine-encrusted Mansion*, Nigro rather playfully examines what might be called the creative process in action. From the descriptions of the three characters, we get the tone of the piece: "Lucy Quoit, an occult investigatirix, alias Imogen; Diccon Mucklestane, brother to Imogen and a barnacle fancier; Daniel Rath, a somewhat disoriented hero." Lucy, holding a book, speaks of herself in the third person as if she were a protagonist in a romance novel. She describes the Lucy of her narrative as fearless, with an ancient soul, and an unquenchable appetite for "the grotesque and outré." Diccon wanders in with a bucket, calls for Imogen, sees no one, talks to "Bill" in the bucket, and goes off to the sassafras tree. Lucy/Imogen, the character in the play, continues her story of Lucy, the character in the novel, by describing in lavish, adjective-laden phrases the labyrinth of the garden into which she has stumbled unawares, carrying her well-used copy of Balzac. Daniel enters, also with a book, addresses Lucy as Imogen and sits beside her on the bench. They do not talk to each other but their lines in sequence tell a story. When Daniel takes off his

spectacles, Lucy puts them on. He and Lucy begin to tell the same story, of Daniel inheriting a mansion where distant cousins Diccon and Imogen lived. Noticing something moving in Daniel's lap, Lucy describes how she will wish for strong arms to hold her as she lies "naked and trembling" in bed. After kissing him on the cheek, she gets up, yawns, and stretches "most fetchingly." We hear the sound of a ticking clock, and Daniel describes how he crept down the spiral staircase to her boudoir. Lucy describes how she waits for him to come, adding a note to herself: "Here insert the sound of mice whispering." And, as with a creaking door earlier, we hear the sound of mice whispering. Diccon enters with his barnacle knife, used for cutting remarks, and Lucy, speaking as Imogen, says that if Daniel doesn't come soon she will start without him. Realizing that she has stumbled into someone else's novel, Lucy tells the ghost of Daniel what has happened: that he does not love her but Imogen. Daniel says he worships Lucy and begs her to write him. But Diccon says that he cut Daniel's throat with the barnacle knife and Lucy continues the story: the brother buried him in the garden, but the sister, covered with her lover's blood, goes mad and tells the brother she hates him; in despair the brother hangs himself from the sassafras tree and the mad sister wanders in the garden, "telling lurid stories to herself." That, Lucy says, is the end of the tale, and she begins another story, Lucy and the Mystery of the Haunted Windmill. Diccon and Daniel look at her as the lights fade and we hear the cooing of doves in the darkness.

A modern-day treatment of betrayal is presented in *Give Us a Kiss and Show Us Your Knickers*, in which two roommates, Amy and Page, are talking on the porch of their house about the imminent arrival of Amy's boyfriend, a person she thinks she could spend the rest of her life with. She goes into the house to pee, asking Page to entertain the man when he arrives. Wes enters and Page tells him that she thinks it's really great that Amy has "finally found a nice guy," considering all that she's been through with "all the boyfriends," and that he understands about the Benny Hill thing. Page tells a confused Wes that Amy thinks that The Benny Hill Show is the "key to the universe," containing the "secret of life." Wes thinks that Page is joking, but she launches into an extended analysis, suggesting that Benny is God, and other characters in the burlusque routines are a chief disciple, the Holy Ghost, and an Everyman figure, while the three women on the show represent the triple goddess and the three fates. When Wes wonders why Amy is so obsessed with these British comedians, Page warns him not to express his skepticism to Amy because she might try to commit

suicide again. Page adds that Amy hates men and fantasizes about killing them. Wes says that he is not going to marry Amy and leaves. When Amy returns, Page says that Wes had to leave but will call her. Page says that Wes tried to kiss and fondle her. She says men wear masks and can't be trusted and that perhaps Wes was on drugs. Amy says that she has had it with men. She cries and Page holds her, saying as the lights dim that Amy will always have Page, always.

*Fog**, is a much more poetically told story of betrayal. Rye, Lea, and Ann are seated on the "ground" surrounded by darkness and a sense of "woods in fog." They speak in seemingly disjointed imagistic phrases, each narrating part of the story that the audience synthesizes. Rye, who sits a bit apart from the two women, begins the play with a series of "because" phrases, speaking of fog, tree branches, desire, naked flesh, her breasts, betrayal, and dream. In a beautifully modulated progression, Lea and Ann join the telling, each presenting a limited perspective on the events they narrate. Rye and Lea tells us of their love-making in the foggy woods, and Lea refers to the fog as a labyrinth that "devours him." Shifting tense, she says that "he will strike his head on a branch and stumble, fall into the leaves." Rye follows with a "because" phrase telling us that he buried "her" somewhere in the leaves. Ann tells us that betrayal is real, that what you see when you look into the eyes of betrayal is "the mirror image of your own unfaithfulness." Ann describes how she let Rye kiss and fondle her, even sleeping in the same bed with him, but not allowing intercourse. She told Rye of her desire for Lea and asked him to swear to help her. He swore but then had sex in the bed with Lea. Ann, who watched them in the darkness, tells Rye she can never love him. Lea finds Rye in the woods and tells him to make love to her. He does, but after, in grief and despair, he strangles her and buries her in the leaves, takes off his belt, and hangs himself from a tree limb. Ann closes the threnody speaking of madness and betrayal, of memory and fog.

Characters from the past in *Deadly Nightshade** tell their story of lust, betrayal, and madness in a manner reminiscent of that used in *Lucy and the Mystery of the Vine-encrusted Mansion*. The time is the summer of 1900 and three characters, Molly, Jane, and Tom, "clean and attractive young people, dressed in white summer clothing (are) sitting among the ferns in a shadowy woodland glade." There is a small basket of red berries between them. Molly, as narrator of the story, begins with a jog-trot rhyming series of phrases about Tom and Jane. She tells us she hears a clicking noise at night and that she has a little cup of vinegar beside her bed in the cloistered nunnery. When

Jane and Tom speak, their lines are followed by Molly's "He/she said." with a comment on what the others are doing. Occasionally, they speak without authorial comment from Molly, but usually she tells us more about what the lovers are doing. Tom tells Jane that once he loved a girl whose eyes were always changing, and Molly remembers being in the garden with Tom. He tells Jane the kinds of things that can kill a person in the woods: "Bears, panthers, Druids, trains, indigestion, envy, plummeting grand pianos," and something else that he forgets. As it begins to rain, Jane wonders if the berries that she and Tom are eating might be the poisonous fruit of the deadly nightshade plant, but Tom, in a display of his "vast botanical erudition" assures her that deadly nightshade berries are black, not red. Molly describes finding the dead, naked bodies of Tom and Jane lying in the rain in the ferns and deadly nightshade. She tells us she took off her clothes and lay between them, kissing their lips and breasts and eating the red berries. "We are all dead together," she says and tells us that at night "you can hear the mad nuns whispering," and that there are bones mouldering in the catacombs. She has left some red berries out for the nuns. She sits in her little room, fingering her rosary, while the mad nuns babble and she hears the clicking of the death watch beetles in the walls.

Another outdoor setting is indicated in *Moonlight**, where there are three chairs (always wooden) in a semicircle facing the glow of an invisible downstage fire, the only illumination of the faces of the actors: Janet, a servant girl; May, her young mistress; and Poole, May's husband. Janet plays the role of initial narrator, telling us of staring into the fire with her mistress while Poole drank in the henhouse. May tells Janet a secret, making her swear that she will not tell her "superstitious" husband that she hears whispering by moonlight at the bottom of the garden. May thinks that the voices are whispering at the edge of the world, from a place where she lived long ago, and that her body is not her own, that she is somebody else. Poole threatens Janet with dismissal if she does not tell him what May has said. Janet says that May is not insane, that perhaps fairies are whispering to her, the same fairies that, Poole believes, steal his eggs. When May says she is somebody else and wants to go home to that other place, Poole takes this as an admission of guilt and shakes May by the shoulders, asking how he can get his wife back. He remembers that a man in Tipperary, under a full moon, took his wife to the garden, naked, tied her to the water pump, put straw around her, and set her on fire. The changeling will be burned and out of the ash, so the theory goes, his real wife will come back to him. Janet tells us that words began

coming out of her mouth, as if another voice was speaking through her, urging Poole to burn the changeling in order to get his real wife back. She narrates how she watched as Poole took May to the garden, stripped her naked, tied her to the pump, and set her on fire. May's screams alerted the neighbors, too late to save May, but they took Poole away and locked him up "forever." Now Janet is alone in the house, staring into the fire. She has begun to hear voices, whispering, that will not let her sleep.

The recurrent theme of the present being haunted by the past emerges from the narrative of *Scarecrow*. Although there are three actors—Nick, 27, in blue jeans and flannel shirt; Rose, 36, and her daughter Cally, 18, both in simple cotton dresses—the setting calls for four wooden chairs on a bare stage. Nigro's directions are that the actors move around and relate to each other but "they do not act out or mime in any way the actions they describe." After her opening speech about the scarecrow in the cornfield next to their house that seems to attract her even though it frightens her, Cally argues with Rose who warns her about walking in the cornfield. Rose says she can smell the scarecrow on Cally's clothes, that it is "a time of rut." As Nick and Cally talk we learn that they have been meeting every day. There has been no sex, according to Cally, and she is surprised when Nick tells her he has looked in her window at her. When Nick asks about her mother, Cally replies that her mother, who used to be a beautiful woman, now acts like an old person and stays in the house writing a book about the nature of evil. Nick asks Cally why she doesn't leave and suggests that the money left by the grandmother, which Rose keeps in a box in her room, is rightfully Cally's and she should just take it. When Rose notices Cally looking at the box, she says that the same thing happened to her, that the man sent her in to kill her mother who ran into the cornfield where Rose found her dead beneath the scarecrow. She offers Cally the money if she will burn the scarecrow where the "man" lives. Cally describes going into the field and approaching the scarecrow, but the matches won't light. Cally tells us she is alone in the house, now, pregnant. At night Nick comes to the house asking her to come outside, but she refuses. She tells us that she will raise her little girl to be strong and cruel, teaching her what to do, and "this time, we'll get him."

A more humorous manifestation of an infernal power occurs in *The Devil*, based in part on a story by Guy de Maupassant. The setting is the cottage of Mother Bontemps. We hear the sounds of farm animals and the snoring of Bontemps from his sleeping place on the floor and

the "pathetic snoring and difficult breathing" of Mother Bontemps in the bed. Much of the humor in this play is created by the noises the actors make and, at a loud crow from a rooster, the son awakes, sees that his mother is still alive, and goes out to pee. La Rapet, an old nurse, enters, followed by Bontemps who complains that he cannot harvest his wheat crop and look after his ailing mother as well. After much haggling La Rapet and Bontemps agree to a price of six francs for the nurse to take care of the mother until she dies and the body is carried out of the house. Bontemps leaves and the nurse sits in a rocking chair, talking with the mother, singing songs, asking if she has had the last rites, and describing what heaven is like with Jesus, handsome and strong, wearing only a little cloth, putting his arms around her and kissing her on the mouth. The lights fade as she sings and when they come up three days have passed, the nurse is asleep in the rocker and Bontemps is slurping porridge. Bontemps tells the nurse that he has made a good bargain, that his mother may live through the winter, and he exits laughing. La Rapet slams pots and pans as she warms milk for the mother, but the old woman starts singing and tells the nurse that she feels like dancing. La Rapet warns her that the devil may appear with a broom, a cape, and a saucepan on his head, uttering "loud and horrible cries" just before people die. Mother Bontemps shuts her eyes as La Rapet wraps the quilt around herself, takes a broom, a washboard, a tin pan, and a wooden spoon and, with a saucepan on her head, climbs onto a chair at the foot of the bed. She tells Mother Bontemps to open her eyes, that Jesus in his little cloth has come to kiss her, and, when the mother opens her eyes, the nurse starts banging on the washboard and the tin pan, waving the broom, and screaming "the most horrible cries and screeches imaginable." Mother Bontemps screams, chokes, gags, and falls back, unmoving. La Rapet checks to see if the old woman is dead, but of course the old woman screams again, and the nurse lets loose with another round of horrible shrieks and noises. After assuring herself that this last assault has indeed finished the old woman, La Rapet puts away her devil's costume, closes the mother's eyes, sings a four-line song, and kneels by the bed to pray.

The manic humor of *The Devil* occurs in a more surrealistic manner in a play nominally about the great Russian playwright *Gogol*. The list of characters indicates that one actor is to play Gogol, the devil, and a gypsy girl, but the devil and the girl are portrayed by the actor with hand puppets and voice changes. The other characters in the play are the Drowned Maiden and "The Nose." The setting is the playwright's

room with a bed, a chamber pot, a round wooden table with some wooden chairs, a closet, a fireplace that occasionally emits a flickering light, a window frame with no glass, a trunk, and "later, a step ladder." The running time for this three-actor play is probably close to an hour. In the dark, we hear the sounds of owls, and as the lights come up we see Gogol, with wild hair and eyes, a long nose, wearing an overcoat. Gogol complains about his job as a history and geography teacher in a boarding school that reeks with the odor of fried fish heads and boiled cabbage. Calling his audience "my friends" and referring to them as "frivolous cows," he says that his mother has the brain of a stuffed squirrel and that while Pushkin had, and Tolstoy has, the clap, he wears the overcoat because he has a case of terminal farting. From the trunk he takes out two puppets, placing the Gypsy Girl puppet on his right hand and the Devil puppet on his left. "He speaks for them, a gruff voice for the Devil, a falsetto for the Gypsy Girl." The Drowned Maiden sits up in the bed with the sheet on her head. When she pulls the sheet off, she spits a stream of water into Gogol's face. She is wearing a "clinging white dress, somewhat shredded and draped with seaweed, with shells and small octopi in her hair" She tells him that she is the ghost of the drowned maiden and has come to rescue Gogol's nose. Gogol believes that a woman removed his nose when he was asleep, but, on cue, we hear a loud sneeze from the closet. He opens the door and a "giant Nose runs out—a person in a large nose costume from head to crotch." Gogol chases the Nose until it hides under the blankets, with its head apparently between the legs of the Drowned Maiden, who begins making moaning sounds. Gogol sits on the edge of the bed and, despite their objections, takes off the hand puppets. He ruminates about his fate as a writer, telling the Maiden that the nose she thinks she sees in the middle of his face is an illusion, a doppelganger. Moaning "Oh, Nose, Nose, Nose," the Maiden puts the Devil puppet on her hand. The Devil, his voice still done by the actor playing Gogol, asks for, and gets, a "big, wet smooch" from the Maiden. The Devil proceeds to kiss down her neck to her breasts, while Gogol, trying not to notice, starts to tell a joke. The Devil puppet (on the Maiden's hand) moves under the covers and throws them back to reveal the Nose. Calling Nose "snotbucket" and "snotbooger," the Devil puppet (on the actress' hand) chases Nose around the room, running around Gogol, who continues speaking disjointedly until the Maiden sits astraddle Nose on the bed, pummeling him with the head of the Devil puppet. When the Maiden lets the puppet fall off her hand into the chamber pot and says she is cold, Gogol, still talking about writing and deciding not

to eat (since he can't manage to blow his brains out), rummages in the trunk and puts a large manuscript in the fire. It is, he says, the second part of *Dead Souls* on which he has been working for ten years but which is "absolute rubbish." He says that his greatest strength as a writer is that his work burns very well. The Maiden puts on the Devil and Gypsy Girl puppets and she and Gogol watch the book burning. Gogol describes some of the medical tortures he is undetgoing and realizes he is screaming. When Nose wheels in a tall ladder, Gogol starts climbing "onward and upward to Hell." He laughs and says that the secret of life is not warthogs, but suffering forever, because Hell is not below but above, in your nose. When he is out of sight on the ladder he calls down, "And goodnight, Mrs. Calabash, wherever you are!" The lights black out and Jimmy Durante music is played.

In *Banana Man**, two men, Buster (Keaton) and Sam (Beckett), sit at a table in an Italian restaurant in Greenwich Village in the summer of 1964. Sam asks Buster, who is eating spaghetti and meatballs, if he has any questions about the movie they are making. A Waitress thinks she recognizes Buster and, returning with some cheese, tells the men that she wants to be in the movies, too. She thinks Buster might be Moe from the Three Stooges but decides he isn't. Buster and Sam resume their stichomythic conversation about movies and writers until the Waitress returns to ask if they are an old vaudeville team that she might have seen on the Ed Sullivan Show. She describes an act that she saw, and Buster tells her that she is talking about the Banana Man. Sam says that he is the Banana Man and Buster says that he is the banana. The Waitress calls offstage as if to her boss, Guido, and Buster tells Sam some of his early experiences in vaudeville with his father. Buster says that he is sorry that he couldn't accept a part in *Waiting for Godot* but that the play didn't make any sense to him. He says he doesn't understand the movie either but he really needs the money. Sam explains that what he is trying to do in the movie is explore the relationship between being and perceiving. The Waitress returns, yelling back at Guido, and needs to be helped to a seat because, as she explains it, she always goes blind when she gets really pissed off. She eats what's left of Buster's meal, drinks some of Sam's beer, puts on Buster's hat, and remembers that she saw Buster on television when she was a little girl. She describes him doing the balcony scene from *Romeo and Juliet*, playing both parts, running up and down a ladder, changing costumes, "the most amazing thing" she ever saw. She says that seeing Buster play that scene changed her life forever, making her know that she had to be in the theatre. Buster says that Sam is the

agent for the Banana Man and, when she goes off talking to Guido, says that he wants to leave a fifty-dollar tip. Sam says he will chip in and Buster asks him how much money he has. Sam has forty-nine dollars, but Buster says he only needs forty-eight. Buster says he will do the movie the way Sam wants him to do it, and they toast the Banana Man and drink the last of their beer.

Another three-character play set in a restaurant is *Attack of the Puppet People**. It is late at night, the restaurant has closed, and Olive, the waitress, wants Ned to go home. She hits him over the head with a tray, three times, and he falls to the floor. But when she bends over to try to drag him outside, he reaches up and kisses her. She tries again to move him but, exhausted, sits on the floor. Ned remarks that the situation is very romantic, two lost people sprawled on the floor late at night, but he admits that the reason he won't leave is that he is hiding from a woman. He says the woman is stalking him and that she is obsessed with puppets. When Olive opens the door and orders him out, Vicky runs in screaming that the puppet people are after her. Ned says that instead of fearing the puppet people, he and Vicky should love them. He puts his arms around Olive, telling Vicky to grab her arms and legs. Olive screams that she is queen of the puppet people and they are not to touch her. Calming down, she says she has no life, no future and very little past, and she is extremely tired. Vicky insists that the puppet people are not in her head, that they want to make everyone into puppets like themselves, and Olive locks the door and goes to get root beer and pie for Ned and Vicky.

The story of *Molly Whuppie** takes place in a remote farmhouse in Pendragon County, Ohio, in an undefined past time and involves Ring, a large blind man, his daughter Carly, and Molly, an orphan girl that Ring agreed to take care of after her mother died All we see on stage is a bed with a night stand. Molly lies in the bed in a white nightgown as we hear owls and then heavy footsteps and the sound of a door creaking open. Ring enters and calls her Molly Whuppie, explaining that that was the name of a poor orphan girl in a fairy tale who killed the giant and stole his gold. Ring is attracted by Molly's smell, which she says is created by vanilla extract that her mother gave her. She tells Ring that he took her in because her mother's will provided money for her care, money that Ring keeps in a wooden box under his bed. She tells Ring that she heard that he strangled his wife, and Ring responds that if he was the kind of man who would do that then he is capable of strangling Molly as well. As Ring is about to touch Molly, his daughter Carly, also in a white nightgown, moves into the light. Ring

says he is going out to dig a hole by the windmill to bury a "dead stray bitch" that he had to strangle because there was nothing for her to eat. After Ring leaves, Carly climbs into bed with Molly to get warm. Molly puts a drop of vanilla extract on Carly's throat and behind her ears. Carly says that she would like to run away to Spain and Molly says that someday she may take the money in the wooden box and go to Spain by herself. After Carly falls asleep, Molly says that Carly is stupid to love her. Ring returns, mistakes Carly for Molly, who slips out of the bed and off into the darkness, and strangles his own daughter As the ights fade to black. .

The last of the three-character short plays to be discussed in this section is a fractured fairy tale version of Hansel and Gretel called *Lust and Shame in the Gingerbread House**. A wooden table with two wooden benches illuminated from the surrounding darkness creates the illusion of a "room in a cottage deep in the woods somewhere near Munich." Greta, a blond girl wearing a low-cut sun dress and red shoes, and Hans, in a flannel shirt, work pants, and boots, are in their early twenties. We hear the sound of ticking clocks as Hans tries to repair a cuckoo clock. Greta begins teasing him, asking him if he would like to kiss her. Hans says he would, but when he approaches her, she moves away, telling him that a question is not an invitation. But then she says she does want him to kiss her. As his lips are about to touch hers she screams long and loud and then explains that she has not yet given him permission to kiss her. Witch enters, in black, with a "frumpy gray sweater that's too big for her," wearing red tinted glasses and smoking a cigarette. Greta tells Witch that she and Hans were rehearsing a play that Hans has written, a play about cuckoo clocks that they were going to perform for Witch's birthday. Witch tells Greta that if Hans is bothering her, she will put him in the oven. After Witch leaves, Hans begins to sob, but when Greta takes his head in her hands and bends to kiss him, he screams as she had done earlier. He tells her that he wanted her to know what the experience was like. Witch enters again and is told that Hans screamed because he saw a mouse. Witch again threatens to put somebody in the oven and roast them with carrots and potatoes if she hears another scream. Greta asks Hans if he remembers their parents, or of being left by their parents in the deepest part of the dark forest because the whole family was starving. Hans does not remember and thinks Greta is insane. When he kisses her she screams and Witch runs in and jams a burlap sack over Hans' head, puts a noose around his neck, hits him on the head with a frying pan, and drags him off. Greta talks about remembering another life, before

the gingerbread house, where her father smelled like chicken and her mother had only one eye. Witch returns, complaining that Hans was almost too big to stuff into the oven, but that she managed without having to saw off his legs. She complains about taking in strays out of loneliness, of not having a clean house since "you two" knocked on her door. Perhaps, Witch says, she invented them, perhaps they are only her creation. Greta asks if what she smells is meat cooking, but Witch tells her never to love anything because sooner or later she will have to eat it. Witch asks Greta if she is hungry. After saying no, Greta asks Witch if she would like to kiss her. A small bird comes out of the cuckoo clock on the table, making cuckoo noises and then going back in the clock. And with that editorial comment on the entire proceeding, the lights fade and go out.

Short(er) Plays: 4 Actors

Of the twelve four-character plays, two are set in fairly recent times; the rest recreate stories from the historical and legendary past. In *Horrors**, three college girls—Lorna, Betsy, and Mona—are in a cabin by a lake. We hear the sounds of thunder before the lights come up on the girls "dressed for bed." Lorna describes a scene in which she is babysitting and her boyfriend, Len, is making out with her on the couch. There is the sound of something being thrown against the window. Betsy goes out to look and returns, saying that the noise was caused by corn and puts some in Mona's hand. Mona moves into the light to examine what she has in her hand and realizes that what she has are "old, yellow, disgusting teeth." Mona accuses Betsy of having one of her friends throw teeth on the porch to retaliate for Mona's having slept with a Bobby Pottdorf. This is news to Betsy, and Lorna starts working Bobby Pottdorf and the corn/teeth into her scenario. There is a loud thud from outside and Lorna finally agrees to look, returning to say that there is a cow's head on the porch. There is the sound of three loud knocks on the door, then five, then seven. Betsy decides to invite "him" into the cabin and calls out that the door is open. We hear the creaking door, then the sound of dragging footsteps as the intruder eners. He is "very large," wearing a ski mask and dragging a bloody ax. Betsy takes his free hand and shakes it in greeting as do Lorna and Mona. Betsy pushes the man back onto the couch and suggests that they all make up a movie that doesn't become a "horrifying mixture of lust and slaughter." Lorna says that since the world is made of sex and death, they have the ingredients of "the most perfect art form." Betsy asks the woodsman if he would like to help them change the script. The man seems to be whispering, but when Betsy bends her head down

to listen he throws his arms around her, ax in one hand, lemonade in the other. The girls scream hysterically until the intruder manages to say, "Arrrrrt is life." He then launches into a cascade of images from movies, sex, death, birth, and Druids to sucking, Amenhotep, and horrors. Lorna and Betsy realize that the man is afraid of them, and Betsy tries to reassure him, saying that they are going to change the script, that he doesn't have to be afraid any more. And then, in keeping with the theme of the play, we hear three, then five, then seven loud knocks on the door.

A house by a lake, an intruder, the question of what reel is real (life as a movie or series of movies) are elements of a longer four-character play, *Swedish Movie** The lights come up on two sisters, Bibi, a 26-year-old blonde, and Harriet, a 27-year-old brunette, in a house by a lake in Sweden furnished with a bed, table, wooden chairs, and kitchen area, with a door stage right leading to a front porch. We learn that Harriet has had mental problems, that Bibi is studying to be a psychiatrist and that Harriet is no longer associated with "Bjorn." The girls' bickering is interrupted by the door bursting open and a man lurching in like Frankenstein's monster. When he starts to speak, his words (or sounds) are interpreted by Bibi to mean that she has pretty legs, and when he falls to his knees and begins kissing her legs, her translation proves to be accurate. When the man collapses on the floor, the women turn the body over and realize that it is Max, Bibi's husband who went out for bread three years earlier and never came back. When Harriet sends Bibi to get water for Max, he tells Harriet that she knows why he didn't come back. After the father of the girls, Gunnar, comes in with a bag of groceries, they reminisce about Frodo, their dog who committed suicide. Bibi wants to know how Harriet knows that Frodo had bitten off one of Max's testicles and accuses her of making "yorny yorny" with her husband. Harriet says it was only one yorny, that it was "horrible," and that Max smells like a "fart factory." Max says he has realized that life is a tragedy played as farce, and Harriet agrees, telling Gunnar that someone has written down the stupid lines they are saying and she will no longer cooperate in a "vicious attempt to make fun of our sufferings." She tells Max that they are part of one of Gunnar's movies, his attempt to make a parody of their lives. Gunnar thinks that Harriet has lost her mind again and insists that "this" is real "flesh and blood life," not a movie. When Gunnar takes Max out the door, Bibi suggests that perhaps she and Harriet are not really sisters. Gunnar bursts in the door, saying that the island is being engulfed by a dark mist that is creeping slowly toward the house. He takes Bibi out

to look for a wireless radio, and Harriet asks Max if he would like her to dance naked for him. She sits in his lap and pulls his head to her breasts, only to be caught by Bibi entering to tell them that Gunnar needs help getting the radio away from the chickens. Bibi tries to pull Harriet away from Max, but since Max won't let her go the three of them fall to the floor. Entering with a wooden chicken on his head, Gunnar tries to pull Max up. Bibi kicks Max in the groin for poking his breadstick at her sister, and Harriet and Gunnar fight over a liquor bottle. They all drink, huddled together on the floor, Gunnar saying that he is distressed by the fog and the darkness and the disappearance of reality. When Max starts naming all the women that Gunnar has slept with, Gunnar strangles him and Max falls to the floor, apparently dead. Gunnar drags the body out the door and the girls talk again about being in a movie Max, angry, wet, "covered with mud and scum," enters screaming and tells the girls that when Gunnar tried to dump him down a well he resisted and eventually dropped Gunnar down the well. Max assures Bibi that everything is all right, that "it's just a movie." He asks if the girls have any bananas; Bibi produces one "immediately." Max peels and eats it, drops the skin on the floor, walks away and comes back to step on the peel and do a "spectacular pratfall." He explains that he is trying to turn "this" into a farce and wonders if he is getting "big yuks." The door bursts open and Gunnar, wet, muddy, furious, enters screaming and lunging for Max who hides under the bed covers. Gunnar strangles Max's foot and speaks into it as if it were a telephone. Max wrenches himself upright, causing Gunnar to hang off the bed upside down. Harriet notices that the light is fading and Bibi thinks it must be a fade-out, a signal for intermission. Max is sure it is the end, even though, as the girls remark, nothing of any significance has happened. Gunnar crawls off the bed and insists that he would never use a fade-out, that a fade-out is a theatrical, not a film, convention, and that he hates theatre because it is too much like life which is too "charged with meaning," while "this glorious film medium" is "utterly, perfectly—meaningless." In a final tableau, Bibi and Harriet hold each other on the bed with Max behind them and Gunnar at their feet, resting his head in Bibi's lap. Harriet says that in the dark she is no longer real, that she is nobody. Max agrees, but Bibi tells Harriet not to be afraid, that perhaps "it is a double feature." The lights go to black and we hear the sound of broken film spinning "around and around," ambiguously suggesting that we have perhaps been watching a movie all along

There is little ambiguity but much humor in *Europe After the Rain**, a play involving the Surrealist painter Max Ernst, detained on Cape Cod by the FBI in 1941. The setting is a beach house with some chairs, an easel, some canvasses, and a telephone behind the canvases, not visible. Ernst is being questioned by Regan and Pruitt, two agents in rumpled suits. Marie, a stenographer, is writing in shorthand what the men are saying. In response to Regan's derisive remarks about a painting, Ernst says that it could be called Dada. The agents think that Dada must be some kind of code and are baffled when the artist describes Dada as "absurd hermeneutics," "the occult investigation of signs." Mis-hearing and misunderstanding almost everything Ernst says, and frustrated by his refusal to admit that he is a spy sending messages from the New York Times to Loplop, the Bird Superior, Pruitt and Regan conclude that Ernst is a Nazi spy sending coded messages to Hitler. Marie inquires about Leonora, the artist's girl friend and the rocking horse, and when Ernst says that the rocking horse ran away, Pruitt pulls out his gun to kill him. The telephone rings, and Regan insists that Ernst answer it. The call turns out to be for Pruitt, but Regan picks up the phone and takes the message that they have been officially ordered to apologize to Ernst and lets him go. Pruitt refuses to follow J. Edgar Hoover's order to apologize and for that refusal Ernst shakes his hand, the left hand, since the gun is still in Pruitt's right hand. Marie tells the agents that she is going to stay for a bit to have her portrait painted. After the men leave, Marie asks Ernst the title of one of his paintings. He says he calls it "Europe After the Rain," and Marie says it looks like a picture of God and wonders if Max would like her to take off her clothes. He does and as the lights fade she takes off her shoes and begins removing her stockings.

In *Rat Wives**, four actresses—Janet Achurch, Mrs. Patrick Campbell, Florence Farr, and Elizabeth Roberts—are backstage at the Avenue Theatre in London in 1896, preparing for their last performance there of Ibsen's *Little Eyolf*. Mrs. Pat, described by Nigro as "a magnificent and formidable theatrical goddess," is putting on makeup for the part of the Rat Wife, "a grotesque character much older than she is." Janet, "tall, blond, and voluptuous," is in costume to play Rita, the heroine, and Elizabeth, "a thin, lovely but somewhat prim American," is costumed to play her sister-in-law, Asta. Florence, as their understudy, is in street clothes. After telling Mrs. Pat that she thinks it is wonderful for a famous West End actress like her to take the part of the Rat Wife, Janet goes to a cabinet and pours herself a drink. Saying that she wants them all to be friends, sisters, Janet asks who has

actually had sexual intercourse with George Bernard Shaw. Florence raises her hand. Janet asks who has had sexual intercourse with Yeats, and Florence raises her hand. When Janet asks who has slept with her husband, Florence starts to raise her hand but puts it down abruptly. Elizabeth thinks that Shaw should be killed or at least have his vocal cords cut. Florence admits to fifteen lovers, sixteen if they count Swinburne. Mrs. Pat accepts a drink from Janet, who has poured herself another, and tells her that she has been asked to take over the part of Rita for a West End production of *Little Eyolf*. When Janet asks Florence if it is true that she is going to play the Rat Wife, Florence asks who has slept with Disraeli, and Mrs. Pat raises then quickly lowers her hand. Florence says she has slept with seventeen men, if they count Oscar Wilde. By now the women are all drinking, and Mrs. Pat says that Disraeli was very sweet and much better in bed than Gladstone. Mrs. Pat wonders why they have not been called to start their performance and tells Janet that Elizabeth cannot be sacked because she owns the English rights to the play. Furious, Janet tells Elizabeth that American theatre is a whorehouse and that Americans worship guns and money. When Janet keeps berating them for betraying her, Elizabeth accuses her of going behind their backs to negotiate her own West End contract. Janet finds in the cabinet a blue bottle that she thinks contains rat poison which she pours into her drink, stirring it with her finger. When she tries to lick the finger, Elizabeth and Florence stop her, struggling, until Mrs. Pat wipes the finger with a handkerchief. Mrs. Pat ends up holding her drink in one hand and the poisoned drink in the other. After wrestling Janet to the sofa, Fslorence and Elizabeth wonder again why they have not been called to start the show. After Janet says that she is pregnant, Elizabeth leaves and comes back to say that it is time for them to take their places for the first act. Janet goes off to perform, and Mrs. Pat picks up one of the two drinks, tells Florence that she is not sure which drink is poisoned, and downs the drink. Blackout.

A four-character play related to art rather than theatre is titled after a painting by John Singer Sargent, *The Daughters of Edward D. Boit*. The script requires that the adult actresses who play the parts of the daughters—Mary Louisa, Julia, Florence, and Jane—be positioned exactly as they are in the painting of 1882. Mary Louisa is in red, standing, stage right; Julia is on the floor with her doll Ppaul (sic); Florence is standing against an urn; and Jane looks out from the darkness. Nigro wants the actors to be able to move their hands and turn and look at each other, but they are not to move out of their

positions. The play, then, is an investigation of a conversation the girls, now dead, might have had, trapped as if alive in the painting. Julia insists that she is not dead, but for Mary Louisa being trapped in the painting is like purgatory; for Florence, it's like limbo. When Julia complains that she has to go to the bathroom, Mary Louisa tells her that she has had to go to the bathroom for "a hundred years," and each of the sisters will always be where they now are. Jane begins narrating an encounter with the Italian steward on an ocean crossing, but Mary Louisa doubts the veracity of her account, saying that if it happened after Sargent painted them, then it never happened and Jane is making it up. Nobody is going anywhere, she says, because they are a work of art and their job is to "stay put and be looked at," although they have had a very long time to contemplate the possibilities inherent in their lives when they were being painted. Julia says that she had sex with the Italian steward as well as Jane and that after kissing the steward she had a baby with six fingers that spoke Portugese, and the steward had a baby that looked like spaghetti. Florence says that she slept with the steward; Jane says that Florence did so, but she, Jane, did not. Julia wonders if they are in hell being punished for their sins, and Florence wonders if the three virgin sisters would like her, the one with "a little experience," to tell them what it was like. Jane says that just because she did not sleep with the steward does not mean that she is a virgin. In fact, she says, after the steward tired of Florence, she, Jane, tortured him by not giving in to his desires, and, since he remembered her till his dying day, she achieved a manner of immortality. Mary Louise agrees that because they are in the painting they are immortal, that Florence is loved in "a more wonderful way" than could be found in any flesh and blood experience. She tells her sisters that even if the original of the painting is destroyed it has been reproduced in "thousands and millions of books and magazines" and cannot be destroyed. "It only takes the possibility of a mere audience of one," she says, "to justify our existence." The girls banter about Henry James, and Florence says that she would not give up the memory of the night she spent with the Italian steward "for anything." Julia wonders whom Jane slept with, and when Jane says she will never tell, "not in a million years," Julia says, "That's okay. We can wait."

* * * * * *

In *Masque** we move further into the past and explore techniques of staging and cyclic repetition that Nigro uses in other plays. In the pre-show darkness we hear the sounds of water splashing and the creaking of "a gigantic water wheel." The light from an invisible downstage fire

comes up on McGregor, sitting on a rug. He comments that a man understands himself imperfectly as time passes, viewing himself as an outside observer, a stranger. Robin, a girl in a white nightgown, appears behind him. Her first line is, "The fire is dying. He is sleeping now." She sits in front of him and puts his arms around her. As McGregor talks to us about life as theatre, Robin tells us that she dreamed of something buried in the mill. She speaks to "Tommy," asking him to come to bed again, but there is no interaction between her and McGregor. Each seems to be speaking a monologue in sentences interrupted by the sentences of the other. As they are speaking, a girl in a white nightgown, Florence, appears behind them and sits next to McGregor, resting her head on his right shoulder. She repeats in order the lines that Robin uttered when she first appeared, and Robin and McGregor continue their stories. Ida appears, also in a white nightgown, saying the same opening line as Robin and Florence and sitting on McGregor's left. As Florence repeats Robin's sentences in order, and Ida repeats Florence's, Robin talks not of objects but of the faces of animals in the windows, of a shaggy "thing . . . with the face of a sheep" looking in at her. After her line, "Your hands around my throat," McGregor begins to strangle her from behind while Florence and Ida continue their eerie recitation. McGregor sings a medieval lyric about three ravens as he carries the dead Robin into the upstage darkness. He continues singing as he returns to sit behind Florence. She and Ida repeat the poetic sentences, fragments from the memory, until Florence is strangled by McGregor, whose lines are slightly different. He sings the same song as he carries Florence upstage, returns, strangles Ida, carries her upstage, singing, and returns alone. He repeats his earlier comment about a man being a stranger to himself, and just behind him, in a white nightgown, we see Robin as she repeats her opening line and the light from the fire fades out.

A somewhat analogous way of telling a tragic tale is found in *The Malefactor's Bloody Register*, set in London in 1765. Under a light suspended from above, three girls huddle together—Mary Jones, Mary Mitchell, and Mary Clifford, all in white nightgowns. Just outside the circle of light stands John Brownrigg with an "ugly looking stick" that he later uses to make the light swing back and forth. The situation is stated in the opening lines of Mary Jones, who tells us that a poor girl was apprenticed to Mrs. Brownrigg, who took in pregnant women. Mary Mitchell tells us that she was treated civilly at first, and Mary Clifford utters a line that is repeated like a leitmotif throughout the play, "One lived. One died. One was lost. Which was which?" John

Brownrigg remarks that his mother was "a kindly woman," but the girls begin a description of whipping, beating, and torture that Mrs. Brownrigg inflicted on them, beginning with Mary Mitchell describing how Mary Jones was laid across two chairs in the kitchen and whipped until Mrs. Brownrigg was too tired to lift the whip. Mary Jones tells of her escape from the house and of coming back later to look in the window. Mary Mitchell tells us that after a year she also escaped but was caught and brought back by John Brownrigg. Soon after, Mary Clifford came to the house and, since she wet her bed at night, was forced to lie on a mat in a coal hole that was, Mary Mitchell tells us, "remarkably cold." Mary Clifford says she was tied up naked and beaten with a hearth broom, a horsewhip, or a cane until she could not speak. John Brownrigg informs us that his mother wrote in a "blood-spattered book" everything that happened with the girls and says that this was evidence of the "great affection" his mother had for them. He has started pushing the lamp back and forth and describes Mary Clifford shuddering from the cold that is "the breath of God, . . . the true nature of God's love." Mary Mitchell and Mary Clifford describe how the latter was tied to the yard door by a jack-chain pulled tightly around her neck and kept naked, and how both of them were beaten so often their wounds could not heal. As they describe the tortures Mrs. Brownrigg inflicted on them, John uses his stick to push the lamp faster, back and forth. Hearing that Mary Clifford had complained to a lodger, Mrs. Brownrigg cut her tongue in two places with a pair of scissors. Mary says, "I never spoke again." John tells her that there are four ways to cope with God's world: "Die. Go mad. Fight him. Or join him." Mary Jones, who has been outside listening and seeing through the window what has been going on in the house, alerts the neighbors who saw Mary Clifford lying in the hog pen. The house was searched and, although Mary Clifford was not found, Mary Mitchell was taken away. Mary Clifford was rescued on information given by Mary Mitchell but died in the hospital a few days later. Eventually caught, Mrs. Brownrigg was hanged at Tyburn, her body taken down and dissected, and the skeleton put on display in Surgeon's Hall. The son and husband served six months on misdemeanor charges. Mary Jones tells us that she married a footman and has children of her own and that once she thought she saw Mary Mitchell "talking to the empty air." John tells us that he went to see his mother's skeleton after he got out of prison and thinks that, for just a moment, he saw in her face the face of God. He says he forgives the three girls, the "sinners," because he knows God's love is infinite.

A story from "the richly tangled labyrinth of Scottish legend," is presented in *MacNaughton's Dowry**, set in the last decade of the seventeenth century. Anne, the elder daughter of Campbell, sits in a rocking chair holding a folded blanket as if it were a newborn infant. Campbell is on the ramparts, "drinking and brooding," while Meg, his younger daughter, looks across the stage at MacNaughton, a young man who, as Anne tells her infant son, had his castle taken away from him because his father fought on the wrong side in the Battle of Killiecrankie in 1689. While the information each character gives contributes to our understanding of the story, each actor seems, at this point in the play, locked in individual remembrances. As each tells a part of the story, we learn that MacNaughton, in an attempt to regain his patrimony, plans to marry Anne and thus get back his castle which was given to Campbell after the battle. Meggy repeats that she cannot drive thoughts of her sister and father out of her mind. Anne starts to tell the infant how she met his father and then, in a direct move out of narrative into the dramatic mode, crosses the stage to speak her first conversation with MacNaughton. They are interrupted by Campbell who invites MacNaughton to supper, confiding in him that once Anne tried to drown herself after he tried to marry her to someone she did not wish to marry. Campbell suggests that if MacNaughton marries Anne he will return his castle to him and include in the dowry a "suitable" amount of money. MacNaughton accepts, but, as he tells us, he "had not then yet met her sister Meggy." In archetypal tragic fashion he falls in love with Meggy and she with him. The focus shifts to a re-creation of the dialogue between MacNaughton and Meggy until Anne enters and tells Meggy to stop bothering him. MacNaughton then speaks directly to the audience, telling us of the father drinking too much and revealing "an ugly streak of cruelty," and of his own increasing desire for the younger sister. Campbell resumes the dialogue by noting that MacNaughton has been with them "a month now" and asks the young man to have a drink with him. The young man declines, saying that he, like his father, is a "very poor drinker." When he tries to explain to Campbell that he wants to marry Meggy, not Anne, Campbell seems to take the news with equanimity, promising that the young man will have his dowry—castle and money—as promised. Meggy narrates the story of the father telling his elder daughter of the change of plan, of her initial screams of pain and rage, and of her apparent acceptance of the news. Meggy tells us that on their wedding night Campbell insisted that MacNaughton drink with him, and being grateful for the prospect of marrying the girl he loved and getting the dowry, the young man

agreed. Campbell locked Meggy in her room and Anne narrates the
wedding at which everyone but the bride was drunk; She tells us of
MacNaughton's passionate love-making but says that in her cries of
pleasure she thought she heard a woman screaming and pounding on a
door. MacNaughton and Meggy narrate their meeting the next morning
and, in dialogue, MacNaughton convinces her to run away to Ireland
with him. She says she will take her father's gold to replace the dowry
that MacNaughton will now never get. Campbell screams that they
have run off with his gold and Anne talks to the blanket/child about
realizing what a blessing MacNaughton had left her with, that all her
love would go to their child. She offers the child to her father who
walks up to the ramparts with it. He tells the child of the castle across
the lake and talks to MacNaughton, asking him if he would like his
dowry, then drops the child, the blanket, from the ramparts. Anne
screams and Meggy says that she sees her sister and the dead baby in
her brain, unable to stop thinking about them. She refuses to allow
MacNaughton to touch her. Anne murmurs to her "perfect little boy,"
Campbell stands on the ramparts staring down into the water, while
Meggy and MacNaughton are motionless as the lights fade and go out.

 *Christabel**, a play prefaced by a quotation from Coleridge's poem
of the same name, is set in what Nigro describes as "an eerie Gothic
world in which all locations interpenetrate and scenes flow . with the
words and movement of an actor." Christabel, in white, under a
moonlight effect, tells us of her dreams of her beloved, a man she has
never met, of climbing over the wall of her father's castle and walking
into the woods to a great oak tree under which she finds a girl, also in
white. The girl, Geraldine, begins the dialogue by asking Christabel if
she is a demoness who has come to kill her. She tells Christabel that
five men on horseback took her from her father's castle and brought her
into the woods and left her there. Christabel suggests that they flee to
her father's castle by going backwards out of the woods. Geraldine
says that backwards out is never the same as frontwards in, but
Christabel insists that "it's simply the wrong way around, as in a
mirror." Geraldine comments cryptically that "once one enters the
mirror, one never gets out," planting the image of the mirror that later
plays a crucial role in saving Christabel. The girls reach the castle,
which Geraldine says looks like her father's castle, "only backwards,"
but she is too tired to climb over the ivy-covered wall. Christabel uses
a key to open a little door and has to drag the seemingly unconscious
Geraldine across the threshold, although once inside Geraldine revives
immediately. We learn that Christabel's mother died when Christabel

was born, and in a few lines the Dead Mother, "a frail, lovely ghost," appears to Geraldine, telling her to leave the house, calling her a "viper," then "whore," "Monster. Vampire. Succubus." Christabel does not see the ghost and urges Geraldine to undress and come to bed. "Yes," Dead Mother says, "show her the demon flesh beneath your gown, why don't you?" Christabel puts out the candle at Geraldine's urging, tells us that she crept naked into bed and thought that she saw two red eyes in the darkness. The next day Christabel introduces Geraldine to her father, Sir Leoline, who remarks that Geraldine bears an uncanny resemblance to his dead wife. Dead Mother objects and tells Christabel that Geraldine is a demoness from Hell who will suck the life from Christabel unless she is killed. She tells Christabel to bring Geraldine at midnight to the mirror ("which is a simple wooden frame") on the other side of which Dead Mother is standing. Christabel puts her arms around Geraldine from behind and Dead Mother puts her palms up to the surface of the mirror, telling Geraldine to touch her. Geraldine refuses, but Christabel takes Geraldine's hands in hers and holds them up to the mirror, "palm to palm with the Dead Mother's hands." Christabel forces Geraldine closer to the mirror and the Dead Mother and Christabel kiss Geraldine on the sides of her neck. Geraldine says she is lost and the Dead Mother pulls her "limp" body into the mirror, turning her to face Christabel. Christabel moves a bit of hair off her brow, and the Dead Mother takes Geeraldine's hand to mimic the move. Christabel says again the lines with which she opened the play, but after the fourth sentence she adds that "from somewhere, close by, but infinitely far away, there is the sound of a girl sobbing, as if from inside the mirror."

In *The Woodman and the Goblins*, we return to a familiar Nigro setting and technique: four wooden chairs on a bare stage with a downstage light illuminating the characters—Woodman ("thin, old before his time"), Nan and Tess on his left, and Lea on his right, the girls in white nightgowns, the man in ragged brown clothing. Woodman speaks, addressing a cat, saying that the people in the town think that he is mad. He wonders what he will find in the woods among his friends, the trees, whose screams he can sometimes hear as he cuts them down. Nan wonders aloud why the man speaks. Woodman tells us (and cat) that he decided to go into town to have his ax sharpened and to get provisions, but the path to the village led ("of course") through the heart of the darkest forest where he found three "enormous" eggs. Thinking that the eggs would hatch into hens and that he would never be hungry again, the man carried the eggs home,

wrapped them in red flannel and set them by the fire. He watched the eggs night and day, he tells us, sleeping beside them, speaking to them, and watching them grow larger and larger. He tells us of the eggs breaking open and three little "half-grown" girls, "beautiful and perfect," emerging. He describes how he dried them off and took care of them, leaving a lighted candle in the room when he had to go out to chop wood. The girls grow "from new moon to full" into beautiful young women whom he teaches to cook and clean and make clothing. And all is well until they begin to talk, a "terrible thing" that he did not teach them. He tells us that he realized that he had helped three goblin eggs to hatch and that they would destroy him if he did not destroy them first. But they are so beautiful that he cannot harm them. Remembering their fascination with fire, he lights the lantern and leads them back into the woods to the great beech tree where he found them. He hangs the lantern on a branch, but loses his way in the woods and returns to the lantern and the beautiful women, sits down with them and stares as they do into the flame as the lights go to black.

 *Doctor Faustus**, Nigro's retelling of the cautionary tale of the medieval magician, begins with a song, music and words by Nigro, sung by Wagner, Faustus' servant, who accompanies himself on a "small stringed instrument." The setting is the study of Doctor Faustus, with a desk on top of which is a large old book, a bed by a window, and some chairs. Faustus is drinking as Wagner sings a parody of "God Rest You Merry, Gentlemen" and Faustus says he has invited us to "this dark place" for a reason, but then talks with Wagner about what one should do when one has exhausted all possibilities. When Faustus suggests playing games with the devil, Wagner advises against it, and Faustus sends him to bed. With a piece of chalk, Faustus kneels and draws a circle around himself, speaking an incantation. As the lights dim around him, Faustus hears a small bell and the soft voice of Mephistopheles. When Faustus asks to see the devil, Mephistopheles pulls back the cowl of the monk's hood to reveal that she is a young woman. She takes a letter opener from the desk and tosses it to him, asking if he knows the ceremony. He commits himself, body and soul, to Mephistopheles, and pricks his left hand with the letter opener so that blood drips through his fingers. Mephistopheles steps into the circle, takes Faustus' hand in both of hers, and kisses it. Wagner begins singing the second of the four songs he sings and Mephistopheles leaves Faustus staring at his hand. In the second scene, Faustus wonders why she is such a cold, frigid devil and tries to get her to talk about God, about her childhood memories of Christmas.

Wagner sings a verse from the first song and the next scene opens with Faustus at his desk calling for Mephistopheles, telling her that he wants to take a wife. When she turns her back on him, saying that he can have any woman he wants but not a wife, Faustus touches her back with the palm of his left hand and when she finally walks away, he notices that his hand is bloody again. Wagner sings a short interlude song and when the lights come up again Faustus and Mephistopheles are playing chess and Mephistopheles, as usual, is winning. Faustus reiterates his desire for a woman, not a wife, preferably Helen of Troy. Declaring Faustus to have a "decidedly second-rate" imagination, Mephistopheles snaps her fingers and, when nothing happens, calls offstage and a "rather bedraggled and wretched little creature" appears, sniffling. Faustus is incredulous, but Mephistopheles assures him that this is the sixteen-year-old as she was at the time of the famous war, although her face probably launched only a few row boats. Faustus introduces Mephistopheles and Helen to Wagner and admonishes him to take good care of Helen. The fifth scene begins as Helen, with lollipop, reads aloud some lines from Faustus' magic book and is surprised by Wagner. Soon they kiss, only to be interrupted by Mephistopheles. After kissing Mephistopheles on the cheek and patting Wagner on the backside, Helen exits. Faustus enters and sends Wagner off, wondering what would happen if he were to slit Mephistopheles' throat, perhaps first stripping her naked before doing very cruel humiliating things to her. To all of his suggestions she responds, "If it pleases you," until Faustus orders her to stop saying that line and tell him what she really thinks. She tells him that he is jealous, insecure, soft, ridiculous, cold, and "exceedingly empty." Faustus slaps her, knocking her to the ground. He tells her to stop crying, puts his arms around her, and kisses her gently, saying that now they are "in for it." Wagner sings again and when the lights come up on the room we see Faustus and Mephistopheles in bed, looking through the window at the stars. Faustus insists that she has emotions, feels pain, cries, makes love, loves him; but Mephistopheles calls him a fool who chooses his own damnation and that he is lost. Wagner sings two verses of the fourth song and then we see Faustus alone, drinking and congratulating himself on being the devil's lover, "the lord of copulatory arts." After sending Wagner for more wine, Faustus orders Helen to sit in his lap. She kisses him as the lights fade and Wagner sings the first verse from the fourth song. When the lights come up on Faustus and Helen in bed, Mephistopheles tells Faustus that he has broken their agreement by betraying her. She will come for him at midnight tomorrow to claim

his soul, and Hell will consume the house and everything in it. The last scene opens with Faustus alone, drinking, addressing the audience as he did at the beginning as "my trusty and my well beloved friends." Wagner puts the house keys on the desk and starts to leave but stops when Faustus tells him to take Helen with him. After they leave Faustus speaks a jumbled series of phrases, partly from Marlow's play, until we hear the sound of the small bell and see Mephistopheles in her robe just at the edge of the light. His punishment, she says, is to go on without her, alone. She kisses him on the mouth and we see blood coming from his lips and chin as she walks away and the bell rings. He raises his hand to his mouth, sees the blood, and shouts, "Murder." After a pause he repeats the word, hollowly, as the lights fade on him and Wagner sings the last verse of the first song.

The last of the four-character plays to be discussed in this section is another investigation of myth and legend, *Briar Rose**. After describing a setting with roses and trellises and a garden, Nigro comments that 'all that's really necessary is something like a bed and a couple of places for others to sit." In a note on casting, costuming, and the flow of action, Nigro remarks that White Queen, Old Mother Quilch, and Red Queen must be played by the same actress, who wears different colored shawls. Lights come up as Rose tells us that since she is sleeping and dreaming, she can open her eyes and speak while she dreams of a garden covered in briars and a castle full of sleeping people. Her father, the King, went hunting a long time ago and never came back and her mother, the Queen, would not allow Rose to enter the garden. White Queen tells Rose that she may have anything she wants except what she asks for. Rose says that nobody loves her and asks for some pickles. White Queen says she was much loved and recounts how she and the King "even attempted having intercourse" in the hope of engendering a child, but that it was not until a frog jumped into the pool in the middle of the rose garden while the Queen was bathing that she became pregnant and, nine months later, Rose was born. After White Queen goes off, Rose, describes how she got lost in her father's castle, climbed up and up a circular staircase in one of the towers until she came to a "strangely familiar" oaken door, turned the key in the door lock, entered the room, and, following a voice in her head, sat down at an old spinning wheel. She feels that she is repeating a performance she has done before, but she goes to a window and is able to look down on the forbidden rose garden. She starts climbing down the tower to the garden, but falls into the pond. Finding herself unhurt, she marvels at the beauty of the garden. Old Mother Quilch, in

a black shawl, is discovered by the lights and tells Rose that she knows why Rose is forbidden to enter the garden. On the day of Rose's christening, Old Mother Quilch says, she was not invited and pronounced a curse. Old Mother Quilch cuts a rose and gives it to the girl, who pricks her finger. Rose sucks the blood and begins to feel sleepy and lies down to sleep, according to Old Mother Quilch, "only for a century or so. Or perhaps forever. Whichever comes first." As Rose sleeps, Old Mother Quilch exults, saying that revenge tastes like chocolate syrup, that everyone in the castle is asleep, and that the labyrinth of vines closes all the castle in an "impenetrable darkness." We hear the sound of owls and the lights come up on Jack, a young man who says he can't sleep, that he has a "tremendous desire" to go into the tangled briar woods even though he knows it is full of wolves and goblins. Red Queen, his mother, suggests that he go hunting with his blind father, who shoots his crossbow arrows at noises. She tells Jack that he needs to eat fresh, bloody meat, dress like a prince rather than a farmer, and never play the bagpipes. The lights go out on Jack and Red Queen but stay up on Rose as she talks of "enduring the long sleep of the beautiful fairy tale maiden," in which she dreams of ascending the spiral staircase to the locked door, entering, and looking down at the sundial in the garden and the skeletons of former suitors hanging on the briars. Then the lights fade on her and come up on Red King, wearing dark spectacles and holding a cane as he sits on a bench with Jack standing behind him. Jack tells his father that he feels he must go into the briar woods because it is part of a story he must live out. Red King wonders where his hedgehog and bagpipes are, then tells Jack that his mother is an ogress, that he went blind after eating an apple from her garden. Red Queen enters with a hedgehog in her hands, complaining that she has stepped on it and her foot is bleeding. Jack slips offstage and Red Queen throws the hedgehog at Red King as they exit, and lights come up on Rose saying that she can see "him" making his way through the briar wood, his head "full of story," in a "feverish lust" to get to the end of the story. She describes him entering the castle, climbing the circular staircase to the tower, opening the door, going to the window, and looking down on her, "his destiny." Red King and Queen are now gazing into the pool, and Red King says that he thinks he is remembering a dream, a dream in which mad wolves ate his wife and children. Red Queen sees Jack climbing down the stone tower into the garden and says that she will eat up Rose. But Jack appears in Rose's light saying that he is "trembling in her dream." Red Queen says that in her dream she has devoured Red King's

children like apples and that at the end of her dream she is thrown
naked into a pit full of "writhing serpents and toads." Rose tells us that
Jack is going to kiss her, that she will wake up and marry him and have
two children, a boy and a girl. The boy will go out hunting and go
blind from eating an enchanted apple and the girl will become an
ogress; both will be eaten by wolves. Jack, Rose, and Red Queen
repeat lines about Jack going to kiss Rose, Rose awakening, and
everything being changed forever. "But," says Red King, "it will all be
exactly the same." Jack kisses Rose as Red King and Queen hold
hands and gaze into the mirror pool.

Short(er) Plays: 4+ Actors

Travelling imaginarily into the past to investigate historical as well
as fictional characters and stories is an integral part of Nigro's
creativity, but in *The Great Gromboolian Plain* time travel of the
characters on stage is portrayed. The title is from "The Pelican
Chorus" by Edward Lear, two verses of which are included as part of
the title page. There are five character in the cast list, but only three of
them—Dinah, early 20's, April, her sister, late 20's, and Magellan, a
man in his late 30's—have lines. Young Man and Nurse, however, are
essential to the structure, since they embody the past to which Dinah
and, eventually, Magellan travel. There are two benches on stage,
representing a park in a very expensive mental asylum to which April
has had Dinah committed for refusing to disclose the location of their
dead father's last book of poems. The play opens with orchestrion
music ("The Band Played On") and we view the opening action by the
"flickering lights as if an old movie." Dinah is seated on a bench and
Young Man on the other bench. A Nurse, in her twenties, enters
pushing "an old fashioned baby carriage." Although Dinah is in
modern clothing, Nurse and Young Man are in costumes from the
1890's, as different times and places literally co-exist on the stage.
Nurse drops a small stuffed animal and Young Man hesitates as if
wondering whether he should pick it up or ignore it. Dinah watches
this scene with fascination, but before the man can act, the lights stop
flickering and both of the characters from the past move offstage as
Magellan enters. In the course of their conversation, Dinah tells
Magellan she has hidden her father's last book of poems so that her
sister April will not be able to publish it. When Magellan asks her if
she visits famous historical moments in her time travels, Dinah replies
that she much prefers "the most peaceful and forgotten little lost parts
of eternity." She says that when she travels she can see and hear and
smell and feel everything in the past, but the people in the past don't

seem to notice unless the time traveler stays too long. Then there is the possibility of being trapped. When April comes in she talks first with Dinah and then with Magellan who wants her assurance that if he gets Dinah to disclose the location of the book of poems April will get Dinah out of the asylum. April explains that she is afraid Dinah will destroy the manuscript if she is released before April is able to have it published. But she assures Magellan that she has no desire to hurt her sister and doesn't want her to get "messed up" any more than she already is. When April leaves, Dinah returns and Magellan repeats his request that she teach him to travel in time. They sit on a bench and hold hands, eyes closed, as Dinah tells Magellan to think about yesterday, and the day before yesterday, and last month, last year, then decades. As she speaks the flickering strobe effect of the lights begins and speeds up as she counts backwards, then slows down. We hear the orchestrion music and, as before, the flickering light stops as Nurse and Young Man repeat their action. Dinah describes the scene to Magellan, explaining that Young Man is in love with Nurse, sees her every day at this time, and is trying to work up the courage to speak to her. She tells Magellan he can open his eyes only if he really hears the orchestrion music. He opens his eyes, the music stops, and the characters are gone. Dinah suggests that he was unable to see the past because he feels guilty for tricking her. He admits his complicity and she tells him about the poems that her father wrote about April, his love/hate relationship with her being the quandary that caused him to kill himself. Dinah says that she took the manuscript to the future and left it in the archives of a library where her father's papers will be kept. She agrees to teach Magellan to time travel if he promises not to tell April what the poems are about. They sit on the bench again, hands joined, eyes closed, as Dinah counts backward and the stage lights flicker and the sound of the carousel music is audible. Dinah urges Young Man to retrieve the stuffed animal that Nurse has dropped. He does, and following Dinah's narration, talks with Nurse, making her laugh, and then begins dancing with her. Magellan thinks he may hear the music, and Dinah tells him to open his eyes, to see what she sees. She asks him to ask her to dance and as they move the lights dim until we hear only the music and, as Nigro would want us to, we may wonder if Dinah and Magellan will stay too long and be trapped in the past, or whether, after this brief interlude, they will return to their present.

 As the lights come up on *Heironymus Bosch*, Bagpiper plays, Boy, a minstrel, plays a "small stringed instrument, Girl dances, Aleyt, the

artist's wife, polishes an apple, and Bosch "sits staring at the empty easel." After Aleyt, Eve-like, offers Bosch an apple, she wants to know what he is painting, looks at the easel, and says it is sick, "looney." And then Boy and Girl speak lines that a much younger Bosch and Aleyt said long before. Girl wants to know if Boy wants to touch her breast, then places his hand there, Bosch commenting that this is a "big mistake," that the boy is "dead," "lost." Girl wants Boy to suck on her nipples and instructs him as he does so, his head under her blouse. Aleyt and Bosch speak in disjointed, imagistic phrases, creating a sense of their young life together, of getting older and growing apart. Aleyt pleads with him to eat the apple, but he refuses. Boy pulls away from Girl, saying he wants more, and starts sniffing "various parts of her body," trying to suck on her nose, her elbow, and eventually putting his head underneath her skirt. She "looses his very baggy pants" and twists so she can get her head inside. Bosch interrupts their duet of oooohhhs and uuummmmms by saying that those days will never come again. Aleyt asks Bosch about specific images in his painting—the funnel, the strawberries, the potty, the dogs, but Bosch replies that "meaning is hogshit." Boy and Girl wrestle to the "grotesque accompaniement" of the bagpipe, and, in the struggle, Boy's pants fall to his ankles and he falls on top of Girl behind the bush, both soon emitting sounds of passion. Bosch picks up Boy's lute and tries to play it and sing as he did long ago, but the result is unsatisfactory. Boy appears, happy, pulling up his pants; Girl follows, saying "more," and the two end up as before behind the bush. Aleyt asks Bosch if he remembers having her behind the bush. Bosch responds with a Beckettian-Shakespearean version of life after which Boy and Girl emerge from, and return to, the bush, but Girl soon comes back saying there must be more. As Bagpiper plays, Girl caresses the bag and the pipes and, as Boy watches horrified, she puts the pipes under her skirt and makes "pleasure noises" accompanied by "rather horrible squeaks" from the bagpipe. Boy screams at them to stop and bangs his head violently on the ground, "a series of sickening thuds, finally climbing onto the easel and assuming a crucified position." Girl tries to console Boy, and Aleyt weeps over Bosch's refusal to eat her apple. When he finally takes a bite, Aleyt tells him that yesterday she "made the beastie" with Greene and "it was delicious." Bosch holds his head in his hands and screams; Boy plays and sings as Girl dances. Bosch makes a final comment on the identity of God, hell, love, and himself, saying that the woman has eaten his face, that "the apple is poison." As Boy plays and sings the

opening verse again, Girl dances, Bagpiper plays softly, and Aleyt "touches Bosch's hair very tenderly."

The only other non-Pendragon five-sharacter short(er) play, entitled *Maupassant**, is the first play we have encountered where four of the five actors play multiple roles, a device Nigro uses in longer plays with sometimes astonishing effects. The lead character in this play is the French author Guy de Maupassant, but the four other actors, two men and two women, play a challenging variety of roles. One actor plays Maupassant's brother, a Clown, a Goat Man, the Horla, and Lucifer; the other man plays Flaubert, a Doctor, a Father, and God. One of the women plays Countess, Gray Lady, Woman, and Nurse; the other plays Brother's Wife, Mother, Goat Woman, and Actress. Nigro says that the set "should be as simple as possible," and the action continuous. The time is the end of the 19th century and furniture pieces and perhaps platforms indicate various locations. Before the lights come up we hear Chopin's Etude #6 in E-flat minor, Opus 10. Then the lights illuminate the actors entering one by one—Maupassant sits on a park bench, Brother and Brother's Wife sit at a table, Countess strolls by, and Flaubert feeds the birds, the sounds of which we hear after the music fades out. Maupassant begins by telling us of his superstitious childhood nurse, a Norman peasant woman who feared mirrors. Maupassant says that he laughed at her fears, but that his Brother, who died like Christ at age thirty-three, took her seriously. Brother and Wife enact a wood-chopping scene as Maupassant enters their time, trying to take the ax from Brother, who says that he is chopping wood to save his wife from "The Other." Brother calls his wife a slut, a demoness, shakes her violently, but then says that he would never hurt her, that it was "the other one." In the second of the sixteen short scenes in this play, Maupassant talks with his "mentor," Flaubert, about sex and writing, saying that writing has "become a very dangerous occupation." Flaubert says that he hates the struggle of writing, knows nothing, but would starve himself to death if the muse would speak to him just once. The scene ends as the Countess says, for the second time, "Come into the water." In the next scene, Maupassant is showing the stars to "the beautiful young Countess Potocka," telling her that he dreams of a beautiful woman, dressed in grey, who drinks his blood by sinking her teeth into his neck. The scene shifts to Brother and Wife in bed, she luxuriating in what for her was a night of passionate love-making, he denying any involvement, saying that the Other has fouled her forever. Maupassant narrates, then enacts, taking Brother to his madhouse cell, tricking him into entering, then leaving him there.

Maupassant describes walking in the forest, becoming disoriented, and finding himself in a Gothic cathedral with goats bleating, and Goat Man and Goat Woman enter, bleating "horrendously;" Gray Lady tells him that his dead brother was right when he told him to fear his reflection in the mirror. In the next scene, Mauapssant tells us he is not able to write, that he feels a scratching inside his skull, and that sometimes the air seems filled with the souls of "creatures" from the past and future, saturated with agony and desire. The Countess tells him that he is responsible for impregnating her dolls. Maupassant suggests the toy soldiers or perhaps her husband and they talk of play, pleasure, and obsession. Flaubert delivers a telegram announcing his own death. He says that as he experienced the seizure that killed him he saw an enormous green parrot. The scene shifts to Maupassant alone, but with other characters on stage, repeating lines they have said before. Maupassant describes hearing a piano playing a Chopin Etude (and we hear the music), of taking a flight in a hot-air balloon named "The Horla" after his story, of seeing the Other waving up at him, of feeling the Other walking behind him in Tunisia, in Carthage. Then in the last five scenes we witness the progressive deterioration of Maupassant's sanity. He speaks of nightmares and hallucinations,and Brother, Gray Lady, and Flaubert (with a stuffed parrot on his shoulder) repeat thematic lines ("Come into the water." "Don't look in the mirror." "You write it, and then it happens to you.") and the Chopin Etude plays again. Maupassant encounters the Horla, "a man in a winter coat, collar pulled up, face mostly concealed by a pulled down hat." On Christmas Day, Maupassant says that his brain continues to drip through his nose and mouth, "in a terrible, sticky paste." Gray Lady comes to him at night with a telegram saying that he must kill himself on New Year's Day. Flaubert, dressed as a giant parrot, appears with a gun. Maupassant wrests the gun from him and tries twice to shoot himself but the weapon has no bullets. He finds a letter opener and tries to stab himself several times in the neck, but although he staggers about saying that there is blood everywhere, he is still alive. Following Flaubert's suggestions, he stands on the window ledge and "falls a couple of feet onto his face." Nurse picks him up and tells him that he is in the same hospital to which he brought his brother. In the penultimate scene, Lucifer, dressed as a dandy with cane, talks with Maupassant about which one of them is going to take over the world. Maupassant is distraught to learn that his life's work means absolutely nothing, but Lucifer assures him that it means as much as anyone else's, no more and no less "than Napoleon's or Gertie the pig farmer's

daughter's, or a French poodle's life, or a clam's life." In the final scene, God, in the costume of an old gardener, says there is someone Maupassant must speak with, but Maupassant, knowing he is talking of the Horla, refuses. God tells him to look in the mirror, "actually an empty frame behind which stands the Horla." Maupassant raises his palms to the imaginary glass; the Horla does the same until their palms touch and they carefully trade places, Maupassant stepping over the bottom of the frame as the Horla mirrors his movement, until Maupassant is behind the mirror and the Horla outside. We hear the Chopin Etude again as Maupassant repeats his warning against looking into the mirror, but the Horla exits, leaving Maupassant, palms out, trapped in the frame.

The only six-character play in this category is *The Giant Rat of Sumatra**, an homage not so much to Sherlock Holmes as to his creator, Sir Arthur Conan Doyle. The setting is Holmes' sitting room, and after the sound of a ticking clock we hear the sound of Holmes scraping a bow across the strings of his violin. Holmes describes to Dr. Watson a dream in which he is walking through the foggy streets of London and comes upon an enormous rat that begins moving toward him to devour him. Victoria, "a lovely young woman," who identifies herself as the daughter of Sir Henry Murchison, the African explorer, enters and tells Holmes that her problem is that she has been having a horrible recurring nightmare about a giant rat from Sumatra. It differs from Holmes' dream in that she finds herself wandering in a huge old house rather than in the streets of London. But the outcome is the same; she comes upon the rat in a thick fog and is convinced that the rat is going to devour her. Holmes recognizes her as an actress he has seen performing with Henry Irving and Ellen Terry at the Lyceum theatre and suggests that she perhaps read of such a rat in some melodrama or perhaps her father told her of encountering such a creature on one of his trips to Africa. On cue, the father, Murchison, a red-faced gentleman with a white mustache. He, too, has come to see Holmes about his dream of a giant rat. His dream begins in the jungle but soon moves to the back alleys of east London, and the ending is the same as the other dreams. Madame Blavatsky, "a large, heavy, impressive old woman dressed in black," enters. Described by Victoria as "the most celebrated spiritualist in London," Blavatsky has come to see Holmes because for the last three weeks some "very troubled soul," dying or already dead, has been interrupting her séances by shrieking into her ear trumpet about a giant rat from Sumatra. Holmes asks Blavatsky to hold a séance to help them get in touch with "this poor lost fellow." and

the group sit around the table. Blavatsky says she feels the presence of an intruder, an extra person. There is "a loud creaking noise," an effect Blavatsky admires, and the Intruder appears, saying he has a message for "the evil one who is among you." The face of the Intruder is hidden under "a cowl or hooded cape," but Holmes yanks back the hood to reveal "the hideous snarling head of an enormous rat." Victoria screams, the rat leaps at Holmes, Watson turns up the lights, and he and Murchison pull the rat off Holmes. Holmes rips the rat mask from the Intruder's head to reveal his arch-enemy, Moriarty. Under questioning, Moriarty reveals that he came to confront Holmes because he believed that Holmes was causing him to dream of a giant rat from Sumatra. Holmes reasons that for all of the people in the room, except one, to have had the same dream is irrational and impossible; therefore, it did not happen. He tells Victoria that her suggestion that they were part of someone's dream was not far from the truth, that in fact they are "fragments of another being's creation." He says that Watson is not Watson, but someone "infinitely more clever, and infinitely more troubled." Blavatsky screams that the spirit is present, and that his name is Sir Arthur Conan Doyle. Watson screams, holding his head, begging to be saved from the giant rat. He tells how he created all of them, that they are not real, except in his head, and now he has fled into this world he made because he is dying, but the rat has followed him into his only refuge. Holmes comforts him by assuring him that he, Holmes, "the greatest detective in history," had already deduced that his world was not what it seemed to be. When Doyle apologizes, Holmes says there is no need, that he has solved his "greatest case," discovering that his identity is the dream of someone else and he has come face to face with his Creator. He tells Doyle that the rat is nothing, something his fear of the unknown has created, that it is a "silly phrase from one of your detective stories, nothing more." He tells Doyle that he is immortal, because Holmes and Watson are not going to die, but will live on in the minds of readers and in theatre productions of Doyle's stories.

The action of *The Foul Fiend Robert Artisson** (seven actors) begins in Dame Alice Kyteler's house, as Dame Alice, Petronella, Sarah, and Eva her friend talk about seeing things as they stare into the fire downstage. Eva says that Dame Alice looks like a girl of twenty and wonders shy she doesn't age. Dame Alice says that she is cursed with weak husbands and good skin. When Sarah says she sees the face of a dark man with red eyes in the fire, Dame Alice says it is a lucky omen, that the demon will warm her when she is naked in bed at night, that

Sarah should get married but that Eva is in love with Dame Alice's favorite son, Will Outlaw. When Sir John, her sickly husband, calls from offstage, Dame Alice says she cannot "stomach the stench of him" and goes off to bed. The women talk of men and marriage and Sir John, in his late forties, once vigorous but now "very broken down," enters, asking where his wife is. Petronella, weeping, sends Sarah and Eva to look at some dolls and tells Sir John that he is being poisoned through witchcraft, that Dame Alice has killed three husbands before him. Challenged, Dame Alice denies everything, suggesting that Sir John and Petronella have gone to bed together and encouraging Sir John to leave. The scene shifts to Eva in Bishop Richard DeLedrede's garden telling the Bishop that Dame Alice Kyteler has poisoned her husband and three other husbands with witchcraft. Sarah Jane then tells Will Outlaw that three men came looking for Dame Alice and took away Sarah Jane's mother, Petronella. Will says that his mother has gone to Dublin, out of the Bishop's jurisdiction, and that if Petronella is innocent, nothing will happen to her. In the prison cell, the Bishop, standing behind Petronella who is seated on a stool, urges her to confess or he will have to question her daughter. Immediately after, the Bishop moves to the adjoining cell and questions Sarh Jane. He says he will let her and her mother go if Sarah Jane will scream as loudly as she can. He takes her hands and twists them until she does scream, forces her to her knees, still screaming, and grabs her hair and twists it, telling her to scream for her mother. The Bishop then tells Petronella that unless she cooperates he will have to question Sarah Jane "at greater length," and Petronella tells him that Dame Alice might have poisoned her first three husbands. She accuses Dame Alice of meeting with others in the woods at midnight, of worshipping demons, particularly one named Robert Artisson. The Bishop then questions Sarah Jane about Robert Artisson, but all Sarah can remember is that the name occurred in "a rhyme to frighten children." Will Outlaw enters to arrest the Bishop on orders from the Marshall of Ireland. He knocks the Bishop down and tells Sarah Jane she is free to go, that her mother is waiting for her outside. At home, Petronella warns Sarah Jane against ever mentioning the name, Robert Artisson, making her swear never to speak that name again. Eva tells Sarah Jane that the Marshall of Ireland was forced to let the Bishop out of jail and that Petronella and Will Outlaw have been arrested. Eva warns Sarah Jane against going to see the Bishop, but Sarah Jane thinks the Bishop is her friend and will let her see her mother. The Bishop orders the Jailer to prepare Sarah Jane for questioning, and Petronella begins to recite

names of those who supposedly practiced sorcery with Dame Alice. When Petronella says there are no more names, the Bishop tells her that her daughter will not be released until Petronella is burned. Sarah Jane, screaming, is dragged away by the Jailer to her cell. The sound of the wind has grown louder and the Jailer, bringing food to the cowering Sarah Jane, tells her that she should be friendly to him because what she smells is the roasting flesh of her mother being burned. The Bishop tells Sarah Jane that her mother no longer suffers, but, holding her, he insists that she must name the thirteenth person in the coven. The sounds of the storm grow louder and Dame Alice steps out of the shadows and tells Sarah Jane that she has brought someone "very special" to meet her, but Sarah Jane must say, "Come to me now, I want you." Sarah Jane does so; there is a flash of lightning and a clap of thunder, and a dark figure can be seen in the shadows upstage. Dame Alice holds Sarah Jane from behind and tells her that she must open herself up to her "bridegroom." Sarah Jane struggles and she and Dame Alice fall to the ground. The dark figure approaches, lies down on top of Sarah Jane, and there is a great flash of lightning and the sound of thunder and absolute darkness. We hear bird sounds; the storm is over, and the light comes up on Sarah Jane asleep on the floor of her cell. The Bishop wakes her and says she must name the thirteenth member of the coven, that Eva died during her interrogation. Sarah Jane asks if he feels ashamed for taking pleasure in the torture and murder of Eva and her mother. Sarah Jane confesses about flying above the mountains of the moon to a place where they have "sacred orgies," describing how she burns when the demon's "cold seed" enters her. The Bishop kneels, asking her to pray with him, but she takes his head in her hands and kisses him, "a long, desperate kiss," then tells him to save himself if he can. The Bishop tells her that the door is open and that she should go. She agrees, saying that she will live in the woods and "make love to the moon." But before she leaves she asks the Bishop if he still wants the name of the thirteenth damned soul. The Bishop says he knows the name. Sarah Jane agrees and thanks him for her salvation. Alone, the Bishop holds his arms, rocking back and forth as he cries and chants the lines of the "rhyme to frighten children" that Sarah Jane had told him.

An eight-character play investigates the last day in the life of the famed Italian actress Eleanora Duse. The setting for *Eleanora Duse Dies in Pittsburgh** is a room in the Schenley Hotel in Pittsburgh in April, 1924, but there are no walls, only a bed, some furniture, an old trunk, and a window frame. Nigro describes Duse as "a small faded

woman of 65," but when the actress speaks, "some strange magic takes over." After Duse, alone, describes walking to the Mosque Auditorium in the rain, Desiree, her companion/housekeeper enters with a bowl of chicken soup and a white rose in a vase, saying that the performance has been cancelled. After telling Duse to eat all of the soup, Desiree disappears into the darkness, Duse gets out of bed and tries to walk and D'Annunzio, the Italian playwright, appears from the upstage shadows behind a cupboard, asking her not to be angry with him, that he has no choice but to make love to her. D'Annunzio helps her get back into bed and tries to get under the covers with her, but she beats him off with a pillow and threatens to bury a fountain pen in his nose if he does not leave her alone. D'Annunzio begins eating the soup as Duse reminisces about her life in the theatre since she was four years old. She mentions her unfortunate marriage to a "poor bit player" and the daughter they had whom she sent away so that she would not have to grow up in the theatre. D'Annunzio tells her again that he wants to make love to her. She laughs and soon allows him to kiss her, telling him that he will always be the same, "three parts genius and seven parts bullshit." While D'Annunzio is kissing her "boobies" and stomach, Duse recalls seeing Sarah Bernhardt on stage. We hear a voice from inside the trunk and Bernhardt, in her underwear, wants to know how Duse could call her a ham after all Bernhardt had done for her, bringing her to Paris and inviting her to perform in her theatre. Duse tries to explain what she meant, but then accuses Bernhardt and D'Annunzio of "rutting like beavers" in her bed while she was going onstage with pneumonia. Bernhardt steps out of the trunk to make herself a sandwich and Duse's daughter, Enrichetta, asks if she can come in. Duse gets D;Annunzio to hide in the cupboard, even though he accuses her of betraying him with Ibsen, "a dead Scandinavian playwright who looks like a toad," and pushes Bernhardt backwards into the trunk, slamming the lid shut. Enrichetta accuses Duse of abandoning her, but Duse tries to explain that acting was the only way she could send money to feed and clothe and educate her daughter. Duse speaks of her pride in her profession and denies that she was "a whore." D'Annunzio bursts out of the cupboard and describes himself as "the greatest living playwright, novelist, and poet" before challenging Enrichetta to a duel. When Enrichetta wants to leave, Duse implores her to stay, swearing that she has been a good woman all her life. The trunk lid opens and, seeing Bernhardt in her underwear, Enrichetta wonders if some kind of "grotesque theatrical orgy" has been going on. Sobbing, Enrichetta tells Duse that she hates her. Then, just as mother and daughter seem

about to reconcile, we hear a loud sneeze from under the bed, then another, two more (as Duse says there is no one under the bed), and D'Annunzio orders whoever is under the bed to come out or be shot. When Bernhardt points out that he doesn't have a gun, D'Annunzio grabs a banana, holding it like a pistol. "Old and squarish," Henrik Ibsen, huffing and puffing, emerges. Bernhardt explains that he is a bit deaf and has suffered a stroke. Ibsen tells D'Annunzio that he is not his mistress, wonders if the Italian is Strindberg, says he doesn't want a massage but would like some meatballs. He asks D"Annunzio if he is the waiter and D'Anunzio, insulted, looks for a glove to throw down as a challenge to a duel. Bernhardt suggests that he use his banana as a glove and D'Annunzio throws down the banana "very impressively." Ibsen hands the man he thinks is Strindberg the banana, confuses Enrichetta with Bernhardt, and wonders where her wooden leg is. D'Annunzio and Ibsen repeat the banana lazzi as Duse tries again to persuade Enrichetta to stay. As D'Annunzio tries to open the window Mussolini jumps through it into D'Annunzio's arms, knocking him to the floor. D'Annunzio screams, Enrichetta screams, and Mussolini grabs Duse, his "beloved," and kisses her "passionately." Duse pushes him away, D'Annunzio recognizes "Il Duce," and Enrichetta leaves. D'Annunzio and Mussolini identify each other as heroes; Duse asks them to leave, but Mussolini sees the salami and is helped in his sandwich-making by D'Annunzio. When Eva, the actress, enters, she wonders if D'Annunzio is Pirandello and tells Duse that she is frightened about opening a show in New York. Then, in a sequence as hilarious as D'Annunzio throwing down the banana, he and Mussolimi fight over a hot sausage that D'Annunzio has found. D'Annunzio, with Desiree, runs off pursued by Mussolini. Bernhardt tells Ibsen that she wants to discuss with him the possibility of "doing *Hedda Gabler* as a musical with tap dancing" and takes Ibsen into the cupboard to show him what happened to her wooden leg. Eva then explains to Duse that she is afraid because she feels she is not good enough to be on the stage. Duse reassures her, saying that no one is good enough, but the stage is a holy place and the most they can do is never give up trying to play their actions as simply and as honestly as they can. Our task as actors, she says, is to give the gift. "It is the greatest act of love to simply give what we have." Duse strokes Eva's hair, "like a Madonna with her child," repeating the "all shall be well" mantra, saying that she has been walking in the rain for years and has finally found the open door. "Pack the trunks," she says as the lights dim. "We must move on."

In *The Gypsy Woman* Nigro investigates a Commedia dell 'Arte scenario published by Flamineo Scala, a member of the Gelosi troupe, in 1611. The seven male and three female characters in Nigro's script have the same names as the original, and the setting is a street in Naples in front of the houses of Pantalone and Gratiano. Captain Spavento, the braggart soldier, enters with Flavio, the son of Doctor Gratiano, and Arlecchino, a servant loaded down with Captain's luggage. Captain has come home to court Flavio's lovely rich sister, the "succulent Flaminia." Flavio discloses that his beloved Isabella, daughter of Pantalone, an elderly merchant, has run off in search of him with her servant Pedrolino, who, Flavio adds, "always used to get me girls." Franceschina, servant to Pantalone, commiserates with Flaminia, Gratiano's daughter, bemoaning not only the disappearance of Isabella but also that of her husband Pedrolino. Franceschina laments the ten long years she has been without the company of her husband and tells us that she has fallen madly in love with Captain. He rejects her offer of love, but she leaps at him, wrapping her arms and legs around him, panting and groaning. Captain calls to Arlecchino for help and the three fall to the floor, moaning and calling out, as Pantalone and Gratiano enter. Franceshina accuses the men of attempting to violate her "precious, innocent, near-virginity," and begins beating Captain, helped by Pantalone and Gratiano until Arlecchno and Captain run off. Oratio, Pantalone's mad son, continues the noise-making he started earlier, while Pantalone and Gratiano do a hilarious bit of dialogue about the nature of suffering in the world and the fates of their children, until Franceschina runs out saying tha Oratio is pouring pastafazoola all over the cow. After the two men exit Franceschina laments her love for Captain and collapses, sobbing. Isabella and Pedrolino, disguised as gypsies, enter and talk about how Isabella can be sure that Flavio will still love her. Pedrolino goes over to talk with Franceschina who wants to have her fortune told to find out if her husband is still alive. Pedrolino takes her palms, then feels the bumps on her head, her face, her body, and tells her to take off her clothes. Franceschina throws herself on Pedrolino who falls to the ground as she pummels him with a chicken she had been plucking, and Oratio jumps on them. When Pantalone and Gratiano return, Oratio chases Flaminia back into the house and Franceschina tells Pantalone that the gypsy (Pedrolino) told her that her husband was dead. Pantalone asks Isabella if his daughter (Isabella) is alive and tries to put his arm around her, inviting her to stay the night with him. Hearing Gratiano utter the word "sister," Oratio goes berserk again and chases Arlecchino and Gratiano "all

around the stage and off." Flavio enters to discover Pedrolino and asks him if he knows whether Isabella is alive. Pedrolino says that she is dead but that he can conjure up the dead body for Flavio to declare his love. As Flavio runs off, Isabella runs out of the house pursued by Pantalone, who is tripped by Pedrolino. Consulting his tarot deck, Pedrolino tells Pantalone that his daughter Isabella is dead, but when Isabella stomps on his foot, Pedrolino amends his statement to "dead to you but not to the world." Hopping on one foot, Pedrolino tells Pantalone that hopping increases sexual potency. After Pantalone hops happily off, Pedrolino tells Isabella to go into the house and put on her "Isabella clothes" because he is going to conjure her corpse for Flavio. He gives Franceschina a recipe for cookies, a major ingredient of which is poison ivy, assuring her that the cookies will make the Captain see the world "in a totally new way." As he exits, Captain, Arlecchino, and Gratiano come on, the Captain saying that he must marry Flaminia. Gratiano yells at Flaminia to come out of the house; she does, but rejects the Captain and goes back inside as Pedrolino and Franceschina run out pursued by a screaming Oratio. He throws Franceschina over his shoulder and runs off. Captain, Arlecchino, and Gratiano "scatter in all directions" and exit, leaving Pedrolino alone. Flaminia runs from the house and begs Pedrolino to cure Oratio's madness. When Captain and Arlecchino return, Flaminia describes in sensuous detail how she plans to take a bath, then leaves. Pedrolino tells Captain that he will not be able to help him get Flaminia, but the threat of Captain's dagger makes him reconsider and promise results in forty-seven minutes. Arlecchino wants a girl as well, and after they leave Pedrolino has to deal with an adamant Flavio demanding to see the corpse of his beloved. Pedrolino gets a chair from the house after throwing a cloak over Flavio so he can't see. Then he brings out Isabella in non-gypsy clothing and puts her in the chair, pronouncing a gobbledegook incantation and yanking the cloak from Flavio's head. Exclaiming over the sight of Isabella, Flavio says he feels faint but he also feels a Petrarchan sonnet coming on. He recites some lines that Pedrolino evaluates mid-way ("God, this really sucks.") and then falls to the floor. Isabella opens her eyes, and, thinking Flavio dead, pulls out her own Petrarchan sonnet, hacks and spits, and then reads When Flavio stirs, she runs into the house and Flavio, threatening Pedrolino with another sonnet, gets him to promise that he will bring back the corpse of Isabella after dark. Pedrolino then promises Gratiano that he will find love if he comes back at night dressed as a woman. Pedrolino tells Captain to also come dressed as a woman, and Franceschina enters with

her poison ivy cookies. Captain eats part of a cookie and gets her to promise to leave the door open that night. Franceschina kisses Pedrolino in gratitude and goes into the house, leaving her cookies on the stoop, as Isabella enters. Pedrolino agrees to help her with Flavio and they go into Pantalone's house as Pantalone and Gratiano enter from the street. The old men eat some of the cookies and Gratiano runs off as does Pantalone after he makes Pedrolino promise to bring "the gypsy girl" (Isabella in disguise) to Pantalone's bed that night. Talking to the audience, Pedrolino absent-mindedly eats a cookie as he tells us he will get no rest until nightfall. The lights black out and we hear an owl, a scream, and a loud crash. Flavio runs out in the dark, telling Pedrolino that the noise was night falling and he must see Isabella's body once more before he kills himself. Pedrolino brings on a sheet-covered Isabella, pronounces some gobbledegook, whips the sheet off, tells her to move one hand, then the other, then to open her eyes, and, finally, to sing. In "grand opera style" she begins ("Ohhhhhhhhhhhh, the monkey wrapped his tail around the flagpole . . ."), then dances a tarantella before embracing Flavio, who faints. Telling Isabella to put her gypsy outfit back on, Pedrolino helps her drag Flavio's body into the house. Captain, dressed as a woman and speaking in a falsetto voice, enters followed by Arlecchino who is told by Pedrolino that if he wants to sleep with Franceschina he, too, will have to get into a woman's costume. When Gratiano enters dressed like a woman, Pedrolino tells him and Captain to continue acting like women and sends them into Gratiano's house, "arm in arm, giggling." Flaminia, followed by Oratio, who is waddling and making noises like a duck, emerges from Pantalone's house and asks Pedrolino to cure Oratio's madness. Locking an arm around Oratio's neck, Pedrolino tells him that if he doesn't begin acting sanely and make love to Flaminia, he, Pedrolino, will cut off Oratio's reproductive organs. Immediately, Oratio is "cured" and is sent with Flaminia into Gratiano's house. When Arlecchino comes back dressed as a woman, he is sent into Pantalone's house. Pedrolino takes off his gypsy costume and goes into Pantalone's house to sleep with his wife, Franceschina. Gratiano chases Captain, both in "heart-speckled underwear," out of his house, beating him. Pantalone chases and beats Arlecchino, both in heart-speckled underwear; Flavio leads out Isabella who has resumed her gypsy attire; and Flaminia brings out Oratio, announcing that the gypsy has cured his madness. Franceschna runs out screaming that the spirit of her dead husband is trying to impregnate her, followed by Pedrolino, also in heart-speckled underwear. After Isabella blows a whistle to

quiet everyone, she demands her two favors—that Oratio and Flaminia be allowed to marry and that Pantalone's daughter Isabella be allowed to marry Flavio. She doffs her gypsy outfit ("Da DAHHHHHHH!"), revealing her identity and Pedrolino tells everyone who he really is. Pantalone wonders if this means that Isabella is not going to sleep with him, and Franceschina wonders where her number six macaroni is. Oratio hears the word "sister" and starts trying to tear Isabella's clothes off. In the ensuing melee Pedrolino is beaten, Franceschina hits Pantalone over the head with the chicken, and everyone runs off, leaving Arlecchino to tell the audience that he has no idea what the play was about or for. When Pedrolino crawls back on stage, "horribly beaten," Arlecchino asks him what it has all been for, what is the secret of life? Pedrolino has Arlecchino taste the cookies that are still on the stoop. When Arlecchino says that he has tasted worse cookies, Pedrolino tells him that the secret of life is to eat your cookie (even when it's made of shit) and be thankful. Arm in arm, singing to their "gypsy dumpling," the two go off to join a band of real gypsies

Before the lights come up on *Border Warfare**, a twelve-character, eight-scene play, we hear the sound of a ticking clock and then see Lena Crow reading the definition of "border' from a large old book as her three sisters—Katie, Susan, and Elizabeth—"appear." After Katie and Susan go off, Joseph Doddridge, preacher and doctor in his middle years, enters, talking to Lena but acting as if Elizabeth is not present. Lena tells him that there is no one else there, but she and Elizabeth look at each other until Elizabeth goes. Lena tells Doddridge of the bad dreams she's been having about seeing herself turn into an Indian in the mirror, of peeling off layers and layers of different colored skin until there is nothing but bones that crumble to dust. Their dialogue is interrupted by the arrival of Lewis Wetzel and William Huff dragging a young girl who is bound and gagged. Doddridge recognizes the girl as Nancy, his Uncle Philip's daughter, who was taken by the Wyandot Indians. He insists that Wetzel and Huff remove the gag and ropes and tries to talk with Nancy, but she tells him that Nancy is dead and, when Wetzel releases her, runs away. George White Eyes, an Indian "dressed as a white man," son of Chief White Eyes, the leader of the Lenne Lenape people of the Delaware nation, is drinking when Doddridge enters his area. They talk about the education George received at Princeton University, and, after Doddridge leaves, George's father tries to explain to his son why he sent him to college to learn the ways of the white people. In the third scene, Wetzel explains to the Colonel that the white people along the border believe that the only

good Indian is a dead Indian. After Wetzel leaves, Nancy McCauley, the Colonel's mistress, worries about his drinking, but he asks her to stop trading furs with the Indians and selling the furniture from the officer's quarters. Huff bursts into the office, furious that his cabin across the Ohio River has been burned down again by the soldiers. The Colonel tries to explain to Huff that the treaty the army has with the Indians is an agreement that if the white people don't build on the west side of the river, the Indians will not attack the whites. Huff replies that no matter how many times they burn him out, he will build again, and he plans on being here long after the army and Indians are gone. George White Eyes enters after Huff leaves, asking why the Colonel allowed Wetzel to go free. The Colonel says that if he tried to hang Wetzel by himself (since none of the border people would help) he would be killed for threatening their hero. Nancy urges the Colonel to come to bed with her and, after taking another drink, he follows her off stage. The action moves immediately to the inside of the shed where Lena enters with a plate of food for Wetzel and asks him how he can keep on killing Indians. When Wetzel asks her if she has ever seen anyone killed, Susan, Katie, and Elizabeth appear, and the lights fade on Wetzel as Lena narrates the event in 1785 when she and her sisters were grabbed by a band of Indians. The girls speak as if the action is occurring in the present. After the light fades on the sisters, Lena tells Wetzel that the Indians murdered her sisters, and Wetzel suggests that she should vent her rage by killing. Distraught, Lena asks Wetzel to kill her, but he refuses and leaves. Then, at night, Huff and Doddridge sneak up behind The Doddridge Girl who is looking into the flames of an invisible downstage fire. She knows they are there and tells them that she is not one of them, not white, that the whites destroy everything they touch, that she would rather die than be like them. Doddridge hands her a mirror and when she looks into it she begins to cry, telling them that the face in the mirror is that of her sister, Nancy, who died. Doddridge and Huff leave, and as The Doddridge Girl looks into the mirror, George White Eyes, drinking, says he is haunted by his dead father and wants to look into the mirror; but the girl says she will kill him if he touches the mirror because her dead sister haunts her from inside the mirror. After she runs off, Chief White Eyes talks with his son about the Great Manitou, repeating the line that runs like a mantra through the play: "There are many bad people in the woods." The scene shifts as Nancy McCauley asks Doddridge if he has seen Huff because the army is not only going to burn his cabin again but kill him if they see him. The Colonel, bottle in hand, accuses Nancy of being

responsible for his loss of command. She says he sent the soldiers out to burn Huff's cabin and kill him because he's a "drunken bully" and was jealous that she and Huff were once lovers. She says that she loves the Colonel but that he never loved her. If he does love her, she says, then he can marry her, right now, with Doddridge officiating. He says he doesn't want to marry her; he wants to kill her for ruining his career. After he leaves, Doddrige notices a figure in the shadows and invites The Doddridge Girl to come into the light and sit on the porch. The Girl wants to know if her parents are dead, but Doddridge assures her that they are well, have moved on, but will be happy to know that she is alive because they had given up hope. The Girl says she came so Doddridge could tell her parents that Hannah was bought by a Frenchman who took her to Paris, but that Nancy is dead, that she took her soul from the mirror and went home. The lights fade on her and Doddridge and come up on Wetzel and Huff by a campfire. Huff brags to Wetzel about his new cabin but Wetzel does not reply when Huff asks him how nice it looks. In the last scene, Lena sits by the embers of the burned-out cabin, brooding that even if there were no people, evil would still exist. She repeats the line about there being many bad people in the woods and says that she hates them and wants to kill them all. George White Eyes comes into the light and listens to Lena talk about what is behind the eyes in the mirror and what happens when the light goes out behind the eyes. He urges her not to throw herself into the river, but Lena moves downstage to the edge of the river. George grabs her and they struggle as Huff appears, and stabs George twice. Lena holds George's head in her lap, crying and saying that she did not want this to happen. She asks Huff what's wrong with him and he goes off to get Doddridge. Lena speaks of a dream she has been having about a child's wooden rocking horse in the woods, unearthed by "last summer's windstorm." Katie, her sister, appears and tells her not to be sad, and Susan stands beside Lena, telling her that "they're just people like us. . . just like us." Elizabeth and Chief White Eyes appear and the lights fade and go out

Chapter Three: Ruffing Plays

.Nigro's explorations of the life and discoveries of the English detective, John Ruffing, are (to date) contained in six plays: a monologue; two one-acts; and three two-act plays. In the monologue, *Creatures Lurking in the Churchyard**, Ruffing, 36, sits in a chair with a revolver on a table beside him. Ruffing's thoughts are of memory and agony as the clock ticks, and he articulates the message of the Buddha, that suffering can be eliminated by eliminating desire through following the eight-fold path. But for Ruffing the eight-fold path is a labyrinth and even in sleep his mind sees "her" face and eyes and hears her voice saying that she loves him, but then comes the image of "a dark hideous thing embracing her." Ruffing hears demons whispering as he walks through the churchyard cemetery at night. He has made a will providing for his daughter, but he knows what effect his suicide would have on her. He says he has spent his life solving puzzles and repairing ancient clockworks (his father was a clockmaker), but he has no solution for the hellish agony he is experiencing. "Suffering is all."

The action of the monologue takes place in 1901, and in 1902, in *Demonology**, Ruffing interviews a girl in a "small private room in an old sanitarium in a small town outside London." For several minutes, Ruffing tries to get the girl to speak, but he is unsuccessful. Finally, with a humorous French sentence, he gets her to smile. He yodels and the girl bursts out laughing. In celebration, Ruffing takes another drink and the girl says, "Outstack," and then other words that Ruffing writes down but does not understand until he makes a connection between the "ness" ending of some of the words and the geography of the islands north of Scotland, the Shetland Islands. Although she gets hysterical and starts hitting him when he asks her about what happened, he manages to calm her down and get her to remember being driven with a

man in a coach into the woods, then running and falling and going to sleep. Ruffing asks her if anyone did anything improper to her, violated her, but she begins asking him questions about himself. He tells her that she reminds him a bit of his daughter and that his wife is dead, agreeing that that is why he drinks so much. He says his wife's name was Kathleen, and the girl says that Kathleen is her name, and asks Ruffing if he would like to kiss her. She says that the man in the coach, Nicholas, is outside in the garden waiting to take her back to where Ruffing's dead wife is. She says that she was Kathleen a long time ago, before she died. She describes her childhood with two older sisters and parents and says that when she grew up a bit she married and had a little girl named Mary. But a terrible thing happened: Nicholas came and took her to a cold, lonely place, a place in an imaginary kingdom in the islands that she had created in her childhood. But, lying on the bed waiting for her beloved, she saw Nicholas enter, and he was a demon, so she fled, naked, into the coach, but Nicholas got into the coach with her and made love to her as the coach churned through the woods. Seeing the eyes of a deer reflected in the lantern light reminded her of her beloved and she jumped out of the coach and fled. She says she was brought to this place to wait with her beloved for Nicholas. We hear the sound of a door creaking open and then, from the shadows, we see the moving figure of a tall man, with a limp, carrying a black bag. Kathleen says hello to Nicholas and holds Ruffing's hand as the light goes out.

The action of *The Rooky Wood** takes place sometime in the first decade of the 20th century and involves Ruffing (in his forties), Moira (young), and Hobb (in his forties). There are four chairs on a bare stage, two upstage and two downstage, that represent a variety of locations. Moira tells Ruffing she is afraid he will think she is not quite right in the head because she "knows" that a woman has been killed in a park. She tells Ruffing that the woman was naked and was murdered, either strangled or suffocated. She agrees to show Ruffing where she believes the body is and walks downstage to sit in a chair next to Hobb. Hobb says he can't stop looking at her because he knows something unusual is going on inside her head. As the lights fade on them, Hobb gets up and moves into Ruffing's area, saying that he came to cooperate with the police. Ruffing says he has a witness and asks Hobb why he killed the girl. Hobb identifies himself as an Inspector who has been investigating a serial killer and suggests that Ruffing could be the murderer. He suggests that Ruffing is ill and that he forgets he has murdered someone and then goes out looking for the killer. The lights

dim on the men and come up on Moira showing Ruffing where she thinks the body is, although she feels that the body may have been moved. She tells him she is experiencing a memory of a boy lost in the woods, stumbling over the body of a young girl, naked, strangled. She tells Ruffing that the memory is his and that she hears clocks. Ruffing admits that his father made clocks and Moira says that she was seeing her own death. She asks Ruffing if he is going to kill her now, and he responds that she should tell him because she is the one who is psychic.

* * * * * *

The mystery of *Ravenscroft* takes place in December, 1905, in "a remote manor house in a rural English county," but the simple unit set is defined by light, not by walls and doors. There are some chairs, some books, a desk, a sofa, and "a place for liquor," but all six actors are onstage, moving in and out of the light as Ruffing tries to solve the mystery of the death of Patrick Roarke, a handyman, who was killed, apparently, by a fall down a flight of stairs. In the course of his investigation, Ruffing learns that Mrs. Ravenscroft's husband died in exactly the same manner, ruled by an earlier detective an accidental death. The characters are Mrs. Ravenscroft (who had been having an affair with Patrick), her daughter Gillian (also involved with Roarke), the housekeeper Mrs. French (also with Roarke), the simple-minded maid Dolly (also), and Marcy, a governess with a daughter to support (no involvement with Roarke). After bringing each of the women into the light and questioning them, Ruffing realizes the futility of what he is doing and accuses Mrs. Ravenscroft of the murder. Gillian smashes him over the head with an old vase, knocking him unconscious. When he wakes, groggy, he says he has had a vision of a woman in a white dress on the stairs. He learns from Mrs. French that Mr. Ravenscroft liked to wear dresses, a white ball gown in particular, and dance at the top of the stairs in the middle of the night with Patrick. When Mr. Ravenscroft put on weight and the dress would no longer fit, he convinced Patrick to wear the dress. But Patrick tired of his new role and refused, starting an argument in which he pushed Ravenscroft down the stairs to his death. Dolly then admits that she was wearing a suit and Patrick the white dress as they danced at the top of the stairs. She inadvertently tripped him, causing his death. Gillian had dreamed that she had pushed Patrick down the stairs and ran into the hall when she heard the commotion. Seeing her, Marcy thought she had pushed Patrick to his death. Ruffing deduces that Mrs. Ravenscroft arranged with Marcy that she would take the blame for Patrick's death, and Marcy explains that Mrs. Ravenscroft promised to take care of her

daughter financially and see that she had a good home in England. Mrs. Ravenscroft wants the details of the story kept quiet and suggests that she, as a "beautiful, lusty, rich young widow," brought up in India with a knowledge of the Kama Sutra, would be an ideal wife for Ruffing, and he could live out his days with them in peace and happiness. Ruffing makes her promise to take care of Dolly and her child (by Patrick) and Marcy and her child. When she agrees, he proclaims the death an accident caused by Roarke drinking too much, and then he asks to be left alone so that he can drink himself into a stupor. When the others have gone, Marcy says that she is very lonely and asks Ruffing to stay with her for the night. Ruffing says that he would be honored and puts down his drink. They look at each other as the lights go to black and we hear a clock ticking in the darkness.

* * * * * *

In *Widdershins** (backward in time, counterclockwise) we see Ruffing in 1902, called in to assist in a case involving the disappearance of an entire family—father, mother, and two grown daughters. The unit set has walls, a door to the outside, an archway to the rest of the house, furniture, and up left center "a dark old mirror in a carved wooden frame" angled so the audience cannot quite see into it. The pattern of the story seems similar to *Ravenscroft*, with witnesses being called or brought into the room for questioning, but four of the people who appear are the missing family members, who enact scenes from the past as the detectives look on. Jenny, a pretty servant girl with a limp, tells Ruffing and his colleague McGonigle that Mr. English wrote about superstitions. English enters and talks with Jenny about her feeling that somebody is spying on her. English then sits and writes in a small notebook as the conversation turns in time to Jenny and Ruffing. When she leaves, Ruffing tells McGonigle that she is lying, hiding something. Ned, a policeman, brings in Ann, who explains that she is not a blood relation to the family but was taken in by Mrs. English when her parents died. Ann has been away at art school but admits to there being "small tensions" in the house when English was interrupted in his writing. Mrs. English enters to tell her husband that a pipe is leaking again in the kitchen. Angry, English walks off, followed by his wife, and Ann tries to explain to Ruffing a note she received from Felicity, the younger of the daughters. Felicity then talks with Ann about her father seeing things and about her own fears that she may be going insane. Felicity kisses Ann on the cheek and sits on the couch as Ruffing and Ann resume their conversation about English running widdershins around the house and about his interest in the

impressionist painters and the nature of reality. Constance, the older daughter, enters upstage and exchanges brief comments with Felicity as English speaks of turning from a study of light to a study of darkness. Ruffing learns from Ann that English was not the father of either Constance or Felicity, that their father was a ship's doctor who died at sea. In a flashback scene, as the other actors look on; Mrs. English tells Ann that her first husband was cruel and that she should not take a decent man for granted. Ann tells her that there are no decent men, only degrees of brutality. Ann introduces Old Betty to Ruffing as a local seer who sells herbs, reads palms, and finds water. Old Betty warns Ruffing about the fairy people from the old times and tells him that he is grieving for a pretty woman whose picture he keeps in his watch and that the missing people have gone to the same place. English tells Ruffing that he and the detective are playing the same game and Ruffing thinks he is having a nightmare. A clock begins chiming and English and his wife leave as Ann enters, apologizing to Ruffing for waking him. Ann discovers that the gun used to shoot rats and rabbits, always hung on the wall, is missing. She leaves for bed and as Ruffing sits in the semi-darkness talking to himself, Felicity and Constance talk about walking into the abyss.

The sound of the ticking clock that ended the first act is heard as the second act begins with Ruffing, drink in hand, staring into the old mirror, talking with McGonigle the following evening about the gargoyle-like carvings on the frame. When Jenny is brought in, Ruffing tells her he has found some nude paintings of her done by English. In a flashback, Jenny tells English that she doesn't want to pose for him anymore and, as the time of the action moves to the present, she asks Ruffing not to tell the people in the village about the paintings. When Ann appears, Ruffing asks her if she knew that English painted nudes, and she admits posing for him after Jenny stopped, but says that English promised to destroy the paintings. Ruffing asks Old Betty again about widdershins and learns that the chuch mentioned in the old ballad was not a modern church but a place where pagan, perhaps Druidic, rituals took place. Old Betty says that she saw the Devil in the village in the "guise of the drowned husband," that the house was his before it was the property of Mrs. English. Ruffing asks Ann if she knows of any catacombs or underground ruins in the area, and Ann says that there was a monastery during the middle ages nearby and that the monks buried their dead in underground vaults or caves. As she leaves, Old Betty tells Ruffing to look in the mirror if he wants to find the Devil. Ruffing puts his hand on the gargoyle in the

woodwork of the mirror and turns it counter-clockwise three times. A click is heard and Ruffing pulls the mirror open, revealing darkness and steps leading downwards. He tells McGonigle that the missing family is "down there," and tells Ann that English was also painting his daughters in the nude. Felicity screams from below and rushes into Ann's arms, breaks away, and is held by Ruffing. Constance and McGonigle enter from below and McGonigle tells Ann that the parents are dead, both shot at close range. Felicity says that it was the Druids, but Constance says it was a madman who escaped through the labyrinth of tunnels. Ruffing sends Ned and McGonigle to set up roadblocks to catch the madman, and then insists that Constance tell him the truth about what really happened. As she begins narrating, Constance and Felicity ask Mrs. English about their father. When English enters, Mrs. English discloses that she knows about the nude paintings and demands that English burn them and all of his manuscripts if he wants to stay in her house, supported by her. When she demands that English burn everything connected with his investigations, both Felicity and Constance object. With his daughters' support, English offers to have his wife committed to a lunatic asylum. She goes down to burn the paintings herself, followed by English as Constance learns that Felicity left the gun in the catacombs and we hear the sound of a loud gunshot. Ruffing, in the present, prompts Constance to finish narrating the story and she tells him that English was shot as he tried to take the gun from his wife, and she was shot when Constance tried to take the gun from her. Constance hid the paintings in the deepest part of the catacombs because "a civilized person simply does not destroy works of art." Ruffing agrees with Amy's suggestion that the madman got away and probably will never be caught. He tells McGonigle that the madman did the killing and asks that McGonigle leave out all mention of the paintings in his report. McGonigle agrees and goes to the mirror which has closed. He asks how to get it open and Felicity tells him "widdershins" as the lights fade and the clock ticks in the darkness.

<center>* * * * * *</center>

To the script of *Mephisto**, a story about Ruffing as a young policeman in London in 1886, Nigro appends a floor plan of a unit set with six locations, including the stage of the Lyceum Theatre with a trap door that plays an important part in the action. The play is written for eight actors, three men and five women, with one actor playing three parts—Nicholas Schofield, Dog Man, and, with an eye patch and cap, Delivery Man. As the music of Saint-Saens' 'Dance of Death' fades we hear the sound of a ticking clock and see, in moonlight,

Kathleen Love, the youngest of three sisters, talking to the voice of Nicholas, telling him to leave her alone, but Nicholas responds that he has come from Hell to be with her, that she is his destiny. As the light fades on Kathleen, the ticking clock modulates into bird song and lights come up on Ruffing, not in uniform, on a park bench. Kathleen and her sisters Meg and Emmy are actors in Henry Irving's company at the Lyceum. Meg wants Ruffing to make Nicholas--a young man that they knew in Cornwall--leave before Mr. Irving finds out that Kathleen is involved in what could become a scandal. Ruffing goes to the antiques shop that Nicholas owns and talks with the shopgirl May Raines who tells him that Nicholas is the Devil. To the sound of a storm, the lights come up on Kathleen seated on a white wicker love seat with a skeleton, cigar in mouth, seated beside her. Ruffing talks to Kathleen, who talks to the skeleton (named Herbert Beerbohm Tree), but they are interrupted by the arrival of Irving trying to create perfect sound effects for his production of *Faust*. After Irving walks off with the skeleton under his arm, Kathleen tells Ruffing what little she knows of Nicholas, admitting that she thinks he hates her and will one day murder her. We see May walking, wearing only a nightgown, speaking to Nicholas, who is not there, saying that she will accept whatever punishment he chooses. She screams and falls to her elbows and knees, and a creature "dressed in a black suit, with the head of a dog, creeps over to her, and drapes himself over her back, dog-wise." She screams again, there is a flash of lightning and a thunderclap, and in the darkness we hear another scream and the lights come up on Kathleen, having a nightmare. She tells Meg that Nicholas is always watching her and is convinced that he is hiding in her closet. Meg opens the closet door and says that there is no one in there, then gets into bed with her sister to comfort her. As they fall asleep, the Dog Man comes out of the closet and turns out the lamp. Ruffing enters the antique shop to find Emmy talking with May. The women pretend not to know each other, and May brings out a glockenspiel that Emmy says she wants to buy and asks that it be delivered. After Emmy leaves, May kisses Ruffing and rubs her body against his, suggesting that he take her to the red room in the back of the shop. After Ruffing runs off, she opens the door to the back room and red light streams out as she tells Nicholas that the middle sister bought a glockenspiel. Ruffing tells Meg that he has just seen Emmy in the shop, and Mrs. Winkle, the owner of the boarding house, enters to tell them that a man has come with a glockenspiel. The Delivery Man puts the box on the floor and, after Mrs. Winkle, ushers him out, Meg opens the box to find a woman's

head wrapped in a scarf. She screams, Mrs. Winkle sees the head and screams, then faints as Emmy enters. Ruffing tells them that the head is a theatrical prop, and the scene changes to the park bench at night where Kathleen asks Nicholas (a voice in the darkness) to go away, and when Ruffing enters Kathleen kisses him and asks him if he has been to the red room. He insists that she tell him everything she knows about Nicholas. As the lights fade on them and come up on May in the shop, the Delivery Man reveals himself as Nicholas. He tells her that if he loved her he would have to disembowel her and hang her guts on the bedpost. The scene shifts to the boarding house where Kathleen tells Meg that she has begun to remember things about Nicholas from their childhood days in Cornwall. When Meg admits to absolute commitment to Nicholas, Kathleen runs off to be sick and Emmy and Meg wonder what Nicholas will do.

At the beginning of the second act Ruffing is drinking from a flask on the park bench and is joined by Irving who tells him that he thinks Kathleen is the most talented of the three sisters. Ruffing asks him if he ever finds himself trapped inside a role so that the mask and the face are the same, and Irving replies that such behavior is lunacy, not acting. Kathleen enters the shop, looking for Nicholas, and when May tells him that his beloved has come, Nicholas appears in the doorway of the red room, the red light behind him creating a Satanic effect. He offers to tell Kathleen what she wants to know if she will drink some of a potion. He asks her if she thinks desire is evil and offers to take her into the red room, but as he moves closer and kisser her, she shudders, saying that she is cold and runs out the door. Back at Mrs. Winkle's parlor, Ruffing questions her about the whereabouts of the three sisters. May enters and tells Ruffing that the girls are in the red room, although she can't say whether they are alive or dead. Ruffing scribbles an address on a piece of paper, gives it to Mrs. Winkle with instructions to call the police and runs out. In the red room, Meg, in "a scandously low-cut gown from the pre-Victorian era, white with great bloodstains on it," is improvising an erotic dance as Emmy, in a "bizarre Venetian carnival half-mask, like a cat's face, a man's bloodstained shirt, and nothing else," makes noises with the bagpipe. Ruffing asks if Nicholas has drugged them. Emmy pulls out a knife and tells Ruffing that after she and Meg give him "the best rutting ecstasy" of his life, they are going to cut his throat like a sacrificial goat. Ruffing learns from Meg that Kathleen has gone to the theatre and he finds her tied to a chair, dressed in an angel costume from *Faust* with the trap open behind her. She tells him that he, not she, is the sacrifice, and May hits Ruffing

over the heqd with a blunt object, twice. Nicholas grabs the dazed Ruffing by the hair and tells him that the women were simply the bait, that Ruffing is his doppelganger, the face he sees in the mirror. Ruffing tells Nicholas that he is not Satan but a very sick man who has used drugs and perhaps some form of hypnotic suggestion to lure the women into his nightmare, and Nicholas admits to giving the girls opium when they were children and following them to London. He says he sees Ruffing as his mirror image and, since he is Satan, Ruffing must be God. A voice from the darkness calls to Nicholas, identifying itself as the voice of Nicholas' lord and master, the Prince of Hell. Nicholas runs toward the sound and falls into the trap. Irving strolls into the light, looks into the trap and says that Nicholas has broken his leg and needs to be committed somewhere. As Ruffing holds Kathleen in his arms, Nicholas starts shouting for her from the trap and May slams the lid shut. The Saint-Saens plays as the lights go to black.

Chapter Four: Full-length Plays

Not counting the plays of the Pendragon cycle, nor those about John Ruffing, the English detective, Nigro has completed thirty-five full-length plays that may for convenience be categorized by subject as plays about theatre or performers (in which I include four plays based on Shakespeare), plays about authors, plays about famous people, plays dramatizing novels, plays investigating fictional/legendary characters, and plays involving "real-world" people and problems. In this last category, two plays, *Pictures at an Exhibition** and *The Zoar Plays**, are interconnected monologues and one-acts performed by a small cast of actors. Both contain nine scenes, three of which are monologues, and both have an intermission after the fifth scene. But each of the monologues one-act plays may be performed on its own.

*Pictures at an Exhibition** requires one man, Middleton, and two women, Joanna and Beatrice. Each play is done on a bare stage with four wooder chairs (although Nigro adds "Greenery" to the set description of the last play). Joanna's opening monologue is entitled *Mirrors**. She tells us that as a little girl, afraid of mirrors, she thought she saw a "something" coming up behind her in the mirror. After their marriage, she says, she and her husband moved to a house in the country and in the attic she found an old mirror in a "dark wood cabinet." She tells us that she lost her virginity in a hall of mirrors with a boy named Johnny DeFlores who worked at the carnival. She planned to run off with him, but the carnival left town without her, and a few weeks later she read in a newspaper that he had been killed, along with a local girl, in a fire that burned down the hall of mirrors. She says that the picture of the girl who died in the fire looked remarkably

like her, and she believes that the girl she sees looking back at her in the mirror is the one who set the fire.

In the second scene, *Painters**, Joanna and Beatrice, a painter's model, talk at first directly to the audience. Joanna tells us that while she did abstract paintings, her husband liked to paint women, and that's how he met Beatrice, who wanted to be an actress but was poor and heard that she could earn money modeling for art classes. When her husband refused to use another model, Joanna went to see Beatrice and Beatrice agreed to pose for her on days when the husband didn't need her to model for him. Joanna then tells the audience how "miraculous" the experience of painting Beatrice has become, that she is no longer afraid to paint something that is alive and looking back at her. Beatrice tells us that she did not tell the husband that she was also posing for his wife, and the women resume their dialogue with Joanna explaining that her relationship with her husband is "largely nonverbal," while Beatrice says that "the most important thing" is what Joanna doesn't want to tell her and that Beatrice does not want to know. They discover they have both missed appointments with the husband.

When the lights come up for scene three, *Brown Study**, Middleton has joined the women. He is pacing while they sit, questioning Joanna about a late-night party she had with a few friends while he was out of town. When he came back early he found "a whole bunch of people" stark naked in his living room. The women tell him that they were "just worshipping the devil," and sacrificing chickens. When Joanna suggests that he is jealous, Middleton suggests that the three of them go to bed together. Joanna is disgusted, but when she wants to leave, Beatrice decides to stay, tells Joanna the keys to her house are under the flower pot and she can stay there as long as she doesn't go into the attic. Joanna leaves; Middleton and Beatrice look at each other.

When the lights come up for the fourth scene, *Eros**, Middleton is alone, talking of Joanna's love of dangerous situations in which they might be discovered making love. He cites a number of instances when Joanna, who had kept him at arm's length for weeks, would suddenly initiate love-making. Now Joanna has stopped having sex with him. He is dreaming animal pornography and informs us of the sexual practices of porcupines, flukes, rhinoceroses, rabbits, flies, ostriches, ducks, bulls, pigs, sea turtles, whales, and praying mantises. He is addicted to the tension of living in "a kind of frenzied waiting, in a state of sexual near-hysteria" for Joanna to ambush him.

In *Napoleons**, Middleton and Joanna sit in Beatrice's apartment (the same four wooden chairs) and we hear the sound of a ticking

clock. Joanna says she found a little black notebook in which Beatrice had written the word "Napoleons" over and over, page after page. They speculate about the possible meanings of the word.and Middleton tells Joanna that Beatrice is a widow and that she will be coming back to her house soon. True to Middleton's analysis, Joanna wants him to make love to her "right now, here." He refuses; they look at each other, Joanna smiling, as the lights fade for intermission.

The second act begins with *Copenhagen**, in which all three characters are seated (Beatrice's house) and the clock is ticking. Joanna asks Beatrice why she is obsessed with Napoleon and what she keeps in the attic. When Beatrice speaks like a Copenhagen tour guide, Joanna tells her that she wants to talk about the shame and excitement she feels at having been caught having sex with her husband in Beatrice's living room. She asks if the other two had sex at her house before coming to Beatrice's. Middleton says no, Beatrice says yes. Joanna says that she also had sex with Beatrice and asks her why she wrote the word "Napoleons" over and over in her notebook. Beatrice swears that she found the notebook on a street in Copenhagen.

The seventh scene, *Dolls**, is a monologue by Beatrice in which she tells us about performing erotic acts in front of the dolls in her attic. The dolls are like a hall of mirrors, she says, but she suspects that they have taken on a life separate from the times when she performs naked before them. She thinks she might be found dead in the center of the attic floor, naked, with little bite marks all over her body.

In *Loup-garou**, Middleton and Beatrice are seated in her house talking of Joanna. Beatrice tells Middleton of a sexual experience she had with a werewolf, Lucas, an American with a pregnant wife whom she met while hitch-hiking in Europe. Middleton is worried about Joanna being in the attic although Beatrice assures him that there is nothing in the attic but dolls. She tells him that his hair and teeth are growing longer, that he should look in a mirror to see what is happening to his eyes. Middleton leaps on her, baring her shoulder and biting down on her neck. She pushes him away, saying that his wife has set fire to her house. Middleton runs off and as the lights create a red glow before dimming, Beatrice says there must be a full moon.

When the lights come up on the last scene, *Doppelganger**, we hear bird sounds and see "greenery" as Joanna sits in the asylum telling Middleton and Beatrice that the dolls in the attic reminded her of the hall of mirrors in which she lost her virginity and the fire in her head got out and set the house on fire. Beatrice says she is going to stay in the asylum with her. Joanna decides to leave even if Beatrice is

staying. After Joanna exits, Middleton asks Beatrice not to leave him alone with "that woman." Beatrice, talking to herself, says that the most horrible thing about the mirror is that there is nothing in there, only reflected light.

Nigro subtitled *The Zoar Plays** "A labyrinth of nine plays," and while the individual plays may be performed separately, all nine plays are intended to be done as one performance. Six actors are needed, three women and three men: Anna (in her twenties), James (her father), Mabel (James' mother), Nina (Anna's daughter age four but played by an adult), Josef (Anna's grandfather), and Ben. In the opening monologure, *Lot's Wife**, Anna describes a dream about having been turned into a pillar of salt being licked by camels. She tells us she looked back because her daughter was in the city that was being destroyed by fire and that her punishment is to be perpetually suspended in mid-journey as layer after layer of her flesh is stripped away until she disappears.

The second scene, *In the Phantom Hotel**, is set in Anna's apartment: a bed with a light by it, a table and a chair. The demands of Nina, her four-year-old daughter, are expressed by an adult actress speaking offstage. Anna wears the same oversized tee shirt with the word "Zoar" printed on it that she wears in every scene. The third character in the scene, Josef, wears a long overcoat and carries a clock that he attempts to fix. He tells her that he was a cook at a hotel and the owner of the hotel, Anna's great-grandmother, had two daughters, one very sweet and loving, the other "just dreadful," and he married the dreadful one. They talk about how everything dies, vanishes, and Josef tries to explain to her that we are always in love with something we have lost. The scene ends as Anne hugs her grandfather and he enfolds her in his overcoat.

In *Egyptology**, Nigro calls for two pools of light that do not touch. In one pool sits Ben, in his forties, and in the other, Anna. They seem to be speaking to each other by telephone, but there are no phones, "nor do they mime having" them. Anna tells Ben that if she comes to see him it will only be as a translator, that she will be able to translate him better if she can see his eyes, that perhaps they will just have a cup of coffee. Nina's voice calls from the darkness and Anna tells Ben that she is definitely not coming to see him, that things are too complicated. Ben says that if she comes, he could take her to see the labyrinth-like garden in Zoar, Ohio. She says she is going to come, then reverses herself as the lights fade.

The setting for the fourth scene, *Crayfish**, is "a kitchen table in a wooden nook with some chairs, surrounded by darkness." We hear the sound of a ticking clock and Anna turns on the light to reveal Mabel, her father's mother, seated at the table. Mabel says she misses crayfish admits to having been a good piano player in Adelaide, and continues talking about crayfish, finding analogies to whatever the subject of the conversation might be, advising Anna to live so that she will have as few regrets as possible for things not done. After Mabel goes off into the darkness Anna says she can only talk to her because she is dead. She smiles as we hear the sound of an "eerily out of tune" piano playing Strauss' 'Vienna Blood,' and the light fades out.

The last scene of the first act, *Night Over Dark Water**, presents Anna in a monologue as if flying over the ocean at night. She is leaving her daughter behind, taking a journey she must take to find the creature lurking in the labyrinth, the "demon" of her dreams. She says she has imagined what it would be like to be making love with the man she is going to see, and she has heard his voice whispering in her bed telling her how to caress herself. She is going into the center of the labyrinth to a place where she will be lost.

The second act opens with *Nymphenburg**, set in Anna's kitchen in Munich: a table and two chairs surrounded by darkness. Anna is smoking and drinking a cup of coffee; Ben sips from a cup of tea; and Nina, Anna's daughter played by an adult, plays with a stuffed animal, Bob the Bear. Nina and Anna act as if they are going to have breakfast while Ben narrates what has already occurred since he came to Munich to stay with them. A conflation of present and past is not unusual for Nigro, but this scene is particularly effective as Ben recounts events like kissing Anna on the bridge over the Nymphenburg Canal while Nina and Anna are speaking of an earlier time. After asking about Ben's picture over Anna's bed, for example, Nina says that she will remember "peeking into your room late at night and seeing you sleeping together so tenderly." And Ben describes in the present tense seeing Nina in the doorway looking at them in bed. Anna tells Nina that she is remembering the future (the same events that are narrated by Ben as past). Nina takes a strawberry (to which she is allergic) and asks Ben if he would like to have it, bringing him into the time and space of herself and Anna. Nina tells him that her mama keeps them specially for her boy friends.

The next scene, *The Questions**, is also set in the Munich kitchen and again Anna begins the action by turning on the light to reveal another character, James, Anna's father, a man in his fifties with a glass

and bottle of Scotch before him on the table. She asks why he abandoned her and he replies that it was because he was young, that her mother wasn't happy, and that sometimes the kindest thing one can do for someone is to get away and stay away. Anna inquires sarcastically if being abandoned in London, a strange city, in absolute poverty was a kindness. James tries to explain that he stopped sending money to them in Germany because Anna's mother would not let him see her. Anna asks how many other children he has, but James is not sure—five or six, perhaps seven. James says that he adored her and mourned for her when she was gone. He says that at least he married her mother, made an attempt to commit to another human being, while Anna has never had the courage to marry anyone. He tells her it is possible to love and still not be happy, that when she is as old as he is she will be as guilty, and he points out that Anna also abandoned her mother. He says that she is just like him. He asks about the American who asked her to marry him and Anna says that he is gone and that he didn't love her. Anna says that love between men and women is a lie and notices that it is almost morning. James asks if he can make her something to eat, and she tells him she wants crayfish.

In *Walpurgisnacht**, Anna and Ben are in bed and we hear the sound of clocks ticking. Anna wakens and turns on the light and wanders into the kitchen area, talking about her Walpurgisnacht dream, of crossing the dark ocean to meet a man whose work she has been translating. Ben says she came to visit him and they went to Zoar; then he came to Munich and they made love for days and days and were happy together. But Anna is in another world, telling Ben that he must be mistaken, that there is something, crayfish perhaps, creeping about in the cupboard. Although Ben tells her what they did together, she continues to deny it, saying that he is making it up, that she doesn't remember. Ben tells her that in March she murdered him on the telephone, and we hear the three voices of Ben, Anna, and Nina each concerned with their individual problems. When Ben says that she told him that she loved him, Anna says it never happened and then, as the light fades and goes out, that it all happened a long, long time ago.

She continues the story in a monologue, *Zoar**, describing how "he" drove her on Friday the thirteenth in a black truck to the "city of refuge called Zoar," how they wandered into and out of the mystical garden and found a shop where she bought a wind chime to bring back to her mother and the man bought a toy dog to give to her daughter. She describes how they left the road and wandered through the leaves to a paved slope that led down into a "wilderness of abandoned fields," and

there they made love in "desperate blinded ecstasy." She says that they knew they had to get into the truck and go back, but that the memory of the day will "linger" in the man's head, that the moment before he dies he will think of that day and her, and that the "most enduring" of all lost things is "flesh that has turned to memory." After the lights fade and go out we hear the sound of wind chimes in the darkness.

An early play, *Terre Haute**, requires fourteen actors, five men and nine women, who play parts in four different time periods—the early 1970s, around the turn of the century, in the 1920s, and the 1930s. The play is structured in three acts with six scenes in Act I, nine in Act II, and five in Act III, but the action in each act is uninterrupted with scene progressions indicated by the chiming of a clock. The set is a sitting room in an old house in Terre Haute, Indiana. As the actors in period costumes play multiple roles in scenes from the past, we become aware that they are ghosts reliving the climactic events of their lives. Those actors not playing the scenes remain on stage involved in what the others are doing, but they are doomed to repeat their lives.

Occasionally in the monologues and one-act plays, Nigro deals with controversial issues, and in the two-act *Martian Gothic** he presents a family torn by conflicting loyalties regarding nuclear power. The play requires two men, three women, a very simple setting, and begins with Sonia, "an extremely attractive young woman, very well dressed," talking to the audience, saying that she often speaks to children and gets paid very well to be spokesperson for their electric utility company. As she shows a photograph of Jamie, her younger sister, Jamie comes out and sits on the floor reading a book. Sonia says that Jamie has no brains and that today is her wedding day. She shows a picture of her father, and Dr. Pretorius, "a distinguished and still rather youthful looking man of fifty," enters and sits in a leather chair. Sonia shows a picture of her dead mother (no actor appears), saying that her mother died when Jamie was seven and Sonia ten. She makes more derogatory comments about Jamie's inability to spell and her passion for saving endangered animals, until Jamie says, "I'm dyslexic. I'm not stupid." The sisters insult each other, and Hofsinger, Sonia's boss, interrupts her lecture to talk with her about not arresting the people who are demonstrating outside the plant. After he leaves, Sonia tells the audience about her fascination with Mars and the fantasies she created about life on Mars, fantasies she had to lock up in her brain when her mother died and she had to take on the responsibilities of a stepmother to Jamie. Pretorius tells Sonia that she and Jamie have got to stop fighting with each other. Sonia says he looks tired and pensive and

suggests that he needs to meet more women. Ruth, 35, enters and sits at the desk as Pretorius tells his daughter that he has recently met a "very interesting woman." Pretorius and Ruth then talk, recreating the time when Pretorius learns that she is the "R. Hoooey" who has been writing memoranda to him for several years. Pretorius wonders why no action has ever been taken on her reports and Ruth replies that the only people who could do anything about the situation are exactly the people who have a vested interest in not doing anything. After Ruth and Pretorius leave and Nofsinger returns to work at the desk; Sonia questions him about the reasons for building the nuclear plant right on top of an earthquake fault. Nofsinger tells her that, even though they only have little earthquakes in this part of the country, the reactor was constructed to be earthquake-proof. The action shifts to Pretorius and Ruth walking. Pretorius says he still doesn't understand why she hasn't been fired for writing so critically of safety procedures in the nuclear industry. Ruth says that her father is in the Pentagon and her uncle in the CIA and she is tolerated because of them as long as nobody reads what she writes. As they move away, Nofsinger comes storming in to Sonia waving a new report on estimated casualties in the event of a nuclear accident, a report signed by "someone named R. Hooey." Nofsinger tells her to find Hooey and charm "him" into revising his figures. Pretorius tells his daughters that he would like them to meet a woman he has met who works for the NRC. As he leaves to get Ruth, and as Jamie sulks, Sonia tells the audience how wonderful her father was when she was a child, and how her whole life has been a long series of attempts "to please him, defend him, help people understand his work." Pretorius, Ruth, Jamie, and Sonia begin to talk and Sonia learns that Ruth's last name is Hooey, the person who wrote the revised worst case scenario for the utility company. When Ruth calls Sonia a comedian for suggesting that someone paid by the NRC would "strive to maintain a somewhat more balanced point of view," the conversation ends suddenly with Pretorius asking if anyone would like some ice cream. Sonia again talks to the audience about Einstein and the Newtonian clockworks universe until Pretorius in his chair asks her not to open the curtains because the light hurts his eyes. He tells her that he thinks Jamie is right about nuclear power. Disgusted, Sonia turns from him to the audience and speaks of the cathedrals on Mars in which the Martian women dance in worship of the miracle of life and beauty.

Act Two begins with Hofsinger wondering why Sonia decided to have dinner with him. Sonia has had a lot to drink but when she kisses him there is a rumbling sound of an earthquake. Hofsinger says he has

to get to the plant, but Sonia assures him that they don't have earthquakes in this state. We hear knocking in the darkness and the lights come up on Jamie and Sonia, who is sitting in her bathrobe, barefoot. Jamie says she was beat up by the "goons" that work for the utility company who were trying to put down a demonstration. After Jamie leaves, Hofsinger enters and tells Sonia that he covered for her in her absence by telling the public that the reactor was undamaged by the earthquake. When Sonia tells him that people at the plant beat up her sister, he says that he will make sure it doesn't happen again. As Sonia and Pretorius talk about her recent behavior, she accuses him of having betrayed her and tells him that she never wants to see him again.. Sonia then discusses with Ruth her worst case scenario, and Ruth urges Sonia to talk to her father and sister. Nofsinger wants Sonia to stress the superiority of American technology over that of the Russians. She says that if he fires her she will sue him for sexual harassment and as she leaves she remarks that she is beginning to enjoy her job, that perhaps she will talk to the Camp Fire Girls about whether condoms can protect them from radiation. She and Jamie then talk about Jamie getting married because she wants to have a baby. Jamie pleads with her to see their father but Sonia says she is busy and has another talk to give. Nofsinger confronts her, saying that she has gotten them both fired with her "damn psychotic talks." Sonia speaks to the audience one last time, telling them that the only solution is to shut down all the nuclear plants, that she chose to speak with them rather than go to her sister's wedding, and that she spoke with the ghost of Albert Einstein in Princeton. Einstein said that when he died he went to God's office and surprised the diety throwing dice.

Another script dealing with an issue from the latter part of the twentieth century, *Nebuchadnezzar**, is set in "a small book store in Vermont," with a desk, some shelves for books, chairs, and a rocking chair. The characters are Eva, 24, the granddaughter of Gott, 70, and Lilah, 28, a visitor to their store. The dark-haired Lilah accuses Gott of being the doctor in Auschwitz who experimented on her mother. Lilah admits to having been in a sanitarium because of her obsession with Gott, who, although saying that he recognizes the picture of her mother, denies that he was anything other than a prisoner with her in Auschwitz. The blond-haired Eva wants to call the police, as does Lilah, but Gott says there is no need and goes to bed. Eva struggles unsuccessfully to throw Lilah out and Gott enters with a bottle, slightly inebriated. He says that he and Lilah's mother were put by Dr. Nacht in a very cold chamber where they made love, week after week, under

Nacht's observation. As they grew weaker and closer to death, Lilah's mother revealed to Nacht an escape plan and all the escaping prisoners were killed. When the camp was about to be liberated, Gott overpowered a guard, took his uniform, sought out Nacht and killed him, then took his clothing and papers and assumed his identity. Gott tells Lilah that he and her mother were lovers for many years after the war and that he is her real father.

The second act begins with Eva accusing Gott of being a murderer. Lilah comes in with a box containing pictures and newspaper clippings that her mother had sent to Gott over the years. Lilah says that Gott is her father and is telling the truth about what happened at Auschwitz. Gott says that he is Nebuchadnezzar and that everything is meaningless. Suppose, he tells the women, that they are wrong again and that he really is Dr. Nacht and that Lilah's mother was a willing co-conspirator with him until he broke off with her. In a long speech he explains how victims can come to believe that they are somehow responsible for their suffering. He tells Eva to make up the guest room for Lilah. After he leaves, Lilah suggests that Gott may kill them both while they are sleeping, but Eva says she is too tired to stay awake, and she agrees with Lilah's suggestion that they both take guns to bed with them. Eva says that eventually it will be morning or they will be dead, and the two women sit holding hands as the light fades and goes out.

<p align="center">* * * * * *</p>

In *Nightingale** four actors—Hawkins, 39, his wife Priscilla, 29, her sister Mary, 24, and his daughter Lisa, 19—are onstage all the time. The setting in a program would be identified as a house in Battle Ground, Indiana, and as a road from Greencastle to Lafayette, but all the audience sees on stage are the familiar four wooddern chairs. Hawkins asks Priscilla if she is happy in his house, and she tells him that she misses her sister Mary wants to bring her to stay with them, saying that Lisa hates her and she needs someone to talk with. She tells Hawkins that if he wants to have sex with her again, he will drive to Greencastle, bring Mary back, and set up his study as a place for her to sleep. Hawkins mimes driving a car "unobtrusively" as he talks with Mary. We learn that it is raining and the visibility is poor. Worried that there might have been an accident, Lisa tells Priscilla that there is a police car in the driveway. Hawkins stands and tells Priscilla that they had an accident, and Lisa brings Mary a blanket and pillow. After Mary and Priscilla talk, Lisa gives Hawkins some soup and tells him that he smells of Mary's perfume. Priscilla wants to call a doctor to examine Mary, but Hawkins says Mary just needs to be left alone. Lisa

agrees but mentions the perfume smell. As Mary and Lisa talk we learn that Lisa "used to be insane" and that she has a scar on her neck. Priscilla and Hawkins, returning to a dark house, hear Mary scream from the study, but Mary explains that she had a nightmare and that Lisa was comforting her. Hawkins questions Lisa about the amount of time she is spending with Mary and Lisa says Mary is drawing a picture of her and thinks she has an "interesting" body. Hawkins and Mary talk, but when he says he wants to leave she tells him that he is not going anywhere (with Lisa and Priscilla both out of the house). Priscilla tells Hawkins that she has become interested in the Latin poet Ovid and asks him if he looked in on Mary and, humorously, if he slept with her. He responds sarcastically, saying that they had sex in all parts of the house. Priscilla tells Hawkins that Mary is accusing him of rape and she insists that Hawkins come into the study with her to confront Mary. Mary says that Hawkins admitted to her that he killed Lisa's mother; but he did not rape her,

In the second act, Priscilla tells Hawkins that the doctor thinks Mary's fantasies were caused by the accident, and she asks Hawkins to help with Mary's recovery by reading to her. When Mary is ready to leave, Priscilla wants Lisa to ride in the car with them, but Lisa claims she has a headache so Hawkins and Mary are alone in a car again. Mary tells Hawkins when he pulls the car off the road during a storm that if he raped her now no one would believe her, and she tells him how John Ruskin found and destroyed Turner's pornographic drawings. The play ends as Priscilla tells Lisa that there is a police car in the driveway. Lisa says that she is lying and the lights go to black.

* * * * * *

Indiana also provides the locale for *Grotesque Lovesongs*, a five-character play with an open unit set representing various locations in and outside a house with attached greenhouse. The characters are Louise, 46 (but looking younger); her husband, Dan, 59; Louise's older son, Pete, 27; her younger son, John, 22; and John's girl friend, Romy, 22. The play opens with the sounds of wind chimes. Romy is on the porch swing, Dan is working in the green house, and Pete is loading fertilizer bags onto a wheelbarrow. We learn that Romy has been married twice and that Louise doesn't think that John is too bright, although he plays the guitar rather well. John returns from his visit to the lawyer McTaggart with the news that a friend, Agajanian, has left him everything he owned. Dan enters telling Pete to replant the aspidistra by the old shithouse, accepts the news that John is rich, and continues talking about the dirt around the shithouse. Romy wonders

why Agajanian left all his money to John and Pete tells her that he and
John used to go to Agajanian's house when they were children and that
Agajanian "was always watching us with this smile on his face like he
knew something we didn't." Louise asks Romy to try to get along with
Pete and to take care of John. As they enter the house, John, from the
attic, plays his guitar and sings a lyric about a dead man meeting a
scarlet lady in the "waste of Terre Haute," and we hear the wind
chimes. Without pause, the second scene (there are thirteen, seven in
the first act) shows us Dan and Pete working in the greenhouse the next
morning. Pete remembers that when he was four or five Dan and
Agajanian would play checkers and that Agajanian drove them to the
hospital the night John was born. In scene three, Louise shows Pete an
old picture of her and Dan and Agajanian, and Pete says that Agajanian
looks like John. When shown the picture, John doesn't see any
resemblance and says the other guy looks like Agajanian with hair,
despite Pete's insistence that Agajanian is John's father. Pete says he is
going to ask Louise and confronts her reading in bed. When John and
Romy come up, Louise sends Pete and Romy away so that she can talk
alone with John. She tells him that Agajanian was his father, that she
was young and bored and doesn't much regret the affair, but she
doesn't want Dan to know about it. In the greenhouse, Pete tells Romy
the story of his wife and their marriage in Las Vegas and of her stealing
all his money and his car and of learning from the police that she had
done the same to many other men. He kisses Romy, twice, and they are
holding each other as John comes down the stairs into the greenhouse
and sees them.

Act Two begins at night on the porch with Dan playing on the
harmonica as Romy comes out of the greenhouse, dusting herself off.
She explains that she cut her finger on a rose bush. When Pete appears,
Dan asks him if he has been rolling around in the dirt. Pete, too, has
cut his hand on a rose bush. Dan says good-night and Romy and Pete
talk about his "deflowering" her in the greenhouse and what they are
going to do about it. The lights fade on the porch swing and come up
on John in the attic playing his guitar and singing. When the song
ends, the lights have indicated a transition from night to morning and
Dan appears in the dining room drinking coffee. He tells Louise that
Pete and Romy slept on the porch and that the young people have to
work it out for themselves. Louise yells at Pete and Romy, waking
them, persuades Romy to help her with breakfast, and tells Pete that the
business with Agajanian is her story to tell or not to tell. But when Pete
comes into the dining room she tells him that if he has something to say

he might as well get it over with. John gives Pete the keys to Agajanian's house and says he had McTaggart the lawlyer put the house in Pete's name and signed over most of the money to him as well. He plans to go to Nashville to sing someplace or work in a stable. After John goes upstairs, Louise decides to tell Dan about Agajanian, but Dan says that he knows, has known since 1957. Romy and Pete go for a walk and Louise and Dan talk about his knowing from the beginning and the reasons he never said anything to her . They hold hands as Romy and Pete talk in the greenhouse. She tells him Agajanian left all his money to John because he wanted "to leave a big neon message ... that Louise slept with him," and she thinks Pete should take the money and enjoy it, fooling John who wants him to feel "as awful and guilty as possible." Pete asks Romy what she wants and she tells him she wants a home with lots of children, his, and trees and flowers and cats and a piano. Pete tells her that the reason he ran off with the woman to Las Vegas was that he wanted his brother's girl (Romy) so badly he thought he was losing his sanity. She asks if he wants to go to "our" house, and as the lights fade on them and on Dan and Louise in the swing, John strums his guitar and sings another verse of the song he sang at the end of the first scene. We hear wind chimes in the darkness.

<p align="center">* * * * * *</p>

Nigro has turned two novels into plays: *The Black Minute** and *Tainted Justice*. The former is based on a book by James Artzner about a murder trial in East Ohio in 1879-80. The play is in two acts, with a unit setting; nine men and five women required. *Tainted Justice* is based on the book, *Tainted Justice 1914*, by David Newton and is set on Cape Breton Island, Nova Scotia, in the late 19th and early 20th centuries. The motto for the play is Turgenev's line that "the heart of another is a dark forest," and the iterated musical melody is 'Love's Old Sweet Song,' which we first hear in a player piano version as the "eerie blue light" flickers on the set "like an old movie," and the eight characters enter. Pearl, the daughter of Tena and Ben Atkinson, tells Jim Maddin that she wants to know the truth about her father's death. She thinks Jim knows because he defended Frank Haynes, the man who murdered him. In jail, Frank reads a letter he has been writing in which he says he has been arrested for murder and asks the woman, if questioned, to say that she sent him money by mail. Hearn, the prosecutor, questions Tena about her husband being found dead on the road, as if thrown from his buggy. Ben then talks with Tena about Frank, an American, who said he knew Ben when they were in the

Klondike. Frank admits to Jim that he married four women and tells Jim that he thinks he first met Bill in the Klondike. Tena answers questions from Hearn and, without moving from her chair center stage, carries on a conversation she had with Frank in San Francisco a year earlier. She testifies that her brother Bill had known Frank in Oregon, that Frank had proposed investing in a mining venture to her, and that she was not surprised when he moved into her hotel in a room just down the hall from where she and her husband lived. Hearn and Jim then talk about the circumstantial evidence in the murder trial. Hearn is convinced that Frank smashed Ben's skull with a rock after dragging him from the buggy, and he tells Jim that, according to Pearl, there was "something going on between Tena and Frank long before he got to Cape Breton." Hearn is cannot trick Frank into any admission of guilt.

Act Two begins as the first act ended, with Maudie playing and singing. The characters enter and take their places, Jim sitting on the cot with Frank, sharing a flask of liquor. Hearn questions Tena about communicating with Frank after the murder of her husband and Bill and Tena then talk about being released from jail and Frank being charged with the murder. Bill is elated but Tena wants her name cleared. Jim says that he feels uneasy about the case, and Frank and Tena speak across the stage to each other in another recreated conversation about investing, risk, and assurances, a conversation with a clearly sexual subtext. Jim then explains to the jury his view of the uncertainty in the universe, an "ambiguity deep down in things," and he repeats the Turgenev statement about the heart of another being a dark forest. Bill consoles Jim after the trial in which the jury found Frank guilty, but Jim says that Tena's statements about her telephone conversations were false and he plans to appeal the verdict. Frank tells Hearn that he and Jim Donalds surprised Ben in the buggy and killed him. Frank says that Tena paid him four hundred dollars of the promised two thousand. Frank says he came back to town after the murder because he had a toothache and because he was in love with Tena. Jim and Maude read the telegram Hearn sent implicating Tena, and Jim says if he doesn't file the papers by five o'clock Frank will be hanged. He asks Maudie if she would like to go to the movies. The telephone rings as they are leaving, but Jim doesn't answer it. Tena tells Pearl that years have passed since the hanging and that Pearl should close the door on the past. Jim asks Maudie to sing for him and we hear "ghostly piano music" as the lights change to blue and begin to flicker on a brothel in the Klondike in the late 1890s where Bill, Frank, and Ben are drinking together. Ben shows Frank a picture of Tena,

his wife, for whom he would kill. Frank looks at the picture and says he believes that Tena is the kind of woman a man would kill for, and Maudie plays and sings 'Love's Old Sweet Song' as the lights fade to darkness and we hear the sound of the wind.

* * * * * *

In addition to turning tales of ambiguity into plays, Nigro is also fond of investigating familiar stories and legends, twice-told tales. In one of these, *Tombstone**, he explores "mythological people:" Wyatt Earp, Doc Holliday, the Clanton brothers, Katie Elder, and Mattie Blaylock. In a unit set various locations in Tombstone, Arizona, in the early 1880s are represented: Wyatt's porch, his saloon, the jail, the O.K. Corral, and "elsewhere." The cast list calls for ten men and five women. Three songs are played on an offstage piano and 'Beautiful Dreamer,' played "very badly" on an accordion offstage. Nigro includes his music for one of the songs, Byron's 'So We'll Go No More A-Roving.' Wyatt and his brothers Virgil and Morgan have settled in Tombstone but Doc Holliday shows up pursued by Katie Elder, who plans to marry him. Wyatt has been carrying on a relationship with an entertainer in his saloon, Josie, and Mattie, with whom Wyatt has been living for some time, knows of the affair but is anti-violence and rejects Katie's suggestion that she shoot Josie. Then, after the renowned skirmish with the Clantons, Morgan is killed and when Wyatt and Doc leave to avenge him, Mattie tells Earp that she will not be there when he returns. She ends the play describing "God's world" as "one big butcher shop" in which heroes are worshipped for being butchers of other humans. The whole country has been made out of violence, she says, killing everything that lived there, and soon nothing will be left but skeletons, desert, and wind. As usual, Nigro mixes hilarity with tragedy as the Drunk in the jail turns out to be the Judge who plays the accordion so badly in the dead of night that everyone wants to kill him. But as the lights fade on Mattie we are left with the sense of a continuing and, because mythical, unending cycle of violence and tombstones.

* * * * * *

Another familiar tale is that of *Paolo and Francesca**, the lovers immortalized in Dante's *Commedia*. In Nigro's version we have the familiar unit set representing locations in Rimini and Ravenna in 1275 (Act One) and eleven years later (Act Two). There are eight actors, three men—Giovanni Malatesta, his brother Paolo, and Guido de Polenta, Francesca's father—and five women—Francesca, her Nurse, Paolo's wife Bianca, and his two daughters Antonia and Lucia. Too

busy running the city to go to Ravenna to pick up the sixteen-year-old he has arranged to marry, Giovanni sends his younger brother Paolo to bring back Francesca and her Nurse. Francesca asks Paolo to be her friend, someone she can trust and talk with, and he agrees. On the wedding night, Francesca tells Giovanni that she needs more time to accustom herself to being what he needs in a wife and, after giving her five days, Giovanni leaves the castle, vowing that the marriage will be consummated when he returns. During the five days, Paolo takes Francesca all over the city, introducing her to people, trying to calm her fears, but when Giovanni tries to force her to have sex with him, she stabs him with a letter opener and he twists her arm and hits her before storming out. Paolo tries to console her, but they kiss each other more and more passionately as the lights fade to black.

In a short time, Francesca realizes that she is pregnant and asks Paolo to get Giovanni drunk so that she can sleep with him and pretend that the baby is his. For eleven years and the births of five children, Paolo and Francesca continue their relationship. Paolo's wife Bianca is convinced that they are intimate, and Antonia, sixteen in the second act, interprets the babbling of the old and almost blind Nurse as evidence that her father and Francesca have been betraying her mother and uncle and deceiving everyone else. Distraught, she tells Giovanni, and in a scene of both power and horror he stabs Paolo and Francesca as they are making love. Bianca, Lucia, and Antonia enter to discover what Giovanni has done, and in an ending that is as abrupt as it is fitting Antonia holds a candle over the bodies, touches Francesca's hair and says that they look as if they have just been born and that no one will ever be so beautiful again.

<p align="center">* * * * * *</p>

Another of Nigro's investigations concerns two characters from Henry James' *The Turn of the Screw*. The unit setting represents a residence in Harley Street, London, in the middle years of the nineteenth century, a bench in Regent's Park, and "several locations in Bly," a country house in Essex. There are three characters: the Master of Bly (early 30s), his valet Peter Quint (also in his 30s), and Miss Jessel (in her 20s). Quint is in poor health and is sent by the Master of Bly to help look after the children of Master's deceased brother. Quint is to be assisted in his task by Miss Jessel, with whom Master has a sexual relationship (as we later learn). The children, Miles and Flora of James' story, are never seen, and Master appears in four scenes—the opening when he sends Quint to Bly, in the middle of the first act when he visits Quint and Jessel at Bly and Quint realizes his relationship with

Miss Jessel, at the opening of the second act when he drinks with Quint and they talk about Miss Jessel (and we learn that Master knew his brother's wife "intimately"), and in the penultimate scene when he tells Miss Jessel of Quint's death. The investigation explores the developing love between Quint and Miss Jessel, Quint's resentment of Master's power over her, and the decision of the lovers to come back from the dead (Miss Jessel drowns herself after her last meeting with Master and Quint is found dead in a ditch with a gash in the back of his head). Miss Jessel asks Quint what they will do with the children they have come back for. Quint says they will teach them to love, "like us," a thought Miss Jessel finds "horrible."

<p align="center">* * * * * *</p>

In *The Transylvanian Clockworks*, Nigro investigates the often-told story of Van Helsing, Johnathan Harker, and Dracula. The unit set represents locations in London and Transylvania in 1888 with the familiar park bench, levels, and appropriate pieces of furniture. A number of sounds are required—"pigeons, wolves, wind, moaning, bits of nursery rhyme and song"—but all are to be created by the actors. The cast, four men and three women, enter as we hear the sound of a girl singing 'London Bridge.' Dracula, an "older gentleman," is dressed "modestly." Harker opens with a series of images of flowers, trees, rocks, snow, of passage from light to dark, and of a woman giving him a cross to wear and warning him that at midnight all the evil things in the world will have complete power. There is no change in the shadowy lighting as we move to Seward and Van Helsing on the park bench, the latter feeding imagined pigeons. Seward, the doctor in whose care Harker has been placed, says that his patient seems sane enough but if the wrong thing is said to him he cries and eats flies. Van Helsing agrees to help with Harker and the two men move to the office where Harker has been standing. He starts to tell them what happened at the castle he was visiting, but the sounds of sobbing, crying, whispering, and laughter increase as Dracula appears and invites Harker to come into his house. Harker wonders why the count wants to buy so many houses in London, and shows Dracula a picture of Mina, Lucy, and Peg. To Harker's dismay, Dracula puts the picture in his pocket and leaves. Van Helsing tells Seward that it is time to try out their secret weapon, Mina. And in the next scene Mina talks with Harker in the asylum office area. Afterwards, back at the castle, Dracula tells him of his ancestor, Vlad the Impaler, and asks him why his God impaled his son. In the parlor area, Seward tells Lucy that he wants an answer to his marriage proposal. At the park bench, Peg tells

Dracula that he has been seen in the garden and wonders aloud if she should leave the back door open for him to enter after everyone is asleep. She moves into the parlor where Seward questions her about her "foreign gentleman" and we learn that Seward and Peg had a relationship at one time. When Seward offers to give Lucy a complete physical examination, she tells him that she knows he has been seeing Peg, and in anger he slams his hand on the table, cutting himself with a letter opener. Lucy sucks on his hand, then cuts her own hand with the letter opener, smearing the blood on his cheek. In the last scene of the first act, Van Helsing and Seward listen to Harker recalling a dream in which three women with sharp white teeth and very red lips and open bosoms are about to attack him. As the women enact the dream, Dracula appears with a black satchel and tells the women to leave Harker alone. He tosses the satchel on the floor and we hear cries of a small child, "horrible noises," apparently coming from the satchel which squeaks and moves as the lights go out.

In the second act, the actors enter as they did in the first act but go to different locations. Peg, in a white Victorian nightgown, talks from the parlor to Dracula in the garden, saying that she doesn't want him to come in. Seward guesses that Peg is pregnant and wants to know if the child is his, offering, as a doctor, to "take care of it." The scene shifts to the park bench where Van Helsing, Seward. and Dracula are sitting, feeding pigeons. Van Helsing asks Seward to consider the possibility that the story Harker has told is true, that perhaps the vampire is already in London. Mina enters and tells them that Peg has cut her throat and they leave Dracula on the bench and move to the parlor where Van Helsing questions Mina about Peg and Lucy and the foreign gentleman. When he offers to give Mina something to calm her down, she orders him not to touch her, that she doesn't like him. Van Helsing then takes a newspaper into the office where Seward continues to drink. A mysterious person has been kidnapping children in the park and Van Helsing believes that Peg, as a newly dead vampire, is sucking the blood of the children and that her foreign gentleman is Dracula. Van Helsing says they must drive a stake through Peg's heart and perform other parts of a necessary ritual to save the children and free Peg's soul. Later, he tells Seward he has seen Lucy in the park after sunset and that he is sure she has been with the creature, that she is corrupt, a living vampire who must be killed. When Seward asks what will happen if someone finds out about Peg, Van Helsing says that they will blame everything on Harker, who will be locked up as a madman, leaving them free to do whatever they have to do. Van Helsing tells Seward

that God is on his side, understands and approves what he is doing, and that Lucy will thank them "with her beautiful dying eyes" for purifying her. Van Helsing gives Lucy drugged milk to drink and promises her that she will soon be even more beautiful and never be tired again. Mina, in her nightgown, and Dracula look at each other as we hear Lucy screaming, and Mina asks Dracula to come into the house. After kissing her hand, he gives her the photograph that he had taken from Harker, but Mina does not recognize the women in the photo. She asks Dracula what his work is, and wonders what he does with those boxes. And for those who have been curious about the "Clockworks" of the title, Dracula explains that he makes miniature clockwork worlds, and agrees with Mina that what he does is "perfectly horrible." Mina extends her hand to Dracula and asks him if he would like to come upstairs with her. In the office, Van Helsing congratulates Harker for doing good work and when Harker wonders who is responsible for evil, Van Helsing hands him a mirror in which Harker says he sees God. In the last scene, Dracula and Mina sit on the bed, holding hands, and Dracula says that he hears something unspeakably evil approaching. We hear the sound of a door creaking open and Van Helsing appears behind them with his black satchel. We hear the sounds of "first one, then many ticking clocks." The sound grows louder and the lights fade to darkness as we recognize the monster as Van Helsing, the repressive patriarchal god of the Victorian era, who has come to kill the artist and the woman who accepts the artist.

<div align="center">* * * * * *</div>

Such a re-thinking of traditional stories is not an unusual outcome of one of Nigro's investigations. In *Cinderella Waltz*, for example, a very funny re-telling of the legend of the poor girl with her stepmother, stepsisters, and fairy godmother, the ending is not what a simple re-doing of the story would lead us to expect. The setting is a yard in front of the Snow family's house (represented by a porch), an abandoned hog trough, a well with a grave beside it, a tree, and "rustic things." The play begins with the sounds of farm animals growing in cacophony to include the trumpeting of an elephant before subsiding. The characters are five women—Mrs. Snow, her daughters Regan and Goneril, their step-sister Rosey, and Mother Magee, a rather different fairy godmother—and four men—Mr. Snow, Prince Alf and his servant Troll, and Zed, the village idiot. Mrs. Snow orders Rosey to do the washing, but Rosey wants to put petunias on her mother's grave next to the well. Troll yells that he has fallen into the well. Zed is identified by the others as the village idiot and we realize that he can make

sounds but not articulate speech. Mr. Snow comes out in long underwear looking for his pants, but Mrs. Snow tells him to look in the bread box, and he goes back inside as Regan and Rosey help Troll out of the well. Troll explains that he is delivering invitations to the big ball that Prince Alfred of Fafrid is holding. While looking for invitations for the Snows, Troll finds a frog in his bag and tosses it into the well, causing water to splash out. We then hear the "sea cow bellow of a hunting horn" and Prince Alf with a "a very long rifle, a hunting horn, and a few stray animal pelts" enters, dropping the gun when Troll shouts his name. The gun goes off and a duck falls to the stage as Troll blows a fanfare on his tooter horn and throws confetti which hits Prince Alf in the face. Mr. Snow, in his underwear, says that his pants are not in the breadbox, but that a duck is, and, noticing the duck on the ground, surmises an epidemic. Prince Alf gives Troll the gun and several carcasses which Troll has great difficulty managing. The gun drops again, and another duck falls down. Prince Alf meets Mrs. Snow and her daughters, including the underwashed cinderslut, Rosey. At Troll's urging, Prince Alf invites them to the ball, but Mrs. Snow takes Rosey's ticket just after Rosey has wondered aloud if she is about to live through an archetypal folk motif. Mr. Snow warns Rosey about the homicidal maniac in the neighborhood and when he goes back in the house, Zed appears and moves slowly and eerily toward her, "one hideous clawlike hand outstretched." Just as Zed's hand is about to touch her neck, we hear from the well "a great bellowing Tugboat Annie voice." Zed tries to hide as Rosey helps Mother Magee out of the well. Mother Magee lands on her head, however, collapsing in a heap and revealing "garishly flowered bloomers." She tells Rosey that she is her fairy godmother, asks her what she wants, and takes a swig from her flask. With humor and some bumbling, she gives Rosey a ticket to the ball and tells her that on the evening of the ball behind the house she will find a pumpkin, some white mice, a rat, and a couple of iguanas that will become a coach with horses, driver, and footmen once she pronounces the magic word, "Novotny." As Mother Magee is climbing back into the well, Rosey explains that she can't dance, but her fairy godmother, with a great cry, falls into the well, causing "a great deal of water to slop out." Rosey cries and Zed comes close to her, trying to speak, but he frightens her and she runs screaming into the house. He sits and listens to a little music box play a waltz.

The second scene opens on the evening of the ball, with the sisters in "ratty old ball regalia," Mrs. Snow "hideously dolled up," and Rosey

in rags. After Rosey says good-night to her father, she bemoans the fact that she can't dance. Zed enters and in a hilarious scene learns to communicate with Rosey. He winds up his music box and convinces Rosey that she knows how to dance because she learned it in third grade with him. When Rosey goes into the house to change for the ball, Mother Magee appears from the well, singing drunkenly of Barnacle Bill the sailor. She offers Zed a drink from her flask which she says contains "wonder gin," but he refuses. Rosey comes out and leaves for the ball and Zed accepts the flask, drinks, and Mother Magee pulls out more flasks and gives them to him. As she heads back to the well, he asks her if she would like to dance. He turns on his music box and as it plays they dance and the lights fade on the first act.

Act Two, the morning after the ball, begins with the same cacaphony of animal noises as the first act, but the sound of dwarfs singing is added. Mother Magee's empty flasks litter the ground around the hog trough where Zed is sleeping. Mrs. Snow and Goneril hold ice packs on their heads but Regan is in a happy mood as she talks rhapsodically about the fun she had and the beautiful girl who left early. Rosey tells Zed that she danced many times with the Prince, that Regan danced with him, too, but that Goneril refused and sat in a corner drinking Margaritas. She asks Zed why he is talking so well. Zed says it is because he is drunk, and Mother Magee pops up from the well and asks them if they can sense a big event coming. She says she is so excited that she is going to break wind, and we hear the sound of the Prince's hunting horn. Troll announces the arrival of Prince Alf. Mrs. Snow and her daughters have hurried out of the house, certain of being picked for marriage by the Prince, but Mrs. Snow is unable to get the slipper on her foot. She wants Regan to bring her an ax so she can trim her toes, and Goneril refuses to let Troll touch her feet. When Troll goes to Regan, she reminds him that they danced a lot together at the ball and then went into the pantry and played strip poker. When the slipper doesn't fit Regan, Troll suggests that Rosey try, but Goneril bursts into tears, saying that she is going to be an old maid. Mrs. Snow grabs her ax and chases Zed around the stage, followed by Mrs. Snow, Troll, Rosey, and Regan. Zed runs into Goneril, knocking her down and falling on top of her; Mrs. Snow and Mr. Snow, wrestling for control of the ax, fall on top of them; and Regan, Rosey, and Troll pile on, in a chaos of writhing and screaming. Mr. Snow succeeds in getting the ax from his wife and tackles her when she tries to pursue Zed. As Regan winds up the music box that Zed has dropped, Rosey drops the slipper down the well. When Mrs. Snow starts yelling at her,

Goneril takes the pants that Mr. Snow is still carrying in his hand and
stuffs them into her mother's mouth. Rosey says she believes the
slipper would have fit Goneril, and Prince agrees, saying she reminds
him of his mother and that he fancies strong-minded brooders. Troll
asks Prince if he and Regan can be married, and Regan agrees to the
proposal. The four of them say good-by and, when she finally gets the
pants out of her mouth, Mrs. Snow starts bitching at Rosey. Mr. Snow
promptly stuffs the pants back in her mouth and leads her into the
house by pulling on one pantleg. As Rosey is looking for the music
box that Regan dropped, Mother Magee appears from the well and Zed
talks fluently because he thinks he is drunk. Mother Magee tells him
that there is nothing but ginger water in the flask, no alcohol at all.
Rosey is disconsolate because she will never be rich and live in a
castle, but Zed taps the music box so that it works again and gives it to
her. As he is about to leave she asks him if he thinks that she had the
wrong fairy tale. She asks him if he wants to dance, and as the music
box plays they dance, and the lights swirl and fade to black on Beauty
and the Beast.

<p style="text-align:center">* * * * * *</p>

In his investigation of the legendary outlaw of Sherwood Forest,
Robin Hood, Nigro creates a cast of twenty men and ten women, with
seventeen of the actors playing two or three (in one case, four) roles.
Rather than the one or two songs that he uses in many of his plays, in
Robin Hood Nigro has nine songs, verses of which are sung by Alan
a'Dale at the beginnings or endings of the fifteen scenes of the play, the
only exception being 'The Song of the Tuxford Maidens' which opens
the second act. As the play begins we hear bird sounds (the location
nominally is Sherwood Forest) and Alan sings a verse of 'The Months
of the Year' as the Sherrif and his men, with Maid Marian and Lady
Quigley, enter on their way to Nottingham where Marian is to marry
Prince John. An Old Lady, "stooped and covered with a hood and a
long dress," bursts on the scene with a blood-curdling cry expressing
her delight at finding people in the woods where, she says, she was
ravished by outlaws more times than she can count. She clutches the
Sherrif, and as his men are occupied trying to free him, Little John,
Friar Tuck, and other members of the band surround them and Old
Lady whips off a hat and wig to reveal Robin Hood. In his normal
voice Robin introduces his men to Marian, who has been left behind by
the routed Sherrif's party. Little John slings Quigley over his shoulder,
persuading Marian to follow and, as they are leaving, Robin asks if

anyone hears an "odd piping sound." The scene ends as Alan sings a refrain from 'The Months of the Year.'

In the next action, a feeble and ancient Yorick, Prince John's jester, trying to tell a joke, jumps up on a table, doesn't quite make it, and rolls on the floor with the table, gets the hiccups, and puts a bag over his head in an attempt to stop them. Sherrif enters to tell Prince John of the capture of Marian and Quigley and is throttled by the Prince. Yorick runs hysterically around the stage, hiccupping and choking as Sally Serving Wench enters with a very large tray and bumps into him. Yorick ends up spread-eagled on the floor, presumed dead, and dragged off by the Sherrif. Queen Eleanor is awakened, Sally crashes into a wall with what's left of the tea service and runs off screaming, Prince John leans on the table and crashes to the ground, and the Queen remarks that his fall was funny. Alan sings a verse from 'Marian's Song' as the locale changes to Robin's camp in Sherwood Forest, where Robin promises to take Marian to her father's if she will stop shrieking and eat her supper. She agrees and the scene shifts to night at the Blue Boar Inn where Ellen and Jenny are cleaning up as Cootie the Drunk sleeps with his head on a table and Crazy Betty lays out tarot cards. There is a "loud and ominous" knock on the door, three knocks, repeated, and Cootie lifts his head from the table and says, "Come in," as the door opens to reveal an "ominous looking figure, hooded, with black gloves on long twisted hands." The Dark Monk learns from Eadom, the tavern owner, where Robin can be found. After he leaves, Little John enters followed by Robin and Will. The girls tell them of the Dark Monk and the scene shifts to the forest at morning where Friar Tuck and Quigley are drinking. Laughing, she tells Tuck that in one night with him she has committed sins she never knew existed, but that drinking sack and eating beans all night has gotten her "all impregnated with gaseosity." Tuck says that he will teach her the pleasures of farting and assures her that "all the great women of history have been prodigious farters." He is reciting a verse about farting by Sappho (as translated by the Venerable Bede) when Marian storms in, wearing only a quilt, demanding to know if Quigley spent the night drinking and fornicating. Mrian says her gown has disappeared, but Robin enters with "a wretched, raggedy dress" that she is to wear if she wants to go to her father's. Alan sings a verse from 'Gifts Given' as the locale shifts to Nottingham Castle where Prince John is looking at a map of plans for the tennis court he plans to build in Sherwood Forest. Bronwen, his mistress, questions him about cutting down the forest, about putting poor people in jail, and about deceiving girls like Marian

about marrying them. Grok, a new jester, does a somersault and although he carries and uses a horn like Harpo Marx, Grok is not mute but speaks sounds that the others don't quite understand. The Sherrif explains that he hopes Grok will eventually learn English, but Prince John gets so frustrated with Grok that he hits him over the head with a wine bottle and promises the Sherrif that if Robin Hood's vital organs are not soon floating in John's soup tureen, the Sherrif's will be. Bronwen tries to help Grok after the men leave, and the scene ends as Queen Eleanor lists to one side again and, without Redcap to push her upright, falls over into the wastebasket.

The scene shifts again to a hovel on the estate of Marian's father, Sir Stephen. Gwenny, "in rags," gives an account of the life of the poor on the estate. Marian assures Robin that when she tells her father he will do something about the plight of the people, but Robin says the father will do nothing, telling Marian she is free to go. Alan sings as Robin exits; the Dark Monk appears and we hear the sound of the pipes.

Act Two opens with a crowd gathering for the Nottingham Fair. Purvis the Peddler (played by the same actor who portrays Dark Monk, Ghost, and a character who is later disclosed as Richard Lion Heart) is hawking Ye Olde Fuzzo as a remedy for all ailments from blindness and baldness to worries and virginity. Purvis introduces The Three Maids of Tuxford who sing and dance. After their routine, Purvis praises the powers of Ye Olde Fuzzo and Three Old Maids of Tuxford (same costumes but "grotesquely old") dance on and sing another verse and two choruses. Purvis tells the crowd that they might as well buy his product that will make them forget their miseries because they're all going to die anyway. The crowd throws tomatoes and cabbages at him until he leaves. The location shifts to the estate where Marian, still in rags, assures her father that she has not been ravished and questions him about the condition of the peasants on his land. He explains Prince John's "drool-down" theory of Reaganesque economics. Marian tells him the peasants may rise up and cut the throats of the rich. She leaves to complain to Prince John, who is pacing back and forth followed by Brekka, a strange woman with wild hair who, according to Bronwen, is a translator for Grok. Marian pushes her way past the Sherrif and insists that Prince John lower the taxes on the poor and double them on the rich to provide food and clothing for the destitute. Prince John agrees but says that Robin Hood must surrender to the Sherrif. Sally Serving Wench enters again with her enormous tea tray, avoids the pacing Prince, but is knocked over by the Constable who has "an auspicious epistle from Austria" saying that Richard the Lion-Hearted

is dead. Prince John rejoices that he is finally to be king and leaves to get fitted for a crown.

Redcap and Cruikshank enter with trumpeter horns, followed by Constable who reads a proclamation to the effect that if Robin Hood surrenders Prince John will not cut down the forest to make a tennis court and will educate and provide for the poor by taxing the rich. Marian joins Robin in the woods but he sends her back to Nottingham with Will Stutely. Dark Monk, hitting Robin with a long stick, persuades him to join him on the trip to Nottingham and a crowd gathers in the courtyard of Nottingham Castle, among them some old women and persons with cloaks. The trumpets blow and Prince John enters, followed by Bronwen wheeling in the old Queen. Robin is seized by Redcap and Cruikshank and Prince John announces that taxes will be doubled on the poor and eliminated for the nobility and Sherwood Forest will be cut down and made into a tennis court. Prince John claims to be acting on royal prerogative and announces that King Richard the Lion-Hearted has died in Austria. Dark Monk challenges John and pulls back his hood to reveal "a hideous skeleton face," and then takes off the mask to reveal his true identity: King Richard. In control, Richard blames John for the poverty in the kingdom and says that he will not cut down the forest to make "a tennis thing." Rather, he will cut down the forest and sell the wood to finance another glorious Crusade to the Holy Land. Instead of doubling the taxes, he will triple them; and instead of food he will give the people "spectacle, law and order" by hanging both Prince John and Robin Hood. Marian objects and is told to be quiet because women remind him of his mother, the only person he ever feared. John points out that she is not dead as Richard thinks. And Queen Eleanor appears behind Richard "in all the majesty of her wrath," seizing the brothers by their ears and telling Richard that he will not execute John, that the forest will not be cut down, but that Robin will still be executed. The Merry Men tear off their old lady wigs and remove their cloaks, planning to rescue Robin by force. A "great confused battle" occurs, at the climax of which Robin stabs the Sherrif (or the Sherrif mpales himself on the blade) and Prince John calls for a retreat. The combatants leave the stage, the crowd disperses, and Gwenny tells Granny that she doesn't know who won but that the poor have lost, as always. Marian, followed by Quigley, comes to the Blue Boar Inn looking for Robin and learns from Little John that he is going to visit a "certain person" and will not be looking behind him to see if he is being followed. Robin sleeps as the Ghost appears, followed by the Sherrif, "green and dead like the Ghost,

with a bloody wound." (The Ghost is Robin's father, the first man he killed.) Robin wakes screaming from his nightmare and explains to Marian that the Prioress, bribed by Prince John, is poisoning him. Marian calls for Little John, telling him to force Prioress to give Robin an antidote for the poison. Robin tells Will Scarlet to shoot an arrow into the air, watch where it falls to earth, and bury him there. Robin then drinks the antidote and gradually all the poor people of the forest and the Merry Men crowd in. Will Scarlet returns to tell Robin that the arrow he shot went up and up and disappeared in a cloud and never came down. Robin takes this news as a sign that he is going to live forever (or at least until the arrow comes down) and leaves with Marian to take a walk in the woods. As the others leave Little John asks Will Scarlet how an arrow could stay in the air and never come down, and Will explains that he tied the arrow to a dove and shot it very softly into the air, and though the dove may eventually come to earth, it will not be where he can see it.

* * * * * *

Students of English Renaissance drama may hear echoes of an anonymous play in Nigro's *Ardy Fafirsin*, and they would be correct. The play deals with the same murder of a husband by his wife as is dramatized in *Arden of Feversham*, a murder chronicled in Holinshed. The familiar unit set suggests outside and inside locations with continuous action. The play begins and ends with a song written by Nigro and sung by Cecily, Alice Fafirsin's maid and sister to Thomas Mosby, Alice's lover. As Cecily sings, the characters take their places, some of them making the sounds of birds singing. The opening lines , spoken like fragments of an imagistic poem by all the characters, are written in what Nigro calls an "anachronistic bastard-Tudor dialect, with its own rhythms and eccentricities." The Sherrif functions as narrator, describing the passionate love that Alice has for Tommy, and the lovers, in bed, talk about the possibility of Ardy, Alice's husband, dying. Alice says she will not make love with Mosby again until her husband is dead, because while he is alive their lovemaking is a mortal sin. She wants Mosby to marry her after they kill Ardy and tells him that she has some money inherited from her grandmother and that Ardy is rich and she will inherit all his wealth. Mosby replies that if she wants her husband killed she had better do it herself. Alice agrees and, following Sherrif's transitional narration, crosses to the cart of Greene the grocer and orders some rat poison. Greene guesses what she wants the poison for and agrees to give it to her only if she will sleep with him when the deed is done. Alice agrees to sleep with him once and

brings the poison home intending to stir it into Ard's porridge. She is flustered and confused by Ard's entrance but finally manages in a ludicrous fashion to get the poison in the porridge. But, as Sherrif advises us, she confused Green'e directions and Ard, choking, wonders why the porridge is blue. Losing control, Alice dumps the poison muck on the floor. After Ard leaves, Cecily cleans up the mess and Alice walks into the cupboard, explaining that she goes in the cupboard to think from time to time. Sherrif tells us that Ard arrived at Canterbury twelve pounds lighter and resolved never to eat porridge or blue food again. Meanwhile, Alice and Mosby are back in bed, talking "post-diddle" about trying to kill Ard again.

Alice returns to Greene, telling him that the poison did not work and asking for another solution. Greene recommends the "most depraved of butchers in all England," Black Will McGump. Alice agrees and Greene negotiates with Black Will and his cohort Shakebag to murder Ard, whom they find sitting with Michael, his servant. As Black Will is about to attack, Meg and Sue arrive to complain to Ard about their living conditions. Black Will wants to kill the girls as well as Ard, but Shakebag suggests that he wait until Ard goes into the bushes to "pish." But Michael is the first to go to the bushes behind which Black Will and Shakebag are hiding. He drenches them ("concealed seltzer bottle, please"), and Meg and Sue also need to relieve themselves, giving Shakebag hopes of a view, but they go off to use the chamber pot which, when they return, they empty into the bush where the would-be killers are hiding. The Sherrif happens by and offers to walk home with Ard and his group, but Ard finally has to relieve himself and does so into the same bush with similar effect. The group leaves, Black Will and Shakebag emerge dripping wet, and the Sherrif tells us that word gets back to Alice that "once again the thing's been botched." Walking in the churchyard among the tombstones at night, Alice tries to explain to Mosby why she needs to be free of Ard, and, in the morning, Greene asks Michael where he and Ard will be staying that night. Greene persuades Michael to forget to lock the gate, but when night comes and Ard goes to bed Michael reconsiders and locks the gate just before Black Will and Shakebag arrive. They return to Greene who tells them to attack Ard on Rainbow Down the following evening but to hurt no one else. Black Will and Shakebag sneak up behind Ard and are just about to pounce when the Curate, shouting about recognizing the smell of Ard's horse, appears, squinting, and the Sexton shouts and appears to greet Ard and the Curate. Back at Ard's house, Alice tells Mosby that she married Ard when she was fifteen because he was their

landlord and they could not pay the rent and he seemed very gentle. But soon, when the ground is covered with snow, she says, Ard will be dead and she and Mosby will have his lands and rents and they will be free. Cecily closes the first act with her song.

The second act opens with Cecily humming her song as the characters (with the exceptions of Black Will and Shakebag) take their places as they did in the first act. The Sherrif relates how Ard has sent a message to Lord Cheyney's house in Sheppieville, and Michael, bringing the reply, is intercepted by Alice who convinces him to give her the letter and to tell Ard that he lost it on the way back. Alice then persuades an exhausted Ard to ride to Sheppieville. She opens the cupboard doors to reveal Black Will and Shakebag, who emerge complaining of mouse farts. Alice tells them that Greene will show them the way to ambush Ard on his way to Sheppieville. Following the Sherrif's narration, Alice brings Black Will, Shakebag, and Greene food and drink as they lie in wait for Ard. With fog rolling in, Michael runs off, leaving Ard alone, but Black Will and Shakebag lose their way in the fog and by the time they find the ferryman, Ard has already crossed the river. Foiled again, Alice insists that Mosby help her in murdering Ard by trying to start a fight with him when he returns. Since she promises to withhold sex, Mosby tries to make Ard angry enough to fight, but Ard will not be aroused and the two men sit down to have a drink together. Finally, in Ard's house, Alice, Mosby, Black Will, Shakebag, and Greene, with Michael and Cecily huddled in the background, plot to murder Ard. Mosby is to engage him at the table in a game with dice and, when he says, "Now may I take you if I will," Black Will, hiding in the cupboard, is to burst out and murder Ard. The signal is given three times by Mosby who shouts it out the fourth time. Alice screams at Black Will to get out of the cupboard, but he shouts back that the cupboard door is stuck. Alice opens the door, Black Will charges out "with a terrible bellow of frenzied pent-up murther," and strangles Ard with a towel, beginning a process of killing that takes five pages to complete. Thinking Ard dead, Black Will releases his hold, but when Ard makes a sound Black Will jumps on him again and strangles him until Ard is motionless. The others come out to look at the body, but Ard gets up with the towel on his head, stumbling blindly. Alice tells Mosby to take the iron and "beat the thing to death." Mosby tries, but Black Will takes the iron from him and beats Ard over the head with it until Ard is again motionless. The murderers follow Alice's suggestion and drag Ard outside to the outhouse. Greene has disappeared but he has given the money for Black Will and Shakebag

to Cecily who dutifully hands it over and the two men leave. Ard stirs, reaching out a hand and grabbing Alice by the arm. She screams, Mosby grabs a shovel and starts whacking Ard's towel-covered head, Black Will returns, gets caught by a backswing of the shovel and ends up face down in the jakes hole. When he takes his face out, it is brown and, cursing, he takes out his knife and cuts Ard's throat. After Black Will and Shakebag leave again, Ard utters one final "Uk uk uk uk uk uk uk uk—" before Alice hits him over the head with the shovel. Fittingly, it is this blow that finally kills him. Mosby, Alice, Cecily, and Michael return to the house and are startled by a loud knocking from the Curate, who has come with the Sexton to have dinner. Before they eat, however, the Curate says he needs to visit the jakes, but Alice insists that he must go outside to water the rose bush. Suspicious, the Curate and Sexton go for help while Alice has Mosby and Michael drag Ard's body from the jakes to the churchyard cemetery. Michael sneaks off, and Mosby and Cecily wash Alice's hands. The Sherrif, with the Curate and the Sexton, knocks on the door, and Mosby runs off. Cecily wants to stay with Alice but is ordered to leave. Alice answers the door and tells the Sherrif that Ard is not home, but they soon discover the body in the churchyard. In jail, Alice speaks to the ghost of Ard who tells her that they are about to read his will. The Sherrif reads that Ard's money and lands are to go to Meg and Sue and the other poor tenants, a thousand pounds to a cat, and a thousand pounds to Belinda the cow. Alice says that Ard did not love her, but he tells her that he left her his most precious gift, his love. As the Sherrif recounts the fate of the murderers, the cast have been slowly coming on stage and sitting quietly "amid the rubble, like tombstones." In a final speech, Alice tells us that no grass grows where any part of Ard's body touched the ground, and Cecily closes the play with a reprise of her song as the lights fade and we hear again the sound of birds singing softly.

<p style="text-align:center">* * * * * *</p>

So far there are four plays based directly on Shakespeare's work and imagined life. *The Girlhood of Shakespeare's Heroines* consists of five monologues which can be performed separately but are to be done in the order indicated if presented as the complete play, with the actresses remaining on stage as audience members. The play begins with Ophelia, in a scene entitled *Dead Men's Fingers*, telling us that she cannot reconstruct her childhood without remembering the drunken, pathetic clown Yorick telling stories. She wears a tattered dress and carries flowers as she relates one of the stories Yorick told about a Frenchman in Wales imitating a chicken flapping and clucking

because he didn't speak Welsh and wanted eggs for breakfast. Thinking him mad, the Welsh threw him into a madhouse. Ophelia says that she feels much as the Frenchman must have felt, unable to communicate with those around her, and she realizes that Yorick must have felt the same estrangement. She also remembers playing Adam and Eve with Laertes, naked, with Hamlet directing and playing the serpent. Later, as a teenager, she found Hamlet crying in his room and gave herself to him. Pregnant, with no one to tell except the ghost of Yorick, she let the madness that she had known since childhood "come gushing out like a freshwater spring." By drowning herself, she played out her part to the end, and, unlike Hamlet, she is now able to see the pattern in "God's megadrama."

As the lights dim on Ophelia, they come up, not on another character from Shakespeare, but on Zoe, "a pretty young woman in her late 20s," who tells us of her encounter in an acting class with *Axis Sally*, a woman who broadcast propaganda for the Nazis during World War II. Zoe, bored with her young husband, enrolled in a Shakespeare acting class one summer and found herself sitting next to a woman of sixty to seventy years of age. The woman had a look in her eyes that reminded Zoe of an animal she saw on her way to class, either a martin or a fisher, that was kept in a cage. Zoe called it Martin Fisher Martin and walked to its cage every night to get away from her husband. The dark, frantic, tragic, and slightly insane look in Martin Fisher Martin's eyes was the same look that Zoe saw in the eyes of Mildred, her aged classmate. Zoe tells us that she was paired with a young actor to do the nunnery scene from *Hamlet*, and one night she went to the actor's apartment to rehearse and ended up making love with him. They did their scene for the class the next day and it was well received. Then Mildred did a pastiche of lines from Lady Macbeth's sleepwalking scene. Her performance, though "impossibly overdone," had "some undefinable horrid sense of truth behind it." Zoe tells us that she only found out later that the woman was Axis Sally who, after the war, had been allowed to enter the United States and was living as a lay sister in a convent in a midwestern city. Pregnant, Zoe stayed with her husband; her daughter is now nine years old, looking more like the actor every day. When she looks in the mirror, she sees the eyes of Martin Fisher Martin looking back at her, "desperate and frantic in his cage, waiting in despair for his inevitable end."

In *How Many Children Had Lady Macbeth?* a young woman of thirty, Bonnie, does warm-up exercises as she tells us some of her criticisms of the American theatre. She says that this evening she is

playing "Mariana in the moated grange" from *Measure for Measure*, but the part she always wanted to play was Lady Mac. She tells us some very funny production mishaps while doing the Scottish play, and then says she got her chance as an understudy when the actress playing Lady Mac broke her nose backstage just before curtain. She went on, and everything was going beautifully, the audience responding, her fellow actors engaged, when, in the sleepwalking scene, her dress was set on fire by an actor tripping and dropping a candle. Bonnie says she decided to play through the scene as if the fire were part of what they had rehearsed; the actress playing the Gentlewoman grabbed a bucket of water and doused the flames, and Bonnie says she might have been able to make the scene work if the over-zealous assistant stage manager had not run on stage and sprayed her with the fire extinguisher. She says she has been having a fantasy of having her children see her play Lady MacBeth. (She has already told us that she does not plan on having children.) She feels that she abandoned her children by deciding to be an actress, that she wrote them out of her play, and she misses them..

In *Notes from the Moated Grange*, Mariana speaks like the character in *Measure for Measure* of love, loneliness, waiting, and betrayal. She says her brother died at sea and lost her dowry. For that reason, Angelo abandoned her and now desires Isabella, who is cold and would sacrifice her brother's life to protect her virginity. She says that in God's world you can have anything you want as soon as you no longer desire it. She says she is a minor character in a dark play and when the performance is over she is buried in a trunk and left backstage. After they play the bed trick, and Angelo sleeps with her, thinking she is Isabella, she will kick him into the moat full of carnivorous fish.

Miranda, in *Full Fathom Five*, speaks like the character in *The Tempest*, telling us that she feels as if somebody is watching her. Her father, a playwright, tells her to enjoy the role she has been given to play, that offstage, in death, we choose the role we wanted to play, forgetting whoever we were in a previous play. He tells her that sooner or later she is going to allow Ferdinand "to invade (her) womb with battalions of sperm." She looks out at the ocean but she thinks people are out in the dark looking at her, and she remembers the eyes of one young man that she will wait for on her island that she will never leave.

* * * * * *

Boar's Head deals with the characters associated with Falstaff in the *Henry IV* and *V* plays—nine men and four women including Mistress Quickly, Doll Tearsheet, Bardolph, Ned Poins, Pistol, Justice Shallow,

Corporal Nym, and Fat Jack himself. Other characters are Robin, a girl who pretends to be a man; Francis and Davy, incompetent servants played by the same actor; Goodwife Keech, Bucket Woman, and Jane Nightwork (also played by one actor); Nell, the wife of Poins; a Windmill Keeper (Shakespeare); Armless Man; and three functionaries—Sneak, Fang, and Snare. The unit set includes the Dolphin Room in the Boar's Head Tavern in Eastcheap, London, an adjoining bedchamber with bed, and an area representing the Fleet Prison. Mistress Quickly opens the show by wondering aloud where "that boy" is, and Robin appears behind her. Doll pulls Robin onto her lap to teach him about love-making. Robin tells Doll that she must keep the secret of her sex or Robin will be burned as a witch by the church for wearing men's clothing. Falstaff, bleeding from a head wound given him by Prince Hal, lurches in demanding sack. He pulls Mistress Quickly onto his lap, promises to marry her, and asks for thirty shillings. Poins enters to tell Falstaff that the Prince requires his presence, and when Ned leaves, Nell tells the women that she is pregnant by the Prince and has determined not to tell him. Nor will she tell her brother because he would kill the Prince and be hanged. Robin offers to marry Nell, and Doll threatens to expose Robin's secret, but Robin convinces her that it is better to save Nell from suicide. Sneak accuses Doll of stealing his purse. They fight, and Sneak staggers around the room with Doll beating on his head until they collide with Pistol and all three fall screaming to the floor behind the table. With the beadles approaching, Robin takes Nell out of the room and the beadles, Snare and Fang, take Doll and Pistol off to prison. Nell tells Mistress Quickly that Falstaff, Corporal Nym, and Bardolph have gone off to the wars with the Prince again. Mistress Quickly and Francis drag the corpse of Sneak off as the lights fade on the tavern.

With no interruption, lights come up on Doll sitting forlornly in Fleet Prison; beside her sit a woman with a bucket over her head and a man with no arms. Bucket Woman and Armless Man argue over Armless Man's attraction to Doll until Mistress Quickly and Nell enter to tell Doll that the King has died and Prince Hal has become King Harry the Fifth, and that Falstaff, now a "very large man in the kingdom," will soon rescue her. We hear Falstaff shouting offstage and then see him hurled violently into the prison. Fang and Snare then push in Justice Shallow, Bardolph, Davy, and Robin, who have been imprisoned by the Chief Justice for disrupting the parade of the new King. Falstaff wants Shallow to marry Robin and Nell. When Mistress Quickly also wants to be married, Falstaff says he cannot marry her

because Pistol wants to have that honor. After they leave, Armless Man cries because he will never be among those who are loved, and Bucket Woman takes the bucket from her head and puts it on him as a token of her love, and they go off to see the wedding as the lights fade on the prison and come up on a bedchamber. In bed with a fever, Falstaff complains of being cold and wishes that he could be as warm as he was the night he spent with Jane Nightwork in a windmill, and Jane, "a lovely buxom wench of sixteen years," enters. Falstaff recognizes her but knows that she has been dead for many years. She jumps on the bed and cuddles up to him wondering why he refers to her in the past tense. Falstaff tells her that he is going to meet his maker, and the Windmill Keeper staggers into the room and explains to Falstaff that he has come to eliminate him from the cast of characters, to write him out of the play, since the patriotism of *Henry V* does not stand up well to humor and Falstaff will be a "terrible distraction." Jane throws a burlap sack over "Willy's" head and drags him off as Robin, Mistress Quickly, and Nell return, followed by Doll. Falstaff babbles of greensleeves and greenfields as the clock chimes for midnight, the last chime sounding just after his last words. Mistress Quickly goes to tell the others of his death as the act ends.

As Act Two opens, Ned and Doll are drinking in the Boar's Head Tavern while Nell knits baby clothing, telling her brother that she is knitting a jacket for the child she is going to have. She admits that Robin is not the father, and Doll discloses that Robin is a girl. When Ned tries to make certain that she is a girl, Robin slaps him so hard that he falls to the ground. Since Ned demands to know who the father is, Doll tells him that the Prince impregnated his sister. Ned rants about killing the King, but Nell urges him to accept the fact and speak no more of it. Doll, drunk, puts her head on the table to sleep, saying that she does not have the bastard of a King in her belly but only the common bastard of a would-be murderer (Ned). As Ned describes how he plans to stab the King, the ghost of Falstaff appears behind him, removes a drink from Doll's hand and tells Ned that his plan is not very good. Ned screams as he sees the ghost but he listens as Falstaff explains that the King is just acting out his role in the play. Falstaff tells Ned that his salvation may be closer than he thinks, kisses the sleeping Doll on the head, and leaves. Pistol and Bardolph come in and tell Ned that they have to fight in the war or else be hanged. Drunk, Ned falls over on his face and Robin says that she will go to war in Ned's place. Bardolph and the awakened Doll try to persuade Robin not to go, but she is determined and persuades Doll not to divulge her

secret. We hear the sound of wind as the lights dim and then come up again on the tavern where Justice Shallow is drinking, waited on by Nell. There is a basket of dirty laundry on the floor. Nell tells Justice Shallow that her little baby son is doing well but that she has heard nothing from Robin. Shallow says he misses Mistress Quickly who, Nell says, was taken quickly by "the falling sickness." Pistol, returning from the wars, tells them that Bardolph and Nym were hanged for stealing and blasphemy and that Robin was part of the baggage train slaughtered by the French. After Doll takes a grieving Nell out, Pistol tells Ned that since Mistress Quickly is dead he will marry Doll. Ned explains to him that he has married Doll and is now the docile and not unhappy husband of a better woman than he deserves. Robin and Falstaff enter, then Bardolph and Nym, and, when Doll and Ned come back, Doll thinks she hears whisperings and wonders if the tavern is haunted. She worries that her dead child is in Limbo, a place of "shadows and darkness," and she worries too that Ned does not love her. But he tells her that they are "the playthings of God," holding onto each other, trying to be as happy as they can. Nell comes in saying that she has had two proposals of marriage, one from Pistol (which she will decline) and one from Justice Shallow (which she is considering). After Pistol and Justice Shallow return from their pissing contest, Nell tells Shallow she will give him an answer in a few days and excuses herself to tend to her crying baby. After the men leave, Doll sits drinking, watched by the ghosts. Mistress Quickly enters with Jane Nightwork, who cradles a ghost baby in her arms. The voice of the Windmill Keeper is heard from under the clothes in the laundry basket and he crawls out, to be identified as God by Falstaff, who describes him as "the playwright who has writ this world." The Windmill Keeper says that the scene they are all playing is composed of "crossed out pages from other plays," and that perhaps he himself has recently died. Robin takes the ghost baby over to Doll, who talks to the infant and nurses her. The dreaming mother and ghost child look "for all the world like a portrait of a radiant Madonna with child." The ghosts look on as the lights fade and go out.

* * * * * *

While *Boar's Head* may be seen as an investigation of characters in an adventure not written by the bard, *The Curate Shakespeare As You Like It* contains a large selection of lines from Shakespeare's play, and the story concerns a small group of actors (four men, three women) who are attempting to perform *As You Like It* for an audience that may not be watching or even present. But, under the direction of the Curate,

they do their best. Aside from his role as director, the Curate plays six parts in Shakespeare's play; Celia plays four roles, including Snake; the actor called Rosalind plays Minstrel, Chorus, Deer, Stage Direction, Bush, and Footnote, and, in a wonderful surprise, recites Jaques' famous speech at the end. William plays three parts in Shakespeare's play; Amiens plays six; Clown plays eight; and Audrey plays four. Each of the principals also has a role as an actor in the company. The stage is bare except for several old trunks from which the players extract wigs, beards, mustaches, hats, and cloaks to facilitate changes of character. The play opens with the sound of a shepherd's pipe and the actors come on stage as if preparing for a performance—donning costumes, putting on makeup, being led in warm-up exercises by the Curate. Celia sits apart from the rest and tells the Curate that she thinks her fellow actors are stupid, that there is no audience, that they don't have enough actors to do the play and the ones they have are incompetent. The Curate says that they will manage despite the difficulties and signals Rosalind to begin singing. As she does, he gets into the costume of Adam and the others set up for the first scene. Rosalind speaks some lines describing the location and the characters and then William, in clothes far too big for him, "terrified nearly to the extent of paralysis, in a shakey, cracking voice," speaks the opening lines of Orlando. As William (Orlando) and Amiens (Oliver) talk, William absent-mindedly starts scratching his crotch. The Curate gets him to stop by placing the hand on his hip, but with the other hand William begins picking his nose. Amiens, supposedly being throttled by William (Orlando), takes William's hand and places it on his own throat, wipes the nosepicking finger on William's shirt, and puts it back on his throat. William and Amiens end up on the floor in "a ridiculous, struggling mess" until the Curate as Adam leads William away. (None of the actors leaves the stage; they move to watch the next scene or help set it up or relate to each other.) As Amiens (Oliver) and Clown (Charles the Wrestler) arrange to beat William (Orlando), William falls snoringly asleep against Rosalind, and when she is called into action by the Curate, William's head falls to the bench with a clunk. Rosalind gives the scene description and the other actors discover that Audrey, who is to play the part of Rosalind, is cowering in terror in a corner. The Curate patiently explains to her that everyone is depending on her to play the part of Rosalind because the cast member Rosalind is totally unable to remember her lines. Celia complains that the play is too complicated with everybody playing everybody else, but the Curate says that the audience will see it as a game and that the world is a stage.

Rosalind announces a banishment scene in a room in the palace, and Celia, learning that Audrey (Rosalind) is in love with William (Orlando), tells her father Duke Frederick (played by the Curate) that she will go into exile with Audrey (Rosalind) if he banishes her. The women decide to wear poor clothes and besmirch their faces so that they may travel into the forest of Arden. Audrey (Rosalind) decides to dress as a man (called Ganymede) and Celia (as Aliena) says she will convince the Clown to join them. As Rosalind and the other actors sing 'It was a lover and his lass' they change costumes and create the Forest of Arden, the crowning touch of which activity is a sign "Forest of Arden" put up by the Clown. The Curate (as Good Duke) says he will seek out Jaques, but the scene shifts to another part of the forest as Clown (Touchstone) supports the weary Audrey (Rosalind/Ganymede) and Celia (Aliena) until they collapse in a heap. Rosalind announces the banquet scene and sings 'Under the greenwood tree.' The others join in the singing as they set up the banquet with "extremely artificial fruit and meat," the Clown in a white chef's hat. Rosalind announces the cue for Jaques' "big speech," and there is an improvised drum roll and a few notes from the Clown's trombone. But Amiens (Jaques) cannot remember past the third line and the Curate orders him to cut it. Rosalind and the other cast members sing, getting louder and more energetic, and, after a "jazzed-up lead in on the trombone" from the Clown, everyone except the Curate orders a lunch break and the actors, as themselves, take out paper bags with real food. Curate gives a two-minute call, but all the actors have to relieve themselves and rush offstage, leaving the Curate to tell the audience that they may also wish to relieve themselves, but he urges them to come back.

The second act begins with Rosalind telling the audience that the scene is the Forest of Arden and William (Orlando) is hanging his poetry on the trees. Then Audrey (Rosalind/Ganymede) enters reading some of the poetry she has found and Celia(Aliena) comes on, also reading poetry aloud. She tells Audrey (Rosalind) that the poems are from William (Orlando). When he enters, Audrey (Rosalind) speaks to him as Ganymede, telling him that he does not look like a man who is in love, but since he needs to be cured of his love for Rosalind, he must woo Ganymede as if he were Rosalind. Amiens (as Silvius) and Celia (as Phoebe—after a quick change into a fright wig) are advised by Audrey (Rosalind/Ganymede) to understand the true nature of their relationship, but of course Celia (Phoebe) has fallen in love with Audrey as Ganymede and orders Amiens (Silvius) to deliver a letter. After an interruption by Rosalind, William (Orlando) and Audrey

(Rosalind/Ganymede) play their love scene and Celia (Aliena) pretends to hear their marriage vows. When Audrey (Rosalind/Ganymede) describes how much trouble she will cause as Orlando's wife, William (Orlando) excuses himself to keep a dinner appointment with the Duke, swearing that he will see her again in two hours. Rosalind announces the return of Oliver, Orlando's nasty brother, and Amiens, after a quick costume change, tells the story of the bloody napkin. Then, as Orlando's older brother (the ragged man threatened by the lion), Amiens describes how Orlando was wounded in the arm and says that the bloody napkin used to stanch the wound was to be brought to Audrey (Rosalind/Ganymede). Seeing the blood, Audrey faints, twice, and is carried off by Amiens and Celia. William and Audrey become entranced with each other, kissing, and ignoring the Clown. Audrey (Rosalind/Ganymede) tells William (Orlando) that his brother and Celia (Aliena) are to be married and that, through the aid of a magician, Rosalind will marry him. Amiens (Silvius) and Celia (Phoebe) enter and Audrey (Rosalind/Ganymede) makes them agree to meet the next day, promising marriage to everyone. The Curate as the Good Duke is about to take everyone into the forest for the weddings when Amiens (Jaques) interrupts, complaining that he can't play three characters in the same scene. Rosalind announces Hymen, god of marriage, and the Clown gets into his Hymen outfit, leaping like a fawn as he throws flowers and confetti, reciting a doggerel poem that goes into a reprise of 'There was a lover and his lass' that begins in a fairly orderly way but soon develops into a kind of primitive tribal rite, "a joyous chaos." Celia stops the festivities, saying that she is ashamed of what they have done, that they have desecrated the memory of Shakespeare and humiliated themselves. What, she asks, is the point? After a silence, the Clown takes down the Forest of Arden sign and drops it into one of the trunks. Rosalind stands and begins reciting Jaques' seven ages of man speech, simply "as if remembering" at first, but gradually getting caught up in the beauty of remembvering and saying it. When she finishes, she looks to the Curate for approval, and he smiles and begins to applaud. Then the entire cast applauds the imaginary audience.

* * * * * *

Although Nigro manages wittily and adroitly to tell the story of Shakespeare's 27-character *As You Like It* with only seven actors, the cast for *Loves Labours Wonne* lists thirty-one parts (22 men and 9 women) to be played by fourteen actors (9 men and 5 women). The setting is the stage of the Globe Theatre and various trunks are on srtage from which the actors "first build and then destroy a variety of

locations in Stratford and London." Shakespeare, in his late forties, carrying a wine bottle, wanders on to the stage, speaking of his career as a playwright, a maker of small worlds that he winds up and watches run. Preceded by some ominous sound effects, Bone enters, sweeping the stage with a broom. Susanna, Shakespeare's daughter, in her late twenties, enters, carrying a folded man's cloak. Before exiting, Bone warns Shakespeare about the open trap on the stage. Since her father has retired, Susanna cannot understand why he refuses to come back to Stratford with her. He tells her he will leave the next day, and she puts on the cloak that his wife made for him. Alone, Shakespeare speaks of being terrified of nothing. Speaking to the audience, he says he hates them, that they are cannibals, and as he talks of death he walks backwards and falls into the trap, screaming. We hear his "best Ghost-father voice say, 'Hamlet, Revenge!'" and the sound of his laughter. Suddenly, the stage is full of people running and singing as they build two sets—a "green and rustic Stratford" and a "squalid and crypt-like London." The actors sing a song about the plague which ends in a dance of death as they exit, leaving Anne in Stratford and the Lady in London, looking at each other across the open trap. Ariel, on a balcony, sings 'Full fathom five' (music by Nigro) as the women drop flowers into the trap/grave. But the Sexton pulls Shakespeare up from the trap, hands him a skull, and exits singing. Anne and the Lady talk of making love and leave as Ariel sings a short lyric. Richard III appears on the balcony and utters the opening line of one of Richard's soliloquies, "grossly overplayed, grotesque." Shakespeare addresses Richard as Dick Burbage, telling him that he should play Richard as a nice guy, a saint. Munday enters to tell Shakespeare that a friend of theirs, a lady, has been drowned in the river. The actor playing Richard removes "his hump and uglies" and reveals himself as Christopher Marlowe. He and Shakespeare chat for a bit about death and ripeness and Marlowe exits laughing. In a brief blackout we hear thunder and see lightning flash and then, on the balcony, Burbage speaks as Machiavel in Marlowe's play as he is watched by Ariel and Shakespeare on one side and by Alleyn and Henslowe on the other. Henslowe interrupts and he and Alleyn criticize what they regard as Burbage's underplaying. Alleyn offers to show Burbage how to act and, climbing onto the balcony, with "great expression, wheezing, maniacal laughter, great arm gestures and strutting, but still quite impressive, in his fashion," he does. The Lady crosses to the desk where Shakespeare is writing; he assures her that he loves her, pulling her onto his lap and kissing her. As he tells her of his wife, Anne

appears in the Stratford set, picking flowers. Mary, Shakespeare's mother, enters and reminds him that Anne cured his father's fistula. John, Shakespeare's father, comes on, cutting gloves, with his brother Richard. Time and place interweave in the present moment of the stage as Anne says that she has a large dowry and wants to marry Shakespeare if she is able to cure his father's infection. The cure is quickly accomplished and Shakespeare is given to Anne. When we hear the sound of a baby crying offstage, the focus of attention shifts to Greene's lodgings where Marlowe and Greene trade insults while Mrs. Isam cleans up and Shakespeare listens. Anne, in Stratford, holds a "baby-like bundle of black fabric," and tells Shakespeare in the London set that he should take care of his family. Greene belittles Shakespeare's chances as a playwright, but Marlowe asks to see a copy of *Harry the Sixth*. The crying of the baby annoys Greene, who is coughing and gagging but begins writing a comment (the famous one) about Shakespeare. Anne in Stratford interjects comments as Shakespeare speaks of living in "the stomach of hell" among death-eaters. Lady says that he should stop writing plays, and as she walks out she bumps into Marlowe. They know each other, to Shakespeare's surprise, and Marlowe tells them that Henslowe has decided to stage *Henry the Sixth*. In another scene where past and present are conflated, Shakespeare prevents Anne from falling into the trap (representing the river) but she lets herself down into it as if going for a swim. Lady tells Shakespeare he was a fool to marry, Ariel sings a verse from the song, and John, Shakespeare's father, asks him how he likes being married, but they hear laughter coming from the trap (now representing a ditch) and discover Richard, Shakespeare's brother, and Anne making love. Anne says that she is not ashamed, that she felt sorry for "pathetic" Richard, and that Shakespeare betrays her because his mind is "always somewhere else." But Shakepeare tells her she has made a mistake and that he now can leave her. The act ends with Ariel singing a song about the universality of cuckoldry.

Act Two opens with Ariel singing 'Fear no more the heat of the sun,' as Marlowe and the Lady sit together drinking and Shakespeare, alone, speaks of his need to touch flesh, to create, although he knows that all is illusion and everything must die. Marlowe excuses himself as Henry Chettle enters looking for Shakespeare. Chettle starts to say that he did some editing on Greene's last pamphlet, but Greene sits up suddenly in the trap, "face green and ghastly in death," to announce the title and subject of that pamphlet, coughs, then quotes the passage that Chettle thinks might have offended Shakespeare before coughing twice

and falling back in the trap. We hear a bell begin to toll and a small funeral party gathers around the trap. Shakespeare and his family have gathered to bury his son, Hamnet, dead from the plague. A bell begins to toll and Doctor, Henslowe, and the Preacher speak "from three corners of a triangle" with Shakespeare in the center. In alternating speeches, the Doctor talks of the humours and of putrefaction, Henslowe describes the theatre as a business of entertainment where thought is bothersome, and the Preacher narrates a grotesque tale of God driving a stake through his son's heart and feeding his flesh and blood to the people. Each speaks three times before Shakespeare screams out, saying he is nothing, but is cursed to be everything. Ariel sings two lines from 'Full fathom five' as Shakespeare moves to Marlowe's lodgings where Marlowe and Frizer are talking "quietly and intensely." Frizer reminds Marlowe about a meeting in Deptford the next day. After he leaves, Shakespeare tells Marlowe that he has been offered a shareholder's place in a new theatre company that Burbage and some others are forming. The scene shifts to night, with thunder and lightning, as Shakespeare, drunk, wanders into his lodgings and falls on his face. Falstaff takes over the stage, announcing the entrance of "England's sweetheart, LITTLE LIZZY TUDOR," and the Queen, resplendent with beads, black teeth, and a referee's whistle around her neck, enters to tell "William Shakepoop" to wash behind his eyes. Polonius rushes on, followed, after the Queen blows her whistle, by Alleyn, Burbage, and the Beggar. They cover Falstaff with a blanket and carry him out. Polonius babbles, the Fool puts his cap and bells on Shakespeare's head, and Greene pops his rotting head up from the trap. Richard II, Polonius, and the Fool recite garbled lines from the plays. As Greene repeats "ripeness," the actors leave, and Frizer, Foley, and Skeres sit with Marlowe at the tavern in Deptford, talking about Thomas Kyd as Frizer borrows Marlowe's knife to peel an apple. Foley and Skeres move to Marlowe's sides and Frizer tells Marlowe he has a present for him. As a slow-motion strobe effect begins and Ariel repeats the line he has said before ("God's spies, eats me eyes, gilded butterflies."), Frizer raises the knife and brings it down toward Marlowe's eyes. Lights black out and the Lady screams "horribly." We hear a knocking on a door and Shakespeare awakens to admit the Lady who tells him of Marlowe's fate. Shakespeare sits at his desk and begins scribbling frantically, speaking hysterically until the Lady tries to hold him as Henslowe enters to say that he would like to produce the Richard III play and that he is setting up a play "manufactory" in which different writers contribute different skills to each script. Shakespeare

refuses the offer and tells the Lady that, although one day his plays will be used to line pie tins (Warburton's cook), he will write for the theatre. Marlowe appears on the balcony after Lady leaves and speaks lines from *Richard III* simply and honestly as Ariel sings the notes of 'Full fathom five.' Munday enters to tell Shakespeare that the body of the Lady has been found in the river. The stage lights darken as the storm returns, but then, suddenly, "the stage is full of singing and dancing people," swirling around the central figure of Shakespeare who, "berserk with rage and sorrow," tears down the sets of London and Stratford. When the song is over and the other actors have left the ruined stage, Shakespeare grasps a staff that Ariel hands him and talks to Miranda from *The Tempest*. She tells him that all flesh is borrowed but that the charcters in his plays cannot be lost because they are made of his soul. Wondering if he will lose his soul to God, Shakespeare falls backwards into the trap. When his scream stops, Miranda and Ariel have left the stage and a cock crows. It is morning; we hear birdsong and the footsteps of Bone who enters and complains about the mess that he will have to clean up. He closes the door of the trap, singing "absently" from 'Full fathom five' as he picks things up, looks up at the sky to remark that it's a "nice day for a play," and continues humming as the lights dim and go out.

<center>* * * * * *</center>

Four other plays deal with various aspects of acting and the theatre. *Pelican Daughter**, Nigro's first full-length script, is about a small troupe of traveling Shakespearean actors in America around the turn of the century; *Henry and Ellen** is an investigation of the legendary duo of the late 19th century British stage; *Monkey Soup** is an hysterically and riotously funny homage to the Marx brothers; and *Punch and Judy** explores the human horrors of the puppet show.

*Pelican Daughter** has five parts, four men and a woman. The Curate, whose ocean-side house and pier are represented in the unit set, is called Willy by Griffin, who represents the Pendragon and Rose Peripatetic Shakespearean Theatrical Company and Medicine Show. Rine and Bok are two actors with the show, and the Girl, called Miranda by the Curate, is his daughter. The edge of the stage right area represents the pier on which the Girl is sitting as the play begins, and steps lead up to a kitchen area from which are steps leading down to a center stage area representing the basement, with wine barrels and bottles, several old theatrical trunks, and a wooden chair. After the Curate finishes talking with the Girl, he leaves to take a walk with the cat and Griffin enters from stage left as if coming along the shoreline to

the pier. He tells the Girl that he needs a place for his troupe to hide because the Bishop is trying to kill all actors. The Curate is disturbed when he returns to find Griffin with the Girl and orders her to go into the house. She is disrespectful and disobedient, but she goes into the house when Griffin tells her that he has moved his little theatrical company into their back yard and his actors are carrying trunks into the cellar. The Curate accuses Griffin of working with the Bishop, but Griffin accuses the Curate of deserting the acting company. As the lights fade on them, we see the Girl in the cellar with Rine and Bok, drinking wine. Rine and Bok scuffle and Bok leaves. The Curate discovers the Girl with Rine, finds a chair for her to sit in, asking her if they want Rine in their house. When Rine tries to put his head under Girl's skirt, the Curate grabs him by the collar and belt and "hurls him violently" into the upstage barrels. The Girl tells the Curate that something is wrong with time, that things are "extremely screwed up" and that it is the Curate's fault. Girl tells Rine a story about a curate whose job was to unscrew the reproductive organs from the statues in the village whenever the Bishop was coming for a visit. Caught putting his head under Girl's skirt again, Rine obligingly throws himself into the upstage barrels. We hear thunder and dogs barking and the Girl runs up and down the starirs, hysterical, because men in hoods have entered the town square, looking for actors, and the dogs are tearing Bok to pieces. Pounding on the door starts and continues as she runs to the Curate's arms. The lights fade as we hear the storm, the dogs, the pounding on the door, and the sound of ticking clocks.

Act Two begins exactly where Act One ended: "No time has passed." The Curate notices that the knocking has stopped and concludes that there is somebody in their house. Griffin appears in the kitchen, with Bok, and says that the Bishop's people are ripping to pieces someone they think is an actor. Griffin puts on some dark glasses and proposes to create a play called *The Curate's Egg*. The Girl wonders why Griffin keeps referring to the Curate, her father, as "Willy," and Griffin again intimates that the Curate was once the playwright for their theatre. As Griffin narrates an allegory of the theatre he and Curate/Willy had created, the Curate sits silent, looking at his hands. Griffin explains to the Girl that his company of three actors needs a woman badly. He then impersonates the voices and behaviors of two actors who were on stage together for fifty years, Gertrude and Claudius, using his own voice for narration. Griffin refers to the Girl as Cordelia, but she says her name is "Miranda. Lilith-Miranda," and learns from Griffin that her father was the

"greatest maker of universes" that Griffin ever knew. He refers to the Girl's mother, and the Curate warns him not to speak of her, and, with "a roar of grief and rage hurls himself like a lion" on Griffin and strangles him. Bok manages to get the Curate off Griffin who then tells the Girl the story of her mother, a beautiful actress who died of complications following the Girl's birth. Griffin wants the Curate to come back to the company and when he refuses, Griffin asks the Girl if she would like to become an actress, playing all the great Shakespearean heroines her mother played. Griffin rummages in a trunk and, after pulling out a skull, a rubber chicken, a prop arm and a hunting horn, hands the Curate the chicken and gives the Girl an "old, worn little book." With Griffin playing Kent, Bok the Doctor, Rine the Gentleman, and, eventually, the Curate as Lear, they do Act Four, scene seven, from *King Lear*. Griffin breaks the spell after Lear recognizes Cordelia, and all except the Curate agree that the Girl is very good, but when she asks her father, he leaves and goes up to the kitchen and out on the pier where the play began. He tells the cat that he is going to lose the Girl, that there is no way to keep her, and tries to bargain with Griffin, saying that he will return to the company if Bok stays at home with the Girl. Griffin likes the idea, but Girl and Bok refuse. The only solution, as Griffin sees it, is for them all to stay and set up a theatre in the basement, "The Pendragon and Rose Non-Peripatetic Shakespearean Theatrical Company and Medicine Show Underground Playhouse." And at Griffin's urging, Curate/Willy begins creating a play called *Pelican Daughter*, the setting for which is the Curate's kitchen and basement with the pier on which Curate and Girl begin speaking the lines that opened the play, and we have come full circle, ending as we began

* * * * * *

In *Henry and Ellen** the unit set represents the stage of the Lyceum Theatre in London, a backstage area, Miss Terry's lodgings, and Waterloo Bridge. Trunks are scattered around the stage, and furniture and fragments of scenery are available to create locations. The play begins near the end of the nineteenth century, goes back about twenty years, and progresses back to the time of the opening, with age differences being created by the actors. The play begins as Ellen, thinking the theatre is empty, recites the opening of a Shakespeare sonnet, only to be interrupted and corrected by Henry. They speak of the fire that has destroyed all the sets and costumes of Henry's company. As Henry moves upstage, Ellen takes off her coat, rolls up her sleeves, and puts a kerchief on her head as the action segues into

the second scene in which the young Ellen and Henry first meet. Ellen
tells him that they worked together years before, but Henry cannot
recall the event, and his dog, which he has left in the vestibule, starts
howling. When he goes to get the dog, he discovers that it has made a
mess on the carpet. After agreeing to play Ophelia to Henry's Hamlet,
Ellen leaves to clean up the mess and Henry takes off his coat and
produces a notepad to give notes to an invisible group of actors down
stage, a group that Ellen soon joins. After Henry finishes giving notes,
Ellen asks him why, since their dress rehearsal is the following day, she
and he have not rehearsed any of their scenes together. Henry says that
since she knows her lines she has nothing to worry about. After he
leaves, Ellen stomps angrily to the edge of the stage which, during the
course of her speech, becomes Waterloo Bridge where Henry finds her
and persuades her that her performance as Ophelia need not result in
suicide. In her lodgings, Ellen tells him that everyone knows about
their relationship and that she will not be touring during the summer
season with him because she has promised to work with her husband
who is sick and needs her. After she leaves, Henry rehearses a
monolgue of Gloucester from *3 Henry VI*, at the conclusion of which
Ellen enters from upstage in mourning clothes. She tells him that she
loves him and calls him an incoherent booby when he proves unable to
repeat the phrase to her, but he does ask her if she would like to marry
him. She suggests that perhaps they could take a year off, but Henry
finds that prospect impossible, though he does promise never to go
away from her.

The three scenes of the second act occur backstage and onstage at
the Lyceum Theatre. Henry finds Ellen hiding in a trunk backstage
because, as she eventually tells him, her arm has swollen and turned
blue from a horse-fly bite, and Bram Stoker's brother, a doctor, wants
to lance the arm. Henry suggests that perhaps Marion, Ellen's sister,
could go on as Viola, but Ellen says that she has become like Henry
and cannot allow a performance to go on without her. She will play
Viola with one good arm. After she runs off, Henry takes costume
pieces from the trunk, transforming himself into Mathias from *The
Bells*. As he rehearses, he is surprised by Ellen who tells him that
George Bernard Shaw, with whom she has been corresponding, thinks
that the best actor should do the best plays, and she repeats her desire to
do modern plays. When she tells him that she thinks it would be a
good idea if they each saw other people, Henry agrees and leaves.
Ellen, suddenly cold, puts on the coat she was wearing in the opening
scene of the play and begins reciting another sonnet. She recalls for

Henry some of the experiences of their touring days and suggests that since the fire has destroyed everything they have nothing to lose by starting over and doing different things. She wants Henry to do a Shaw play with her, but he refuses, telling her that she must go her own way, do the parts she wants to do while she can. After she leaves, he comes down to the edge of the stage and talks to the audience, smiling, looking out into the darkness as the lights fade and go out.

<p style="text-align:center">* * * * * *</p>

The setting of *Monkey Soup* is again a stage, this time of a New York theatre in the 1930s, representing a "ritzy mansion drawing room." There are eight characters, five men and three women, with no doubling of parts. Mrs. Lillian P. Quackenfurter, a once renowned actress, is described as "a tall, hefty, rather formidable woman, handsome and dignified, with a particularly impressive bosom." Thelma, "a blonde bombshell," is the wife of Edgar, "the heavy, tall, gruff, and bald," while Lucy, "a pretty ingenue, plays the maid." Goosey Gander is the assistant stage manager, Luigi Boccalucci is the stage manager, and Dr. Cornelius T. Fartwhistle is "the great director." The cast is completed by Dick, "the bland leading young man." The action begins as Mrs. Quackenfurter announces to the cast that she has been able to replace the director of their show with the internationally renowned Fartwhistle. Hurled onstage from the wings, Fartwhistle, with Groucho-like patter, insults Mrs. Quackenfurter several times before launching on paragraph-long diatribes about small-game hunting, his mother, and the need for naked women in theatre. When he learns that Mrs. Quackenfurter is the playwright, he fires her and then puts the moves on Thelma, Edgar's wife. After he, Boccalucci, and Goosey all practice kissing Thelma in front of Edgar, Fartwhistle sits in Mrs. Quackenfurter's lap and comments on her size. Boccalucci takes a rifle and shoots it into the air; a duck falls and Goosey retrieves it with his mouth and, on all fours, chases Lucy offstage. After Mrs. Quackenfirter leaves to assemble the cast for rehearsal, Fartwhistle tells Boccalucci and Goosey that he is really Dr. Hassenfusser, and that Fartwhistle died in his dentist's chair. Boccalucci and Goosey agree not to reveal Fartwhistle's true identity if he allows them to appear in the show that night. The cast then rehearses the play from the beginning, with Goosey honking for the telephone ring, and Lucy using the goose as a phone. Mrs. Quackenfurter makes a grand entrance as the teen-age heroine, Lady Edwina Furtwinger, and Dick announces that he has brought with him the love of his life, Masie McGurk of the Coney Island McGurks. Thelma enters, Mrs. Quackenfurter swoons,

Dick puts her medicine in a teacup for her, and Edgar storms in with a
gun (he is Maisie's husband, Waldo). But the gun will not fire because
they have run out of blanks. Goosey offers to honk, but Fartwhistle
tells Edgar to "just yell BANG for now," promising to return with real
bullets after the lunch break. Mrs. Quackenfurter as Edwina is shot and
commences a long, literary death speech, complemented by satiric
asides from Fartwhistle. Boccalucci calls the lunch break and speaks to
Lucy on Goosey's behalf. Lucy says that she cannot marry Goosey
because she is in love with Dick, but Mrs. Quackenfurter and Thelma
both say that they love Dick. The three women ask Dick to tell
everyone which woman he loves (he has apparently been with them
all), and Edgar, in a rage, begins chasing Dick around the stage and off,
followed by the women. Boccalucci tells Fartwhistle that he has spiked
the water cooler with vodka, sleeping pills, loco weed, Spanish fly, and
a couple of other things. Fartwhistle ends the act by telling the light
person to turn off the lights, adding that he can drink from the water
cooler if he does.

Fartwhistle begins the second act by announcing to the audience
"the gala New York opening of Mrs. Lillian P. Quackenfurter's
breathtaking new masterpiece of American drama, *Lady Furtwinger's
Lover*," but Boccalucci and Goosey indicate that he needs to delay the
opening because of trouble backstage. Eventually, talking to the
horse's hindquarters that Goosey handed to him, Fartwhistle announces
the beginning of the play, and the cast, totally sloshed, begins the
performance. But the phone cue is late and Lucy starts her expository
speech without it, eventually throwing the goose phone offstage, only
to have it thrown back at her, followed by other geese. She tries to pick
up the geese as she continues with her speech, announcing the arrival of
the young and beautiful Lady Edwina, who does not appear on cue but
then, with a "WHEEEEEEEEEE" hurtles on from the opposite side..
From this point on, chaos reigns as the actors try to follow the script
but get caught up in an unending series of physical actions (with
accompanying screams and honks), culminating in Edgar's entrance
with the gun, which calls our attention to the grotesquely hilarious
tangle of bodies on the chair and couch. Because Thelma is passed out,
Boccalucci is saying her lines in a falsetto voice. Trying to shoot Dick,
Edgar hits Mrs. Quackenfurter and then shoots Dick, who falls on top
of her. A revived Thelma takes the gun from Edgar and shoots him;
then, learning from Fartwhistle that he plans to do the play again the
next night, herself. Thinking he has four dead actors on the stage,
Fartwhistle is disconcerted to learn from Boccalucci that Goosey put

tranquilizer darts in the gun, not bullets. As Mrs. Quackenfurter doggedly continues her death speech, Edgar and Thelma join the melee until Goosey hits Edgar in the nose, then Mrs. Quackenfurter, who was about to tell us what Queen Victoria said to Prince Albert on their honeymoon. We hear the sound of a foghorn, "very loud," and Lucy goes to answer the door and returns with a large package for Fartwhistle. The package turns out to be a bronze statue shaped like a frankfurter, and Fartwhistle announces that it is the Pulitzer Prize. Boccalucci hands the weiner to Goosey, who speaks for the first time: "THE PULITZER PRIZE? THE PULITZER PRIZE? HOLY SHIT!" And, as in the old movies, we go to black.

<div style="text-align:center">* * * * * *</div>

At the extreme borderline of farce, *Punch and Judy** explores the horrific violence underlying the puppet façade, and while there are many very funny lines and actions in this play, the final effect is, for me, after all the laughter, a feeling akin to that aroused by tragedy, where compassion, terror, and similar emotions are evoked by the virtual reality of the performance and, being felt, subside, "all passion spent." The script requires five men and two women, with one of the women playing the squalling voice of a baby and three other parts, one man playing three parts, and two of the men doubling parts. In a commentary following the script, Nigro calls Punch the "id incarnate," a force at once destructive of all that opposes its will and creative in its "all-things-are-possible" world. Nigro's Punch is a grotesque—huge nose, pot belly, and hump His first action, after ordering his wife Judy to make dumplings for his supper, is to smash the baby against the wall because it won't stop crying. (The "baby" is clearly a doll, an inanimate object like Punch himself, but the virtual effect is horrifying.) Punch throws the now-silent baby out the window but retrieves it when Judy wants to know what happened. Explaining that it doesn't matter what they do since they are only puppets, Punch demonstrates that it is all "a fake" by uinscrewing the baby's head, banging it on the wall, and tossing it to Judy, who, dropping the head, grabs a cudgel and begins beating Punch violently over the head until he takes the cudgel and beats her. She runs off to get the Beadle who, coming to arrest Punch, is beaten over the head with the body of the baby that Punch is holding and collapses on the floor. Judy's Ghost enters, explaining to Punch that she hanged herself from a lamp post. Punch begins hearing whispering sounds, perhaps, he thinks, from a "dark satanic crocodile," and is terrified when the Beadle bursts out of the trunk, beats him with the cudgel, and drags him off to jail. Alone,

Judy takes the body and then the head of the baby from the trunk and puts the baby's head to her breast inside her ghost gown. We hear again the sound of an old Jack-in-the-Box playing 'Pop Goes the Weasel' with which the play began. And as Judy calls the baby cruel for biting her nipples, the light fades on her and goes out. But the music continues as the lights come up on the jail, created with light and the shadows of bars. One prisoner sits upstage with his back to the audience, turning the crank of the music box; another is curled up under an old blanket, and Joey the Clown stares at Punch. Clown tells Punch that he is to be hanged, and Punch wakens the figure under the blanket who turns out to be Judy's Ghost. She pulls out the baby with its head on backwards held in place with duct tape. Punch thinks he hears the crocodile whispering again, says that he can't breathe, screams, and falls down as if dead. The actor upstage who had earlier operated the music box announces that he is a Doctor, certified by mail to treat dead people and puppets. Doctor asks Punch if he is dead; Punch says he is and wants the Doctor to summon the undertakers and get him out of the prison before the hangman arrives. Punch beats the Doctor until he screams for the undertakers and Undertaker and his Wife run in with a coffin in which they put Punch and, with the help of Clown and Judy's Ghost, carry it offstage. Lights come up on the gallows, a noose dropped from a batten over a small wooden box. Jack Ketch, the hangman, is preparing for the hanging as the Undertakers, the Doctor, Clown, and Judy's Ghost drag and push the coffin onstage. Ketch does not believe that Punch died in childbirth and asks Punch if he has a death certificate. Ketch says he must hang Punch for killing his baby and because he, Ketch, loved Judy, Punch's wife. To prove that they are involved in a puppet show, Punch tells Ketch that what happens next is that Punch tricks Ketch into hanging himself, a routine they have done a million times. Ketch puts his head in the noose to show Punch that it will fit over his hump, and Punch kicks away the box, leaving Ketch struggling and gasping for air. Punch starts hearing whispers again and he runs off flailing his arms "in distracted terror."

Act Two is situated in the Crocodile Inn, where a fire is glowing on the hearth. Punch and Clown come in, cold, and Punch, noticing a frying pan full of sausages on the fire, picks up the hot pan and hands it to Clown when they hear the Innkeeper coming. Clown stuffs the pan full of sausages down the front of his pants and begins squirming and moaning and jumping around. Punch explains to the innkeeper that the Clown is from Lapland and is doing a rain dance as Clown runs off and on stage, finally sitting in a bucket of water. The Innkeeper says he

will put a red hot poker up the nose of anyone he catches stealing his sausages. Punch grabs the poker and shoves it up the Innkeeper's nose. The Innkeeper screams and pulls Clown off the water bucket so he can put his head in it. Punch holds the head in the bucket until the body goes limp. Having killed the Innkeeper, Punch feels a powerful urge to drown his "post-violence tristesse,/ with a little sweaty grunting copulation." On cue, we hear the Innkeeper's Daughter calling for her father. Clown lifts a creaky trap door so that he and Punch can throw the Innkeeper's body in the cellar, and Punch tells the Daughter that he has purchased the Inn from her father who has gone to Peterhead on top secret business, hoping that Punch and Daughter would marry. With Clown as Parson Joey, Punch rushes through the ceremony, gives the bride a big kiss, and tosses her over his shoulder to carry her upstairs to bed. Clown meditates on the events that have, and are, transpiring as we hear the sounds of Daughter's screams along with wind and thunder. Lightning flashes, the lights go out, and when they come back up to the sound of 'Pop Goes the Weasel,' the ghosts of Judy, Jack Ketch, and the Innkeeper are playing Firehouse Pinochle with the Clown. Clown says that he has felt three-quarters dead himself since the Daughter went mad on her wedding night, and we hear the girl singing lines from 'Pop Goes the Weasel' as she enters. She carries the dead baby doll which Judy's Ghost has loaned her. Punch grabs the baby and beats the Daughter with it, but the head falls off and as she crawls around to find it he keeps beating her with the torso until Clown shoves the red hot poker into his eyes, blinding him. Crawling on the floor, Punch finds a pair of scissors and jabs them into his head to prove that his pain is an illusion, but after a moment he screams and writhes on the floor in agony. Judy's Ghost runs off to the bogs to be with her dead infant, and Kietch runs after her. After telling Punch that there is ointment in the cellarage, the Innkeeper leaves to find his Daughter. Hearing the sound of crows, Punch looks up and asks if the bird could be his friend, but is answered by a white glob the size of a pancake dropping onto his face. The Puppeteer's voice, from above, tells him that he is not a puppet and that he must go into the cellarage if he wants to know who he is. Punch opens the trap and puts his head into it, asking if anyone is there, and a Crocodile, with "a gigantic, shocking, hideous, surreal, amplified roar," opens its jaws and swallows the screaming Punch head first, dragging him into the cellarage. Clown runs back in with a hand puppet with the head of Mr. Punch. We hear Punch call for help from the cellarage, but Clown acts as if the hand puppet were speaking to him, closes the trap door and sits

on it as he continues his conversation with the puppet, imitating Punch's voice, saying that Joey has married the Innkeeper's Daughter. When Clown wanders off to look for sausages, we hear the music for 'Pop Goes the Weasel' again and we hear Punch calling for help from the cellarage. The music stops abruptly when the tune gets to "pop" and the lights go out. We hear the sound of crows in the darkness.

* * * * * *

The seven plays that investigate the lives and deaths of writers range chronologically from *Maelstrom** (Edgar Allen Poe), *Blood Red Roses** (pre-Raphaelites), *An Angler in the Lake of Darkness** (Tolstoy), and *The Dark Sonnets of the Lady* (Freud) to *Lucia Mad* (Beckett and Joyce), *Mandelstam** (the Russian poet killed by Stalin), and *A Lecture by M. Artaud** (Antonin Artaud). In *Maelstrom** two of the twelve actors have single roles—Poe and Mary Rogers—while ten of the actors play multiple roles. The set Nigro calls for is "a dark, Gothic construction like joined fragments of haunted houses." Two levels are needed with staircases, a coffin-shaped window seat, an empty oval picture frame, and a trap down center that can be opened from beneath. The play begins as Virginia, "a frail, lovely girl in a white nightgown, holding a lamp," sings (to a Nigro melody) the opening lines of Poe's poem, "Annabel Lee." As she crosses up to the bed, the "tall, dark, gaunt figure' of the Red Death, his face hidden by a cowl, emerges from an upstage door. As Virginia finishes her song, a small bell rings over the downstairs right door and Poe enters with a bottle of wine. He speaks the opening lines of one of his stories, falls as he tries to sit, and asks Mary what he is doing in Baltimore. She tells him that he is in the El Dorado Tavern, drinking too much. Anderson, the owner of the cigar store where Poe is drinking, asks for money and Poe offers him walnuts and begs for shelter for the night. Daniel Payne, the man who possibly got Mary Rogers pregnant, leaves a white rose on the stone bench where he had been sitting and exits. As Mary and Anderson put Poe to bed, he calls out for Reynolds and shouts lines from his stories, experiencing sensations of being buried alive before falling asleep. After Anderson and Mary leave, Virginia sings four lines from "Annabel Lee" and crawls into bed with Poe as time and place change to Poe's cottage years earlier. Henry Wadsworth Longfellow enters through the center downstairs arch, scribbling in a notebook and reciting the opening lines of "Hiawatha." Eliza, holding a floppy baby doll, trips and the baby falls, landing in a pram wheeled out by Fanny and John Allan, Poe's adoptive parents. Virginia expresses her desire to have a baby when she is stronger, and

Poe goes out to solve the murder of Mary Rogers whose bloated body has been dragged from the water. Virginia sings eight lines from "Annabel Lee" as we segue to Poe, drunk, wandering the streets. Ossian and Charlie Kellenbarack, the brothers who raped and killed Mary, are the faces in the oval frame. Poe meets the actor Junius Brutus Booth who tells Poe that he ought to write for the theatre and then trades insults with Edwin Forrest, a fellow actor, also drunk. Anderson tells Poe that he has hired Mrs. Helen Whitman, a clairvoyant, to call up the spirit of the dead Mary Rogers, and Booth and Forrest join the séance. Although Helen summons the spirit of Mary Rogers, it is the voice of Eliza, Poe's mother, that we hear, speaking of her career as an actress and of her three lost children. Then we hear Mary's voice and Eliza leads her into the light. Poe wants to know who killed her because he needs the ending for his story, *The Mystery of Marie Roget*, but Virginia enters, saying that Reynolds has been looking for him. After the séance ends with a brief blackout, the lights come up on Poe, Forrest, and Booth in a jail with Ossian and Charlie Kellenbarack. Ossian admits to killing their mother, Mrs. Loss, because she wouldn't stop talking but denies involvement in Mary's murder. Helen, preceded by an "Ourang-outang with a big ring of keys and a policeman's hat," bails Poe out of the jail. As Virginia sings, the lights dim on the jail and come up on Poe and Helen walking in moonlight. Mary is now in the oval frame, but Poe, screaming, falls into the trap left open by the Ourang-outang, and Helen tumbles in as she tries to help Poe out. Helen's mother, Madame L'Espanaya, trying to beat Poe with her rolled-up umbrella, also falls into the trap, but Poe manages to get out, pursued by the mother as Helen crawls out of the trap and up the stairs to bed. Poe, after being nearly smothered by Helen's bosom, asks her to help him speak with the dead Mrs. Loss, and Helen begins having a vision of a bloody thicket, but Madame L'Espanaya, with umbrella, comes through the door and beats Poe out the window, falling out of it after him. Poe, talking with Payne, realizes that they are in the place where Mary was killed. Mary and Payne reprise the conversation they had on the day Mary died. Payne, drinking poison, thinks that Poe was the dark man that Mary went to meet the day of her death and attacks him with the razor as lightning flashes and thunder booms and the Ourang-outang runs on screaming, hoists Payne over its shoulder, and runs off with him. Virginia sings as Mary and Red Death look at Poe and the lights fade and go out.

Act Two opens with the sound of bells, the storm, and Virginia singing. Poe questions Mrs. Loss about Mary Rogers but she tells him

that her sons had nothing to do with the girl's death. As she begins beating Poe with an umbrella, the Ourang-outang throws her over its shoulder and runs offstage with her screaming. Poe screams and runs out after them, but falls through the upstairs window, and then jumps on Longfellow's back, riding him in circles until they both fall to the floor. The lights fade and then come up on Poe and Virginia as she speaks to "Eddy" of the happy times early in their marriage and tells him she wants a child. She sings, then giggles, then coughs, and then blood "comes welling out of her mouth, bright red, shocking and terrible, and runs down her chin and over her white dress." She vomits blood again, and her head lolls back as Poe holds her. Poe screams "No" five times and again we have lightning and thunder, ravens, and bells as the lights go to black, then come up on Poe sitting on the stone bench, mourning the death of his child bride. Rosalie opens the coffin window seat and takes out five penguins as Muddy calls down to Poe to come inside. She tells Poe that someone named Reynolds came to see him and said that Poe had never answered his letter about meeting him at some house. The Ourang-outang wheels out a table on which a girl lies, covered by a sheet. Crommelin enters and begins to describe, clinically, the state of Mary Rogers' corpse. He identifies himself to Poe as an undertaker and taxidermist for the Upper Classes, tells Payne when he enters of Mary's death, and urges Poe to look at the body. As Poe reaches to lift the sheet, Madeline (played by the actress who also plays Virginia) sits up abruptly and there is a "great flash of lightning and thunderclap." The men scream, but Madeline, addressing Poe as Roderick, gets down from the table wearing a white nightgown. Payne collapses on the table, sobbing, and Crommelin wheels him off. Madeline begins coughing and Doctor Tarr, honking a bicycle horn, gallops into the room, followed by Professor Fether, a bald man with a huge nose. They collide, do a quick Marx Brothers routine in which Doctor Tarr repeatedly whacks Professor Fether over the head with a "large cudgel," throws Madeline over his shoulder and, like Teddy in *Arsenic and Old Lace*, shouts "CHARRRRRRRRRGE!" as he runs off with her. Fether grabs Poe and "drags him in a madcap gallop around the stage" while Doctor Tarr returns and puts Madeline on the bed upstairs. He tells Poe that she is dead and he and Fether carry the body downstairs to bury her beneath the foundation of the house. When Poe starts to open the coffin window seat, a gigantic raven, screeching "hideously" as the storm rages, chases Poe around, flapping its wings. In the darkness, we hear Virginia singing and the lights come up on Poe and Anderson drinking as Anderson tells Poe that because he,

Anderson, gave Mary money to go to the abortionist because he loved
her, he is responsible for her death. Mary takes Poe upstairs and tells
him that, during the abvortion, she changed her mind, but it was too
late, and that after she left Mrs. Loss' tavern, Ossian and Charlie
followed, raping and killing her. The doorbell rings, and when Poe
opens the door the Raven chases him, screeching "NEVERMORE" and
the Ourang-outang joins in the chase, finally capturing Poe and holding
him by the arms center sstage. The Red Death appears upstairs and
slowly descends to Poe as the stage is bathed in red light and we hear
the beating heart and the pendulum clock. The Red Death pulls back
his cowl to reveal a "hideous skeleton head, blotched in red," and
introduces himself as Reynolds. As the Red Death describes an
expedition to the South Pole that he is planning, Fanny wheels out the
pram and Rosalie takes penguins out of the pram and puts them all over
the stage. Raven and Ourang-outang put Poe in the coffin window seat,
and Ourang-outang starts nailing the lid shut as Virginia, with three
black roses, enters singing. Mary joins Virginia in her song as they sit
on the coffin lid, joined, after the exit of the other characters, by
Rosalie. After the Red Death leaves, Virginia sings the last line of the
song ("in her tomb by the sounding sea") alone.

<p style="text-align:center">* * * * * *</p>

*Blood-Red Roses** begins in the dark, with Rose La Touche singing
from Ophelia's St. Valentine's Day song, music by Nigro, with the cast
already in place on the simple unit set composed of levels and furniture
pieces. Aside from Rose, we soon meet Lizzy (Elizabeth) Siddal,
Dante Gabriel Rossetti, Christina Rossetti, John Ruskin, Jane Morris
and her husband William, Effie Ruskin, Algernon Charles Swinburne,
and the painter John Everett Millais. The changing relationships of
these pre-Raphaelite poets, painters, and lovers form the substance of
the play as we move back and forth in time and place in the second half
of the nineteenth century. In the opening scene, the characters speak
lines evoking their past, their obsessions, and suggesting parts of the
story to be enacted. In the second scene, Ruskin asks Rose, now 18, to
be his wife and she declines, saying that her parents do not approve of
Ruskin's friends, particularly that "horrible" Rossetti, the "wicked"
Swinburne, and Morris, who lets his wife be painted with her breasts
naked. Rossetti, drinking, belches, and is told by Jane Morris that he is
killing himself with drink, mourning his dead wife Lizzy. Rossetti bets
Millais two bottles of wine that he will fall in love with Effie, Ruskin's
young and beautiful wife, and the action returns to Ruskin and Rose,
talking about a scandal involving Effie and Millais, and Ruskin wishing

he had never gone to Scotland. Time shifts again and we see Millais
painting Ruskin with Effie looking on, expressing her boredom more
and more angrily. Rossetti, Morris, and Jane then talk about the
animals Rossetti keeps in his garden—three bullocks, a wombat, a
tortoise, a white bull, and a peacock that is stuck under the sofa.
Swinburne enters and Morris tries to get the peacock out from under
the sofa, eventually succeeding in dragging out a scraggly carcass of a
dead peacock. When Rossetti says that everything seems to disappear
or die, Swinburne implies that Rossetti killed his wife, Lizzy. In the
next conversation, Effie tells Millais that her life with Ruskin is
unbearable and that their marriage is and has been a joke because
Ruskin has never fulfilled his husbandly duties. Christina tells her
brother that he is spending too much time with Lizzy and, like
Christina, Millais is concerned that Rossetti has cut himself off from
everyone because of his obsession with Lizzy.

Act Two begins as did Act One, with the actors in place and Rose
singing. Ruskin tries to get Rose to marry him and Rossetti and
Swinburne talk about Lizzy's aversion to sex, and then, when Rose tells
Ruskin how she likes to take off her nightgown and lie down in the
grass of the garden, he is shocked. He tells her that Rossetti did not
murder his wife and is not sleeping with Jane, the wife of his good
friend. He says that Jane was a stableman's daughter when they first
met her and the scene shifts to Rossetti admiring Jane with Lizzy,
Swinburne, Morris, and Millais. Rossetti suggests that Morris ask Jane
to marry him so they can keep her around to paint her. Ruskin, "in
another time and place," very excited, tells Lizzy and Rossetti hundreds
of previously unknown Turner drawings have been found in the
basement of the British Museum. Lizzy and Rossetti argue but
eventually she agrees to marry him. Effie tells Rose that Ruskin is
incapable of making love with a woman and invites men to the house to
do it for him. Lizzy tells Christina she lets Rossetti make love to her
even though she cries, because he married her and she feels she owes
him something. She then tells Rossetti that they are going to have a
baby and that she will not have sex with him because it might endanger
the child. Effie and Millais talk about his work, because although he is
famous and wealthy the painter feels that his best work was done long
ago under Ruskin's encouragement. Again, "from another time and
place," Ruskin wanders by with a bunch of drawings in his hand,
astounded that the drawings he is holding by Turner, his idol and
inspiration, "the greatest painter since the bloody Renaissance," are
pictures "of men and women fucking," pornography. Rossetti then

says that he buried three years worth of poetry in manuscript with Lizzy, but Jane enters the conversation jarringly, telling Rossetti that he created Lizzy so he could destroy her and dramatize his guilt to make himself a melancholy tragic figure. The scene shifts to Swinburne, Lizzy, and Rossetti wondering who is going to pay their restaurant bill and who is going to take Lizzy home. When Rossetti goes to the restroom, Swinburne tells Lizzy that if he wanted to kill himself quickly and easily he would take laudanum in a glass of water. When Rossetti comes back, Swinburne has collapsed with his face in a plate and Lizzy goes to the table by her bed, mixes some powder in a glass of water, drinks the potion, and lies on the bed, saying that she will haunt Rossetti, who discovers her body and collapses by the bed, sobbing. As Morris and Jane are talking casually of their marriage, Rossetti and Swinburne enter, drinking, but Rossetti leaves and Swinburne unthinkingly tells Morris that Rossetti is sleeping with his wife. After Swinburne leaves, Morris asks what harm his wife's relationship with Rossetti does to him. Rossetti tells Swinburne that he tried taking laudanum as Lizzy did, but it didn't work. He describes digging up her grave to retrieve the poems he had buried with her. Ruskin describes almost incoherently his reaction to Turner's drawings and his decision to burn them. As Rose sings and the others look on, Rossetti talks to Lizzy's ghost, asking her to forgive him, but she says she has become a perfect work of art, and there is darkness as Rose finishes her song.

* * * * * *

Nigro's investigation of the life of Leo Tolstoy, *An Angler in the Lake of Darkness**, takes place on a simple unit set that, as usual, represents a playing space in which past and present flow seamlessly. Four men (two playing double parts) and six women (one actress plays two parts) enact scenes from Tolstoy's life from the time he was a young man until his death (with a short scene in an afterlife in which he fishes with Chekhov). One actor plays the young Leo and another actor Tolstoy from middle-age through old age, and one actress plays Sonya (his wife) as a young woman and another actress plays her as older, the Countess. The play begins with the sound of crickets and the ticking of a clock in darkness; then the Countess enters carrying a lamp, goes to the desk, and begins searching. Tolstoy follows her and tells her he has given some diaries to Chertkov to transcribe, but she says Chertkov is just waiting for him to die. They argue about an illegitimate boy Tolstoy fathered years earlier, and Lisa, Sonya's sister, runs on, excited that Leo (young Tolstoy) has come to propose to her. Sonya (the Countess as a young girl) tells her to sit down, but Lisa runs off, saying

that she has to throw up. When Leo enters, he tells Sonya that she, not Lisa, is the one he loves, and she agrees to marry him. When Lisa learns this, she is furious and tries to strangle Sonya. The Countess and Tolstoy comment on this scene from their past, and then Leo hands Sonya an armload of diaries, from one of which Sonya begins to read aloud. The entry describes one of Leo's affairs, and as she reads, more and more of Leo's liaisons are detailed. On their wedding night, Sonya tells Leo that she has learned from his diaries that sex is the end of love and that is why she doesn't want to consummate their marriage. But eventually they kiss and fall onto and then off the bed. After Tolstoy and the Countess comment on their early married life, she wonders why he is giving away all the money he has made from his famous books, leaving their children in poverty. Their three daughters, Tanya, Sasha, and Masha run out to talk with Turgenev, who has fallen off a see-saw. At their urging he shows them how to dance the can-can until they all collapse, laughing. The Countess tells Tolstoy that he wants her dead so that he can have other women, but that she is in love with another man, Taneyev, a pianist and composer. Taneyev enters, announced by Tanya, and Tolstoy asks Masha where his gun is. The Countess wants Taneyev to take her with him, but he runs off. During the ensuing argument, Tolstoy gets dizzy and is helped to the sofa by Tanya and Masha as Sonya, giggling, leads Leo out into the rain to make love.

We hear the sound of gulls as the second act begins and see Tolstoy and Chekhov sitting on a downstage bench, fishing and talking about the theatre, whores, love, and marriage, but when the Countess calls from offstage, Chekhov leaves. When an operation on the Countess is first proposed, Tolstoy refuses but then agrees to it. He sits weeping, but Masha returns to tell him that the operation was a success and that he should be there when the Countess awakens. Tolstoy leaves and as Leo and Sonya talk in bed, the Idiot Girl sits down on the bench and starts nursing a doll. The Countess berates Tolstoy for not grieving when their son died, and Leo and Sonya re-enact what they said at that time. Tolstoy sits on the bench next to the Idiot Girl and tells her that his daughter Masha has died and, when Masha, dressed in white, kneels and puts her head in his lap, he "strokes her hair tenderly" as he tells of holding her in his arms as she died in a scene that reminded him of *King Lear*, a play he detests. The Countess wants Tolstoy to sign over to her the rights to all his writings so that the publishers and/or Chertkov won't get all the money, but Tolstoy experiences a stroke and is led to the sofa by Tanya and Sasha. Chertkov urges Tolstoy to sign a will leaving all his writing to Chertkov, and when Tolstoy signs the

paper Chertkov shouts with joy and does cartwheels off the stage, but soon returns saying that Tolstoy has signed Dostoevsky's name to the paper. When the Countess, exhausted, falls asleep, Tolstoy gives Sasha a note for her and takes a suitcase as he leaves. Sasha joins Tolstoy on a bench at the train station and tells him he has a fever. Tolstoy speaks incoherently as the Countess runs in screaming and knocking Chertkov over with a flying tackle, sitting on his chest and demanding to know where her husband is. After telling her that Tolstoy is in the railway station in Astpovo with Sasha, Chertkov runs off to get there before she does. But when Chertkov wants Tolstoy to sign a document giving him control of the diaries, Tanya kicks him out the door. The Countess comes in to talk with Tolstoy in his last moments. After he dies and Masha closes his eyes, the Countess sits at the desk and writes in her diary that she went to court to get all the manuscripts and diaries back from Chertkov, saving every line for posterity. Tolstoy then goes to sit on the bench with Chekhov who has brought two fishing poles. The Idiot Girl gives Leo wildflowers which he gives to Sonya, telling her that he loves her. After Sasha leaves, the lights fade on four duos: Countess writing with Tanya at her shoulder; Leo and Sonya on the bed, kissing; Idiot Girl and Masha going up and down on the seesaw; and Tolstoy and Chekhov fishing in the lake of darkness.

* * * * * *

In *The Dark Sonnets of the Lady*, Nigro investigates Sigmund Freud and the patient he called Dora. The four men and four women of the script move into place on the unit set as the last measures of Strauss' 'Emperor Waltz' are played. Their actions at various points in the play are tightly choreographed to waltzes and both acts end with characters dancing. The characters are Freud, Dora, her Father and Mother, her brother Wolf, Herr and Frau Klippstein, and the children's nurse, Marcy. The Klippstein children are represented by two life-size dolls with button eyes, dressed in Victorian clothing. As the opening waltz ends, the characters freeze for a moment and we hear a click and see a "shutter effect" from the lights as if the group has been photographed. Freud and Father then talk about an "infection" that Father says he got before his marriage and about Dora. Father crosses past the Klippsteins having tea with Marcy and the children; and Dora and Mother, a compulsive cleaner, talk about going to see a doctor. Freud holds out a hand to Dora and they begin talking as she crosses to his office area. As she answers his questions, Dora continues to interact with Mother and Wolf until she says she can't breathe and screams for her father. Freud asks her why she wrote the suicide note that her Mother found,

and Dora tells Freud that her father is having an affair with Frau Klippstein. She describes seeing them together on the street and Father and Frau Klippstein act out the scene she has started to describe, with Dora participating. After Father leaves, Frau Klippstein reminds Dora what good friends they used to be and denies any involvement with Father. Dora tells Freud that Herr Klippstein attacked her and suggested they make love. Herr Klippstein and Dora enact this scene that occurred at the lake, but as he reaches out to touch her face, the actors pause, and Freud questions Dora about what happened next and whether she told her Father. Father tells Freud that he doesn't believe his daughter's story and is convinced that Dora misinterpreted Herr Klippstein's intentions. As the music of 'The Blue Danube' plays, the actors move through a tightly choreographed routine of moving in and out of rooms and up and down stairs, bumping into each other, screaming, and ending with Father doing "a majestic belly flop" as the actors end up where they began when the music started. Father announces that the family is moving to Vienna (where the Klippsteins also moved) and Dora tells Freud that she saw her Father and Frau Klippstein more and more often walking together. Father and Dora argue again and Freud enters the conversation when Dora says she can't breathe, telling her that her reproaches against others divert suspicion from herself, that perhaps she wanted to sleep with Herr Klippstein. Freud asks her to tell him what she has dreamed and as eerie music plays 'Vienna Blood' and thunder is heard, the stage begins darkening to a "hellish" red, and the actors reprise a house- burning episode, with Mother shouting that she must save her jewel case and Father trying to get everyone out of the house. Freud asks Dora to explain what the dream means to her and talks to her of transference, of a patient becoming emotionally involved with her analyst. Dora shreds a cigar and throws pieces of it at him before "storming away." The music of 'Vienna Blood' is heard and Herr Klippstein asks Dora to dance, but she refuses. Father and Frau Klippstein dance, Marcy and Wolf dance; Mother dances with her duster. Freud lights a cigar and he and Dora look at each other as the dancers go off, and the music ends.

Act Two begins with 'Tales from the Vienna Woods' and the actors enter, looking at each other as directed, freezing momentarily when the music ends for a second photograph. Wolf questions Dora about her sessions with Freud, who enters the conversation to suggest that Dora is in love with her Father. Freud questions Dora about her knowledge of sex and anatomy and Herr Klippstein begins waving "a long, floppy sausage," asking Dora to touch and kiss it. Wolf enters in an old-

fashioned bathing suit with a sausage in the suit "to suggest exaggerated privates in surreal relief," singing alone and then being joined by the women, except Dora, in chorus, and Father. As they finish the song with a rousing chorus, Dora tells Freud that she does not have sexual fantasies, and the actors, disappointed, walk away, Herr Klippstein with his sausage drooping. Freud asks Dora where she learned about sex. Dora says that Frau Klippstein read to her about sex. Eerie music from 'Vienna Blood' plays, lights create a strobe effect, and Dora describes and acts out a dream of walking in a strange town, asking for directions to the station. The music stops and we hear bird sounds as the actors become trees in the thick wood that Dora is walking through, and then the music starts again, and Dora is home where Wolf hands her a huge key, but the actors have gone to sit in chairs, representing tombstones in a cemetery. Freud feels that Dora is hiding something from him, that she feels guilty for something that he has not yet been able to uncover. Dora tells him two secrets and then, as Freud lies on the couch as a patient, she tells him things about himself that make him very uncomfortable. He questions her again, "stonily," and offers her a lollipop which she begins to lick and suck more and more erotically. The other women also suck on lollipops and the men light cigars as Dora tells Freud how her Father may be satisfying Frau Klippstein even though he is impotent. As they talk, she begins unbuttoning her blouse and "stretching in an intensely erotic pose," succeeding in flustering Freud. He holds her to comfort her, telling her that soon they will find the truth. Dora says it doesn't matter, since this is the last time she is going to see Freud. As Marcy and Frau and Herr Klippstein re-enact a breakfast encounter that Dora witnessed, and Marcy admits to Dora that she gave in to Herr Klippstein's advances, Freud says that he has found the missing piece of the puzzle, because on the very next day after Marcy told Dora of her involvement with Herr Klippstein, Dora was propositioned by him. Herr Klippstein and Dora re-enact the same scene at the lake they did earlier in the play, line for line, until Dora slaps him and accuses him of sleeping with Marcy. Freud interprets this as jealousy, suggesting that Dora wanted Herr Klippstein for herself. Freud decides that Dora was jealous of the relation between Frau Klippstein and her Father because she loved Frau Klippstein and Frau Klippstein betrayed her. After Dora says that she is leaving and never coming back, Freud talks with Father, whose condition has improved, about the possibility of a cure for Dora, and then Freud puts on gardening clothes to work on plants on a woodern tray. Dora appears, dressed in black, to tell Freud that

she feels better and that she attended the funeral of one of the Klippstein's children. Herr and Frau Klippstein act out the scene in which Dora tells Frau Klippstein that she knew about the affair with her Father, and she gets Herr Klippstein to admit that what happened between them at the lake was not just a figment of her imagination. Dora tells Freud that she now has a job that she likes and is good at, and she thanks him for helping her cure herself. Freud says that she is not cured, that she has not yet come to terms with her feelings for Frau Klippstein, but Dora says she is going to marry her "idiotic young man" to prove Freud wrong. The music of 'Emperor Waltz' is heard and, as Freud puts away his gardening tools and apparel, Dora and her Father begin to dance. Wolf dances with Dora as Father and Mother dance; Herr Klippstein then dances with Dora as Wolf dances with Marcy. Dora leaves Herr Klippstein, who begins dancing with Frau Klippstein, and crosses the stage to dance with Freud. As the music ends, the actors move into their original positions for the photograph. There is a flash and a click; the music stops; and the lights go to black.

* * * * * *

The title character in *Lucia Mad* is James Joyce's daughter, and her relationship with Samuel Beckett is the focus of the story. Nora (Joyce's wife), McGreevy (a family friend), Joyce, the psychologist Carl Jung, a Pimp who stabs Beckett, and a character who thinks he is Napoleon complete the cast. The unit set represents various locations in France and Switzerland from the late 1920s to the 1980s. As the play begins we hear Lucia singing 'Come into the Garden, Maud' (words by Tennyson, music by Nigro) and the lights come up slowly on Beckett in his chair and Lucia sitting by the window. Each speaks to the audience, not to each other, Lucia of memory and Beckett of his physical ailments. Joyce enters, singing the same song Lucia sang, goes to his desk and starts writing. Lucia enters his time and place, asking him what is wrong; he tells her he has made the blunder of asking a young Irishman, Samuel Beckett, to dinner, making thirteen at table and bringing terrible luck. But Beckett tells Joyce that he thinks he is the greatest living writer and that *Ulysses* is the greatest book since Dante. Lucia tells Nora that she has decided to marry Beckett. As Lucia and Beckett sit on the sofa she tells him that she wants to have sexual intercourse. Beckett beats a hasty retreat only to have Joyce warn him that if he should ever hurt Lucia his balls will be in a pickle dish. Lucia tells Beckett that she will stop pestering him if he proposes marriage to her. Following her directions, Beckett gets down on one knee and asks her to be his wife. At that moment, Joyce enters the

room and Lucia accepts Beckett's proposal (having sworn earlier to reject it). Joyce goes off to tell Nora the good news as Beckett tries to explain to Lucia why they cannot be married. With McGreevy as witness, Beckett tells her that he can never marry her and asks that she go with him to her parents to explain the misunderstanding. Lucia runs away, followed by Beckett, to Nora, who threatens to sue Beckett as Joyce walks in and orders him to leave and not come back. As they sit in a café, McGreevy tells Beckett that Joyce will eventually relent, but Beckett feels guilty for hurting Lucia. After McGreevy leaves, a Pimp approaches Beckett, asking if he wants a woman. When Beckett repeatedly says he does not, the Pimp stabs him in the chest and Beckett crawls off. McGreevy tells Nora and Lucia that Beckett is in the hospital. Joyce talks with Beckett as he sits in a wheelchair in the hospital, asking him to come back and help him with his work. He starts singing as he pushes Beckett off in the wheelchair and the lights go out with Lucia watching them.

Act Two begins as did Act One, with Lucia singing by the window and Beckett, old, in his chair. Lucia speaks of Beckett thinking of her and Beckett, in ironic counterpoint, meditates on wanting nothing. When Beckett returns to the Joyce home, Lucia tells him that she will go mad if she is not loved. She calls him a coward and he tells her that there is no love because there is no self to be in love, only "the futility of desire, humiliation, suffering and death." Lucia decides to accept her madness and in the next sequence Nora and Joyce discover that she has cut the telephone line and put the instrument in the bread box. Although believing that her daughter is crazy, Nora convinces Joyce to let Lucia travel to London. Lucia tells us that she tried to find Beckett in London, failed, and followed him to Paris. When she finds him in a café, and he leaves, she shouts after him that she will haunt him, that he will never get away from her. Nora tries to convince Joyce to send Lucia to see Dr. Jung, and, in a very funny scene, Lucia plays a word-association game with Jung who then tells Joyce that Lucia should be certified insane. Joyce, speaking to Beckett of the death of Yeats, considers his own death and his guilt about Lucia's insanity. Nora visits Lucia in the madhouse to tell her that her father is dead. Nora tells Lucia how she met Joyce, and Joyce, "rather green and cobwebby," appears behind Beckett who is writing and drinking. Joyce asks Beckett to visit Lucia, and Beckett crosses the stage to find her playing cards with Napoleon. Beckett and Lucia talk of Beckett's role in the war, and she tells him that her dead father, whom she sees all the time, is writing a book about Beckett's great love for her, called *Lucia*

Mad. She asks Beckett to take her away with him, but, realizing he cannot, she tells him that when he is dying she will be the last thing that he sees. Beckett goes back to his chair and Lucia sings again the two verses of her song. Beckett says that he sees, is haunted by, the sad eyes of the mad girl.

* * * * * *

The simple unit set for *Mandelstam**, the Russian poet killed by Stalin, consists of two desks with telephones stage right and left, a kitchen table with chairs up center, and a platform above the kitchen with a cot and window., There are benches down right and left and a stool down center. Six parts are played by four actors: Pasternak, Mandelstam, Stalin/the voice of The Devil, and Nadezhda (Mandelstam's wife/voice of Mrs. Pasternak). In the opening scene Pasternak answers a phone call from Stalin, who has called to ask Pasternak if his friend Mandelstam recited a poem to him describing Stalin's fingers as fat maggots and his mustache as being like a cockroach. Pasternak equivocates and Stalin asks him what should be done with Mandelstam. Pasternak suggests that sometimes it is better to do nothing. We hear the sound of a funeral march as the lights fade on Stalin and come up on Mandelstam and Nadezhda who are joined by Pasternak as they watch Lenin's funeral procession in the street below. Nadezhda asks Mandelstam how he can listen to Pasternak call "that reptilian murderer" a great man. She says her husband is not a writer like the others who write only what the Party wants them to say. Again on the phone, Stalin says that he cannot understand Pasternak's poetry but that he likes him and asks again what should be done with Mandelstam. Pasternak crosses up to the kitchen area to congratulate Mandelstam on his new apartment, but Mandelstam says he needs neither apartment nor paper nor pen to write, only his brain. When Mandelstam calls Stalin a "homicidal psychopath," even Nadezhda gets worried and Pasternak hurries to a park bench down left. As he feeds imaginary pigeons, Stalin comes up behind him, telling him that he learned everything he knows about freedom of expression from the priests in the seminary who burned his books. As Stalin leaves the bench, saying it is time to deal with Mandelstam, we hear the sound of a ticking clock, and Mandelstam and Nadezhda, playing cards and talking about writing the truth, are interrupted by repeated knocking on their door. Mandelstam gets up to answer the door and disappears into the stage right shadows as Nadezhda starts laying out a hand of solitaire. Then we hear the sound of an iron door slamming and the lights go to black. In the darkness, we hear the sound of footsteps and

the creaking of another door opening and slamming shut. As it slams, the lights come up in a circle around Mandelstam on a stool down center. Stalin, circling him, never completely visible, says he is not going to kill him but is going to send him away so that he can come to understand "the collaborative nature of art." Stalin leaves, the door slams, and the lights go out on Mandelstam. We hear crows in the darkness and as the lights come up to dim, we hear Mandelstam talking to himself, pacing back and forth. Nadezhda tells him that she is going into exile with him. In darkness, The Devil, with "an insidious but rather engaging whispering with echoes," speaks to Mandelstam of suicide. Turning on the light, Nadezhda tells Mandelstam that he was having a nightmare. He strokes her hair until she dozes, then goes to sit on the window sill. She wakes and lunges for him, screaming as he disappears out the window and the lights go to black, ending the first act to the sound of pigeons cooing.

Act Two begins with the sounds of birds singing and we see Mandelstam in a "wheeled chair," one arm in a sling, and Nadezhda behind him. His suicide attempt having failed, Mandelstam regrets that he cannot elevate his finger in a proper salute to Stalin. But at least, he says, his suicide attempt has caused them to be moved to a better place where they must learn to live like actors, survivors in Purgatory. He notices that Nadezhda is pale and weak and insists that she go to the doctor, seating her in the chair and pushing her off. Pasternak calls Stalin on the phone at 4:00 a.m. but Stalin assures him that although one jumped out a window and the other had typhus, both are doing well. Mandelstam says he is going to write a laudatory poem about Stalin in the hope that Nadezhda will be left alone after his death but decides he can't write such shit and throws the papers out the window. As Pasternak sits, trying to write, we hear the "not very sweet" voice of his wife offstage, berating him for maintaining contact with the Mandelstams and refusing to allow them in her house. We hear a train whistle as Pasternak joins the Mandelstams on a railway bench at the edge of the stage. Mandelstam says that he is still writing but Pasternak can write nothing except translations. Mandelstam tells Stalin that he and his wife have nothing to eat and no place to live, and Stalin says that time will take care of everything. Back at his kitchen table, Mandelstam tells his wife that he can hear the fluttering of a moth's wings in his head. We hear five loud knocks on the door, then five more as the lights fade and go out. As Pasternak sits at his desk, we hear his wife's voice complaining that her children are obsessed with cows and that it is all Pasternak's fault. To the sound of crows

and wind blowing, the lights come up on Mandelstam, huddled on a bench, cold and lost, saying aloud the words of a letter he is composing to his wife about being taken away again, alone. After Stalin tells Mandelstam that something in his heart is about to burst, Pasternak tells Nadezhda that he is sorry about the death of Mandelstam, and she says that, although the authorities have been confiscating and destroying every copy of her husband's work that they can find, she has been committing all his poems to memory. We hear a storm in the distance as Mandelstam walks over and looks over Pasternak's shoulder. Mandelstam says that he has a job delivering telegrams from Hell, and his message is that Stalin is dead, drowned in "a large vat of bullshit." When Pasternak wonders why Stalin never got around to killing him, Mandelstam tells him that Stalin was about to sign the order for his execution when he died. Mandelstam tells Pasternak that he found a line of his own poetry carved in the wall of the cell in which he was incarcerated. Then Stalin, "white and dead," dials Pasternak's number, but Mandelstam picks up the phone and tells Stalin that he dialed the wrong number. Now, he tells Pasternak, you can get on with your work, and Pasternak begins to write as Nadezhda paces in the kitchen, mumbling poems to herself. Mandelstam watches her, Stalin dials again, and the phone rings and keeps ringing as the lights go to black.

* * * * * *

The ten actors (five men and five women) in the cast of *A Lecture by M. Artaud**, with the exception of Artaud and Dr. Frankenstein, play a challenging variety of roles. Again, Nigro asks for a simple unit set to represent many locations, with the play moving "in one unbroken flow like a series of kaleidoscopic hallucinations." All the actors except Artaud are members of an audience, chattering expectantly until Madame introduces some of the "flower of French intellectual society." Some of the chairs hold life-sized puppets and when Jean-Paul Sartre is introduced, the actor playing Camus manipulates a pipe-smoking puppet so that it stands and bows. Gide introduces Artaud and turns to the side of the stage from which he expects him to appear. But nothing happens until we hear a "very loud crash" from the other side of the stage and Artaud appears with a box over his head, moving like "the Frankenstein monster." Gide removes the box and Artaud, looking like "a dead Beckett character," stumbles to the lectern, stares at the audience and starts making sounds that Madame and then other members of the audience try to decipher, as if playing charades. The message that Artaud finally communicates in this hilarious scene is that he was born, an action he demonstrates by crawling up under

Madame's skirt with much mutual screaming. Dr. Frankenstein, telling
Madame to bear down, stands a few feet away from her ("like a
quarterback in the shotgun formation"), calling signals and catching a
baby doll that flies out from Madame's legs. He passes the baby to
Nurse who wraps the doll in a blanket as Artaud, still under Madame's
skirt, makes baby noises, and Dr. Frankenstein takes over as narrator:
"Chapter one. The tortured man is born. The end." The transitions
between scenes are aided many times by sound effects in the darkness:
a toy piano, hurdy-gurdy street music, bird sounds, "sounds of
babbling, moaning, shrieking, and mad laughter," giving us a sense of
location and theme. The second scene, "on the tortured man's
childhood," shows us Artaud singing a spell to kill his sister. A doll
represents the sister and the actors in the first scene have assumed
grotesque poses like motionless toys. Mama tells Artaud that his sister
Is dead and first the Sister Doll and then the other toys begin singing
the nursery tune that Artaud used in his spell, and Artaud curls up with
the Sister Doll as the Princess Puppet sings and the toys ring small
bells. In the third episode, Artaud is stabbed by two pimps on a street
in Marseilles and Artaud wakens, in the next scene, in the insane
asylum run by Dr. Frankenstein, who listens to Artaud's complaints
and leads him through the darkness to a spot of light on the stage.
Artaud stands in the light and is "utterly transfigured." A Director
listens to Artaud audition, hires him, and immediately the other actors
are in rehearsal where Artaud meets the actress Genica. Artuad gives
Genica a poem he wrote and very quickly they kiss and disappear
behind some furniture, making "extraordinary animal noises" until a
bell rings and the Director announces rehearsal. Artaud in sunglasses
and with a cane and "enormously ratty gray wig" plays Tiresias to
Genica's Antigone. Everyone applauds and Artaud and Genica run
behind the furniture and start their animal noises again until another
bell sounds and they come out to play Colic and Apoplexy in a
medieval morality play. Again applause, the run to the furniture,
animal noises, and another bell. This time Genica is an ingénue/victim
and Artaud is Urdemas, a demonic marionette. The Director interrups
Artaud and Genica behind the furniture to inform Artaud that his father
is dying. As Father talks about God and women, he stops suddenly,
utters "a hideous death rattle," and, unable to free his hand, Artaud
crawls under the bed, dragging Father behind him, until Artaud, lying
on the bed where his Father was, finally frees himself and runs out
calling for Genica. He finds her behind the furniture with Paul, an
actor. After she leaves, Artaud screams "an enormous, swelling,

surreal bellow of animal grief," and Sister Doll sticks her head up from behind the furniture and sings "I love you" over and over. Rehearsal continues for a play about Charlemagne, and Artaud enters with the emperor's crown and robe, crawling, with a hog's nose, and grunting like a pig, then standing on his head on the throne. The Director suggests that unless Artaud can behave himself he should leave and Artaud begins shouting about what theatre should be. He tells Dr. Frankenstein that what he wants is magic, and a Clapper Girl snaps a movie clapboard in front of Artaud's face and Dr. Frankenstein narrates Artaud's career in silent films as lights create a strobe effect and we hear the sound of film going through a projector. Artaud mimes a monk hopelessly in love with Joan of Arc, Jean-Paul Marat in his bathtub, and a beggar in *Threepenny Opera*. This last forms a segue to a scene in a café where Artaud, Brecht, and Hitler talk about movies and theatre and Brecht urges Artaud to direct his own plays. Brecht and Artaud leave Hitler to pay the check, but Dr. Frankenstein sits with him and buys him a drink as the act ends.

Act Two begins with Artaud trying to direct actors for a stage production, but the rehearsal is interrupted by Surrealist/Sheep, Surrealist/Nose, Surrealist/Banana, and Surrealist/Cow, who hurl catcalls and fruit at Artaud and run off with the cast. Artaud concludes that nothing from the old theatre can be kept; the "THEATRE MUST BE LIKE THE PLAGUE." At the lectern, his face lit from underneath, Artaud speaks of and enacts his dream of the plague with screams, sound effects, cartoon characters crossing the stage, and grotesque contortions. At the climax of his agony, he pulls a doll from his trousers and puts it on his stomach, speaking in images of disease and destruction, of a theatre that drains "our collective abscess." He throws the doll offstage and apparently dies. But in the darkness we hear the footsteps of Anais Nin who assures Artaud that she was the one who stayed for all of his lecture the previous night. As they walk, Anais reads from her journal, a daily account of everything that happens to her, but Artaud runs off, shouting that he must go to Mexico and learn from the Indians. We hear drums, strange chanting, and the sounds of birds in the darkness and then see Artaud wandering through a jungle ruin where the gargoyle statues are actors. Artaud tells Old Gargoyle that he is searching for the secret of life and is handed a bottle marked XXX which Old Gargoyle says contains drugs. Artaud drinks and lies down on what appears to be a stone altar. A beautiful Indian Girl, repeating"I love you, Antonin," raises a knife above him with both hands. The lights go out and Artaud emits a "horrible scream." The

lights come up on Artaud lying on Dr. Frankenstein's examination table (what served earlier as the altar) and Cecily enters to introduce Artaud to her parents, but he ends up calling them"fat, stupid, complacent French hogs." In the dark we hear gulls, the ocean, and nuns singing and Artaud appears in a nun's habit, looking for a virgin. Mother Superior orders that the bell be rung and Artaud, screaming in pain, holding his ears, struggles to get out of the habit and falls to the ground. The ringing of the bell is supplanted in the darkness by a loud foghorn and we see Artaud in a straitjacket, sitting in a chair. With appropriate light and sound effects, including Artaud's scream, Dr. Frankenstein gives his patient three "tremendous" jolts of electricity. After other actors move and scream in a "shadowy nightmare landscape," we see Artaud in bed under a blanket. Mama says she will get him some warm milk to help him sleep, and Sister Doll, in bed beside him, sits up and repeats, "I love you, Antonin." The light goes out as Artaud's screams are accompanied by the sounds of "a horrifying crowd of demonic mice giggling." The giggles modulate into bird song and we see Artaud in a chair at the asylum. He confuses Cecily with Genica and, promising to tell her the secret of life, screams at her, urging her to scream more loudly, then chasing her with a claw hammer. He stops abruptly and criticizes her performance. When Dr. Frankenstein tells him that he has been cured and has been declared a "perfectly normal Frenchman," Artaud exits with the hammer to thank the Nurse, and we hear her screaming offstage. Dr. Frankenstein puts Artaud back at the lectern and takes the hammer from him. Artaud's concluding remarks are, in part, a vivid desxription of his physical and mental suffering. Saying that he wants his words back, he falls dead over the lectern. Gide thanks him for his insights on life and art and asks the audience to respond. Napoleon tries to give Artaud a large fake hand, and, as Gide leads the applause, Dr. Frankenstein and Nurse stand behind Artaud and manipulate him like a giant puppet in a "hideous bow of acknowledgement," and the lights fade and go out.

<div align="center">* * * * * *</div>

Some famous non-literary figures that Nigro has investigated are Christopher Columbus (*Mariner*), the violinist/composer Paganini (*Paganini*), American coke and steel magnate Henry Clay Frick (*Pandemonium**), the Stanford White/Harry Thaw/Evelyn Nesbitt affair (*My Sweetheart's the Man in the Moon**), and the painters vonStuck (*Sphinx**) and Munch (*Madonna**). The story of the Italian sailor Columbus is told in a series of flashbacks as the dead sailor is questioned by Torquemada, the leader of the Spanish Inquisition. The

unit set is created by the wreck of the Santa Maria, with the crow's nest fallen through the deck, and tables and chairs down left and right. With the exception of the actors playing Columbus, Torquemada, and Princess Juana the Mad, the six men and seven women in the rest of the cast play multiple roles (as many as four in several instances). As music plays and the lights come up, the characters take their places on the set in an idyllic mood until a sudden flash of lightning and the sound of thunder signal the entrance of Torquemada, the adjudicator in an inquiry to determine the fate of Columbus' soul. His defense is undertaken by the mad princess Juana, daughter of Ferdinand and Isabella of Spain. In a flashback, Lucinda tells her Mama that a body has been washed up on shore. Although Mama threatens him with a knife, Columbus charms her with his "bullshit"and they give him clothes and food and directions to the church attended by Senor Moniz and his niece, the beautiful Felipa. In the church, Columbus pretends to faint from hunger and Felipa ignores the warnings of her Nurse and brings Columbus home to her bed. Columbus is discovered by Moniz and chased away to a madhouse where various lunatics—a screaming Desdemona with a rag doll like a necklace choking her, Pig Woman (a ragged old lady carrying a stuffed pig), Headless Man, Crow Woman, Maria, and Crocodile Girl (with a crocodile hand puppet)—cross his path until he is grabbed from behind by Dr. Slawkenbergius who demonstrates, on a table brought on by a Two-headed Man, and with a head given to him by Maria and a pomengranate from Crocodile Girl, that the earth cannot possibly be round. Dirty Carlos grabs Columbus and pulls him into the bedroom where Moniz, Nurse, and Felipa tell him that Felipa is pregnant. Colubus agrees to marry her and, after he goes off to Iceland , settles down with her on an island in the Atlantic. Thunder and lightning herald the appearance of the Vivaldis, "dead and green, in tattered clothing, trailing seaweed." Like the Ancient Mariner earlier in the play, the First and Second Vivaldis tell Columbus contradictory stories. Columbus interprets this nightmare as a sign that he must ask King John of Portugal to finance his voyage to China. The Jester honks his horn and Prince John, his court composed of the madwomen from the asylum, brings on Dr. Slawkenbergius as the authority who refutes Columbus' notion that he can get to the east by heading west, and the whole court mocks Columbus as the Jester pies and trips him. When he gets home, Columbus is told by Moniz that Felipa is dead, although she appears as a ghost to tell Columbus to go to Spain. In a tavern, Columbus meets Diego who brings him home to his cousin Beatriz, who, enamoured of Columbus, suggests a way for

him to get an audience with Ferdinand and Isabella. Ferdinand and Isabella argue over her decision to support Columbus, but she prevails. Columbus demands that he be known "henceforth and forever more as the Admiral of the Ocean Sea." The act ends as the Prosecutor, a dark figure in a monk's habit and cowl, appears.

Act Two begins in a tavern in Palos where Columbus is looking for Pinzon, a sailor whom he persuades to help him gather a crew to sail to China. At sea, the Ancient Mariner explains the life of a sailor and land is sighted by Rodrigo. The Prosecutor lowers his cowl to disclose his identity as an Indian, a "savage," and Columbus admits that he saw the Indians as "an excellent and abundant supply of slaves." Columbus sails back to the court where Ferdinand wants to know how much gold Columbus has brought back and the Ancient Mariner leads in the three Native Girls who have collars with ropes around their necks and muzzles on their mouths. The Prosecutor reminds Columbus that he raised money for his third voyage by selling the natives as slaves. Landing at Hispaniola, Columbus is thrown into chains by Bobadilla, the newly appointed governor, and shipped back to Spain. Isabella says Columbus may have one more voyage, but when he returns, after having been shipwrecked in Jamaica, he learns from Juana that the Queen is dead and Ferdinand will not see him. Torquemada condemns Columbus to Purgatory for his sins of pride and lechery, but commends him for reducing the number of savage and non-Christian people in the world. As the other characters turn away from him, Columbus tries to justify what he has done, but they all leave him, except for Juana, who, like Aase welcoming home Peer Gynt, puts his head against her breast and comforts him. The lights and the music fade out and we hear the ocean and the gulls in the darkness.

* * * * * *

In *Paganini*, a play with 12 actors (7 men, 5 women), most playing multiple roles, Nigro investigates the tortured career of the famous violinist and composer. The unit set for this play, representing various locations in Europe from 1782 to 1840, requires some special units: a piano that a man can crawl into, a window from which people can be thrown, a trunk with a false back, a wheeled cart, several wooden cabinets in which people can be concealed, and a "man-sized bottle with cork." In addition to eight of Paganini's caprices for violin, recorded music includes the main theme from Mussorgsky's 'Night on Bald Mountain' and, by Beethoven, 'Fur Elise' and part of the 'Ode to Joy' from the Ninth Symphony. The play begins with Paganini in a circle of light describing his torment, how music, perhaps from the

Devil, distracts him from his path to salvation. An Apple Wife pushes on her cart and Paganini, drunk, falls into it and upsets it. The Violin Merchant enters, pays for the spilled apples, and gives Paganini a drink from a bottle. Admitting that he had to pawn his violin to pay for gambling debts, Paganini accepts a violin from the Violin Merchant, promising to pay for it. Angelina tells us that she met Paganini on a stormy day in "the gloom of a forsaken schoolhouse," and the Clockmaker, as Angelina's father, introduces the violinist to some of his clockwork mechanisms—a Jack-in-the-box with an insane, horrible laugh, a mechanical Bear that comes out of a cabinet and crashes two cymbals next to Paganini's ears, a Gorilla from another cabinet that assaults his hearing with a blast on a horn, a Clockworks Girl who dances with him, a Clockworks Violinist who plays schreechingly, and a Sibyl who tells Paganini part of his future. The scene and conversation end as a bird pops out of a cuckoo clock and does thirteen cuckoos. Then, in a tavern, Paganini drinks with a Soldier, played by the same actor who played the Violin Merchant, a resemblance that Paganini notices, but he is too drunk to stay awake. When Paganini stumbles into his room to find the Soldier in bed with Angelina, he tries to stab the Soldier and then suffocates Angelina with a pillow. We then see Paganini in prison with Deflores, a Murderer, and a Man in the Iron Mask. The Violin Merchant gives Paganini his violin and the lights fade on the prison and come up on Mrs. Testa, a restaurant owner, and her patrons, Pantaleone and Isabella. Paganini denies that he ever murdered anyone, but when the ghost of Angelina appears, Paganini screams and runs out. In his room, Paganini talks with Marina, the innkeeper's daughter. Learning that she is fifteen, Paganini tells her he will protect her, but her father, Rappacini and two thugs, Ugo and Bosco, burst into the room, beating Paganini and taking his money and his violin before throwing him out into the garbage cans. Paganini crawls to the edge of the stage (representing the edge of a canal in Venice) but the Violin Merchant gives him back his violin, saying that the music is not yet finished. Paganini is prevented from throwing himself into the canal by the arrival of Antonia, a young woman who invites him to share her life. They leave for her room, taking the violin, and as the lights fade and we hear the 24th Caprice and the sound of ticking clocks, Angelina and Marina appear and follow, holding hands.

Act Two opens with Mama and Papa Paganini; he wheels in a cart full of dead birds and she tells us that shortly after his birth her son Nicolo died. In a hilarious routine, Dr. Moribundi comes on with a rag doll representing young Nicolo and, after swinging the doll back and

forth and beating it on the head with a large rubber hammer, pronounces the child dead. Asked for a second opnion, Dr. Moribundi introduces three colleagues—Drs. Polemus, Pestilenza, and Hungersnot—who sing like a barbershop quartet. As the doctors leave, arguing with Papa over being paid in dead birds, an Angel (played by the same actor who played the Violin Merchant and Soldier) appears, smoking a big cigar, and brings the doll/child back to life. He promises Mama that her son will be rich and famous and gives her a violin. In the dark, we hear the 11th Caprice and Paganini screaming, and when the lights come up he tells Antonia that he has had another nightmare. Learning that she is pregnant, Paganini decides that he wants to be a father. At home, he talks to the rag doll (now his son Achille) using a high voice for the child. He is startled by the sudden appearance of Angelina and Marina, and when Antonia comes in she thinks Paganini is talking to a woman under the bed and throws the doll across the room into a wall. Paganini puts the doll in the trunk, and when Antonia won't stop throwing apples at him he throws her out the window. Antonia runs back in, daring him to throw her out the window again, and he does, twice. On her fourth re-entry, Antonia jumps out by herself. Angelina and Marina, who have been commenting on the situation, offer Paganini conflicting advice and he goes to get Achille from the trunk. But when he lifts the lid, Antonia jumps out at him and tries to pull him back into the trunk to make love to her. He escapes and jumps out the window as Antonia goes back into the trunk. In the dark we hear the 16th Caprice and the lights come up on Watson, who tells us that Paganini lived in the same rooming house in London. Paganini plays with Achille (the doll), talking of the lovely voice they hear in the next room. When Charlotte enters, Paganini suggest that she might like to sing in the intervals of his performances. Miss Wells, a singing protégé of Watson, interrupts, followed by Watson, Charlotte's father, who suggests that Miss Wells, not his daughter, should sing at Paganini's performances. Miss Wells appalls the violinist with a "very loud and extremely awful note," and the scene ends with a thunderclap and lights darkening as Watson tells us of Paganini's "demonic sadness and evil." At night as a thunderstorm rages, Paganini, in bed with the sleeping Charlotte, talks with the dead Beethoven, who is playing 'Fur Elise.' When Paganini asks for the truth, Beethoven conducts, and we hear, the famous sixteen-bar phrase from the 'Ode to Joy.' Admonishing Paganini to listen for the silence, Beethoven climbs into the piano and slams the lid shut. Charlotte wakes and Miss Wells and Watson enter to discuss her singing in

Paganini's concerts. After Miss Wells emits three notes of increasing volume, Paganini grabs his pants, his violin, and Achille, and runs off, followed by the others. We hear the 5^{th} Caprice and see Paganini and Achille sitting on a curb as he tries to get into his pants. The ghosts of Angelina, Marina, and Antonia sit beside them, telling Paganini that they have brought doctors to help him. And the barbershop quartet of Polemus, Hungersnot, Pestilenza, and Moribundi make their singing entrance. Saying that they have come to remove all his teeth and some of his brain, they whack Paganini over the head with a large rubber club and throw him onto the bed. Paganini flails about, screaming, but the four doctors with "large, ugly looking utensils," surround him and begin throwing teeth (chicklets) over their shoulders. Antonia holds Achille as Marina picks up teeth for a necklace and Angelina sweeps up the rest. Paganini is visited by a Monk who has come to administer the last rites. Paganini recognizes him as the Violin Merchant/Soldier and says he is the Devil, chasing him away. Returning to bed, he pulls back the covers to reveal Angelina, Marina, Antonia, and Charlotte lying side by side. They tell him he can still save his soul if he goes to the top of Bald Mountain on the night of the autumnal equinox. With thunder, lightning, and Moussorgsky's music playing, Paganini encounters the Apple Wife; whe leads him to what she calls a cider press, but to Paganini (and to us) it looks like a vertical coffin. She tells him that if he opens the door he will find his salvation, but when he does open the door the Violin Merchant walks out demanding payment. As the Apple Wife holds the struggling Paganini, the Merchant begins strangling him, but seems to run out of energy and finally stands, frozen. The Clockmaker steps out of the doorway and rewinds the Merchant, telling Paganini that his salvation is on the other side of the door. The quartet of doctors stick their heads in, one at a time, singing, then grab Paganini and stuff him in "a huge glass bottle." They drop his violin in and seal the top with a huge cork. We can see Paganini screaming and pounding, but we cannot hear him. Alone, Paganini picks up the violin and begins to play and we hear the last part of the 24^{th} Caprice as the storm and lights fade. In the darkness we hear the sound of clocks ticking.

* * * * * *

The opening sounds of *Pandemonium**, Nigro's investigation of coke and steel magnate Henry Clay Frick, may be seen in restrospect as an overture comprising all the major story-line motifs of the play. In darkness we hear birds singing and a little girl laughing, then "an increasingly eerie cacophony" including wind, rain, songs on an organ

grinder and orchestrion, thunder, singing, train whistles, bagpipes, rushing flood waters, and children screaming, all building to "a horrendous din which concludes with a loud gunshot." The lights are then turned on by Helen, Frick's daughter, who urgtes her father to get some sleep. We hear the sound of crows cawing as Carnegie enters singing and joining Frick downstage and suggesting that Frick give the wildcat strikers what they want. When Carnegie mentions Rockefeller and Morgan, we hear the sound of a bicycle horn, and the two robber barons ride in on a two-seater bicycle. Rockefeller says that what is good for the rich is good for the country and reminds Frick and Carnegie of the poker game that night before he and Morgan pedal off. As Frick returns to his desk, Alexander Beckman bumps into him and wonders aloud why he didn't shoot Frick when he had the chance. Frick's wife, Addie, tells him that the poor people who live down the gorge from a lake that Frick created by building a dam are afraid that the dam will break. Beckman rushes in and fires three shots at Frick, who clutches his neck and falls. In "a strange, yellow light, angelic, reminiscent of Vermeer," Frick and Rosie (in her twenties, holding an old-fashioned girl doll) sit on the downstage bench. Rosie tells Frick that she is his dead daughter all grown up and we learn from her that she died from swallowing a pin in Paris. A strange moaning sound is identified by Rosie as coming from a crumpled paper bag containing the ashes of Captain Billy, the man who ran Frick's steel mills and was killed when the blast furnace blew up. Frick is then terribly frightened by the appearance of a large Headless Man, decapitated by a cannonball during the Homestead strike, who grabs the bag and runs off. Visiting Beckman in prison, Frick learns that he was shot because Beckman was unable to build a bomb and only had three bullets for his rusty gun because that was all he could afford, even though his beloved Emma put herself on the street to try to get some money. As the organ grinder's version of 'Little Annie Rooney' plays, a Vermeer-like light comes up and Frick and Beckman act out the shooting scene, Beckman narrating, with Rocklefeller and Morgan and the Headless Man rushing to their rescue. Carnegie appears in a circle of light, reading a cable from Frick about the incident. Frick tells a skeptical Beckman that he will get a fair trial, and Rosie sings 'Father Was Killed by the Pinkerton Men' (words and music by Nigro) as the members of the court take their places. Morgan is the judge, Rockefeller, Carnegie, Frick, and Commodore Vanderbilt (a full skeleton in a yachting cap and outfit manipulated by the Headless Man) are the jury, and Emma is the stenographer. A Clown and an actor in a kangaroo suit provide comic

relief. Pronounced guilty and sentenced to "four hundred and twelve thousand years in prison," Beckman, calling Emma's name, is dragged off by the Clown and kangaroo.

As Act Two begins, we hear pigeons and Carnegie singing and we see Rembrandt painting at an easel. He tells Frick to get out of the light and asks him what he wants, then folds his easel and leaves. Frick asks Helen for something that will allow him to sleep without waking up. She tells him that the reason her soldier didn't ask her to marry him was because someone told him that her father would cut her off without a penny. Frick says the boy was a bad investment and that he is going to change his will to frighten off fortune hunters. Helen mixes powder in a glass of water and gives it to her father, urging him to drink it all. There is a faint wind sound and a rinky-tink piano plays 'Little Annie Rooney' as the scene shifts to Rocky's Chop House with Rockefeller dressed as an old-time bartender, Morgan devouring a chicken like Henry the Eighth, Carnegie blowing his bagpipes, and Teddy Roosevelt cleaning his elephont gun. After giving Frick a drink, Rockefeller directs his attention to two bottles that he inherited from his father's "traveling snake oil medicine show," one of which contains the stomach of a man who died from alcoholism and the other the stomach of a "healthy" man. Rockefeller tells Frick that the stomachs are symbols for what God does to people: eats them alive. After some talk of Morgan's nose, Rockefeller wonders what will happen to the stomachs when the dam bursts, saying that a big rain storm is coming. We hear the eerie moaning sound and the sound of wind blowing as lightning flashes and thunder booms. The capitalists, each clutching his property, are blown off stage and Frick wanders in the storm. Addie, Helen, Rosie, and Emma describe what happens as the dam bursts and water eighty to ninety feet high smashes through the gorge, destroying homes and blast furnaces, and Johnstown. The women describe in detail the agony and devastation, and Frick dictates a memorandum to the members of the South Fork Fishing and Hunting Club telling them to deny that their dam had anything to do with what happened. As Rosie tells a non-believing Frick that Helen killed him with poison, the other three women sit "knitting like the Fates." Then, in a reddish fog, Morgan, Rockefeller, Carnegie, and Commodore Vamderbilt (moved and spoken for by the Headless Man) sing a barbershop quartet version of 'Little Annie Rooney' as they set up a table for a poker game. Emma gives Beckman a mirror to look at himself, and Carnegie tells Frick that the secret of life is that God is one of the rich, the powerful, the survivors. Beckman accepts this

explanation as true and sees his life as a lie. As Frick joins the card players and Rosie sings, Beckman takes out a gun and holds it to his head. Rosie comes to the end of the chorus, there is a loud gunshot, and the lights immediately go to black, leaving us with the after-image of the men playing cards in Hell and the women knitting.

* * * * * *

*My Sweetheart's the Man in the Moon** is a play that deals with the murder of architect Stanford White by millionaire Harry Thaw and the relationship of both of them to Evelyn Nesbitt, remembered from a vaudeville act as The Girl in the Velvet Swing. The title is from a song written in 1892 by James Thornton, a song that Evelyn sings part of near the beginning of the play and the rest at the end. The unit set represents New York in the early twentieth century and elsewhere. Besides the three principals, there are two other characters, Mrs. Nesbitt, Evelyn's mother, and Mrs. Thaw, Harry's mother. The action begins with the sound of an old piano playing the music of 'My Sweetheart's the Man in the Moon' as the lights come up on Evelyn, speaking of significant events in her life. The dialogue begins with Harry telling Mrs. Nesbitt that he is a great admirer of Evelyn's work in the theatre and as a model. He says that since she is a virgin she should be in school, for which he offers to pay. Mrs. Nesbitt and Evelyn refuse Harry's offer and Evelyn moves into the spotlight for her stage performance of the song. As she finishes, Stanford White appears, calm and urbane. After Stanford kisses her on the top of her head and leaves, Harry tells Evelyn that he is the only man in the world for her. Stanford tells Evelyn he married his wife for her money and she tells him that she spent the night with John Barrymore but that they both had too much to drink and slept with their clothes on. Then, in the Thaw house in Pittsburgh, Mrs. Thaw tells Harry that she wants him to marry into English nobility like his sister and that she will cut him off without a penny of the forty-million-dollar family fortune if he marries Evelyn. When Evelyn tells Stanford that she is going to Europe with Harry, Stanford gives her a letter of credit in case of emergencies. Harry is furious when he learns that Stanford "ruined" Evelyn, but she tells him how she met Stanford, how he pushed her in a red velvet swing and sent her to the dentist to get her teeth fixed. She describes how Stanford took her into the bedroom and gave her champagne as piano and strobe lights create "a mad, violent carousel effect," an effect that changes suddenly to silence and a single spot on Evelyn as she remembers waking, naked, screaming, with blood on the sheets.. The next morning Stanford tells her that nothing is spoiled, that everybody

does these things, and that her mother will never know because Evelyn won't tell her. When Harry discovers some underwear that Evelyn bought with the money she obtained by cashing Stanford's letter of credit, he hits her and says that Stanford is invading his brain, but begs Evelyn not to leave.

In the second act, Evelyn tells Stanford that she came back alone from Europe because Harry tied her naked to a chandelier and whipped her until she bled. Stanford gives her his lawyer's card and tells her to stay away from Harry. Harry speaks a letter to Mr. Comstock, head of the Society for the Prevention of Vice, accusing Stanford of the "habitual debauching of underage girls" and offering a personal check to help the Society hire detectives to follow Stanford. Evelyn tells Stanford that she is going to marry Harry, no matter what Stanford says, but Stanford only tells her never to trust rich people. Despite Harry's promises, the beatings continue after the marriage, until Mrs. Thaw finds out. She threatens to cut off Harry's money and his gonads if he ever harms Evelyn again. Stanford reminds Evelyn not to trust anyone, and the scene shifts to the rooftop theatre of Madison Square Garden, with Evelyn and Harry at one table and Stanford at another, watching a show. Harry says he has a gun and wants to shoot Stanford, and Evelyn tells him that the contest between the two men is not about her at all, that Stanford is the one that Harry can't stop thinking about. Harry crosses the stage and points his gun at Stanford's head. Lights and music create a slow-motion mad carousel effect until we hear the sound of a shot, then the lights and music stop and we hear two more shots in the dark silence. We hear the sound of a gavel banging and see Evelyn in a circle of light as Stanford and Harry circle her, always opposite each other, questioning and commenting. Evelyn learns that Mrs. Thaw has given her mother a hundred thousand dollars not to testify against Harry. Evelyn talks to Harry in the asylum and then learns from his mother that it is against the law to divorce a legally insane person, and she can't get the million dollar settlement until she is divorced. But, Mrs. Thaw says, she could manage a small allowance if Evelyn will testify that Harry is now sane. Evelyn says she can't sleep unless she takes drugs. In the madhouse, Harry tells Evelyn that he is getting out in a week, that he is divorcing her, and that she won't get a penny. Evelyn tells Harry that the only man she ever loved was Stanford, and she moves into her spotlight to tell us that she is very big in vaudeville now and is a heroin addict but that some day she will get off her addiction and be an artist when she is old and no longer cursed with beauty. In "eerie blue light" she sings the last verses of her song.

* * * * * *

The investigation of the work and loves of Franz von Stuck in
*Sphinx** uses a single set, but time fluctuates in the scenes from present
to past. Stuck, identified as the Artist, enters a room in his villa in
Munich in 1928 carrying a lamp. We hear his wife's voice calling him
back to bed and the sound of the flute from Debussy's 'Afternoon of a
Faun,' and then a woman's voice, the Sphinx, speaking. By the light of
his lamp we see a "beautiful dark haired woman wearing a silk dressing
gown." The Artist asks her to take off her gown so that he can paint
her. She says that he must first answer the riddle. Assuming she
means the riddle that Oedipus answered, the Artist is dismayed to find
that she does not mean that riddle. The Stepdaughter's voice calls from
offstage and then she enters in a nightgown, wondering what's going
on. She identifies the Sphinx as her father's model, Lydia, and her
father confirms this identity. The Artist's daughter, Mary, enters in a
white nightgown, calling the Stepdaughter Olga and recognizing the
Sphinx as Lydia. The Artist tells Mary that he and Anna, her mother,
had some very happy times together, but he never admits to loving her
and agrees that he never married her. The Daughter wants to know
why she was called Mary, the name of the Artist's wife (and birth
mother to the Stepdaughter). Time shifts to a period some years earlier
as the Mistress, "young and beautiful, in a white dress, with a great
armful of weeds," walks in. The Artist tells her that he has met and
plans to marry another woman. Unruffled, the Mistress says that she is
carrying the Artist's child. The Artist tells his Wife and the two
women discover that they both have posed nude for the Artist, and the
Wife shows the Mistress a photo of her young son and daughter, adding
that their father is dead. The Stepdaughter complains that she and her
brother were sent off to live with a governess and accuses her mother,
the Wife, of loving the Daughter more than she loves her own flesh and
blood. The Daughter insists that she be told why her mother gave her
to be reared by another woman. After a pause and the sound of birds
singing, the action moves to a time when the Artist tells the Mistress
that he thinks it would be better if the Daughter came to live with him
and the Wife, saying that the child would have more opportunities.
They assure the Mistress that she will be able to see her child and that
she will be taken care of financially.

Act Two begins with the sound of a ticking clock and with the
actors in exactly the same positions they were in at the end of the first
act. The Mistress tries to explain to the Daughter why she allowed the
Artist and Wife to take her into their home. Then, in a scene from a

later time, the Artist tells the Wife that the Stepdaughter is behaving oddly toward the Daughter, holding her head under the bath water and encouraging her to dance on the ledge of a second-story window. The voice of a male character called Goat is heard, and the character enters the action to tell the Artist that he has come to fight him for the woman (all women are the same woman, he says). The Goat takes off his coat and shirt, getting ready to fight (his hairy upper body looks like a shag carpet to the Daughter), and, although the Wife protests, the men begin wrestling. The Wife brings out a picnic basket and the Stepdaughter and Daughter argue as the men scream and struggle. The Artist manages to yank the Goat's head back and we hear a loud cracking noise and the body of the Goat goes limp. The Artist is then challenged by the Sphinx to pick one thing, one moment, that he is absolutely certain "was not a lie, or a fantasy, or a dream, or a hallucination." The Artist says he remembers swimming in the sea with a woman, "the greatest moment of his life," but he doesn't remember who the woman was. He tells the Sphinx that his life has been about art, and when the Sphinx says that nothing is real to him except what he makes, the Artist agrees, thinking that he is having a nightmare, that he is loved by the women in his life, that "work is the only illusion that is real." He tells the Sphinx to take off her dressing gown, but she says he has not yet answered the riddle, that art is nothing, that he has wasted his life. Defeated, the Artist says that when he can no longer create, he is lost and must die. But the Sphinx kisses him "very tenderly" and tells him that she is going to stand naked before him because she chooses to do so, to show him the answer to the riddle. Then, just as she is about to remove the gown, the lights go to black

* * * * * *

Another painter of the early 20th century, Edvard Munch, is the central figure in *Madonna**, a play for twelve actors (seven men, five women, with some doubling). As the play begins we hear the sound of a ticking clock and a piano playing Schuman's 'Aufschwung.' The lights come up on Munch, 80 years old, painting, as Knut Hamsun, 84, enters and speaks to him. It is December, 1943, and Norway is occupied by the Nazis. Hamsun recalls the times of their youth when they frequented a tavern called The Black Pig with Strindberg, Przybzewsky (pronounced ShivaSHEVsky), and Munch's model, Dagny Juell. As he speaks, Dagny appears in a robe and reclines on the bed (for her, it is 1893 in Berlin). She asks why Munch paints so many small, pale, lovely but dying girls, and Munch's sister, Sophie, enters in a nightgown, complaining of the cold (her time is 1877 at their home in

Oslo). Munch tells Dagny that Sophie and his mother died of tuberculosis, and Sophie begins coughing blood into her handkerchief as Papa Munch enters, followed by Munch's aunt, Karen (his mother's sister, in her late twenties). In a juxtaposition of times and places, Karen kisses Munch on the cheek, Dagny asks him if he would like to make love to her, and Hamsun brings Munch a small portrait of Nietzsche, whose appearance (his time is the late 1890s in Weimar) deepens the interpenetration of times and places. Nietzsche says that God is dead but has come back as the Holy Ghost to haunt his son, Nietzsche. Munch moves to his easel while Dagny puts on her dressing gown and exits as pounding is heard on the upstage door. It is Strindberg (the time is 1896 in Paris) complaining that Przybyzewsky (whose name is consistently mispronounced as Poppofsky) plans to electrocute him. Dagny, dressed, asks Munch to take her out and, after a cautionary word from the dead Nietzsche, we see a young Hamsun, Strindberg, Przybyzewsky, a German Girl, and a Russian being introduced to Dagny by Munch. After the bar scene, Hamsun and Munch, both old again in 1943, refer to Eva, a violinist that Munch almost married, who talks with Munch in a clinic in Copenhagen in 1909. In another scene from the past, Papa Munch asks Munch not to be angry with him for not asking his patients for money after Sophie died. The anger theme is picked up by Dagny (Berlin, 1893) who thinks that Munch should not be angry with her for sleeping with whomever she wants, even though she hasn't slept with anyone but Munch, yet. Strindberg urges Munch not to be ashamed of madness, that it is a part of genius. Karen enters with a picture Munch has drawn of her (Oslo, 1879), and when he shows her other drawings she tells him he has a gift of which he must never be ashamed. She insists that Papa recognize his son's talent and accept that he wants to be a painter, not an engineer. Alone, Munch startles Dagny who has been out late. She tells him that he makes his own pain, that she is not the woman who makes him suffer. Sophie, Karen, and the Dead Mother call out, "Eddie?" but Dagny tells Munch that she wants him to make love to her, puts his hand inside her blouse, and then starts to undress by the bed. As Munch hesitates, Strindberg bursts into the room (Paris, late 1890s) saying that he has proof that Przybyzewsky is trying to kill him. He rants on about the importance of madness to the artist, and again the women's voices call "Eddie?" and the Dead Mother appears in greenish light telling her son not to be afraid. As the light fades on the Dead Mother, Hamsun tells Munch that his country needs him, that he, Hamsun, has come to stop Munch from committing the greatest

betrayal of his life. And Dagny then insists (Berlin, 1893) that she is not betraying Munch by deciding to marry Przybyzewsky. She asks him to come to bed with her, and the other women look on as he crosses to her and the lights fade out.

The second act opens with the sound of the Schumann and, as Nietzsche delivers a disjointed monologue, the other actors take their places at The Black Pig (1893). The Russian dances with Dagny, telling her that he is her destiny. The German Girl comes in and asks Przybyzewsky for money to feed their children, and he gives her what little money he has, telling her that while he was married to her in spirit, he is married to Dagny by law. He takes some money from Strindberg, who has passed out, and Munch contributes as does the Russian, who obeys Dagny's order to take the German Girl home. Alone, Munch talks again (in 1943) with Hamsun, who advises him to be on the side that is going to win the war, the side of "the good old Aryan values." Ibsen tells Munch not to worry about being insane because his work is the only thing that matters. Ibsen takes out a bottle of wine from his coat as we hear thunder, and, with a smile he tells Munch about Cato the Elder being so virtuous that he only made love to his wife when it thundered. He says he always knows when a storm is coming because the cat goes under the sofa and his wife "gets first cranky and then extremely amorous." We hear Suzannah, Ibsen's wife, calling, and Ibsen skips off. Hearing a knocking on the door, Munch admits Dagny who has been out in the storm. She asks Munch if she can stay with him, and Munch hugs her and helps her undress and get into bed as Nietzsche tells him that he loves a corpse. Dagny tells Munch her nightmare about a former lover coming into her bedroom to kill her. She says that Munch's pictures have also begun to appear in her nightmares. Sophie tells Munch that she has had a dream about kissing Death, and she and the painter are back in Oslo in 1877, sitting on the bed. Sophie asks her brother to kiss her and he refuses at first but then does so, twice, as Nietzsche wanders on with a commentary on sex and leaves as Przybyzewsky comes in and sits at the table, drinking and telling Munch that Dagny and the Russian are lovers and that he is going back to Berlin to see his children. Strindberg rushes in to tell Munch, among other things, that Przybyzewsky has been let out of jail for murdering his mistress and children because he was in Paris at the time of the killings. Munch speaks of his visions of women and Dagny enters in a nightgown, saying that she wants a child. As Dagny and the Russian laugh in bed, Munch looks on. Dagny tells the Russian that Munch is the only man she ever loved. Taking his gun, the Russian

tells Dagny that he is going to kill her, and when she says that the cold gun against her leg makes her tremble, the Russian tells her that is almost exactly what her husband's German mistress said on a recent, very similar occasion. As the lights on the bed go out, Munch simultaneously hits the table with his fist, "making a loud report like a gunshot." Munch who has been in red light throughout this scene, describes the woman in his painting 'The Scream.' As the light changes, Dagny and the Russian stay in the bed, and Strindberg suggests that Munch go to see Ibsen, who has had a stroke and is dying. With Suzannah's help Ibsen haltingly explains that he is trying to teach himself the alphabet so that he can write the plays that are in his brain. Hamsun tells Munch that he gave Goebbels his Nobel Prize medallion and still believes in Germany as the only salvation for Norway. He tells Munch that if he does not join a board of adjudicators who will tell the public what art is acceptable, his own work will be destroyed. Munch sees Karen and Laura (in an asylum in Oslo in 1910) and Karen urges Munch to talk to Laura and then asks him why he did not return to Norway. She tells him she did not agree to marry his father, although he did ask her a year before he died, because she knew it would cause Munch pain. Laura asks if her brother is leaving again, but Munch says he will come to see her every day and paint a picture of her that the whole world will admire. As Hamsun asks whether Munch will capitulate or not, Karen and Laura remain where they are and Sophie joins Dagny on the bed while Nietzsche, Przybyzewsky, and Strindberg join the other actors on stage. Munch tells Hamsun that if his work is destroyed he will just have to start all over again, from the beginning. He tells Hamsun that he pities him and orders him to go home. Hamsun leaves, "sadly," and we hear the Schumann as Munch paints, the other actors look on, and the lights fade to darkness.

* * * * * *

*Thane of Cawdor**, a play about Scottish families in the early sixteenth century, is related to the Pendragon series of plays. The script calls for ten actors (five men and five women, with one actor playing three male roles), and the action begins with the sound of doves cooing in the darkness and Isobel Rose singing two stanzas from 'The Cruel Mother,' words and music by Nigro. The lights come up on Muriel (Rose) Calder who speaks to the audience of her nightmare being always the same, and the three women in that nightmare—Isobel, Margaret Gordon, and the Nurse (with a bloody mouth) scream lines from the shadows as Muriel tells how the Nurse bit off a joint of her little finger and Isobel branded her bottom with a key heated in the fire.

Muriel does not understand why the women have hurt her in this way, nor why the Steward has been killed. She only remembers being held and comforted by a man with strong hands. Campbell of Inverliver then becomes visible and speaks lines of comfort as if to a small child. Muriel talks of growing up in Inverary Castle, a Campbell stronghold, but when she was fifteen she was summoned by her guardian, Archibald Campbell, the Second Earl of Argyll, who tells her that he wants her to marry his son, John Campbell. Very apprehensive about her wedding night, Muriel asks how Elizabeth, John's sister, can stand being married to Lachlan Maclean, a man she doesn't love. Elizabeth says that she has been trying to poison him and urges Muriel to enjoy sex and love her babies, that the wedding night experience will be over before she knows it. Muriel tells the audience that John's tenderness destroyed her defenses and that when he finally made love to her she "knew the ecstasy of the animals." But the nightmare returns in the next scene, with the addition of Argyll, who seems to wake Muriel from her dream to tell her that he has died in battle. John wakens Muriel from her nightmare, and she tells him that she saw his father Argyll, bloodstained and dead. John tells her that he has just received word that his father was killed leading a charge against the English at Flodden Field. After Isobel sings, Muriel talks with Campbell of Inverliver, the man who wrapped her in a blanket and took her from her tormentors at Kilravock Castle years earlier. Campbell lost all seven of his sons as they tried to prevent Muriel's Calder uncles from recapturing her. Elizabeth then tells Muriel and John that her husband chained her naked to a rock and walked away as the tide came in to drown her. Some fishermen rescued her. Asked why her husband might have treated her this way, Elizabeth eventually admits that she did try to murder him once or twice. Campbell enters to tell John that he has a guest, whispering a name in his ear, and John insists that his sister hide in the closet, because her husband is about to come in. Maclean enters, dressed in mourning, and says that his wife fell into the sea and was drowned. Elizabeth demands that Maclean be killed, but John insists on civilized behavior, saying that he does not kill house guests as he allows Maclean to leave. Muriel tells us that she felt uneasy but hopeful because her husband had refrained from murder, but one night she dreamed of Maclean walking at night and the dream becomes flesh as Maclean, John, and then Campbell appear. Campbell grabs Maclean's arms and John stabs him twice in the stomach and then, in thunder and lightning, apparently stuffs Maclean's severed privates into his mouth. John tells Elizabeth that her husband has had

an unfortunate accident, falling off his horse in the storm and accidentally biting off his own ballocks. Elated to be a widow, Elizabeth thanks John for the bad news and skips off. Muriel says that she dreamed that John killed Maclean and says that she cannot sleep next to a murderer. John tells her that he has decided that it is time to claim her inheritance. As heiress of Cawdor, making him Thane of Cawdor by marriage, they must live in the castle if they wish to keep it. Muriel narrates another dream in which she encounters three women on a dark heath sitting before the fire. The women—Isobel, Margaret, and the Nurse—wear cowls hiding their faces, and when Muriel tells them that she is lost and doesn't know who she is, Margaret asks her if she has the key, telling her that when she finds the key she must open the box with it and she will find whatever it is that she is looking for. They tell her the key is in the garden where the doves coo, a garden she can find by looking inside.

Isobel's singing opens the second act, and Muriel narrates her return journey to Kilravock Castle and the nearby Cawdor Castle. The nightmare scene of the first act is reprised with the three women screaming the familiar lines. Muriel asks the Nurse why they did such horrible things to her. The Nurse talks about walking in the garden with young Muriel listening to the doves cooing until they heard the sound of horses coming and ran back into the castle. The Nurse insists that Muriel's mother, Isobel, is alive, and Hugh Rose, Laird of Kilravock, Muriel's uncle, enters to verify the fact. Isobel recognizes Muriel, but believes she is dreaming and wonders if Muriel has come to kill her. Muriel asks why she was tortured, and as Isobel begins to narrate the story of her father, Kilravock speaks as if to a child and the Nurse and Margaret, Isobel's stepmother, repeat their lines about the branding with the key and the biting off of the finger joint. Isobel tells Muriel that Kilravock was going to be tried for murder, but Archibald Campbell, the Earl of Argyll, was Justice General of Scotland and had jurisdiction over the case. In a scene from an earlier time, Kilravock and Argyll make a deal: Kilravock will not be tried and Muriel, when grown, will marry Argyll's son John, bringing her enormous dowry, including Cawdor Castle and all that appertains to it with her, increasing substantially the Campbell estate. Muriel and Isobel have observed this scene and Isobel tells Muriel how she was awakened one night by an argument between her father and stepmother. We then see Kilravock and Margaret argue over giving Muriel to the Campbells, and Kilravock says that when the furor over the murder dies down, he will marry the girl to one of the Roses and keep the dowry in the

family. Isobel tells Muriel that Argyll didn't trust Kilravock and sent a troop of Campbell horsemen to take her by force. The women enact their decision to mark the child so that the Campbells will not be able to kill her and substitute another fair-haired lass of their own. Thinking she was saving the child's life, the Nurse bit off her finger joint. In the shouting and screaming, Margaret insists that Isobel put a key in the fire and use it to mark the child. Muriel says that she thought they were screaming and cursing at her, that they hated.her. She says her whole life has been a lie and rages at what the Campbells did to her. John says that neither one of them had any choice in what happened in the past, but that he loves her deeply and has and will protect her. He admits to being violent when he has to be, but adds that he has never been violent and never would be violent towards her. Alone, to the cooing of the doves, Muriel uses the key her mother gave her to open an old casket jewelry box containing a small jar. In the jar, pickled in brine, is the last joint of a child's little finger, hers. She says she will soon forgive her husband and allow him to touch her again.

* * * * * *

Anothrr play related to the Pendragon cycle, *Maddalena**, is set in Armitage, Ohio, in 1938 (and earlier in Italy). The cast is composed of four men and four women with two of the men and three of the women playing more than one role. Uncle John Belizzi, the sherrif, never leaves the stage in either act and Maddalena only moves into the upstage darkness at the end of the play. As the action begins we hear an old recording of 'You Tell Me Your Dreams' and see Uncle John at his desk. Seated in a chair by the desk is Maddalena, a beautiful Italian woman in her thirties. Uncle John says that when people find out what happened they will want to hang her. He asks her what she was thinking and, with no break, Jason Cornish, her husband, steps into the light and asks the same question in the present tense, but the place and time are Italy during the First World War. He tells her that he is the man she has been waiting for, and Uncle John in his 1938 time says that her husband thinks she might have killed her brother and father back in Italy. She tells Uncle John that her father and brother were caught scavenging corpses and were shot by the soldiers. Cyril Pelly enters and sits at the kitchen table, shouting to Violet, his daughter, to make him some sausages. Jason moves into the kitchen area to confront Cyril who tells him that his mother, Cyril's sister, signed the house and farm over to Cyril. The mother, Darah, sits in a chair in a mental hospital, putting clothes on a rag doll. Jason accuses Cyril of stealing his inheritance, but Cyril suggests that Jason and his new bride

(Maddalena) can live and work on the farm. Masddalena moves into the kitchen area and tells Jason he should go to see his mother and accept Cyril's offer. Darah tells Maddalena about Jason being involved with Glynis, Harry Macbeth's granddaughter. When Maddalena turns back to Jason, he explains that he, Glynis, and Con Quiller were friends since childhood. Cyril accuses Maddalena of changing his daughters and says that although he loves her cooking and is pleased with the way Jason is helping out, he feels uneasy. Maddalena visits Darah again, offering to bring her two small children to visit and learns that Darah gave birth to a baby girl before Jason was born but that Cyril in a drunken rage stomped the baby to death. Darah says that after she saw Cyril bury her baby in the barn, she dug up the corpse on her wedding night and put it in a locked trunk in the attic. She gives Maddalena a keyring with two keys, one for the attic and one for the trunk. Cyril goes to the barn with a shovel, discovers May (his other daughter) and Con Quiller in the hayloft, and falls off the ladder on to a pitchfork. When Maddalena says that she shouldn't be seeing a married man, May says that Con has also slept with Violet and that the three of them are thinking of going out together. Maddalena learns from Con that his wife, Glynis, may be having an affair with Jason. When Con tries to kiss Maddalena, she bites his lip, drawing blood, and warns him to stay away from May and Violet. Uncle John asks Maddalena who the fourth person in the car was the night they died in the crash. (This accident and the people involved are referred to in *Great Slave Lake**, just one of many instances of intersecting paths in this labyrinth of stories.) On the sofa, with May in the middle and Con on her left with his palms up as if driving a car, the three talk about picking up a figure they see standing in the rain. As the light on them dims, Maddalena tells Cyril that his daughters are dead. He tries to strangle her, kisses her instead, then falls to her feet saying that he cannot breathe. The first act ends with the tableau of Cyril prostrate before the erect Maddalena, the two girls and Con on the couch, Jason drinking at the kitchen table and Darah sitting in the madhouse as the scratchy old record of 'You Tell Me Your Dreams' plays and the lights go out with Uncle John still at his desk.

Act Two begins with the recording and the sound of crickets in the night as we see Uncle John drinking at his desk, Maddalena in the upstage bed, and Jason trying to console Glynis, who says she is glad Con is dead. She tells Jason that she let Con make love to her long ago because she wanted to hurt Jason and married Con at her grandfather's insistence. Maddalena tells Uncle John that she and Glynis became

friends and that Glynis was wonderful with her children. Uncle John points out that Glynis stole the affection of Maddalena's children just as Maddalena had manipulated Violet and May. Harry Macbeth tells Jason that Glynis has not remarried because she is still in love with Jason, and he suggests that a war-time marriage could be easily annulled, clearing the way for Jason to marry Glynis and inherit Harry's money. Jason discovers his son, Andrew, with Glynis and punches him. Later, Andrew tells Maddalena that Jason is making love to Glynis, and Maddalena describes to Uncle John how she found them making love. Maddalena asks Glynis how long she has been sleeping with him and Glynis tells her of a night long ago when she made love to Con with Jason watching, even though she wanted Jason. She says that Jason married Maddalena to punish her. After she runs off, Jason suggests to Maddalena that she might go back to Italy to visit her family. She implies that he may not be the father of the children, that perhaps Con was. Jason slaps her and tells her to get out. Uncle John tells Maddalena that he has been to the madhouse to see her daughter Ariella, who sits where Darah sat, playing with the same doll. As he questions her, Ariella describes her recollections of hearing voices and music (the recording of 'You Tell Me Your Dreams' begins playing) and of going up the stairs to the attic where Glynis is wearing Darah/s wedding dress. Glynis says that Jason found the keys in Maddalena's jewelry box and gave them to her. Ariella opens the trunk and takes out a dark object wrapped in old newspaper, screams, and runs out, locking the attic door. Glynis screams that she has knocked over a candle as the music stops and the lights go to black on the attic area. Ariella runs from the house to Uncle John. When she gives him the keys, he realizes that she locked Glynis in the burning house, killing her. Maddalena says that everyone will believe that she, not her daughter, set the fire, but Uncle John throws her his car keys and tells her to drive away and get on the first train going in some other direction. After Maddalena takes the keys and goes off into the upstage darkness, Uncle John pours himself a drink and we hear the record playing again. Jason sits at the kitchen table and begins drinking and Ariella in the madhouse says that everything is lost.

Chapter Five: Pendragon Plays

While more plays will be written, there are now nine monologues, eleven one-act plays, and sixteen full-length dramas that tell the complex stories of the Pendragon clan from Wales in 1736 to the latter part of the 20th century in America. In the monologue *Haunted*, Elaine speaks in "perhaps 1823." Her four-page reminiscence is written as a stream-of-conscousness three-sentence effusion as she tells us of being haunted, of an incubus, of Zach Pendragon who married her mother and may have murdered her father, of her sister Margaret and her half-brother Johnny. She tells us of her mother going slowly, quietly, mad and Margaret becoming more introverted while she and Johnny explored the labyrinthine old house, walking at night on the edge of the roof and swimming naked in the pond. She says that when she walks naked through the house she can hear the sounds of couples moaning and straining as they make love and she can feel the incubus entering her. She says that when she is dead she will be a ghost in the house, with her child, wandering the halls and feeling always "the straining bodies/of the damned."

In *Esmeralda Scorpio*, a beautiful 26-year-old bareback rider speaks to her sleeping children, telling them that her words will get into their dreams and their dreams will make the words true. The year is 1849, and Esmeralda, who has one green eye and one brown eye, has dreamt of something whispering in a satchel by a ruined windmill in Wales. (We learn that she is the daughter of Rhiannon, the subject of the next monologue, and that her children's names are Theresa and Bartolomeo, and their uncle is Robespierre.) When they were boys, Robespierre and Napoleon, the children's father, found Esmeralda in the satchel and brought her with them to America. She tells her children of a dream about three sisters (looking at past, present, and future) who live in a house by a stream that flows into the worlds of the dead where a dragon gnaws at the roots of a great tree that grows from the breast bone of a

man named Pendragon. A squirrel runs up and down the tree,
fomenting hatred between the dragon and an eagle who lives at the top.
Esmeralda says that she sometimes dreams of her mother Rhiannon
riding her nightmare bareback, naked. She says that when the
grandfather's monkey died he burned it under a lady's window and that
the next day the woman was accused of smothering her baby and was
stoned by the villagers. But the baby was really stolen away by the
father who was afraid of babies and planned to kill it, but left it in a
satchel by a windmill. She says that they came to America because a
voice in the grandmother's head told her that they would find French
Gold buried in somebody's apple garden; but King George DeFlores
always said he came to America because there was somebody they
were fated to torment. Esmeralda tells her children that she is leaving
with "this ridiculous acrobat person" because of her nightmares and
because there is somebody she is fated to torment, although she doesn't
know who it is.

In *Rhiannon*, we hear the sounds of "a strange calliope" as the lights
come up on Merlin Rhys, in his sixties, who speaks to the audience
from somewhere in the backwoods of West Virginia in the 1860s. He
narrates in disjointed fashion his vision of Rhiannon, a young girl in
Wales riding a pale horse through an apple orchard. His story is
interrupted several times by a remembrance of a giant clawed hand
coming through a window. He tells us that King George DeFlores
asked him to rescue a mother and her new-born baby that would be left
by the side of the road because DeFlores' wife, Belladonna, refused to
endure the sight of the child that her husband had created with her
sister. The sister, Proserpina, died in childbirth, but Merlin tells us that
he raised Magdalena and then, at her insistence, married her. She had
two children, a boy (Rudd) and a girl (Bel), but died after the girl was
born. Rudd was "dumb as a stump" and Bel was "as mad as a barrel of
rats." We learn that Rhiannon gave birth to a child in Wales but
claimed that a great clawed hand snatched the child from her bed. But
the villagers did not believe her and stoned her. Merlin says he rescued
her but that she ran away from him into the ruins of Pendragon Castle.
In America Belladonn asked him what he had in the bag when they saw
him at the windmill in Wales years earlier, and Merlin said that he had
a badger in the bag which he left in the windmill, perhaps the child of
Rhiannon.

The time of Jessie's monologue in *Autumn Leaves* is 1927, a little
over 100 years after Elaine, but like Elaine she wears a white dress.
We hear clocks ticking as she tells us that her favorite painting is

'Autumn Leaves' by John Everett Millais in which four young girls are raking leaves, two in black, one holding a rake and looking very sad, and one with a red sash around her throat who is eating an apple as she looks at the leaves. The painting for Jessie represents the loss of innocence and the realization of death as part of the cycle of life. She tells us of her half-brother, John Rose, a professional actor who ran away when Jessie was six. She speaks of her sisters—Lizzie, "the queen of the kitchen," Molly who is pretty and talkative, and Dorothy who is deaf and does not speak. Jessie tells us that she wanted to have many children, but that all dreams turn to leaves and fall. When John Rose returned, he and Jessie made love in the leaves by the pond, and after he had gone away again she realized she was pregnant. Her sister Lizzie's baby had died, and when Jessie developed pneumonia by going out dancing on a rainy night, still weak from giving birth to a little girl, she gave her daughter to Lizzie. Now Jessie too is a ghost, walking in the leaves while her relatives live out their lives in the "dark, sad labyrinth" of the house.

Jessie's older sister, Aunt Dor, tells us from her rocking chair in *The King of the Cats* of her cat named John Foster Dulles and a man named Rooks "who was kind of what a gorilla would be if it had swapped brains with a cockroach." She tells us that her sister Lizzie took care of Jessie's baby, Becky, after Jessie died, and took in Dor after their mother died, and took in Ben Palestrina when his father was off coaching third base and Becky had married Rooks. Dor says that Rooks hated cats, especially John Foster Dulles. John Foster would torment Rooks by staring at him, easily evading everything that Rooks threw at him and would keep Rooks awake at night by batting walnuts across the hardwood floor. When Rooks tried to kill John Foster with his pickup truck, Ben told him that he would kill him if he ever got anywhere near the cat with his truck. About a week later, Dor tells us, Rooks had two men cut down the pine trees that had been in front of the house since Tom Jefferson was President and cart all the wood away. When Ben came back from school he took an ax from the tool shed, smashed the window of the truck and continued whacking it until it was good for nothing but landfill. Dor says that Ben wasn't able to take John Foster to college with him, and when John Foster realized that Rooks was in charge, he went away, but not before shitting on the driver's side of the seat of Rooks' shiny new pickup truck. Rooks raged, but the stench wouldn't go away, and he became convinced that John Foster was still around, knocking walnuts across the floor at three in the morning. Unable to sleep, Rooks drank and walked around with

a shotgun, calling for the cat. One night the gun went off and there was a terrible commotion. Rooks had tripped over a walnut and fallen down the cellar stairs, breaking his right leg, left arm, and clavicle. Dor says that she was hoping for a neck, but she thinks if she makes some noise late at night and leaves a walnut at the top of the cellar steps, next time she'll get the bastard. At least, she says, that's her dream.

Clete, of *Uncle Clete's Toad*, is the husband of Molly, sister to Dor and Lizzie, and his experience with an animal, the toad of the title, is even more mysterious than that of Rooks with the cat. Uncle Clete is an old man who begins his story by explaining that one morning his wife shrieked at him about a toad that had appeared in their bathroom. Clete caught the toad, put it in a bucket, took it into the back yard, and set it loose under an apple tree. But the next morning, the toad reappeared. He then takes the toad farther away from the house and lets it go. Again, the toad returns, and then again. Clete wonders if this could possibly be the same toad, so he puts a spot on the toad's back with Molly's lipstick, drives all the way out of town into the country, and puts the toad in a stream. The toad is back the next morning, and Clete thinks he sees a smudge of lipstick on its back, but he can't remember which side he put the mark on, so this time he paints a little hat on the head. Again, he drives the Buick (for which he has no license because of poor eyesight) halfway to the Pennsylvania state line. He gets pulled over by a policeman who knows him. Clete tries to explain why he is driving with a toad in a bucket, and the officer dumps the toad in the ditch and watches it hop into the weeds. After three days, the toad returned. Clete couldn't tell if the lipstick hat he had painted on the toad was still there or if the smudge on the toad's head was the toad's natural coloring. Sometimes, Clete decides, a little mystery in a person's life is the best thing about it. He tells Moly that she will either get used to peeing with a toad in the bathroom or she'll have to learn to pee in the garage.

In a circle of light on a bare stage, standing, as if dictating a letter, Rebecca, a woman in her early seventies, speaks, in *Mooncalf*, to her son, Ben, about how their cow gave birth one winter night. Her husband, Clarence Rooks, refused to help with the birth because of the cold, and in the morning they discovered the calf, dead, and the cow unable to get to its feet. Clarence tried to pull the cow upright with a rope, cursing and kicking it. Rebecca says that she went out to help and eventually the cow got up by itself and sniffed at the dead calf. They got the cow in the barn, although something was wrong with its hip, but later in the day the cow came out again, fell, and couldn't get

up. Infuriated, Clarence got a gun from their trailer and shot the cow in the head. Rebecca says that it nearly broke her heart to see such a sad thing but that at least they now have all the hamburger they can eat. She ends her letter with a plaintive request that her son write to her.

* * * * * *

Nigro has created three monologues for Ben Palestrina: in *The Dark*, Ben in his late thirties tries to describe a childhood experience of being someone else; in *Boneyard*, he talks about just turning forty; and in *Looking Glass*, at age fifty, he recalls an experience he had when he was twelve. In *The Dark*, Ben recounts dusting his toys with his mother in the bedroom of his house in Armitage and suddenly feeling that he is someone else. But his reverie is broken by the sound of his mother's voice just as he was about to remember who he was and where he had come from. Later in childhood he had similar experiences of feeling he was something much older and other who had somehow forgotten. As a writer he has tried to get back to that place and the certainty of that experience dusting toys. Years later, he wanders onto a darkened stage of a university theatre and has the experience again, just for a moment, of knowing who and where he was and what he had been sent to do. Fragments of the experience are still there when he enters the stage of an empty theatre, a holy place where all times and places coexist.

Childhood experiences, particularly memories of black and white television shows, are the focus of Ben's ruminations, in *Boneyard*, on reaching the age of forty. He talks of the old cowboy heroes and their sidekicks, saying that when he and his friends played, none of them wanted to be sidekicks. Trying once to jog a girl's memory (to find common ground), he imitated Gabbie Hayes (he does a few lines) and the girl left. But he says that the memory of early television that has come to mean the most to him is one of Buster Keaton doing the balcony scene from *Romeo and Juliet*, running up and down a ladder, playing both parts. (This memory is given to the Waitress in *Banana Man*.) Ben sees Buster Keaton looking back at him from the mirror, but he remarks that Pancho, Cisco's sidekick, eventually does get up on his saddle and ride off, disappearing in the "waste of the desert, in the valley of dry bones, in the vast wasteland of lost time." But, Ben says, he really doesn't mind being forty. "I really don't. I don't."

Finally, as a man of fifty in *Looking Glass*, Ben describes sleeping in the front room of his Aunt Moll's house, right on Route 30, and at night in the rain he can hear the trucks and see their headlights reflected in a mirror over the fireplace and in a three-sided mirror across from it,

reflections of reflections of reflections. He is twelve and his world is being torn apart and he can do nothing about it. So he watches the light being relected, and, for that moment, nothing matters.

Pendragon One-acts

Of the shorter plays in the Pendragon cycle, five are two-characteer plays. In *Tales from the Red Rose Inn*, James Armitage and Susannah Rose are in an upstairs bedroom in the Red Rose Inn in Armitage, Ohio, in 1779. Susannah, 17, is huddled in a nightgown on the bed, complaining that although James won her in a game of dice, he doesn't own her. James agrees, saying that she is free to leave, but that he plans to settle down and run the Inn with her as his wife. He tells her that he killed Christopher Rumpley, the former owner, and buried him in the back garden of Mrs. Turley's Bunch of Grapes Inn in Boston. He tells her that after Rumpley found and bought the land where the Red Rose Inn stands, he went back to Boston, fathered a child, and then, sick of living, asked James to kill him and claim his land. James suggests to her that perhaps he is Rumpley, that, sick of the life he was living, he decided to murder himself and took a new name---James from his actor/thief father and Armitage from his actress mother. He asks Susannah to join him in his new role and make up their play as they go along. She asks if she may call him Christopher when they are in bed together, and he says she may call him anything she pleases.

In *Palestrina*, Becky Reedy, 19, and Anna Palestrina, 58, are on the porch of a house in Armitage in 1946. Becky, seated on the steps, has been vomiting and Anna is holding a towel to the back of her neck. Becky says that she knows Anna doesn't want her seeing Johnny, Anna's son, because Becky is a nineteen-year-old widow with two daughters, aged three and two. Anna tells Becky that people say that her baby girls were fathered by a gypsy with the carnival and that is why her husband hanged himself in the barn. Becky says that she is lonely and that she is going to marry Johnny. She says it is not her fault that her mother (Jessie) died when she was born and that she never knew her father. She says all she wants is a chance. After telling Becky how she met her husband Rafaello, Anna says that perhaps she will teach Becky how to make spaghetti sauce.

Three of the two-character Pendragon plays deal with Ben Palestrina (Becky's son) and his girl friends. In *Things that Go Bump in the Night*, Ben, in his late twenties, and Tracy are in a living room late at night. Tracy has been sitting in the dark thinking about the foutons they saw on stage in a production of Pinter's *Betrayal*. She reminds Ben that when each scene was over the lights would go out and people

dressed in black clothes would come out and move the foutons into different positions so that when the lights came up the audience was to think the actors were in a different place. She says she can't sleep because she can't stop thinking about how the fouton-movers came to seem more important than the actors, taking more and more time between each scene so that the play was not about betrayal but about "weird little people dressed in black moving these fucking foutons." She says that she thinks the furniture in their living room seems to be in slightly different places in the morning, that Ben nearly broke his neck tripping over the antimacassar. Ben explains that an antimacassar is like a doily and that he tripped over the footstool/ottoman because it was dark not because phantom fouton movers rearragnged the furniture while they were sleeping. But, after telling her that he will never betray her because he loves her, Ben sits on the sofa next to Tracy to wait for the fouton people to show up. And if they never come out while he and Tracy are watching, then he will never trip over the antimacassar.

In *Mutability Cantos*, Tracy surprises Ben by coming to the Pendragon house in the middle of the night. They have not seen each other in more than four years and Ben demands to know why she has come. Tracy says that she wants to make a life with him and have a child, telling Ben that she dreams about the foetus she aborted (dramatized in *Seascape with Sharks and Dancer*). She says the girl would be about ten years old and she dreams of sitting in the back yard of Ben's house, looking at the woods as the sun sets and drinking lemonade, telling their daughter how they met. Ben has insisted that he will not be available again for Tracy to hurt. He describes the pattern of her coming back and leaving again and says that he can't do it any more. But he admits that he, too, dreams about the child they might have had and, when Tracy offers to leave, he suggests that she stay at least until the rain stops. She curls up on the couch next to him and he strokes her hair as the lights dim and the sound of rain continues.

An older Ben, rather like the one who has turned forty in *Boneyard*, sits in a swing on a summer night with Rose, a young woman drinking a glass of lemonade, in *The Lovesong of Barney Google*. He tries to kiss her, but she asks him who Barney Google was. She thinks there is a song about him, but Ben says the song lyric is about goo goo googley eyes. He tells her that Barney Googgle was in the funny papers a long time ago and she is too young to remember. When she wants to know more, Ben says that the sum total of his knowledge about Barney Google is that he had a horse named Sparkplug. Under her questioning, he elaborates, describing what Barney Google wore, where

he lived, what he did in his leisure time in Chicago. She says that she asked him only because he is so much older than she is and she thought he would know. Ben says that the truth is that Barny Google and his horse Sparkplug were big stars until they met Snuffy Smith and his wife Loweezy in Hootin Holler, Kentucky, and people got more interested in Snuffy Smith than in Barney Google, so Barney rode Sparkplug off into the funny paper sunset. Rose says that her father used to sing her the song about Barney Google because she was afraid of the dark, and he would bring her a glass of lemonade and hold her in his arms and sing; she felt safe and happy and would fall asleep. She gives Ben some lemonade, kisses him on the cheek, and puts her head on his shoulder as the lights dim and we hear the sound of crickets.

<center>* * * * * *</center>

Stella Rose, a play for one man and three women, takes place in east Ohio in 1927 and at various times in the preceding ten years. The song 'Waltz Me Around Again, Willy' that serves as a leitmotif was written in 1906 by Cobb and Shields, and Nigro provides the words and a simple version of the tune. Flickering lights, as if from an old silent movie, come up on Stella and we hear the piano playing the song. Stella says that when she was a little girl she used to go to the movies with her older sister Erma, who enters with popcorn. The movie scene segues seamlessly into the kitchen where Stella's mother, Mary Annora, asks her to help peel potatoes. Stella tells us that the boys at school call her mother an Indian lady. Her mother tells her she doesn't know for certain about her heritage but says that Stella should be whoever she is. Hammy Rose, the husband of Mary Annora and father of Stella and Erma, comes on in his stocking feet, carrying his shoes and asking where the shoe polish is. After he goes off, Stella asks her mother how she met Hammy, and Mary Annora tells her that she and her father are similar in that they both love to dance. Hammy comes back, singing, as he sits and polishes his shoes, and he continues singing as Erma says that it has been over a month since she got a letter from Buddy, her boyfriend. Hammy does a dance turn with his wife and her basket of laundry and then sits on the sofa with Stella who tells him that she saw him doing more than dancing with a young girl. Hammy tells her that her mother likes to stay home with the children and he likes to dance and he believes in doing what he loves. After he leaves, Stella speaks of what a stupid nurse is doing to her (time and location have changed again) and then tells us that when she went in the bedroom the first thing she saw was the blood spattered on the rose pattern wallpaper, and then she saw what was on the bed. Stella tells

Mary Annora that she has been dreaming that her grandson is writing about her but getting things wrong. Erma reads aloud her letter from Buddy in which he tells her that he is going to marry a French girl. Stella complains again about the nurse, asking where her baby is. Hammy comes in after his evening of dancing and tells Erma that if any gravediggers bother her she should tell him and he will get the shotgun from behind the kitchen door and have a serious conversation with them. After he leaves, singing quietly, Erma sends Stella off to bed and Mary Annora sits knitting at the kitchen table as Erma tells us that three days after she was certain she was pregnant, she got the letter saying that Buddy was going to marry someone else. Stella describes to us how Erma took the shotgun, put the barrel in her mouth, and pulled the trigger with her toes. Stella says her first baby was so easy that she thought the second would be too, so she had it at home with a midwife. When Stella wanted to go out dancing, she convinced Matthew to take her, but she started to bleed and was rushed to the hospital in East Liverpool. We hear Erma singing the song and then see her dancing a bit in her white dress as she sings. Stella asks why she has come and Erma says that she has come to take Stella to the dance where the dead girls go. She says that Stella has an infection and pneumonia and nothing can be done for her. Mary Annora sits on the sofa next to Hammy as Stella takes Erma's hand and they walk off into the upstage darkness. The piano plays the end of the song softly and the light fades into the flicker of the silent movie effect before going out.

The set for *French Gold*, an old bench in a rose arbor and some old Victorian chairs, represents the "tangled and overgrown garden of the old Pendragon house just outside of Armitage, Ohio. . . in 1950." The characters are Davey Armitage, 70, Molly Rainey, 50, Lizzy Hopkins, 55, and Becky Palestrina, 23. They have just buried Sarah, their housekeeper of many years, and Lizzy and Molly, Davey's half-sisters, want him to leave the house and move in with one of them. Davey says that he is determined to stay. When Lizzy and Molly go off to look for Sarah's cat, Davey talks with Becky, who says that Molly's husband, Cletis, told her that there was French gold buried in the garden. Davey explains that there was a story that years earlier, as the French retreated from the advancing English during the French and Indian war, they took all the gold they had in Fort Duquesne (now Pittsburgh) and headed west into the hilly country of east Ohio where they buried the gold. Zach Pendragon supposedly built his house near the gold, but the Frenchmen died before they could come back to dig it up. Becky tells Davey how unhappy she is and how much she wants to leave

everything and just run away. Davey tells her that there is no place to run to, that all we can do is love those close to us for the time we have before we die. He says that the capacity to love "unreasonably, hopelessly," is buried deep inside each of us, like lost French gold. He says that Sarah knew this and loved Becky. He holds her as the leaves blow about the garden and the lights dim.

The next three Pendragon one-act plays have two men and three women in each. *Glamorgan* takes place in Wales in 1736 but is narrated by Jane Lamb from the Bunch of Grapes Inn, Boston, in 1780. On a unit set that represents the dark ruined "fragments of a Gothic castle," the five characters—Jane Lamb, Owen Pendragon, Jane Griffith, Mary Pendragon, and Zachary Lamb—speak from different times and places but "are onstage and visible at the same time. . . always in character." From Jane Lamb and Owen Pendragon we learn that he is the last of his line, that he feels responsible for the deaths of his three wives. Jane Griffith, a servant girl of 19, tells him that he is not responsible for the death of his wives; she says he has had too much wine and should go to bed. Owen agrees, providing she goes to bed with him. Jane Lamb tells us that Jane Griffith shared his bed every night thereafter and in time gave birth to a daughter, Mary, but the bleeding would not stop and Jane Griffith died, and Owen Pendragon "grieved/like a soul in hell." Jane Lamb tells us how Owen created the fiction of Mary being a distant relative so he could rear her and give her his name. Time shifts without a break and Owen, now 55, talks to Mary, 19, about bad dreams. Zachary Lamb, a teacher that Owen hires, loves Mary, and when the castle goes up in flames, killing Owen, Mary tells Zachary that she murdered Owen. Fearing that she will be hanged or put in a madhouse, Zach escapes with her on a ship to America. But as soon as the ship docks in Boston, she runs away. Two months later, Zach finds her working for Mrs. Turley at the Bunch of Grapes Inn. Telling her that the inn is really a brothel, Zach persuades Mary to marry him. But Mary has dreams when it storms and thinks that Owen has followed her across the ocean. She and Owen then play out the incident that started the fire in the castle. Drunk, Owen thinks that Mary is her dead mother, Jane Griffith. When he realizes who she is, he is horrified that she wants him to hold her and pushes her away, and, as Jane Lamb tells us, her arm knocked over a candle that fell into the spilled wine and set the castle ablaze with Owen at the top of the stairs and Mary below, looking up at him through the flames. When Mary and Zach finally become "true husband and wife," they have a child, Jane, to whom Mary tells old Welsh stories about a key in a clock that

opens a door in a haunted castle. Jane Lamb says her mother's spells of being visited by demons got worse as she grew older, and she tells us that her mother gave her a locket with a picture of Jane Griffith in it, saying that she is the convergence of four nightmares. Shortly after, on a winter night, Jane Lamb is awakened by Zach who carries her from their burning house and goes back to save Mary. But both die in the fire and Jane is taken in by Mrs. Turley where she soon, as she puts it, "learned a new trade." As the other characters speak their final lines, Jane says that she will learn to live without love and Mary ends the play with images of fire leaving only bones and ashes.

In *Green Man*, Gavin, a 19-year-old wounded Union soldier, has been brought to a chapel by a house in Mary's Grove, Maryland, by Robey, husband of Fay, father of Holly, and son to Mrs. Robey. There are five wooden chairs on stage, one of which is a rocker, and some sprigs of holly. Light comes in from above through a stained glass window. The time of the play is the period from Christmas to New Year's, 1864-5; the five actors involved are on stage the whole time "as if trapped in a dream," but they are aware of, and sometimes speak to, each other. Fay describes herself as the lady of the castle and says she wants to be an enchanter and shapeshifter. Holly tells us that her father, who found and brought Gavin to the chapel, is a hunter of deer, boar, and fox. Fay cautions Mrs. Robey not to mention the Pendragon name, and she warns Holly and Gavin to stay away from each other. When Gavin tells Robey that he is in the area to buy some horses, Robey says he may know a man with horses and will take Gavin to see him when he feels better. Fay tells Gavin that she knew a man who loved a woman, but the man went away to a war and the woman's father sold her to a horse thief who took her far away, without her child, so she had another, a beautiful girl. Fay says that her friend John Pendragon let her sit in his library every evening so she could read to him from his father's books. Gavin says he has to get the horses for John Pendragon and tells Fay when she asks that his mother's name was Rose. Fay says she knew her, that they were friends long ago, but that Gavin must leave because Robey plans to kill him. She tells Gavin where the gun is located and says she will show him a way through the woods. With the gun, Gavin approaches Robey, who is holding his ever-sharpened ax. Gavin wants to know the truth about what happened between John Pendragon and Robey a long time ago. Robey replies that he has removed a piece from the gun so that it won't fire. Fay tries to get between the men, and Holly tells us that as Robey raised the ax to kill Gavin, she shot her father twice, killing him. She

tells us that her mother told her to bring the gun outside and asks Gavin to take her with him, but Gavin says he cannot and drops the money he had to pay for horses in the snow. Fay holds the dead body, crying, accusing Gavin of being sent to kill her husband. Holly describes how Gavin left and Mrs. Robey picked up the money in the snow.

* * * * * *

In *Nocturnes*, "a few pieces of simple wooden furniture" represent a room in East Liverpool, Ohio, a garage in Armitage, both in 1947, and a bar in Pittsburgh in 1954. Before the lights come up we hear "an old, scratchy recording" of Chopin's Nocturne in E-flat Major, Opus 9, Number 2, and then we see Nell, 37, in "an old flowered dressing gown," wearing an eye patch. Nell is saying lines that don't seem to make much sense, until Molly, 47, comes in with her arms full of grocery bags. She is followed by John, 23, carrying even more bags, and Becky, 20, carrying one small bag of potatoes. As Molly helps Nell put on a coat she asks her what happened to her eye, and Nell moves the eyepatch to the other eye, saying that she is blind in one eye but forgets which one. Molly introduces Becky as her dead sister Jessie's little girl, and her friend, Johnny, who is Italian, not Indian. Molly tells John that Nell is a poet, but Becky says that she is drunk and insane. Nell tells Becky that she was a friend of her mother, Jessie, and Becky asks if she knows who her father was, complaining that nobody will tell her anything about her father. Nell suggests that she talk to Nell's brother, Jimmy Casey, who runs a garage behind the brickyard in Armitage. Nell thanks Molly for the groceries and tells John to look after Becky. After they leave, Nell puts on the old Chopin recording and the lights fade to come up on a night scene in Jimmy Casey's garage. Becky asks if Jimmy is her father, but Jimmy says that Jessie didn't sleep around. Becky asks if her mother was raped, but Jimmy says he would have known it that had happened. When Becky offers to sleep with him, saying she might as well be a slut like her mother, Jimmy grabs her by the shoulders and tells her never to speak about her mother like that, that her mother was the best person he ever knew or ever will know. Jimmy tells Becky to marry "that Italian kid" and to realize that nobody really knows what happened in the past. The lights dim and when they come up, it is seven years later, and Becky and Nell are in a bar in Pittsburgh. Nell says she was sorry she couldn't make it to the wedding of Becky and John but she was drinking at the time. Nell guesses that Becky has run out on her husband and children and has come to find out who her father was. Nell tells her that Jimmy took care of her because their parents were

crazy, that all the girls loved him but he only loved Jessie. Nell almost tells Becky that Jessie loved her own brother, but stops before completing the sentence. She tells Becky that every night before she goes to sleep she thinks about when her girls were five and three and would cuddle up with her in bed feeling safe and happy and not needing to know anything else. Becky says she is going home and leaves as the lights fade on Nell and the Chopin Nocturne plays.

The last of the shorter Pendragon plays, *DeFlores*, takes place in Mary's Wood, Maryland, in the autumn of 1865, about ten months after the killing of Robey by his daughter Holly (*Green Man*). Nigro suggests that the two plays might be done as an evening of theatre. The DeFlores family consists of four men—Bartolomeo, 20, Robespierre his uncle, 60, Napoleon his father, 58, and King George, his grandfather, 88—and two women—Teresa, 23, Bartolomeo's sister, and Belladonna, 80, his grandmother. The lone outsider is Holly, 17, who enters followed by Bartolomeo carrying a bucket full of milk which Holly has given him for his grandfather. Bartolomeo explains to her that they are like a small traveling carnival, that his grandmother tells fortunes and his uncle makes livestock, particularly pigs, disappear. Holly is anxious to get her bucket back so she can leave, but Bartolomeo kisses her just as his sister Teresa enters. Bartolomeo leaves with the bucket and Teresa tells Holly to go home, that she is stupid for liking Bartolomeo. Robespierre startles Holly, coming up behind her and asking her how she likes his pig. When she replies that she doesn't see a pig, he exults, saying he hasn't lost his touch. He urges her to drink a glass of wine. Teresa tells her that her uncle has just made a pig disappear and that Holly should not drink the wine. But Holly drinks the wine as Robespierre delivers a short disquisition on pigs and warns her about Bartolomeo. Helping Belladonna from the wagon, Bartolomeo introduces her to Holly. Using cards to tell Holly's fortune, Belladonna turns up the Ace of Spades and asks Holly if someone has died. When Holly tells her that her father has died, Belladonna asks if she killed him and says that Holly is a dangerous girl. She looks in Holly's eyes and says that she sees an old house full of ghosts, the house where Holly's destiny will be sealed. Then she has Holly drink another glass of wine with her, and King George comes out of the wagon asking to see the pretty girl. Without warning, he throws her over his shoulder and tries to carry her into the wagon but collapses under her. Asking Holly if she is a virgin, he tells her that he can renew his life and live a "whole other lifetime" if he has sexual intercourse with a virgin. But Bartolomeo says that Holly is not a

virgin, that he made love to her in her barn. Saying it is time for him to die, King George allows Teresa to help him into the wagon. As Holly, affected by the wine, dozes, Teresa tells Napoleon that King George is dead. Belladonna accuses Holly of killing her husband and demands "the blood vengeance." Napoleon tells Holly that there must be a trial, but that it is just a formality. Although Bartolomeo speaks in her defense, Holly is voted guilty and her punishment is to marry Bartolomeo, come away with them, and have twenty children. When she agrees to be married rather than eviscerated, Bartolomeo gives her a long kiss and Napoleon begins the wedding ceremony. But a loud "HIC" is heard from the wagon, followed by several more, and Holly looks in the wagon and says that the dead man has the hiccups. She tickles the body and King George laughs but soon sticks his head out to assert that he is dead, that he is a ghost. Holly asks why they would all play such a horrible trick on her. Napoleon explains that they needed a wife for Bartolomeo and thought they could scare her into the marriage since they didn't want to kidnap her. Bartolomeo tells Holly that he will climb in her open bedroom window later that night and make love to her. Holly says that she has a gun and will shoot him. She leaves and Robespierre runs in with her milk bucket, asking where she is, but Bartolomeo tells him that he will bring the bucket back to her because they have an appointment in the dark.

Full-length Pendragon Plays

Horrid Massacre in Boston takes place in the spring of 1777 and the following year in Mrs. Turley's Bunch of Grapes Inn and requires four men—Oyster Man, 50, Timothy Swan, 27, Peter Malone, 26, and Christopher Rumpley, 33—and four women—Jane Lamb, 20, Meg Scarborough, 25, Mrs. Turley, 65, and Ophelia, 24. Ophelia opens and closes each act by singing a short lyric (words and music by Nigro) about being killed, eaten, and buried under a juniper tree. Mrs. Turley has taken Jane in after the death of her parents and tells Meg that Christopher Rumpley is coming. Meg doesn't like Rumpley, but Mrs. Turley sends her to get Ophelia and tells her to mind her own business. The Oyster Man bursts in with Swan and Malone, and Malone says that Rumpley will be late. When Ophelia enters she accidentally knocks a tray into Meg's face, causing her nose to bleed. They sit to eat and Oyster Man starts talking about a massacre seven years ago but his images and sentences, like Ophelia's, are rambling and disjointed. Ophelia says she hears Death approaching and Rumpley stomps in, shouting at Mrs. Turley that he thought she was dead and buried. Rumpley sits next to Jane who asks him questions about the war and

Ophelia says that Rumpley is a dead man. Mrs. Turley explains to Jane that Oyster Man was struck in the head seven years earlier during the Boston Massacre and has not been right since. She says that Rumpley pays for Oyster Man's room and board when he stays at the Bunch of Grapes Inn. (Rumpley also pays for Ophelia's care.) Alone with Rumpley, Jane tells him that she will not allow anyone to take liberties with her, and Rumpley informs her that she is living in "a genteel brothel," and that he is delighted that she may be a virgin. Jane runs up to the bedroom and locks herself in. Meg tries to talk with her through the door, but the sudden appearance of Oyster Man behind her in the room makes Jane scream. Quite coherent for the first time in the play, Oyster Man explains that there are secret passageways in the house that smugglers used and that one came out in her closet. He says that he owns the house and Mrs. Turley only runs it for him, and Jane is not the heroine of some book but is living in the real world. He says that Rumpley caused Ophelia's mental condition one night when he was drunk. Jane says that if Rumpley expects a virgin he is going to be disappointed because she was seduced by a young man in a windmill. She says she will not be tricked or used ever again by anybody. Oyster Man gives Jane a knife, putting it under the pillow and telling her to find the right moment to use it. Oyster Man goes out the door, leaving it open, and as Jane runs to re-lock it, Rumpley crawls in the bedroom window. Lying on the bed, Rumpley explains that he had hoped for a little companionship before doing a nasty job later that night, and Jane makes him swear on her Bible that if she sleeps with him he will not kill any human being that night. She pulls the bedcurtains shut and the lights dim on the bedroom as they come up on the kitchen area with Ophelia singing her song.

The other characters in the kitchen are talking as Rumpley emits a "hideous bellow of agony" and then stumbles in, falling to the floor with a knife sticking out of his back. Meg thinks Jane is too small to have done it, but Jane says from the top of the stairs that she "rather enjoyed it," and that she was defending her honor. Mrs. Turley has a seizure and falls on top of Rumpley, flopping like a fish. Following Jane's instructions, the others, except Ophelia, carry Mrs. Turley off, and Ophelia watches as Rumpley crawls his way across the floor and out the door into the garden. She then locks the door and sweeps as she sings her song ending the first act.

She sings again as the second act lights come up on Mrs. Turley in a chair with wheels. A year has passed and Mrs. Turley makes sounds that are sometimes understandable. Jane, clearly in charge, tells Meg to

get supplies and then sits at the kitchen table to work on a ledger. Rumpley enters and, when Ophelia screams, puts his hand over her mouth and holds her while he talks to Jane. When Meg enters, Rumpley has her take over the task of holding Ophelia, but he had heard Meg mention a baby and eventually learns that when he ejaculated as Jane stabbed him, he fathered a baby boy. Rumpley says that he has some unfinished business to take care of, business that was interrupted by his "untimely and unfortunate death." He wants Jane to have a supper and invite Oyster Man, Swan, and Malone. Jane says she wants no violence in her house and Mrs. Turley stammers out "Deaddd mannnnn," recognizing Rumpley.

With everyone gathered for supper, Rumpley explains that his personal business concerns something that happened the night of the Boston Massacre. He says he was working for both the British and the Colonists and was present when Sam Adams planned to have rifles fired at the crowd. He says that he was in love with a young girl and, knowing there was to be trouble in the streets, he told her to stay at home. He says that while he was out throwing bricks at the British, someone beat and raped the girl, Ophelia, and she never regained her memory of the event or her sanity. Rumpley goes on to explain that Mrs. Turley was going to give him a final piece of evidence proving that one of the men in the house had attacked Ophelia, but that the messenger had been run over, several times, by a coach. Since neither Swan nor Maolone will confess, Runpley says he will kill them both to make sure he gets the right man.

When Rumpley starts taking Swan out to kill him, Jane discloses that the Oyster Man gave her the knife and told her to kill Rumpley a year ago. Rumpley says he didn't see Oyster Man at the massacre and suggests that since he knew Rumpley would be out he sneaked back and attacked Ophelia. Perhaps, Rumpley says, Ophelia hit him in the head and, since it would help Sam Adams to have a man everyone believed was brain-damaged overhearing secret plans, Oyster Man has been feigning incompetence all the time. Oyster Man tries to hide behind Jane, but Rumpley jumps on him with a roar and strangles him. When Jane suggests that Ophelia stay with her, Rumpley concedes, suggesting that they bury the body of Oyster Man in the garden. Rumpley gives Jane a will, dated before his death a year earlier, leaving her his property in Ohio and a bank account. After Rumpley leaves, Jane orders Swan and Malone to dig a deep grave for the body and, if anyone asks, they're to say it's the grave of a "patriot martyr Rumpley." Jane tells Meg that she is going to raise her son to be "the

smartest son a bitch in North America," never to be tricked or used by anyone. But when the baby cries, she says she is unable to touch anybody and sends Meg to care for it. Mrs. Turley bellows for her money, but she is ignored as Meg comforts the baby and Jane and Ophelia work while Ophelia sings her song.

* * * * * *

The story of Jane Lamb's son by Christopher Rumpley is told in *Armitage*, a play requiring 12 actors, six men and six women. The unit set is like "an opened up haunted house" and represents the Pendragon house in Armitage and places in New York and Marylnad from 1804-1863. The play begins with the sound of a ticking clock and wind as the lights come up slowly and the actors enter one by one and take their places. Margaret Cornish, elder daughter of Eva and James Cornish identifies her time and place as November 12, 1859, in Armitqage, Ohio. She says that Zachary Pendragon is outside in the cold, prowling among the tombstones, getting ready to die. John Pendragon urges his father to come into the house, but Zach says that his life is going to be snuffed out after a "paltry eighty-one years on earth" and he expects stars to explode and galaxies to collapse, but nothing is happening. Eva, wife of James, then Zach, and mother of John, calls out Zach's name and moans in sexual pleasure, an echo from fifty years earlier. Zach says that siring John must have been an accident, and Christopher Rumpley, from his center stage location, comments that there are no accidents except life.

Elaine Cornish, younger daughter of Eva and James, speaks from her attic location (her time is 1823), saying that she is the Queen of the Rain, and Fay Morgan, identified in the cast list as a servant girl, speaks (in 1846) of how she loves the house and how she will one day be mistress of it. In imagistic fashion, Elaine says that fornication is not a sin, Margaret says, "Murderer," and Nicholas Robey, identified as a horse thief, says that he doesn't kill women. When all twelve characters have said at least one line, and as Margaret speaks her thoughts in June, 1848, about Zach returning from Europe in 1804, Eva moves to Zach and tells him that she is now a married woman with two daughters and hopes that Zach is not going to kiss her. James enters their space/time and asks if Zach has been talking about their time at Yale. He tells Eva that all the girls fell in love with Zach sooner or later. Then, as James and Eva walk up to their bedroom, Margaret calls Zach a demon, the "Gothic villain" of her life. Zach, as an 81-year-old, gives a quick summary of his origins: born in 1778 during the Revolution to a father he never knew and reared by a mother who may

have killed his father. Rosanna Rose, who keeps house for Zach and sleeps with him, joins John in urging the old man to come in from the cold. Zach tells John that he saved him from the Morgan girl (Fay) and gave his bastard son a life.

As if writing in her diary for September 4, 1845, reporting that Rosanna has taken in the poor ragged daughter of "that unfortunate Morgan woman." Margaret describes how, when she was 17 and Elaine 15, her sister led her down the stairs and out into the rain where she danced in her nightgown. Margaret says that she saw Zach watching her, with the "eyes of a werewolf," but he never spoke of it.

The scene shifts to John telling Fay in the library that reading to him each night will be part of her duties. In another series of quick imagistic flashbacks, Jane tells Zach as a boy to avoid attachment to mortal creatures because things begun in love and kindness always end in disaster; Eva, in 1809, now Zach's wife, complains about life in east Ohio, and Elaine, in 1822, also unhappy with life in the Pendragon house, accuses Zach of killing the hangman, Lake, and walling him up with her mother in one of the rooms he keeps adding to his house; and Fay and John in the library in 1845 talk about incest and John going to the war in Mexico. Fay says that he is all she has in the world and that he should always trust the flesh. She kisses him, and the scene shifts to a tavern in New York in 1807. James makes Zach swear that he will take care of Eva and the girls. Margaret, in her time, says that yesterday she found the saddest thing as she went through an old trunk in the attic. As Elaine watches from her past time, John shows Fay the paintings his half-sister made and tells Fay that , like Elaine, she makes the house alive again. Fay wants John to make love to her, but the action shifts to Zach and Rosanna by the tombstones in 1859 as he tells her that he found his wife, Eva, with Lake the hangman. And Eva tells Lake that she detests Zach and wants Lake to take her away with him.

Margaret notes in her diary entry for May 12, 1846, that Zach had caught John and Fay fornicating in the attic and is furious. Zach tells John that Fay has planned the whole thing, and John says that he is going to Mexico to fight with General Taylor and that if Fay still loves him when he gets back then they will be married. Fay tells Rosanna that she is pregnant and that her son, Zach's grandson, will inherit the house and everything in it. As the lights begin a slow fade, Margaret repeats her line about finding the saddest thing in the trunk in the attic and says that Elaine was so beautiful when they pulled her naked dead body from the water.

The second act begins as did the first, but now Margaret is speaking as the actors take their places. Rumpley tells Zach (November, 1859) that he is the ghost of Zach's father and has come to take Zach to Hell. John wonders who Zach is talking to and Zach says that he was talking to his dead father who looked very like the Jim Armitage who used to read Shakespeare to John when he was a boy and who squatted in the Red Rose Inn like a spider. After Zach (in 1846) agrees to let Fay stay in the house and have her child, the action shifts to the attic, in 1822, where Elaine tells Zach that he is obsessed with her and that they both need each other. Fay (in 1847) accuses Zach of intercepting her letters to John. Zach says he can set up a house for Fay in Maryland where he used to stop when he was a Congressman on his way to and from Washington. But he wants her to leave the child with him and Rosanna. Fay says she would rather kill the child than give it to him.

Speaking in 1853, Margaret comments that the most infuriating thing about Zach was his persistent refusal to explain himself or why he did things. Then Zach makes an arrangement with Robey, who is to be hanged for stealing horses. He wants Robey to take Fay to the house in Maryland and take care of her, the house, and the garden. If he does, he will never have to worry about money or food or shelter again. But if Fay is ever harmed, Zach will kill him like a dog. Then Zach tells John, returned from the war in 1848, that Fay ran off with a horse thief named Nicholas Robey and that they are living in Zach's house in Maryland. Rosanna tells John that Fay gave birth to their son. She says that Zach loved Fay's mother but could not or would not marry her, and that Fay is their child, Zach's daughter and John's half-sister.

In the autumn of 1823, Elaine tells Margaret that she is pregnant with Zach's child, that it is something she wanted but that she is frightened and doesn't know what to do. Outside in 1859, Rosanna urges Zach to tell John about Fay and her mother, but Zach talks about building the labyrinth of the Pendragon house as a way of recreating the Bunch of Grapes Inn where he grew up. Zach does tell John that his mother Eva and Lake are living in New York. After Margaret mentions seeing scars on her mother's body, Zach and Eva talk in New York in 1820. Zach asks her to come back, saying that he will never speak of the matter again, that he will stay out of her bed, that her daughters and his son will have a mother, and that she will have a decent place to grow old and die in. She says to tell her children that she is dead. Zach tells John, in 1859, that he arranged for Lake to get a job in a printing shop he owns and paid him a substantial wage for thirty years and now employs his son. He says that Eva is alive and her

address is in a locked desk. He gives John the key but asks that he wait until after Zach is dead.

When John talks with Fay in Mary's Grove, Maryland, he learns that she knew that Zach was her father. She says she is going to have another baby and she never wants to see John again. After John leaves, Robey tells Fay that he won't stop her if she wants to go after him. He swears that Zach did not pay him to intercept her letters and John's when he was working at the Post Office.

John, in 1860, finds Eva in New York. Learning from him of Zach's death, Eva wonders how he had her address after she had moved three times. John says her daughters "turned out well" and that he has a son. She tells him that the thing she remembers most about his father was meeting him at a nasquerade party sixty years earlier. Elaine, in 1823, tells Zach that she has to touch someone or she will go insane, that if it can't be John or anyone else then it will have to be him. She starts crying and Zach starts to leave but comes back and puts his arms around her. She lifts her face as if to kiss him, but Margaret tells Zach to get away from Elaine. Margaret says that Zach killed their father and beat their mother to keep her from telling and then killed her and her lover and now is corrupting Elaine. Zach says he never struck their mother, ever. Zach tries to explain to Margaret that her father became a different person when he drank and the time shifts to 1908 and James telling Zach that he is sure Zach told Eva about what James did, while drunk, to a woman in New Haven. James says he would not do that to Eva even though he is convinced that she loves Zach. James plans to kill Eva and then the girls and himself and accuses Eva of committing or at least thinking of committing adultery with Zach. She grabs a letter opener, calling for Zach to help, but James takes it from her. Zach comes in and pulls James away from Eva, but James throws Zach across the room, dropping the letter opener. Eva picks it up and, running at her, James impales himself on it. Margaret sees Zach standing over her father, and screams that he murdered him.

Margaret's last diary entry is for November 27, 1863. She explains the saddest thing that she referred to earlier: a bundle of letters from John to "that Morgan girl" and from her to him. Margaret gave herself to Robey in exchange for the letters, thinking that she was protecting her brother. She can't bring herself to burn the letters because they are so beautiful, so full of love and trust. She only had one lover, she says, and Zach sent him away with the girl who wrote the letters. The ghosts whisper to her at night and she says she will not die but simply become

one of the ghosts. The actors are motionless as we hear the ticking clock and a faint wind and see the lights fade and go out.

* * * * * *

In *Fisher King*, Zachary Pendragon's son, John, is a Major in the Union army, traveling through woods with four soldiers—Case (who sings and plays the song used throughout the play), Rudd, McGort (a medic), and Gavin Pendragon (who believes himself to be the son of Zach and his housekeeper, Rosanna). Rudd and Gavin see Perce, the son of Mrs. Welsh, sitting in the dirt, imitating bird sounds. The soldiers need water and Perce tells them there is a spring behind the cabin. Major Pendragon enters with Case and McGort. Case wants to stop and rest because his feet are bleeding and Rudd says that his father, a preacher, has a tent nearby and perhaps they could stop there so he could see his sister. Mrs. Welsh appears from the cabin, points a shotgun at the soldiers, and tells them to get off her land. At Perce's urging, she allows them to go for water but tells Perce that he cannot leave her to be a soldier. She fires the gun at him and the soldiers come running. Perce says that his mother dropped the gun and it went off and reiterates his wish to join them to fight the Rebs. The Major tells him to go into town and enlist. Rudd asks again if they can stop to see his father, perhaps get a good meal, and have Gavin meet and eventually marry his sister. Perce tells his mother he is leaving and Mrs. Welsh shouts advice after him, noting that he has taken her gun. As she wanders off, we hear the sound of an organ playing and see Bel, Rudd's sister, playing it as her father, Merlin, sits on the ground eating leaves. When Rudd and the soldiers enter, Bel runs to hug him. Rudd pushes Gavin and Bel closer together, urging them to talk. The Major says that he has heard gunfire over the hill and that if Rudd doesn't follow him in thirty seconds Gavin is to shoot him. After Rudd and Gavin leave, Bel sits at the organ and begins crying, banging on it, creating "bizarre noises." Perce enters and asks if the raggedy tent is a church. Bel doesn't move as he puts his open hand near, and then on, her breast, saying it's all right if he is Jesus. As they kiss, she sits back on the keyboard of the organ and we hear bizarre and frantic noises as the lights go to black.

The lights come up on the soldiers' camp where, in the Major's absence, Rudd is calling him a horse's ass. Jen, the Major's girl, advises Rudd to be quiet and throws coffee in his face. Gavin and Rudd wrestle as the Major comes back, and Rudd, complaining that he was drunk when he enlisted, leaves. The Major tells Gavin not to go after him, saying that when Rudd comes back they will hang him. The

Major says they have orders to move out and as they do we hear the sound of Bel playing the organ off-key. Her clothing is torn and her hair messy. Rudd enters, telling her that he has deserted from the army. He asks what's wrong with her and Merlin, cackling, says that a boy shamed her on top of the organ. Bel says that Jesus was the one who did it, but Rudd guesses that it was Perce and goes off to kill him. He encounters an old man, McAllen, fishing in a creek, who invites him to come to his white house, meet his beautiful daughter, and have some chicken. Rudd says he has to find the boy he is looking for and leaves.

Mrs. Welsh, alone, tells a once-upon-a-time story about an old woman who dreams of a big white house in the woods where God lived, but nobody ever asked him a question and so the woman died. As she is speaking we see Rudd by a campfire taking apart his gun and cleaning it. Perce stumbles in, carrying a gun, and as they talk Rudd calmly puts his gun back together and tells Perce that he is going to kill him for what he did to Bel, but Rudd's gun misfires, twice, and Perce shoots him in the face, killing him, then taking his hat, bandana, and shirt. We hear faint bagpipe and calliope music and as the lights fade we hear Case singing.

After Case begins the second act with his song, we see Perce, a little drunk, playing cards with Gavin and McGort as Jen looks on. Perce asks if there is a reward for killing a deserter and, as the sound of shells gets louder, says that he shot Rudd and "screwed his sister on an organ in the woods." He throws the bandana and Rudd's canteen in front of them as proof and Gavin, after repeating quietly that Rudd was his friend, attacks Rudd and beats his head into the ground, "savagely," until McGort and Jen manage to pull him off. Perce crawls away, sobbing, calling for his mother, and there is an enormous explosion from a shell hitting close to their camp. The soldiers scatter, lights flash, and then, in the dark silence, we hear wind chimes, "a distant calliope, and voices, blended, like a bizarre Gregorian chant done backwards." We see Perce, blood on his head, wandering, as the calliope, bagpipe, and voices blend in "a kind of hymn with animal noises." Perce falls on his face at the feet of McAllen, the fisherman, who invites Perce to his house to meet his daughter, Lily, and have chicken and gravy and mashed potatoes. They leave singing a bawdy verse to 'Rock of Ages.' Back in the camp, Jen tells the Major that he is never going to marry her because he still thinks of the girl his father sold to the horse thief (Fay Morgan/Robey). Guessing that Gavin may be the Major's son, Jen tells him that if he shoots Gavin for deserting to find Rudd it will be the end of him and of their relationship because she

would never let him touch her again no matter how much she might want him to. The Major throws his coffee in the fire and walks off and, as Case plays his song, Jen follows.

In the McAllen house the old man is asleep in a rocker and Perce has apparently just finished a meal. Lily, the old man's daughter, deals out tarot cards, telling Perce that he can stay in her room for the night or he could stay in the back room. She asks if he wants to play strip poker and begins loosening her clothing. She presses his face to her half-uncovered breasts, and McAllen awakens, shouts at Perce and grabs him as he tries to get away, telling Lily to bring the ax. When Perce falls and hits his head, the lights go out and he says he can't see. We hear the noises building to a "terrible din," then silence and then a bird singing.

The lights come up on Bel, her dress stained with blood, Perce's head in her lap. When Gavin enters, his gun aimed at Perce, he tells Bel to pick up Perce's gun and take her father down the path. Perce tells Gavin of the house with gold and jewels and food and a beautiful woman and says they can share it. Merlin announces that he has had a celestial communication that Perce's mother is dead. Bel fires the gun and Perce runs off. She points the gun at Gavin and asks him if he will marry her and be a father to the baby that Jesus put in her. Gavin says he will marry her, but as we hear the sound of shells, Bel tells him to leave, that she doesn't need him.

Perce returns to the McAllen house where he pulls Lily from the rocker, bangs her head against the door of the back room, and pulls on the door which falls off its hinges revealing Mrs. Welsh, Rudd, and McAllen playing cards in an eerie reddish light. Also at the card table is a human skeleton wearing a gambler's visor and holding five cards. McAllen and Mrs. Welsh invite Perce to come in, but Gavin has entered with a gun, apparently not seeing the room behind Perce. He shoots as Perce jumps at him. Lily goes over to stroke Perce's head and Gavin says that there is nobody there. After he leaves, Lily takes Perce's hand and leads him into the room. Case sings and plays as the Major, Jen, and McGort drink coffee around their campfire. When Gavin enters he tells the Major that he killed the boy that killed Rudd and that if the Major is going to kill him he should do it right away. The Major says that he saw a naked lady looking at him from a window in a white house in the woods, long ago, but he didn't stop. He tells Gavin to sit and have some coffee. Case sings the last verse of the ballad as the lights dim and go out.

* * * * * *

Sorceress picks up the story of Fay and Holly Robey in the fall of 1865, after Holly's encounter with the DeFlores family.. The lights come up on the "Gothic skeleton" of the Pendragon house and Fay, 35, and Holly, 17, enter carrying two old traveling bags. Saying that this is their home, Fay pulls Holly into the house. James Lake, 44, startles Holly as he enters with garden shears, but he tells Fay that both John Pendragon, 55, and Gavin (Rose), 20, are married. John sends Lake away. Fay tells John that her husband is dead and introduces him to Holly as the man who sent Gavin to kill her husband. Jen, John's wife, 23, and Gavin enter and Fay is surprised that Jen is John's wife, but she tells Jen that Gavin is going to marry Holly because he has made her pregnant. Bel comes down the stairs saying that they are going to wake up the triplets. Gavin explains that the triplets are little pigs that Bel keeps under the bed because, as Bel said, they kept getting out of the breadbox. He tells Fay that Bel did have triplets who died and that she has been "unstable" since he married her. Fay says that Rosanna was not Gavin's mother, and Margaret Cornish, 64, John's half-sister, comes down the stairs, recognizes Fay and calls her a 'vampire witch woman," a "sorceress" returned from the dead to kill her. The light fades on them and our attention turns to John and Jen on the porch swing. Jen says that Fay and Holly threaten her life and she wants them out of the house.

John passes Holly sleeping on the sofa and goes to the library where Fay is reading. She says she is not as she was when John deflowered her in the library on "a wet night a hundred thousand years ago." She tells him that after her husband died she went to the bank and found out how much money John's law partner, Jake Armitage, sent to her husband every month, money that he was paid to look after her. John asks why she didn't come back with him when he went to Maryland for her, and she says that she was pregnant and that he had never answered any of her letters. John tells her that he wrote her hundreds of letters, but she never wrote to him. When he urges her to take Holly back to Maryland, Fay says she wants him to make love to her and the lights fade on the library.

Holly wakens and talks to Margaret who says that she should have killed Fay a long time ago, adding that John's father (Zach) murdered Margaret's mother (Eva) and drowned Margaret's sister (Elaine) in the pond. After Margaret leaves to get tea and pound cake for Holly, Gavin asks Holly why she lied about his being the father of her baby. Holly says that she would have liked him to be, but that the real father was Bartolomeo DeFlores. She says she is not going to cry and Gavin

puts his arm around her as Bel comes in, calls Holly a slut, and tells Gavin he won't be sleeping in her bed. She stomps off, Margaret comes in with tea and cake, and Gavin leaves.

Outside, Jen is walking and talking by the tombstones. Lake steps into the light and she asks him if he desires her. When he says that she always looks beautiful, she tells him to go hang himself. On the sofa, Holly tells Fay that she has terrible dreams and misses their cozy house in Maryland. Fay tells her that she and John had the same father, and that she was pregnant with John's child when he went off to fight in the was in Mexico. That child, Gavin, is Holly's half-brother. Fay says that she believed Robey, Holly's father, when he told her that Zach had not paid him to steal the letters that she and John said they wrote. Holly tells her mother that the DeFlores boy got her pregnant. Bel stomps in, wearing a nightgown and brandishing a pitchfork with which she tries to stab Holly and Fay. Holly screams and Fay calls for John and Gavin. Bel lunges again and again and Fay finally grabs the pitchfork and, as she and Bel struggle with it, Gavin and John rush in and Holly says that she's bleeding (losing the baby). Margaret and Jen appear on the stairs and John calls for Lake. Margaret says there is no help as the lights fade ending the act.

Act Two occurs two years later. Bel sits on the porch swing with Lake on the porch step, whittling. John is in the library, Holly on the sofa sleeping with Fay in a rocker beside her, and Jen and Gavin are walking among the tombstones at night. Fay moves to the library and John tells her that she has to leave, but Fay tells him she is going to have another baby. John says he will not desert Jen, but Fay says she will tell Gavin about the incest if John doesn't marry her. In an argument over whose house it is, Fay tells John that her father, John's father, built the house. She leaves and Jen tells John that if he doesn't choose her she will make his life absolute hell, that somebody is going to get killed. Gavin goes out on the porch to take Bel to bed, but she will not let him touch her, saying that there is someone with "shaggy goat loins" scratching at her bedroom window and that she has had a vision. Then, abruptly, she decides to go upstairs and wait for Gavin to come up for her "ritual violation." As she leaves, she kisses John, who has come out with a liquor bottle. John and Gavin decide to go hunting, and John tells Lake to lock the liquor cabinet. After John and Gavin leave, Jen tells Lake how much she hates Fay and drinks from a flask that Lake offers her. Lake says he can get rid of Fay if Jen wants him to, and Jen says she would be "infinitely grateful" to anyone who could get Fay out of her life forever. They drink from the flask, taking

turns, as the lights fade on them and our attention shifts to Fay and
Holly in the library. Margaret comes in to take Holly upstairs to get
some sleep and Holly asks her mother to be kinder to Margaret. After
Margaret and Holly leave, Lake tells Fay that he is going to put her and
her daughter on a train. When he grabs her, she pokes him in the eyes
and then slashes him across the face with a letter opener.

The scene shifts to a campfire in the woods where John and Gavin
are drinking coffee. John tells Gavin about Zach building the
Pendragon house around old trees, speculating that perhaps they have
Druid blood. As the lights fade on the men, we focus on Jen and Lake
among the tombstones. Jen thinks that Lake has killed Fay and Holly
and hidden their bodies in the house. She says she never intended for
anyone to be hurt, but Lake wants payment, not in money. He pulls her
to the ground as she screams and tries to crawl away.

On the sofa, Fay is stroking the hair of her sleeping daughter,
speaking of how much she loves the woods and the house and
enumerating the various places on the grounds and in the house where
she and John made love. Jen comes in, her dress torn and dirty, her
hair "messed and wild," telling Fay that she is supposed to be dead.
She hugs Fay and Holly and when Holly asks what's wrong, Fay says
that Jen has "had a bad experience with Mr. Lake." Holly gets a pistol
and heads out to the barn to get a horse and bring a doctor for Jen. Jen
and Fay struggle for the letter opener and end up on the sofa with Jen in
Fay's lap. Bel comes in and tells Jen that Fay, the sorceress, is
pregnant. Holly runs in, saying that she found Lake's body hanging in
the barn. Jen starts reiterating that her flesh, the house, everything is on
fire. Bel leaves to get some water and comes back down the stairs
carryng a large old hat box. At Holly's urging, Margaret gives Fay
something to drink and Jen says that if she ever had a baby girl she
would raise her to be cunning, a sorceress, to take back the world from
the men and burn down all the houses because they are evil coffins.
Margaret tries to take the hat box from Bel and "many, many letters"
spill out on the floor. Fay wants to know why Margaret had all the
letters she and John wrote to each other and why they have all been
opened. Margaret says she did it to protect her brother John from Fay,
that Nicholas Robey, who worked at the Post Office and went to
Maryland with Fay, stole them for her. Margaret says the price she
paid for the letters was to let Robey violate her virgin body. As this
revelation is being made, Jen has gone off in the direction of the back
yard, noticed only by Bel. When John and Gavin come in, Bel says
that Jen went for a swim in the deepest part of the pond and

disappeared. John pushes Fay aside and runs out, followed by Gavin. Holly tells Bel that she killed her father who was going after Gavin with an ax. John, wet, comes in carrying the limp, wet body of Jen, but as Fay and Holly sit among the scattered letters, he carries Jen out. Bel, looking out the window, says that John is putting her back in the pond and Gavin, realizing what his father intends, runs out after him. Bel describes John going deeper and deeper into the water until she can't see him any more. She describes Gavin being unable to find them as Margaret wonders why she can't die. Holly says she wants to go home, but Fay says she is home, that she has always lived here and always will. She recalls how John made love to her in the afternoon under a honeysuckle-entwined sassafrass tree and how at night she would wait for him to come to her, knowing that she had his soul forever.

<p style="text-align:center">* * * * * *</p>

In *Tristan* we see "the interconnected labyrinth of memories and experiences of six people:" Matthew Armitage, 37 (a lawyer), Sarah Pritchard, 17 (a housekeeper), Rhys (pronounced "rice") Rose, 17, Alison Morgan, 19, Gavin Rose, 41, and his wife Bel, 40. The play begins with the sound of a thunderstorm and Matt telling us that he drinks like his grandfather, who was a drunk, but, like his father who never drank, Matt never gets drunk. He tells us about the arrival (and we see it enacted) of Alison at the Pendragon house during a drenching thunderstorm. Rhys carries her into the house to the sofa . Planning on giving Rhys and the girl some wine to warm them up, Gavin asks why there is only one wine glass and is told by Sarah that Bel broke the others by throwing them at the preacher. Rhys takes a sip of wine and hands the glass to Alison, who takes it in both hands and drinks it down like water. Alison tells them her name but says she is not sure of her last name or where she is. Rhys and Sarah take her upstairs to put her in some of Bel's clothing. Gavin says that if Bel can be nice to Alison it will prove that she has finally conquered her madness. As the lights fade on them, Rhys, Sarah, and Alison enter Matt's law office. Rhys introduces Matt as the grandson of Rhys' father's law partner. Matt says that he was about to go to Maryland to settle the affairs of a friend who had recently died, and when Sarah and Alison leave to buy some clothes for Alison, Rhys asks Matt if he will try to find out who Alison is. Matt tells us that he didn't take the train to Maryland but went out to the Pendragon house that evening to talk to Alison. He asks her how she could leave her sister alone after their mother's death, and Alison says that she has come home. She says her mother told her the house would be wonderful and the people horrible, but Alison feels that the

opposite is true. She says she doesn't want to cause any trouble and she will not tell Gavin who she is, but she is not going back, she just wants to get to know her family. After Matt leaves, Sarah slams things around in the kitchen, complaining that Alison never does any housework, and Alison walks in asking if she can help. Sarah says she doesn't need any help, that she has lived and worked in the house all her life, and that she has been running things since her mother died when Sarah was fifteen. Sarah leaves as Bel comes in to see Alison breaking beans. Bel says she is making an enormous effort to be nice to Alison but that it is extremely difficult because Alison looks so much like a sorceress she used to know. But, Bel says, she is beginning to feel a sense of friendship towards Alison. Matt then tells us about an ancient tree near the pond at the back of the Pendragon house. Alison tells Rhys that Sarah is in love with him, but Rhys says that he loves Sarah as if she were a bad-tempered sister. In telling Rhys about her dream of a knight cutting off the head of a dragon, Alison mentions her sister Holly, and Rhys asks her if she remembers anything else about her family. He kisses her, but she says that kissing is not a good idea and leaves. Bel tells Gavin that Alison will be a nice replacement for Sarah when she goes. Matt in his office then tells us that there was a dance the night he returned from Maryland, and that he and his wife attended, along with Rhys, Alison, and Sarah. Rhys tells Alison that everyone thinks she is "beautiful" and wonders who she is. They talk of Sarah's boyfriend, Evan Unkefer, and how Sarah, according to Rhys, will make his life a living hell. As Rhys tries to kiss Alison, Sarah comes running out of the dance area, "crying and furious," because Evan asked her to marry him and she responded by punching him in the nose. Matt assures Sarah that the Pendragon house and the family will survive if she leaves. Sarah says that she can handle Evan and that being married to him would be a better life than most women she knows will ever have. As Sarah goes back upstage to the dance area and the lights fade on Matt, we see Bel in a white nightgown describing how she heard the dragon whispering in her brain, telling her to burn the sorceresss. Bel describes how when she turned to look at Sarah, the candle fell and started burning the nightgown and she screams. Sarah screams, Alison, waking, screams, and Bel crashes through the ancient window, falls on the roof, then off into the grass and then stumbles and crawls, still burning, to the pond where she drowns. After the light goes out on Bel we see the "dim reddish lantern light" in the Indian caves and Rhys assures Alison that what happened was not her fault

and makes her promise that she will always stay with them. He kisses her and she responds as the lights fade, ending the first act.

As the second act begins, we hear the sound of a ticking clock and then see Matt at his desk, Rhys on the porch, Alison sitting on the bed, Sarah in the kitchen, Gavin by the pond, and Bel, "looking radiant and quite serene," sitting on the sofa dressed in white. She explains to us some of the advantages of being dead and says that the living appear as a confused jumble of voices. Each of the actors speaks lines that do not connect with the other lines being spoken and Alison speaks of a dream in which she is attacked by a wild boar and that there was a ring of flour around her bed. Then Sarah, working in the kitchen, berates Alison for not helping her, and Alison says she is not feeling well and has been sick to her stomach in the morning. Sarah asks if Alison has had her period and gets furious when she realizes that Alison is pregnant with Rhys' child. When Gavin enters, Sarah tells him the news and Gavin, blaming himself, tells Alison she must not tell Rhys she is pregnant. Making Sarah promise not to tell Rhys, Gavin hustles Alison out the door to go with him to see Doc McGort. Rhys comes in and Sarah tells him that Gavin and Alison have been gone for two or three hours. Then Gavin enters, followed by Alison, and Gavin tells Rhys that he and Alison have just gotten married. Alison tells Rhys that he will be going off to college and that marrying Gavin seemed "a very sensible solution." Angry, Rhys struggles with his father and Gavin strikes his head on the cabinet upstage. He staggers to his feet, holding his bloody forehead, and as he is helped up the stairs by Sarah and Alison, he tells Rhys to go and not come back. Matt urges Rhys not to leave, telling him that Gavin has been supporting Alison, her mother, and sister for years. He informs Rhys that Alison is Gavin's sister, and when Alison appears Matt tells her that he has told Rhys who she is. Alison then tells Rhys that her mother raised her to come back and claim her share of the house. She says she made an agreement with Gavin that he would marry her and take care of her and she would have a home and he would never touch her. She says he married her to save her and Rhys from each other. Sarah asks Alison if she told Rhys about the pregnancy, suggesting that perhaps if he knows he will stay. Alison thinks the knowledge would be hell for Rhys, but Sarah persuades Rhys to talk with his father before he goes. Rhys tells Gavin that he is going to New York to write for newspapers. Gavin says that the house is Rhys' home. After Rhys leaves, Sarah goes to the kitchen to make supper and Alison goes up to sit with Gavin as Matt moves downstage and tells us that each time he would go out to

the Pendragon house he would feel an intense sexual excitement at the thought of seeing Alison. And, he says, the family needed him even more because Gavin had begun to act strangely after suffering the blow to the head in his scuffle with Rhys. Alison and Sarah squabble over how to look after Gavin and we see him wandering with the white-clad ghost of Bel. Sarah, not seeing Bel, asks Gavin who he's talking to and tells him to come into the house because it's getting cold. Gavin tells her he will come in after he watches the sun set and she leaves. Gavin speaks of the grail house in the woods that he realizes is the same as the Pendragon house, the labyrinth of his own brain. He feels explosions in his head as Bel asks him not to leave her any more, and, as he walks off into the darkness, he says he will never leave her. Matt tells us, before movintg to join Alison and Sarah, that Sarah found Gavin in the pond, not far out, and that Doc McGort said that he had died from a stroke caused by a blood clot. Matt tells Alison that the property is to be divided equally between her and Rhys and that money has been set aside for Sarah and Alison's sister. Alison asks Sarah to stay, telling her that she is the only friend she has in the world. Sarah says she will stay for the sake of the child, adding that both she and Alison will live to regret it. Sarah goes back in the kitchen as Alison and Matt, in alternating lines, articulate their perspectives on what has happened. Alison says she has done what she was raised to do, destroyed them, one by one, and gotten her mother's house back for her. Matt says he has the privilege of going home to make love to his wife who loves him very much. And Alison, alone on the sofa with her hands on her stomach, says that she hates the house, that it is her prison, and that she will be trapped in this evil place until she dies.

<p style="text-align:center">* * * * * *</p>

The unit set for *Pendragon* must represent various locations in Boise, Idaho, in 1910 and 1937, a tavern in Bilboa, Spain, in 1937, a hill outside Gernika, Spain, Mark Twain's porch in Connecticut in 1910, and Teddy Roosevelt's study in 1918. The cast lists eleven actors, 6 men and 5 women, with three of the men playing at least three roles, and two of the women playing two roles. Nigro explains in his notes for this play that John Rhys Pendragon Rose changed hs name to Rhys Pendragon when he left the ancestral manse in Armitage, Ohio, and started writing for New York newspapers. We see him first on a hill outside Gernika (the Basque spelling) in 1937, as he narrates a news story about the destruction of the ancient city of the Basques by Fascist aerial bombardment. He remarks that he came to Gernika, not because he had advance knowledge of the attack, but because of a

promise he had made to a drowned Basque girl in Boise, Idaho, in 1910. He mentions that was also the year of Halley's comet, the ill-fated comeback attempt of boxer Jim Jeffries, and Mark Twain's death. As he finishes his monologue (and the flask he has been drinking from), we hear the banjo player plucking and singing the first of three songs, 'Take Me Away, Mr. Halley,' and Revelation Red, a ragged, drunken, prophet bum enters McPherson's Tavern in Boise and the year of the action is 1910. Red warns of the coming destruction of the world and, learning that Rhys is a reporter, insists that he tell the world that the end is near. Alison McPherson comes in behind the bar, but before she can get Rhys a drink Bunny Wong, a pretty Chinese girl, rushes in to tell Alison that Joe Navarro, drunk, just tore up her father's restaurant and is heading for the bar. Bunny says that Joe is grieving because the Basque girl he was supposed to marry drowned when the ship sank. Joe comes in and wants to fight Rhys, but Rhys easily evades his wild punch and Alison hits Joe in the head from behind with a bread board and Joe collapses. Rhys explains that he is in Boise to write about the boxer Jim Jeffries who is in training to fight Jack Johnson for the title. Charley Wong runs in with a cleaver to cut off three of Joe's fingers for wrecking his restaurant and accidentally hits Rhys in the head, nicking his ear. Charley and Bunny take Rhys out to their room over the restaurant, and Joe tells Alison that she smells like his girl, Isabel, the girl who drowned. Joe follows Alison into the back room as the banjo plays and our focus shifts to the train station where Isabel is sitting forlornly and Rhys is trying to get a ticket back to San Francisco. The Stationmaster says he has no idea when the next train for San Francisco will arrive. Isabel then hands Rhys an envelope with "Navarro's Basque Boarding Hotel" written on it, and he offers to take her there. Ama, Joe's mother, asks Joe why he has been so cheerful recently, guessing that he has been with a woman. Rhys brings in Isabel; Ama recognizes her, but Joe says Isabel drowned. After Ama takes Isabel to get her cleaned and dressed, Joe wonders how Isabel could be alive when everyone else drowned and why, since Isabel knew Basque, Spanish, and English, she does not speak.

Then, as Rhys walks over to the tavern in Bilboa in 1937, Henimgway bellows a greeting to him and tells him a man of his 67 years should be home with his grandchildren. Rhys tells Hemingway he is going to Gernika to keep a promise he made in Boise in 1910. Back in McPherson's Tavern, Angus McPherson says he knows about Alison and Joe, and Isabel tells Rhys how she somehow survived the shipwreck and traveled on several trains to Boise. She tells him that as

she was drowning she heard someone singing a song about the Tree of Gernika. Boone, Jeffries' trainer, calls to Rhys as the locale changes to the training camp.

Jeffries stalks Rhys, threatening to beat him for writing that Jeffries had no chance of winning his fight with Jack Johnson. Jeffries goes off running, followed by Boone and Joe, and Rhys, back in the tavern, tells Alison about his family and the house in the east Ohio woods that his grandfather built. He tells her that Joe wants to talk to her and asks if he got her pregnant. She asks him not to tell Joe. Hemingway, entering with a bottle, returns us to the Bilboa tavern in 1937 as he says that Ring Lardner told him that Rhys had interviewed everybody in the world. Rhys says that he interviewed Mark Twain and walks away from Hemingway to Twain's porch. Twain says that he was born in the year of the comet and always thought he would die when the comet returned. As Twain exits, a pretty woman of 26, Anne Pendragon, has come into the Bilboa tavern in 1937. Rhys introduces her as his daughter to Hemingway. Anne says she needs to talk to Rhys about her mother and about what happened in Boise in 1910. The Banjo Picker closes the act by singing 'The Song of the Drowned Basque Girl.'

The second act begins in Teddy Roosevelt's study in 1918 as Rhys tells Roosevelt his wife died recently and that he has an eight-year-old daughter who is in boarding school. The scene shifts to Wong's Restaurant, Boise, 1910, as Mr. Bengoa, an old Basque gentleman, comes in followed by Red, who is talking about the comet, saying that if he could find a virgin lamb of the flock, like Jepthah's daughter, to sacrifice, perhaps the comet's disaster could be averted. Charley comes in, telling Red to leave, and as Charley and Bengoa learn to speak American, Rhys enters. Charley and Red shout at each other until Charley chases Red out and explains, in hilarious Pidgin, the First Amendment to Bengoa. Alison comes in to tell Rhys that his editor from New York is on the phone in her father's tavern, swearing, and when Rhys leaves with her, Red approaches Isabel, pretending to have a coughing fit. She helps him out the door, thinking that they are going to his place so he can rest. In the McPherson Tavern, Alison tells Joe that if her father sees him in the bar he will shoot him. Bunny runs in saying that she saw Red taking Isabel into the woods and all the men run out as the scene shifts to a shack where Red tells Isabel that she is going to be the virgin sacrifice. When he pulls out a knife, she tells him that he is lonely, hungry, and very messed up, that he just needs a friend. Red is in the act of handing her the knife when the men rush in, and Red grabs Isabel, saying that he will slit her throat. Red raises the

knife high in the air, but Charley runs at him from behind and bites the hand with the knife. Red manages to get away and runs off chased by Jeffries, Charley, and Boone.

Cleaning up in the tavern, Alison sings 'The Bloody Knight,' and when Isabel comes in tells her that she doesn't want to talk with her. Isabel tells Rhys that she will go away with him if he wants her to. Joe enters and says he has decided that he and Isabel should be married. Isabel says she will give him her answer the next day. She tells Rhys that if his editor sends him to Europe he should go to Gernika and see the tree that is the symbol for the Basques, outliving everything. Rhys promises that he will. After Isabel leaves, Rhys asks Alison what she is going to do and asks her if she would like to marry him. She hits him in the face, knocking him over a chair and onto the floor. He gets on his knees, promising to take good care of her and her child. They discuss it for a while and Alison says she will need some time to pack.

Anne and Rhys, in the Bilboa tavern, 1937, talk about McPherson writing a letter to Anne, saying that her real father was a Basque man in Idaho. McPherson also left Anne a lot of money in his will. Rhys says her father's name is Joe Navarro and that he never told her because her mother didn't want him to. Anne accuses Rhys of never caring for her, and Rhys tells her that every penny he has earned has gone to her upkeep and education. Hemingway says good-bye to Anne, then to Rhys as the scene shifts to Twain's porch, where Twain explains to Rhys his six hypotheses about the nature of God, saying that it is time for him to "shuffle on into the big dark house." Anne talks to Joe, gray and in his fifties, in the boarding house and learns that the Fascists have just bombed Gernika. Joe's sixteen-year-old daughter, Isabel, runs in and invites Anne to their home for dinner. Joe says he would not trade his daughter for anything in the world. Anne says she would like to stay for dinner but has to go back to Spain to be with her father. We see Rhys standing on the hill as at the beginning, where he is approached by a Basque Girl with a shotgun. He explains that he is not a Fascist and that he promised a friend, now dead, that he would come to Gernika one day to see the tree. The Girl tells him that the tree is still there, that she will show it to him if he will tell the world what happened. She takes his hand and leads him down toward Gernika as the Banjo Picker sings the ending of 'The Song of the Drowned Basque Girl,' and the lights go out.

* * * * * *

In *Chronicles* the members of the Pendragon clan gather just before Christmas in 1920, although there are three flashback scenes. Our

guide through the labyrinth is Dorothy, the second daughter of Matt Armitage and Alison Rose Armitage, who serves as narrator as well as playing her part in the play. As the action begins, Dorothy, 24, "bright eyed and pleasant looking," tells us that John Rose and Davey Armitage are both back for the first time since the war, that her father and mother rarely speak to each other even though her father is dying, that Lizzy (her elder sister) is still grieving over the death of her baby a year earlier, that Cletis Raines is kissing Molly (her younger sister) every chance he gets, and that Jessie, 18, the last of the daughters, has come into bloom like a Japanese garden. Jessie runs into the room, flushed, asking where John Rose has gone, turning Dorothy so that they are facing each other and gesturing as she speaks. Dorothy's response is a "shrill, guttural noise," written "Uhhhhhhhhhhhh," and we realize that the narrator who can speak clearly and perceptively to us cannot hear what the other characters are saying. After Jessie "gallops" up the stairs and goes off, Dorothy explains that when she was seven years old she got a fever that took away her hearing, and, though she learned sign language, she has always used more primitive ways to communicate with her family. She says she was a piano prodigy before she lost her hearing and still loves to play the piano, although everyone runs from the room when she sits down to play. She says she and her three sisters are the offspring of her mother's second marriage to Matt Armitage.

We go back in time as we hear bird song and see Matt, 42, and Alison, 24, walking in the orchard (downstage) in 1892. Matt is still grieving over the death of his wife, and Alison, whose husband has died, tells him that she is worried about the money running out and about the wild behavior of her four-year-old son, John. Alison tells Matt that perhaps they should get married although she doesn't know if she can be with him "in a conjugal way." She says she may need some time. Sarah Pritchard, the housekeeper, tells Alison that her son John has set fire to the cat but that she drenched the animal with the hose. Alison exits, and Matt tells Sarah that he and Alison are going to marry.

The light comes up on Dorothy wondering what the first years of the marriage must have been like and how Davey, Matt's son, got along with John Rose, Alison's son. When Lizzy wants Dorothy to help Sarah in the kitchen with dinner, Dorothy refuses and tells us that sometimes she has to stand up for herself or Lizzy, especially cranky since the death of her baby, will run over her.

The scene shifts to the library in 1894, when Matt was 44 and Sarah 24. Sarah tells Matt that Alison is in love with Rhys and asks Matt when he thinks Alison will let him sleep with her. As Matt turns to go

she runs to hug him from behind, saying that she is sorry, that she is so unhappy she wants to die. Alison sees them hugging and tells Sarah to make her son go to sleep. Matt asks Alison why she should be jealous and Alison asks Matt if she can sleep in his bed.

Back in 1920, Dorothy remembers her childhood before she lost her hearing as a happy time, and Jessie runs in again, asking Dorothy, and Davey when he comes in, if they have seen John Rose. She runs off, John comes in, and Davey tells him that Jessie just wants to talk to him. The front door slams, John runs off, and Jessie, wearing Davey's coat, runs in and scampers up the stairs. Dorothy tells us that everyone in the family still alive is in the house now except Rhys, of whom she has vague memories from 1901. As she goes into the kitchen, we hear a baby crying from upstairs in 1901 and Alison, 33, asks Sarah, 31, what is wrong with the child. Sarah says that Molly is a healthy child with a big voice and that Dorothy is watching her. Rhys enters, explaining to Matt and Alison that he was traveling and decided to stop by. Matt shakes his hand and tells him that it is his house, too, and Alison says he must meet the children. When Matt leaves to pick up John and Lizzy from school, Rhys tells Alison that he figured out that she was pregnant when his father married her and that John is his son. She says his father never touched her, that she never slept with him. Rhys tells her that every minute she was thinking of him, he was thinking of her. He says that he has been writing about wars as a journalist and wanted to see his son before he died. The baby cries and after Alison goes to care for her, Sarah hugs Rhys "very hard" before sending him upstairs.

Dorothy, in 1920, sees John Rose and points where he is as Jessie runs after him. John Rose is surprised by Jessie who pulls him over the back of the sofa so that his head is in her lap. She starts tickling him and they get all tangled up on the sofa, laughing and giggling, as Rhys enters. Jessie screams and asks him if he is a bum, and Rhys agrees that some would say that he was a bum, and the lights go out.

The second act begins exactly where the first act ended, with Rhys, Jessie, and John looking at each other. John tells Rhys to get out, but Jessie recognizes him and wants him to stay. Alison tells Rhys that she is sorry his wife died. Rhys explains that he had to put his daughter in a boarding school because he couldn't take her with him all over the world and that she hates him. Alison says that Matt has a right to be furious with them because they did a terrible thing to him and when Matt comes in he orders Rhys to leave. Rhys says the house is half his and John pushes him away from Alison. Sarah says that Rhys has as much right to be there as anybody and that she will leave if Rhys does.

After the others leave, Jessie wants Alison to tell her "the long, bloody story" and, when her mother is reticent, begins tracing the genealogy of the family from Zach Pendragon through Gavin Rose to Rhys, John Rose, and her sisters. She asks why Rhys hasn't been back since the year before she was born and she wonders why John and Matt hate Rhys so much. Alison tells Matt to stop punishing Jessie for something she knows nothing about. Alison leaves, and Jessie asks Matt why he doesn't love her mother. When Davey and Rhys come in, Sarah tells Davey to make sure Rhys and John don't start drinking. Davey leaves John and Rhys to talk and John accuses Rhys of running out on Alison twice, once when she was pregnant with him and once when she was pregnant with Jessie. Rhys asks John why he keeps running away from Jessie and John replies that he takes after his father.

After the meal, Jessie tells Davey in the library that she is afraid her father (Matt) will die before she finds out why he hates her, why he never touches her. When Matt comes in, Jessie kisses Davey good night on the cheek but when she goes shyly to kiss her father, he flinches. When Rhys comes in Matt refuses to stay and gets as far as the sofa before sitting down. John joins Davey and Rhys for a drink, and the scene shifts to the parlor where Alison tells Matt that she wants their children to know that they love each other, and when Lizzy comes in she tells her that she didn't sleep with Matt for the first two years of their marriage because she thought she was in love with somebody else. She tells Lizzy that she regrets that lost time and urges her to try to work things out with her husband Lewis. Lizzy agrees and goes out on the porch to talk to her husband as Rhys enters the parlor to tell Matt and Alison that Davey has fallen asleep. Matt goes in to wake him and Alison asks Sarah to tell Matt that she has gone upstairs to bed. Rhys asks Sarah if she would like to take a walk in the moonlight, But John comes down the stairs with a satchel. He tells Rhys that he is leaving because of the curse, that he and Jessie are sexually attracted to each other, and he cannot trust himself with her. Saying he is his father's son, he leaves as Jessie comes down in her nightgown, learns that John has left without her, sits on the sofa and cries. Matt asks what Rhys has done to her and Rhys says he is going for a walk with Sarah and that Matt should talk to his daughter. Matt sits on the sofa and puts his arm around her, telling her that she will have everything she wants, promising her that everyone she loves will always love her back. As he rocks her, Dorothy turns the lamp down low, and goes up the stairs.

* * * * * *

In *Anima Mundi*, Madame Blavatsky performs a function similar to that of the inimitable Dorothy in *Chronicles*, but her narrative based on tarot cards is supplemented by thematic comments from Mr. Yeats And while *Chronicles* concentrated on Christmas in 1920 with three flashback scenes, *Anima Mundi* covers the life of David Armitage from his adventures in England and France around the turn of the century through the First World War, then Ireland after the war to America in the twenties and fifties. The cast requires thirteen actors—8 men and 5 women—with nine of the actors playing at least two roles. Chopin's Waltz #12 ends as the characters take their places on the set and Blavatsky, "a large and rather formidable old woman," enters singing a verse from the ballad 'Lord Randall' (music by Nigro), as she sits and putters with her cards. Armitage, not quite 20, tells Blavatsky that he thinks there is some fundamental secret about God's universe that she can help him with. She says he's an idiot and asks him how much money he has. She shouts for Elizabeth, and Elizabeth Carrollton, "a very beautiful and self-possessed young woman" who has been standing next to Yeats, comes over and smiles at Armitage as she goes off to make tea. Blavatsky says that Elizabeth will take him around London and introduce him to Yeats, and when Elizabeth returns and Blavatsky goes off to "piddle," Elizabeth questions Armitage about his search for God and tells him she can see in his eyes that he is doomed. Blavatsky returns, a small bell rings (as it does each time she turns up a card), and lays out the tarot cards, turning up The Fool. And as Blavatsky describes the various meanings of the cards, Armitage moves to a table where Rex and Everett, two American soldiers in 1918, sit; and at another table Mr. Dowson and Mr. Wilde are seated in a time some years earlier. Armitage moves easily from one table to the other and back. Dowson tells Wilde that he should make love to a woman, offering to pay for it himself, but Suzanne offers to sleep with Wilde for free. Dowson and the girls help Wilde up the steps and Armitage tells Dowson about Elizabeth as she does warm-up exercises. Wilde appears at the top of the stairs, announcing that the deed is done. Dowson and the girls applaud as he descends the stairs and Suzanne sings part of the 'Fisher King Ballad' as she cleans the tables.

Blavatsky turns up the Hermit card and Armitage, now old, moves from Angelique to Pound, "very old," on a bench outside St. Elizabeth's Hospital. Pound talks about Yeats and asks if Armitage married that beautiful dancer. Armitage watches Yeats and Elizabeth stroll off and tells Pound that he chose to stop writing. Pound recalls

Joyce and Eliot and shouts that he will stick his finger in his veins and write on the walls before he will stop writing.

Blavatsky turns up the Temperance card and Armitage watches as Elizabeth, in leotards, dances free style to Chopin's Waltz #3 and Yeats speaks a letter (to Maud Gonne) about them. Elizabeth tells Armitage about the poet's love for Maud and says that she has taken a vow of chastity. She asks Armitage if he is a virgin and he says he is not, but Elizabeth giggles as he walks away.

Blavatsky turns up the Chariot card and we hear the sound of explosions as red flashes illuminate a ruined farmhouse in 1918 France. Armitage, Rex, Everett, and a Blind Soldier discover a French Girl carrying a dead baby. As the explosions continue, Everett tells the French Girl about his sister, Mary Margaret, and she appears in a white dress at a hospital in New Jersey after the war, speaking to Armitage about her brother Everett who does not speak or respond to anything.

The bell rings again and Blavatsky turns up the Magician card and we see Elizabeth and Armitage having tea with Alistair Crowley as Mrs. Crowley screams offstage. The screaming continues as Crowley details his sexual experiences and tells Armitage to do what pleases him whenever it pleases him. When Crowley leaves to quiet his wife, Elizabeth tells Armitage that she thinks Crowley is fascinating and she gets angry with Armitage when he wants her to leave. After Armitage leaves, Crowley invites Elizabeth to a meeting of their study group and predicts that she will return.

The bell rings, Blavatsky turns up the Death card, and the scene shifts back to the farmhouse. Armitage tells Rex that the baby the French Girl is holding is dead. When Rex tries to tell her in French that the baby is dead, she spits in his face but is able to sing a nursery tune with Everett. After another explosion, Captain Blood and Corporal Duck burst into the farmhouse. Captain Blood orders Corporal Duck to take the French Girl and the Blind Soldier back to their lines, but the French Girl screams when Corporal Duck tries to get her to move. Everett, confusing the French Girl with his sister Mary Margaret, jumps on Corporal Duck's back, and the Blind Soldier, standing up to speak, is shot by a sniper and falls to the ground.

The bell rings, Blavatsky draws the Lovers card, and we see Armitage and Elizabeth sitting in front of a fire as he tells her about the Pendragon house in Ohio. She says she will visit him there in a hundred years when he has grown up. After talking about Crowley, she kisses him "rather passionately" and asks if he is going to continue seeing his girl friend. He says he won't and asks her if they are going

to make love. She says absolutely not and says that he will get old and she will get ugly and they will die. She stomps on his foot and he crashes to the floor, asking her as she leaves if he is supposed to be able to read her mind. As he gets up, he is old again with Pound, talking about why he stopped writing, and we hear Chopin's Waltz #10 as Elizabeth dances and the other actors leave the stage. After Pound walks off, Elizabeth looks at Armitage across the stage and the lights fade "like sunset" and the music ends in darkness.

The second act begins as did the first, with Chopin's Waltz #12, as the actors take their positions in moonlight. Blavatsky sits and turns over the Moon card as Elizabeth talks to Armitage and Yeats about Meister Eckhart and the infinite love of God. Crowley, his wife, and a younger Pound join them for a séance. Wilde appears, "pale and ghastly," in his own light at the top of the stairs. Questioned by Elizabeth, Yeats, and Armitage, Wilde says the color scheme is absurd and the food tasts like porridge, and, from a human point of view, God seems a "pretty evil old thing." The light goes out, interrupting him in mid-sentence and Blavatsky claims technical difficulties. As the others leave the séance, Everett speaks from the hospital in New Jersey about seeing God in his sister Mary Margaret's belly button when they were taking a bath together as children, but only Armitage sees him.

After the bell rings, Blavatsky turns over the Empress card and Elizabeth and Armitage stroll in the park, talking of Crowley's influence on her. A Beggar asks for money and they both give him some; then Elizabeth gives him all she has. Armitage refuses to give any more, but the Beggar asks Elizabeth if he can kiss her hand. As he is about to, Armitage grabs him by the collar and throws him on the ground. The Beggar runs off blowing a whistle and Elizabeth tells Armitage that she thinks it is selfish of him to be writing poems about a God he doesn't believe in while better poets are dying in the war.

The bell rings and Blavatsky turns over the Hanged Man card. Elizabeth tells a letter to Armitage about Crowley and dancing and a rifle shot rings out as we are back in the farmhouse. Captain Blood orders Corporal Duck to go out and kill the sniper and notices the breast of the French Girl trying to nurse her dead baby. When he touches her, she spits in his face, and he takes the baby from her and places it high up on the steps. Everett charges Captain Blood but the Captain knocks him unconscious. The French Girl tries to get her baby but is shot by the sniper, and, infuriated, Captain Blood ties Everett by one ankle upside down to the banister. As Captain Blood is about to shoot Everett, Armitage raises his rifle and shoots the Captain in the

chest, killing him. Coeporal Duck comes back, saying that he has killed the sniper, and Rex tells him that the sniper killed the Captain just before Duck got the sniper. Duck asks if he will get a medal and Rex tells him he can have his.

The bell rings and Blavatsky turns over the Devil card. Yeats speaks of tragic joy and Elizabeth speaks a letter to Armitage, telling him that the real power of the universe is not with God but with Satan. She says that Crowley may be Satan and that she has practiced sex magic with him. A drum beats and the Satanists gather in robes and masks. Elizabeth is the sacrifice, and as red light shines on the group closing in on her, "hideous" bagpipe music grows louder and more discordant; she is pulled onto a table serving as an altar and held down as the chanting and animal noises grow to "a horrifying din." Crowley, shouting the dominion of Satan, puts on a goat mask and "descends" on the screaming Elizabeth. The lights go out and there is "sudden, absolute stillness."

Then the bell rings and Blavatsky turns up the Tower card. Yeats recognizes Armitage, back from the war, and is glad he is alive. Yeats says that Elizabeth has gone off with the Antichrist and Armitage should write poetry and think of his experiences as metaphors for poetlry. Armitage tells him he is wrong and the bell rings.

Blavatsky announces the Wheel of Fortune card and Mary Margaret brings Armitage to meet Everett and Rex in the hospital. Dulcy, a young girl, is wrapping string around Rex's fingers, and Mary Margaret explains that it calms Rex down but that Everett never talks. Rex speaks about the White Sox throwing the Series and Dulcy announces that she is going to take off all her clothers and do an exotic dance. Mary Margaret offers to put Armitage up for the night and suggests a meal, but he says he has to go. Rex announces that he is going to take Dulcy back to Terre Haute with him. He urges Armitage to be a friend to Mary Margaret.

The bell rings and Blavatsky turns up the World card and we see Armitage, now an old man, in his garden in Ohio in the late 1950s. The other actors are "scattered about like garden statuary . . . still but not frozen." Armitage speaks of grief and betrayal as Elizabeth, "young and beautiful, in a white dress," appears behind him. Armitage tries to remember his long poem, "Anima Mundi," but Elizabeth tells him that though she may appear young to him she is "quite dead." Armitage tells her that he gave up his work and never married and looked for her for years before coming back to his father's garden. Elizabeth says she has brought him a present and introduces him to "someone he has

always wanted to meet." The Curate tells Armitage that he has learned that if anything accidentally loves you, you should be thankful and love it back. Elizabeth thanks the Curate, but he says there is no use thanking him because he is also dead. Hand in hand, Elizabeth and Armitage walk to Blavatsky's table.

The bell rings for the last time and we are back at the beginning with all the cards laid out on the table. Blavatsky refuses to tell their future and says that Elizabeth will introduce Armitage to Yeats. Elizabeth and Armitage thank her and go back through the "silent, still figures" to Yeats. Blavatsky takes out a flask and pours some into her tea, then takes a long swig from the flask. She gathers, shuffles, and deals the cards for a game of Patience, singing the concluding lines from 'Lord Randall' with which she began the play.

* * * * * *

The connection of *Beast with Two Backs* to the other plays in the Pendragon cycle may not be obvious, but the link is Mary Margaret, the same girl who offered Armitage friendship in *Anima Mundi* and who, in *Laestrygonians*, encounters John Rose, Armitage's step-brother and, in *God Rest Ye Merry Gentlemen*, agrees to marry him.The setting for *Beast with Two Backs* is McLish's apartment house in Greenwich Village, New York City, in the late 1920s. Two apartments are shown, Mary Margaret's on the third floor and,, beneath it, the apartment rented by Al, a painter in his late twenties. Other characters are Jem, Mary Margaret's boyfriend, McLish, and his wife Rachel. The play begins as we hear a scratchy recording of 'Saint James Infirmary' and the "muted sounds of a party in progress." Al and McLish appear on the landing of the stairs and come up to the hall where McLish, in a monk's habit with a skeleton mask hanging from his neck, kicks open the door to the apartment he is going to rent to Al. The room is terribly cluttered and, as he talks to Al, McLish is in constant movement, picking up and rearranging the clutter so that by the end of the scene the room looks habitable. As he talks about art, McLish hands Al various items to hold—a moose head, a scythe, a stuffed owl, a book, and a skull. As he is about to leave for a party, Mary Margaret, in "a long, clinging, low cut angel suit with wire halo," and Jem, with a cloak, long tail, horns, and pitchfork, come up the stairs. Mary Margaret, a bit drunk, is singing, and Jem tells her to shut up. As they continue up the stairs to the upper apartment, McLish identifies them as an actress and a poet of some kind. Mary Margaret and Jem argue, and McLish says that Al may be able to hear them but that they cannot hear what's going on in his apartment. Al discovers that he has no place to

put his clothing and listens as Mary Margaret tells "Everett" that Jem won't let her take a shower with him. Mary Margaret dozes on the bed and McLish bursts into Al's room with a bottle and two glasses, informing Al that there are no locks on any of the doors. McLish explains that to survive as a writer he wrote stories for sex and confession magazines but then came back to New York, married Rachel and became a slum landlord. He has not written anything since but adds that Rachel, who sleeps with everyone except him, will be up to see him. Al asks McLish who Everett is and learns that he is Mary Margaret's brother, a "war vegetable" in a hospital in New Jersey. When McLish goes out he slams the door, waking Mary Margaret who notices that Jem is dressed to go out. She follows him down the stairs, then comes back up, crying and angry, opening Al's door and slamming it behind her. She flops on the bed, right in Al's lap, screams, and asks him what he's doing in her bed. Al turns the light on and they introduce themselves. Mary Margaret admires Al's paintings, saying that sometimes she models for artists. McLish bursts in again saying that he heard screaming. Mary Margaret shakes Al's hand and leaves to go upstairs and put on a bathrobe and a recording of Chopin's Waltz #3 in A minor. McLish remarks that Mary Margaret cannot or will not recognize Jem for the chicken barf that he and Al know he is. Mary Margaret speaks to the imaginary Everett about Al and puts on a recording of Chopin's Waltz in A flat major which plays as the lights go to black and then come up on McLish reading a newspaper in Al's rocking chair and Mary Margaret reading magazines on her bed. Al tells McLish that he wants to move out because he hears too much from Mary Margaaret's apartment. McLish gives him "a grotesque pair of moth-eaten ear muffs," and tells him that he is "stuck" on her. Al wonders why she stays with Jem who "treats her like vermin," and McLish tries to explain why women are attracted to "shark" types, but is stopped by Mary Margaret coming to the door with a pan containing turkey for "the starving artist." After eating some of the turkey and getting a kiss on the cheek from Mary Maragaret, McLish leaves and she tells Al some of her jobs in advertising and asks Al if he would like her to pose for him. After some discussion of whether she should remove her clothing and some unsatisfactory poses, she tells him that her name is Mary Margaret Duncan from East Liverpool, Ohio. She says her parents think that she is "a shamelss, fallen women . . . living in sin and all." She says she came to New Yokr to be near Everett and to be an actress. Al shows her some paintings by Munch, Brueghel, Turner, and Renoir, trying to explain why he paints. They kiss, but as

things get more involved, she pushes him away and runs out the door and down the stairs, passing Rachel who is on her way up to Al's room. Rachel has been crying because she is worried about her husband and thinks he is sick. She tells Al that he is in love with Mary Margaret, then asks him if he wants to fool around. Al says that McLish is his friend and he is not going to sleep with her any more. She says that she didn't stop sleeping with her husband; he stopped sleeping with her and she was never unfaithful to him before that. She says she is cold, and asks Al to hold her. He does as we hear the scratchy recording of 'Saint James Infirmary' and the lights fade, ending the first act.

The second act begins with McLish singing a bawdy version of 'God Rest Ye Merry Gentlemen' with his arms around Jem's shoulders as they lurch up the stairs and burst into Al's room. Above, Mary Margaret pulls the blankets over her head as McLish introduces Al to Jem as Heironymus Bosch, the only man on the block who doesn't inseminate McLish's wife. Pulling out a bottle, McLish says that Jem is going to explain his philosophy of women. Jem says his secret is that he talks about "the nature of true human love." He expostulates on freedom and Freud and "then you get a few drinks into her, feel her up a little and bang the hell out of her." Jem says he will marry a nice girl and have kids when he's an old man like McLish, but he says he would never marry Mary Margaret because she isn't a virgin. Jem leaves and McLish tells Al that he and Rachel had a baby, "a cold little feller." Rachel and Mary Margaret talk about men and Mary Margaret says that Rachel can curl up under the blanket with her to stay warm, and Al puts on his coat and goes out as we hear 'Saint James Infirmary' (a "faint, sad instrumental version") and the lights fade out.

In the next scene, early in the new year, Mary Margaret tells Al that she was supposed to go to Vermont for the week-end to be photographed with some other girls for an advertisement, but when she learned she was the only woman she came back. She thinks she will surprise Jem who assumes she will be gone for the week-end. She says that Al is the only person she knows who actually works, and then she begins to cry and says she wishes she could take Everett far away from the hospital and go where no one would bother them. After Al kisses her, they see Rachel and Jem going up the stairs to Mary Margaret's apartment. Al tries to get Mary Margaret to leave but she can hear what Rachel and Jem are saying as they take off their clothes and she refuses to go. Realizing that Al has heard everything in the upper apartment, she gets furious with him, then shouts up to Rachel before running out of the room and into McLish who is coming up the stairs.

Rachel struggles into her dress, finds only one shoe, hits Jem over the head with it, twice, then runs down the stairs, pushing McLish aside, calling after Mary. Jem pulls on his pants and runs down the stairs after Rachel, bumping into McLish, who follows him down and we hear stomping, screaming, and doors slamming before there is silence and McLish comes back into Al's room. He pushes Al violently, calling him a "filthy wife-fucker" and smashing three of Al's paintings over the bedposts. Al pushes him into a dresser, knocking him to the floor. Jem and Mary Margaret come up the stairs to her room and Jem says he will take her to Hollywood to be in the movies and that he will take Everett with them. They kiss as they lie down on the bed. Below, McLish gets up and leaves, bowing to Rachel who climbs into Al's bed and pulls up the covers. We hear the instrumental version of 'Saint James Infirmary' and then, as the lights fade, Chopin's Waltz #10 in B minor.

In the final scene, Mary Margaret, in "Sunday school dress, all white," comes in as Al is packing. She explains that she has been to a funeral at Coney Island and that she has never had any mourning clothes. She kisses Al and says good-bye, waves, smiles, and goes out the door and up to her apartment to play the vocal version of 'Saint James Infirmary' (last verse) as Al gathers some paintings and his hat and coat. McLish comes in and Al hands him a painting before leaving. McLish looks at it and hangs it on an upstage nail. The picture is completely white. McLish sits in the rocking chair as the record ends and scratches, over and over. Mary Margaret sits without moving and McLish rocks. The lights fade to black.

* * * * * *

The story of Mary Margaret in Hollywood is picked up in *Laestrygonians* but the focus of the play is John Rose and the narrative link is created by Jessie as she tells the letters she writes to him. The play spans the years from 1908 to 1929, beginning in 1923 with Jessie, then 21, speaking her letter to John about their mother grieving over her husband's death. We then see John Rose entering Mary Margaret's bungalow, stumbling over a pile of dirty blankets and old clothes and disturbing Mary Margaret who had been sleeping under the pile. John tells her that his stepbrother, David Armitage, asked him to look her up because he was worried about her. He tells her that he used to be an actor in Andrew McGuffy's Shakespearean touring company. He tells her about his sister, Jessie, who died two years earlier and who loved him more than anybody in the world.

The scene changes in a second to John creeping down the stairs of the Pendragon house in 1908, carrying a duffel bag. Jessie, six years old in 1908 (but played by the same adult actress) is sitting on the top of the stairs and cries when she realizes that he is running away. He tries to comfort her, saying that he will bring her a present. She wants him to promise to marry her and he tries to explain that because they have the same mother they cannot marry. She says if he doesn't promise to marry her she will scream, and wake everyone in the house. Swearing her childhood oaths, he agrees, and she tells him to watch out for panthers.

Then, as McDuffy, an old actor with a shock of white hair, tries to remember lines spoken by Othello, John watches and then introduces himself as David Armitage's stepbrother, saying that McDuffy had told Yeats that he needed somebody and that Yeats had told Davey's friend, Elizabeth, and she had told Davey. Marina, McDuffy's daughter, tells her father that they have to be going, and McDuffy threatens John with castration if he ever touches her. John says that he saw McDuffy and his company do *Pericles* and was enthralled by it. McDuffy sends John to help load the van and we see Jessie at age 10 speaking a letter to John who is traveling with the acting company in Ireland.

Then, in Mary Margaret's bungalow, 1929, John tells Mary Margaret that he poured her liquor down the drain because she is killing herself. Jessie, in 1912, age 11, speaks another letter to John about her sisters and reading all the plays that he is acting in. In the same year, James Mahoney, an actor in the company, suggests that John has "a dark, terrible secret." In her letter of January 6, 1914, Jessie thanks John for sending pictures and newspaper clippings and tells him that if Cletis Rainey, Molly's boyfriend, keeps trying to kiss her when Molly isn't looking, she will punch him in the nose. She says that if Marina is John's girlfriend then she will have to come over there and punch her in the nose, too. She says she was hoping John would surprise them for Christmas and thanks him for the books, particularly *Ivanhoe*.

In the bungalow, John gives Mary Margaret a drink from his flask and she shows him a cowboy hat that Buck Jones gave her. She says she made ten movies in four months, but as she made more and more money, Jem got meaner and meaner, sleeping around, calling her names, and hitting her. She says that Jem is dead and that she wants to die. She asks if John killed his sister, and Jessie, 15, speaks a long letter to John about her sisters and their boyfriends. She reminds him

that he promised to marry her, saying she will "just die" if she doesn't see him soon.

The men, drinking again, talk about theatre, McDuffy recalling some of the actors he has worked with and about to explain the "secret" when he passes out. Marina comes in to put her father to bed and John kisses her; she kisses him back, "very passionately," but McDuffy sits up and shouts, "MY KINGDOM FOR A HORSE!" before allowing himself to be helped off by his daughter.

In the bungalow, Mary Margaret repeats that she killed Jem and her brother Everett. John tells her that when Mahoney was very drunk, he would ask anybody, "What's the worst thing you've ever done?" When Mary Margaret asks John that question, he says that he killed his sister Jessie.

We then see and hear Jessie "being a letter" at age 15 in 1917. She tells John how excited she is that he is taking time off from the Canadian tour to come home. She says the pond that Papa drained because "various loony members of our family kept running out and drowning themselves in it," is filling up from an underground spring. She refers again to the very strained relations between her mother and Papa and closes by reminding John to bring the wedding ring, although she says she is just kidding.

Act Two opens with John, 29, and Jessie, 15, walking by the pond in Armitage in 1917. When Jessie says she can't believe that he remembers what they said so many years ago when she was a little girl, John says that she told him to watch out for panthers. She tells him that she wants to live to be a hundred years old, something only the fearless can do. She asks him to take her with him, but he says to ask him when she is eighteen, and they shake hands on it.

The scene shifts to Marina, McDuffy, Mahoney, and John drinking. McDuffy and Marina notice that John is different since his visit with his family and Marina says that he is afraid, running from something. Mahoney suggest that John has discovered the worst thing he has ever done or is going to do. He hasn't done it yet, but he now knows what it is. McDuffy agrees and asks John what that worst thing is, but John responds that he is leaving the company to join the Army. McDuffy acquiesces but makes John promise to come back, and Jessie speaks a letter dated July 12, 1918, in which she tells John that she thinks war is stupid and that her friend Jimmy Casey, who used to take her to dances, has also joined up.

In the bungalow in 1929, Mary Margaret tells John about her brother Everett, saying that she understands how Jessie felt about her older

brother. John says that when he returned to the theatre company he no longer felt as if he belonged and we see him telling McDuffy that he is going back to Ohio because his stepfather is dying, and he will not be coming back. McDuffy is furious, saying that he planned to leave the company to John, and, calling him a Judas, he banishes him, telling him never to come back.

Back in Armitage during Christmas of 1920 (the story told in *Chronicles*), John is berated by Jessie for deliberately avoiding her. She guesses that John is going to Hollywood and says that she can be an actress. Reminding John of his promise, she says that she is now eighteen and he should take her to Hollywood with him.

In the bungalow, John tells Mary Margaret that he snuck out of the house that Christmas without telling Jessie, and Mary Margaret wonders how John killed her if he didn't bring her to Hollywood. John responds by asking Mary Margaret how she killed Jem and Everett, and Jessie, age 21 in the summer of 1923, speaks her letter to John, telling him how she goes to see his movies with Jimmy Casey, but that she is waiting for something, her special destiny.

In the next scene, the year is 1924 and John has come to Vancouver, Canada, to see McDuffy's troupe. McDuffy, still angry at John's desertion, says he cannot stay in the same room, and Marina goes to put him to bed. After telling John that the company cannot last much longer, Mahoney tells John about the worst thing he, Mahoney, ever did. As a teenager he had run away from home during a terrible storm and was admitted to a farmhouse by an old woman whose granddaughter had just died. Her body was in the attic covered by a sheet. Mahoney was to pray over the dead girl's body while the old woman tended to her sick husband, but Mahoney could not resist looking at the girl's face, then her body, kissing the still-warm flesh and then making love to the girl in "some sort of Druid resurrection ceremony." After pulling the sheet back over the body, he realized that although he was filled with shame he wanted the girl again, and so he climbed out the window and jumped off the roof into a tree and back down to the ground, running in the rain until he was completely lost. Soon after, he joined up with McDuffy, but whenever he makes love to a woman he still feels the flesh of the dead girl. When Marina comes back, Mahoney leaves so they can talk, and John tells her that he makes "ridiculous amounts" of money and offers to help support the company. Marina says she doesn't want his money, that what they are doing is a noble thing. McDuffy enters in "a moth-eaten bathrobe" and confesses to John that he let him go off to war in the hope that he would be killed.

McDuffy says that he was jealous that John was going to take his daughter away from him and some day be a better actor. He felt redeemed when John returned and planned to give him everything, even his daughter, but when John left again, McDuffy was trapped in his guilt forever. Marina takes her father off to bed and with no pause Mary Margaret starts telling John what happened to Jem and Everett.

She says that Jem was drunk and had driven her and Everett up a canyon and stopped the car right at the edge. Eveerett got out of the car with Mary Margaret, who was crying, and told her that there were at least two solutions to any problem. Then he kissed her on the forehead, got back in the car, and drove it over the edge. And that, she says, is how she killed them. John says that she knows it wasn't her fault, that it was an act of love, and Mary Margaret asks him again how he killed his sister, and we see, on a cold night in 1927, John and Jessie walking on a railroad track.

Jessie tells him that the reason he drinks and runs around with women and wastes his life and the reason she acts the way she does and is never happy unless he's around is that they love each other. She says they have to be lovers, if only once, or they will never have any peace. She says that if he walks away from her again she will stay on the tracks until the train comes to run her over. We hear the sound of a distant train whistle and Jessie says that if she can't have him she would rather die, perhaps by drowning in the pond behind the house. John says that if they make love, even the once she is asking for, it will kill them. They struggle on the tracks as the train gets closer, eventually falling off the track with John on top. The lights go to black and there is the sound of the train going by, and then Jessie in a letter dated 16 June 1927 tells John that she is going to have a baby but will never tell anyone who the father is. She asks him to write and thanks him for "this incredible gift."

John then tells Mary Margaret that Jessie had the baby, a girl, but died a month after because of an infection and pneumonia. John invites Mary Margaret to come to England to join McDuffy's company.

The play closes as Jessie speaks her last letter, 17 November 1927, telling John that she has named the baby Rebecca after the character in *Ivanhoe*. Jessie says she may have to go to the hospital and has asked Lizzy to take care of the baby if anything happens. She wants John to promise that, if she can't live to be a hundred, he will. She ends by telling him to watch out for panthers.

* * * * * *

.In *God Rest Ye Merry Gentlemen* the story of John Rose and Mary Margaret Duncan continues on stages and backstages of various theatres in England, Ireland, and Wales during 1929-30. As the lights come up on a backstage area of an old English theatre towards the end of 1929, Mary Margaret, described as "27, small and pretty," and John, 41, a "dark leading man," are discussing her negative reactions to the people she has met in Andrew McDuffy's touring theatrical company. She wants to go back to America, although John assures her that the members of the small company are his friends and are "the gentlest, kindest, best people in the world." In quick succession, they enter: Marina McDuffy, 40, the manager of the company; James Mahoney, 52, "a sad faced little character actor;" and finally Andrew McDuffy, 79, "a big, powerful old actor." Mahoney and McDuffy are surprised to see John Rose. When Marina says that John Rose is rejoining the company, McDuffy says that he does not want him. Marina points out that McDuffy is almost broke and suggests that the presence of John Rose will bring people back into the theatre. She says they have no leading man, that McDuffy can no longer play Hamlet and they must have a Hamlet. She says the company will die if they don't take John back. John tells McDuffy that he wants to come back because the company is the closest thing to a home he will ever know. He tells McDuffy that he wants Mary Margaret to be a member of the company as well. McDuffy gets furious when John says it is both of them or nothing and Mahoney climbs into a trunk and closes the lid after him. Relenting, McDuffy sends Marina and John Rose off so that he can work with Mary Margaret. McDuffy doesn't believe Mary Margaret when she tells him that she and John are just friends. McDuffy says that his daughter Marina is desperately in love with John and that since he needs John in his company he must accept Mary Margaret as part of the bargain. He says she can wash costumes, run errands, and, since she is pretty, be a lady-in-waiting, but she will not be given any lines to say. He tells her that she is to stash liquor bottles all over the set so that he can get a drink whenever he wants one. She agrees and leaves and the lights fade as McDuffy lifts the trunk lid.

In the darkness we hear the sound of a recording of a boy's choir singing 'God Rest Ye Merry Gentlemen' and as the lights come up we see John putting on makeup and Mary Margaret laying out props for *A Christmas Carol*. She says she appreciates how he got her out of the drunken mess she was in in Hollywood and has given her a chance at a new life. But she wonders why he did it and what their relationship is. When he suggests that they go to bed together so that she can forget

about it, she rejects the offer and leaves. Mahoney sticks his head out of the trunk and tells John that he, Mahoney, loves and has always loved Marina, but that she loves John. John tells him that if he stopped drinking for five minutes Marina might take him seriously. McDuffy, half made up as Scrooge, comes in complaining about how much he hates the play. He says the theatre is full of bats and is also haunted. He asks Mahoney if it is necessary for Tiny Tim to be roaring drunk every night and suggests to Marina that he can pretend that Tiny Tim is invisible. John asks Mahoney why he only seems to get drunk before the Dickens play and not before others. Mahoney says he hates the character and the name of the character. McDuffy chases Mahoney around the stage, saying he is going to squash him like a tick for refusing to go on as Tiny Tim any more. In the next scene, Mary Maragaret rehearses the part of Tiny Tim with McDuffy and ends up punching him in the nose. McDuffy tries to explain the nature of acting and theatre to her. They drink together and he warns her about John, kisses her hand and walks off.

Act Two begins backstage after a performance. McDuffy remarks that Mary Margaret is doing a good job playing Tiny Tim. She wonders how he can continue with the "incredibly difficult life" of being an actor. He suggests that Mary Margaret play the part of Cordelia, and Marina, who has played the part since she was fifteen, be moved up to play Goneril. Marina storms out but comes back saying that the change will be good for the company.

Alone with Mary Margaret, McDuffy explains his feeling of failure—in his art, his life, with his daughter. Mary Margaret says that she has seen him play Lear and found the experience beautiful and holy. After McDuffy leaves, Mary Margaret asks John why he doesn't marry Marina, but he evades the question.

In the next scene McDuffy explains the need for comedy in tragedy and answers Mary Margaret's questions about *King Lear* and Cordelia. In the course of running lines McDuffy confesses that he loves her, knowing that he is acting like Pantalone. She puts her arms around him and he touches her hair "tenderly," as Marina comes on and sees them. She rages at her father and he responds in kind. Mary Margaret runs off followed by McDuffy, and Mahoney tells Marina that she is loved and appreciated, that he loves her, but knows that she is, like her father, too self-involved to see him. He says he would do anything for her, but she tells him she doesn't want to hear anything he has to say.

Hearing John and Mary Margaret approaching, Mahoney hides in a trunk and Mary Margaret comes on with a suitcase that falls open.

John tells her that if she wants to be an actor she has to learn to accept her fellow actors with all their faults. Mary Margaret says that what matters is "us" but that there doesn't seem to be any "us." She says she is lost and John tells her that she is home and asks her to marry him. She says that she will marry him if he will sit down and make things right with McDuffy. When McDuffy enters, and Mary Margaret urges the men to talk with each other, John says he is sorry for having run off in the past and tells McDuffy that he has asked Mary Margaret to marry him. He says McDuffy is a great teacher and Mary Margaret will become a fine actress and that they will both carry on the work of his company. McDuffy wonders what will become of Marina, and John says she will stay with the company. John leaves and Marina learns from her father that John and Mary Margaret are going to marry. Marina says that she is going to leave, that she can't do it any more and feels that she serves no useful purpose. She begins to cry and McDuffy holds and rocks her, Lear with Cordelia, telling her that she is and always will be his one true love.

<p align="center">* * * * * *</p>

The story of the Pendragon family continues in *The Circus Animals' Desertion* as we see Becky, Jessie's daughter, arguing with her Aunt Liz about wearing lipstick at age 15. (Scenes occur at various times from October, 1942, to October, 1945, on a unit set with seven locations.) Aunt Liz asks Becky not to go to the carnival because it will upset her grandmother who does not like the DeFlores people who run it. But Becky leaves and we hear the eerie carny music and see Romeo DeFlores, 19, smoking on a bench behind the Labyrinth of Mirrors. He tells Becky that this is a forbidden place but that he will take her into the Labyrinth of Mirrors if she wants to go. She hesitates but then goes in as he puts out his cigarette and follows her.

Back in the kitchen a few months later (December, 1942), Aunt Liz tells her sister, Aunt Moll, that Becky has been sick a lot in the mornings but otherwise is eating voraciously. When Becky appears, Aunt Moll checks her forehead for fever and then notices that Becky has put on some weight around her tummy. Becky stuffs doughnuts in her mouth, trying to talk back, and Moll accuses her of getting pregnant with the carny boy. She says that Becky must get married or they will take her to Pittsburgh to a home for unwed mothers. When Becky goes into the next room, the two aunts wonder what they are going to do. Aunt Liz goes to get some pie that Becky asked for and we see Becky walking over to the bench where Romeo DeFlores sat, but it is December and the carnival is long gone.

Albert Reedy, 54, the town librarian, is tossing corn to the pigeons. Becky is crying and Albert offers to help, to listen if she wants to talk. Becky tells him about the home for unwed mothers and says that she never had a mother and is not going to give up her baby. Albert says that any man would be happy to marry her and that he would marry her himself. Becky says that she wants to keep her baby and that she could keep Albert company, that he could be like the father she never had. She hugs him and kisses him on the top of the head before leaving him to feed the pigeons as she goes to tell Aunt Liz the news.

A year later, Aunt Liz and Aunt Moll drink coffee in the kitchen, talking about how happy the baby seems. But Aunt Moll wonders what kind of marriage it can be with Albert being so much older than Becky. Becky comes in, dressed to go out since the baby is sleeping and Albert has to work at the library. She says she may stop at the carnival, adding that she has a wedding ring and a nice husband and is not afraid. Aunt Moll questions her about her relations with Albert, saying that she doesn't think it a good idea to go to the carnival, particularly since Becky says that she and Albert never have sexual intercourse. But Becky goes out and the aunts drink their coffee, troubled, as the lights fade; we hear carny music and see Romeo on the bench, smoking.

Becky asks him if he remembers her and he surprises her by knowing not only her name but the names of Aunt Liz and her husband and knowing that Becky's mother died just after she was born and that she never knew her father. She tells him that she is married and has a baby girl named June, born in July, and that he is the father. He asks her to go into the Labyrinth of Mirrors just once, for old time's sake. She says she is not afraid and they look at each other as the carny music plays and the lights fade.

Then, on a gloomy afternoon in November of the same year, Albert sits reading, talking to himself of premonitions and of his wife's beauty. We hear the ticking clock as he speaks of being happy but fearing that everything returns to desolation. Becky asks what he is reading and learns that it is a translation of Maupassant. She tells him that she is going to have another baby. She asks him if he is angry, but he says he isn't and goes into the kitchen to make her a pot roast.

In her kitchen with Aunt Moll two months later, Aunt Liz insists that Albert must be the father, but Aunt Moll guesses that Becky went back to the carnival and got pregnant by the same boy. The lights fade on the aunts nibbling on chicken and we hear a baby crying as Albert sits in his chair drinking and reading. It is October, 1944, and he is talking aloud about mirrors and reflections. Becky asks why the baby

cries all the time and says she is going out. Albert asks her not to go to the carnival, and she swears she will not go, but as Albert leaves to tend to the crying infant, we hear the carny music and the lights fade.

Romeo is on the bench, but when he asks Becky if she wants to stay, Becky runs away. Romeo goes into the Labyrinth and Albert steps out from the shadows, believing that Becky broke her promise and that what he saw was her kissing Romeo good-bye after having made love in the Labyrinth of Mirrors. Saying that he is a nice man who must never show emotion, Albert speaks of violence in his head, of blood and flesh and "places that he (Romeo) has befouled, engendering babies, more babies, more evil." He sits on the bench as the carnival music plays and the lights fade out on Act One.

Act Two opens with calliope music in the darkness and we see Albert surprise Becky in the library and then explain to her that mirrors have always been associated with death. He accuses Becky of breaking her promise, of going into the Labyrinth of Mirrors, of letting the other man put another child in her. When Becky screams, he clasps his hand on her mouth and wrestles her to the ground so that she is sitting with her back against his chest. He says that the devil in the mirror has told him how to eliminate the problem forever, and he tells her that he is going to make her free. After he leaves, Becky runs out after him, thinking that he means to harm her babies.

The focus shifts to the Pendragon barn and Albert finding a rope and wishing the children Merry Christmas as he turns his lantern out. We hear faint calliope music blend into the sound of a church organ and that music fades as Aunt Liz wheels in her mother, Alison Morgan Rose Armitage, called Grandmother in the script. It is a few days after Christmas, and Grandmother wonders why people bake cakes when somebody dies. She sends Aunt Liz and Aunt Moll away, asking Becky if she is pregnant again. Becky explains that she is not pregnant but that she eats when she is upset. Becky asks Grandmother who her father was but Grandmother tells her that she has to straighten her life out and makes her promise never to see "that carny boy" again or any Italians. Becky agrees, and Grandmother then tells her not to let any man get her underpants off until after the wedding cake and makes her promise to never run off and leave her children.

As we hear the familiar calliope music, Becky is getting dressed to go out. It is another October (1945) and the ghost of Albert, "rumpled, pale, and a bit greenish," startles her as she is putting on lipstick. Becky says that the babies have been driving her berserk, Lorry screaming and throwing things all the time and June trying to crawl out

the second story window. At Albert's insistence, she swears that she will not go to the carnival. After she leaves, Albert stares into the mirror and says that the face is still in there and again we hear the carny music as Becky approaches Romeo, but we also hear distant thunder. Becky tells Romeo that she is a widow and asks him if the DeFlores family is out to get her family, but he responds by asking her how her husband died. She tells him that Albert hanged himself in the barn because he had mental problems and then she asks if she can come with Romeo when the carnival leaves town. She says she will die if she can't get away, that her Aunt Liz will take better care of the girls than she could, that he can have her every night in the Labyrinth of Mirrors. Romeo says that it is bad luck to sleep with a suicide's wife, that it means your children will die. When she begs, saying that she will do anything, he tells her to go home and pack her things.

The lights fade as Becky runs off and Romeo goes into the Labyrinth of Mirrors and then lights come up on Becky in her room trying to cram clothing into a suitcase. Aunt Moll warns her about the DeFlores family and says she will call the sheriff, charging Becky with child abandonment. Becky says she has to escape and finally gets the suitcase closed. She starts to leave without it, and, when she goes back to get it, Aunt Moll locks her into the room from the outside. Cursing, Becky drags the suitcase to the window and throws it out, then goes out after it, climbing down the rose trellis as the lights dim and the sound of the storm gets louder.

Becky arrives at the bench, but the carnival has gone and a Soldier sits smoking where Romeo did. Becky recognizes him as Johnny Palestrina, a baseball pitcher that she saw striking out everybody. The Soldier explains that he was wounded in the Battle of the Bulge and is still in uniform even though the war is over because he is going to hospitals. Becky tells him she remembers the smell of the bread his mother used to bake in the mornings and that her family hates gypsies and Italians, although she thinks dark men are attractive and "kind of dangerous." The Soldier asks if she would like to get something to eat. Walking with a cane, he lifts the suitcase. And she helps with her hand on the handle. As they go, she looks back at the bench. The lights dim and faint carny music plays. Albert looks after them, then sits on the bench and starts feeding the pigeons as the lights go to black and we hear "the distant, ghostly carny music."

* * * * * *

The eleven characters in *Dramatis Personae* are the surviving members of the Pendragon-Rose-Armitage family, representing their

past and, in the case of the Italian and Becky, their future. They have gathered in April, 1946, at the old and decaying Pendragon house to await the imminent death of Alison Armitage, Becky's grandmother and mother to Lizzy, Dorothy, Molly, and John Rose. Other characters are Davey Armitage, Alison's stepson, Rhys Pendragon (Rose), her stepson and former lover (father of John Rose), Anne Pendragon, identified in the cast list as Rhys' daughter, and Sarah Pritchard, the housekeeper. Before the lights come up we hear the sound of a ticking clock and a thunderstorm in the distance, and then we see Alison, 78, in an old wheelchair as she tells us of her dream about struggling as a girl through woods during a thunderstorm and coming to a huge house and seeing Rhys; but then she wakes up and he is gone and she is old and dying. Sarah, 76, speaks to Alison from the upstage shadows and the lights come up on the room as Sarah tells her that everybody is waiting to see her. Alison tells Sarah that she has seen Death, parked in a black Chevy in her driveway.

The focus shifts to Becky, 18, in her own pool of light, sitting on the sofa as she tells us her dream about trying to escape from an old man who lives in a grandfather clock. Lizzy, 51, enters as the lights come up on the area and asks Becky who is parked in the driveway in a black Chevrolet. Becky tells her that the owner of the car is her boyfriend, an Italian. When Sarah comes in and Becky complains that she hates the house and all the people in it, Sarah explains that the strange people are her relatives. Dorothy, 50, in her own spotlight, tells us of her dream of hearing a piano playing (a miracle, since she has been deaf for 43 years), and running into a room full of family members to discover that what she thought was a piano is in fact her mother's coffin.

The lights come up on the library as Lizzy asks Dorothy to help make lunch. John, 58, an actor, comes in with a glass of iced tea and Lizzy leaves when Dorothy insists on communicating with him. Dorothy indicates that she wants to stay in the house with Sarah after her mother dies and wants John to stay, too. But he says he has a theatre company to run and adds that, although he hated the house, he keeps having dreams about it. Molly comes in looking for Davey, and when she tells Dorothy to help out in the kitchen, John offers to help make spaghetti. Anne, 35, asks John if he has talked with his father and John says that he doesn't want to interrupt Rhys' drinking. Anne tells John that she understands why, after her mother died, Rhys had to put her in boarding school. As a journalist, traveling all over the world, he tried to visit her whenever he could, and when she looks at things from his point of view she thinks that he has always done the best that

he could. Anne tells John that he may not have another chance to make peace with his father.

The spot comes up on Alison saying that she dreams of hearing voices in the library and sees herself as a young girl greeting her family, but they are all dead and point to her hands, and when she looks she sees them wither and become like claws and when she looks in the mirror she sees her body decomposing and a shadow of something dark approaching over her shoulder. Learning that the Italian man in the Chevy is waiting for Becky, Alison tells Sarah to warn Becky and asks her to keep him out.

Sarah comforts her and the lights fade on them as we hear Rhys, 76, singing a limerick and then see him and Davey, 66, approach Becky who is sitting on a bench in the garden. Rhys guesses that Becky is brooding about a young man and tells her that "happiness is the ability to concentrate on the playing out of one's action." Anne tells Becky that Lizzy is looking for her and Becky runs off. Anne then tells Rhys that John is looking for him because he wants to talk. Rhys leaves to find Sarah and Davey tells Anne that they have all fled from the house but that it has "remained as the geography of our souls."

As the lights fade on them we hear birds singing and then a child crying as Lizzy, in her spotlight, speaks of her dream about hearing her dead baby crying and finding a small coffin and carrying it down the stairs but dropping it into a cold darkness. Then the lights come up on Lizzy, Molly, and Becky in the parlor as Becky complains about having to sit around waiting for her grandmother to croak. She is afraid that her boyfriend will get tired of waiting and drive away and never come back. Sarah comes in and says that Alison wants to drink some bourbon, that she has thrown away her medication so that her mind will be clear when she talks to her family.

The lights fade and we hear the sound of an approaching storm as Alison, in her spot, speaks of a dream about her home in Maryland and her mother protecting her from a werewolf. Sarah calls her name and the lights come up. From her window, Alison sees Becky talking to and kissing the man Alison thinks is Death, but Sarah assures her that the man is Becky's boyfriend, not Death. Learning that the man is Italian, Alison says she has to stop her granddaughter's relationship with a Mafia hit man. Sarah tells Alison that Becky must make her own mistakes and that Alison had to relive her mother's mistakes. Alison takes a swig from the bourbon bottle, finds it amazingly good and passes the bottle to Sarah as the lights fade on them and we hear

thunder, ticking clocks, and a piano playing Beethoven's 'Fur Elise,' ending the first act.

The second act opens with an extraordinary fugue for voices and sound effects. Each of six characters—Davey, Anne, Rhys, Molly, John, and Becky—speaks three times, each talking about dreams they have, and each narration is preceded and followed by sounds that are associated with it. Each character is isolated in a spotlight and Nigro writes that the sounds should be "a quiet, interpenetrating tapestry" that connects the words. Davey's opening statement about wandering in "an endless labyrinth of house" is preceded by the sound of a ticking clock and followed by the sound of bombs falling. Davey is in the garden and as the light fades on him a spot comes up on Anne in the library speaking of hearing a child crying in her dream of the war in London. As she finishes and the light on her goes out we hear a child sobbing and the light comes up on Rhys in the garden. His dream is about walking through a ravaged landscape filled with rotting corpses, and we hear the sound of crows as he finishes and the lights come up on Molly in the library. Her dream is about Jessie lying naked in a room and as her light goes out we hear a child sobbing and then the sound of a train whistle as the light comes up on John in the parlor. He speaks of holding his sister Jessie on the railroad tracks as a train approaches and we hear the sound of "calliope and orchestrion carny music" as the light illuminates Becky in the parlor, teling us her dream of a merry-go-round with no people but with the eyes of the horses looking at her. The child cries, then the crows caw and Davey picks up his story, beginning the sequence again. 'Fur Elise,' the sounds of a woman moaning, a cacophony of voices, a woman crying, and a door creaking and slamming shut are added to the polyphony as the characters articulate their deepest fears and desires.

In the next scene, John tells Becky that she looks like her mother, Jessie, and Becky complains that no one will tell her who her father was. Then, in her own spotlight, Sarah tells us her dream about swimming naked with Rhys when she was sixteen, of feeling him on top of her in the hayloft and of hearing a voice telling her that although she will live to be an old woman that moment with Rhys will be her only moment of complete happiness. When the lights come up on the library, Sarah tells Rhys that Alison is drinking bourbon, and she asks him if he remembers swimming and the hayloft. She says that he has had many moments like that but for her that one moment was all she had. She says that she hoped something might happen between her and Rhys until Alison showed up at the house in the rain and everything

was lost. She tells him that Alison doesn't want to see him for the last time, knowing it is the last time.

Sarah leaves to tend to Alison and we hear a piano playing Chopin as the lights fade on Rhys and a spot comes up on Dorothy. As she tells us her dream, the piano music, faint, of Liszt, Schumann, Strauss, Tschaikovsky, and Beethoven is heard. Dorothy dreams that she can hear the music "all blurry," as she walks into a huge ballroom with a grand piano in the center. A cat on the piano bench plays one "lovely and perfect note," and then she wakes "and everything is silent again, forever."

When the lights come up on the parlor, Rhys, John, Davey, Anne, Molly, Becky, and Lizzy have joined Dorothy. Molly says that her husband Cletis thinks they should sell the house. Sarah enters and says that Alison wants to see Becky. When Becky says she doesn't want to go, Sarah grabs her by the wrist and drags her off. The light comes up on Alison in her wheelchair as she tells us her dream, and then Sarah comes in with Becky. She identifies the man in the car as Johnny Palestrina, a decorated Italian war hero. She adds that she loves him and he "kind of" loves her. Alison says that she wants to see him. After Becky goes, Alison drinks from the bourbon bottle and talks as if she were luring Death into a trap as the light fades on her.

John Rose in a spotlight then tells us his dream of being backstage in an old theatre, confused, then, hearing his cue, stumbling from the wings to be blinded by the lights on the stage. He starts playing a violin for an audience of skeletons that clatter out of their seats and come up on stage, converging on him as he plays. He feels the teeth of one closing about his neck. The music stops and the lights come up on the family again as Becky tells them that Alison wants to see her boyfriend

After she goes to get him, Dorothy begins crying and Davey says that he will move into the house with Dorothy and Sarah, that it is finally time for him to come home. Anne suggests that the family members are the remaining dramatis personae in the play of Alison's life and she wants them all together at the end. John tells Dorothy that Davey will be moving into the house. When Dorothy signals that she is hungry, the women and Davey go into the kitchen, leaving Rhys and John to talk about John's family and theatre company. Rhys thinks they should try to break down the wall of resentment between them, but John says it isn't worth the trouble. But he does invite Rhys to come backstage and meet his family

The lights fade on them and come up on Alison as we hear calliope and orchestrion music faintly, and Alison tells us that she dreams of going to her sister's bedroom in Maryland and seeing her and the gypsy in the throes of sexual intercourse. The music fades and the lights come up on Becky, Sarah, and the Italian, "a dark young man of 24." Alison sends Becky and Sarah away, then tells the Italian that she doesn't like Italians and that Becky has no money. In answer to her questions, the Italian says that he likes Becky, that they get along, that she seems kind of lost. He says that he is still healing from the war and may be able to play baseball the next season. Alison says that Becky is lucky to have found a good man to look after her and her children, but, she adds, when Becky finds out that the Italian isn't as dangerous as she thinks he is, she will dump him "like a sack of fertilizer and move on to the lowest form of sewage she can find." Then Alison says she felt a small explosion in her head, and she identifies the Italian as Death in disguise, come to fetch her. She says she is not afraid and asks if she can see her family first. She asks the Italian to send in Sarah, and after he goes she says that the final jest is that Death is a gentleman. She talks of crows in the rooky wood and speaks of a man making love to her in the rain as the light fades and goes out.

* * * * * *

In *The Reeves Tale* the decaying Pendragon house has been reduced to two usable rooms, the kitchen and the former parlor which has been converted by the Reeves family into a room with three beds, separated by "ancient curtains," and a large walk-in closet. Nominally based on Chaucer's fabliau in which two students repay a miller for cheating them by swyving his wife and daughter, Nigro's story is set in the late 1970s in a terrifyingly polluted land from which no one escapes. As the play begins, John and Alen, in their late twenties, drink coffee at the kitchen table while Pap, Abby's grandfather, sits in a rocker trying to tie his shoelaces. Pap is, or pretends to be, nearly blind. John and Alen talk about whether they are ever going to be paid by Sim Reeves for their work, and Alen suggest that they could diddle Sim's daughter, Molkin, 16. John doesn't like that idea and suggests that they should leave for Phoenix, but Alen reminds him that his truck wouldn't get past the mailbox. When the men tell Pap that Sim has not yet paid them, Pap chuckles and tells them they should leave, that the place has had a curse on it since it was built by Zach Pendragon. Pap says he can hear something upstairs and "the soil's gone funny and the trees is weird" and have funny colors at night. John says the problems are caused by the chemicals dumped in the landfill, but Sim, who has come

in from outside, says nothing is wrong. Molkin gets up from her bed and comes into the kitchen wearing a skimpy nightgown. Abby comes out of the walk-in closet wearing a robe and tells Molkin to put her clothes on. Molkin says that Abby is jealous because she is 32 years old and Molkin has a nice body. Sim takes the newspaper from John and complains that there are no pictures of women in it, that "a man likes to see some tits in the morning." Sim explains that he doesn't believe in dirty magazines because they aren't Christian but that he looks forward to the day when television has advanced to the state of art where you can see naked women and look between their legs. When Molkin comes back in shorts and a tube top, Sim makes her put on a bulky sweater. Sim leaves and Molkin and Pap go into the bedroom to watch cartoons. After teasing Abby into leaving, Alen urges John to occupy Abby when she goes into the kitchen after Sim falls into a drunken sleep, and while John and Abby are in the kitchen, Alen will crawl into Molkin's bed. John agrees and they go out to work with Sim as the lights fade on Molkin and Pap watching cartoons.

It is night in the next scene, with the house lit by moonlight. Abby and Molkin are in the bed nearest the kitchen, Sim and Pap are in the center bed, and Alen and John in the bed by the far wall. Abby gets up and goes into the kitchen. Reluctantly, John puts on his pants and goes out to join her. Abby says she used to like the quiet but that now there's a buzz from somewhere outside and she doesn't know what it is. As Abby tells John about meeting and getting involved as a sixteen-year-old with Sim, they both hear Molkin say, "You stop it, Daddy, I'm tired," as Alen caresses her. But Abby ignores the sound and continues with her story, talking as if to cover the moans from the bedroom. John kisses her, twice, but she pulls away and stumbles into the bedroom, pulling back the covers to discover Molkin and Alen. She moves to the far bed, followed by John and they fall on the bed together. Sim wakens, announcing that he has to piss like a racehorse but that he will give Molkin something to keep her warm when he returns. Reaching under the bed covers, he discovers Alen and shouts that he will kill him. Alen starts crawling across the room to his own bed, but finds, as does Sim, that John and Abby are in it together. Pap awakens and a wild chase begins, Sim growling and moving like Frankenstein's monster. Pap crawls under his bed and the others scream, bounce, and wrestle until Abby accuses Sim of incest and he begins strangling her. Pap crawls out with an old rifle that goes off into the ceiling, and John grabs the rifle by the barrel and slams the stock into Sim's head,

knocking him out. Alen pulls on his pants and runs out, telling John that he is taking the truck.

In the next scene, Sim is sitting in a chair in the bedroom, unable to move or to speak, though he does emit "a hideous guttural noise of frustration and anger" when Molkin taunts him with her breasts. After she stomps out, John tells Abby that he didn't run away with Alen because he likes her and he likes the feeling of having a home. Abby wants John to make love to her and throws a blanket over Sim's head. Molkin finds the bedroom door locked and asks if she can watch and Pap wakes up in the middle bed and goes over to watch as Abby and John roll off the bed onto the floor. There is a strnge buzzing noise outside and "a kind of growling" as Molkin shuts the kitchen door.

Then it is evening in the kitchen and Pap tells Abby that he heard a ghost upstairs in the night. He says that all the lechery is tied together with something foul in the water, the soil, the vegetables, all through the house. John says that the trees are moving even though there is no wind, and Molkin complains about the taste of the vegetables. Abby starts shouting that there is nothing wrong, banging Molkin against the wall "repeatedly," then abruptly calming down and asking that everyone sit again at the table because everything is "just fine." As she wipes Sim's face and starts to feed him like a baby, we hear "a faint buzzing sound" and see a "kind of glow from the windows" as the lights go to black and the act ends.

It is morning when the second act opens, and Sim is missing. Abby thinks he crawled away and wants to go look for him. John, reading the paper, repeats Sim's line about a man needing tits in the morning and Molkin recites what she learned about turtles and birds in biology class. Pap sings part of 'Silent Night' and John goes out to the barn. Then, at supper, John tells Molkin that she can't go to the circus and, when she tries to leave, he throws her into the closet and locks the door. Abby says that John has become worse than Sim, and Pap looks out the open kitchen door, marveling at the glowing colors of the animals and trees. He goes out the door, thinking that bareback ladies are calling to him, but neither John nor Abby notices. Abby manages to get away from John and tries to look for Pap, but John crawls after her, making animal noises, until she hits him over the head with a flour sack. John collapses, covered in white flour, and Abby lets Molkin out of the closet. Abby closes the door of the kitchen on the buzzing noises, the peculiar lights, and the "faint, eerie merry-go-round music," and she and Molkin take John to the center bed and lie down next to him,

singing 'God Rest Ye Merry, Gentlemen' as the buzzing gets louder and the room is illuminated in "a kind of hideous Christmas glow."

Then, as John, Abby, and Molkin are eating in silence, Alen comes in, learning from Abby that Sim and Pap are gone. Ignored, Alan rummages for food, saying that things are very strange outside and that he thought he saw a light in the upstairs window. At a sound from above, John tells Alen to go up and investigate, and he and the women go into the bedroom to huddle together in the center bed. Alen asks if he can join them, but they all refuse and as he tries to pull Molkin into the kitchen, we hear the sound of heavy footsteps pacing upstairs. Alen encourages the others to fight what is happening to the house and the farm, but the buzzing and pacing noises get louder and John wraps a pillow case around Alen's throat and starts choking him as he drags him from the bedroom into the kitchen and kicks him out the kitchen door. Alen pounds on the door, begging to be let in, but his cries stop suddenly, and John, Molkin, and Abby go back to the bed, all with pillow cases over their heads.

In the morning, Abby says that she went upstairs and talked with the ghost, a dark man who was playing a harmonica. When she tries to get out, John blocks her way, insisting that she stay with them and fight whatever "it" is. Abby says that she would never jump head first down the well, that she just wants to go outside and dance naked in a celebration of life. She pretends that she wants John to make love to her and gets him in the bedroom with his pants around his ankles, pushing him inside the closet and then forcing a chair under the doorknob before running toward the kitchen door. Molkin wrestles with her, calling for John to help. John comes out of the bedroom and the three of them twist and roll on the floor, ending up with John sitting on the floor, his arms around Abby, who has her arms around Molkin. Abby wants to stay in the position of togetherness they are in, but John wants to get up because he has ejaculated in his pants. They get up and as John turns away from Abby to loosen his pants, she hits him over the head with a frying pan. She throws Molkin into the dazed John and they both fall to the floor as Abby runs out into the pulsating light and noise. Molkin tries to follow her but John tackles her and slams the door, holding her tightly. Pulling out a mess of knotted rope and assuring Molkin that he is not going to leave her. John sits in the rocking chair with her in his lap and wraps the rope around them. The lights and noises from outside increase in intensity as John speaks of television shows like *Rawhide* and *Secret Agent* and the various acts on the *Ed Sullivan Show*. Molkin huddles against him and closes her eyes,

and there is "a sudden horrible blast of noise and lights," but the lights go out as the noise increases, then stops, and a purple light comes up on John, screaming from a nightmare. The ropes are untied and Molkin is gone. Raging that he will not give in, John staggers around the room, beating the walls, biting his hands, speaking incoherently of girls in jungles and radioactive garbage dumped on the garden. He tells a story of a house made from the death of trees with people feeding on animals, defining this as the great betrayel. Hearing a harmonica from upstairs, he opens the door and a stream of blue light is seen. Saying that this is his garden, his home, he starts climbing the stairs and the lights go to black on the ruin of the Pendragon house.

* * * * * *

Set in a bungalow on Cape Cod, far from east Ohio, *Seascape with Sharks and Dancer* concerns the relationship between two characters, Tracy, 20, and Ben, late 20s. The connection with the Pendragon saga is that Ben is the son of Becky and Johnny Palestrina, the Italian-American war hero of *The Circus Animals' Desertion* and *Dramatis Personae*. It is night, and we hear the sounds of the ocean as Tracy, wrapped in a blanket with her hair in a towel, wakens on the couch and calls for service. Ben asks her if she would like some hot chocolate and brings out two cups from the kitchen. She asks him to guess why she was out in the ocean in the middle of the night. Ben offers scuba diving and tuna fishing as possible answers, then gives up. Tracy tells Ben that he is ineffectual and afraid of everything. She talks about living with some guy in New York and then says that she was dancing in the ocean. After she calls him a eunuch, Ben says that he saved her from drowning and gave her hot chocolate and the towel and blanket she is wearing. She says that if he weren't a eunuch he would have raped her when he had the chance. She gets angry and starts throwing things when he says that she is homely, and she knees him in the groin when he tries to calm her down. She tries to go out the door, but the blanket is wrapped too tightly around her and she falls to the floor. When he tries to help her she hits him in the nose with a wild swing. He tries to stop the bleeding by lying on the couch with his fingers up his nose, but she goes into the kitchen and returns with ice in a paper towel, a damp towel, and some other paper towels that she tears into strips and stuffs into his nostrils. After putting the ice under his head as he rests it in her lap, she wipes the blood from his face with the damp towel. Ben asks her to tell him a story, a true-life adventure. She relates a story about a "very bright little girl," "very wicked," who hitched rides all over the country, shacking up until she'd done "almost

everywhere" even though she was only twenty and a half. She ended up in New York shacked up with a handsome prince who also pushed a little dope while she worked in a store selling orthopedic brassieres until she got fired. When she went home she found that the handsome prince had left, taking everything but the cockroaches. So she took her last subway token and went to Coney Island where she was fascinated by the sharks. She breaks off her story, saying that she has never before been abducted, giving Ben specific instructions on the kind of ham and cheese sandwich she wants him to make for her. She finishes her story of how the girl ended up by the ocean in Provincetown. When Ben returns with two sandwiches, she badgers him into telling a story and keeps interrupting with questions as he talks of a young bewildered man rescuing a looney bird from the ocean. He tells her he is writing a novel and that he works in a library. She begins sneezing and reacts sharply when he touches her, but he gets some pillows and another blanket and gets her to lie down on the couch. He tells her that no one is going to hurt her or make her do or be anything she doesn't want, and he goes into the bedroom. After a bit, Tracy gets up and goes into the bedroom, too.

In the second scene, late the next morning, Tracy, wearing the top of a man's pajama, denies having a nightmare and Ben, wearing the pajama bottoms, tells her that he dreams of wandering in old houses. Tracy thinks he must be crazy to have dreams with no people in them. He manages to tell her his name, and after describing her nightmare, she tells him hers. They share an apple and Ben offers to go into town to buy her some clothes. She goes into the bedroom to put on some of his clothes, asking him to help her. When she throws out the pajama top, he takes a bite out of the apple and goes into the bedroom.

In Act Two, a couple of months have passed and Ben finds Tracy sitting on the couch at four in the morning. He says the restaurant where she works makes her nervous and suggests that she could get another job. When she doesn't respond, he puts on a long raincoat, galoshes, and a Cleveland baseball cap, acting out a scene in which he goes down to the restaurant to punch somebody in the nose. She giggles and says that he won't like what's wrong with her. He says that she is pregnant, that he has suspected it since she began throwing up every morning. They argue and she tells him that he doesn't understand her, that she is not domesticable, that babies are the worst trap there is. He tries to argue that they will be able to manage, that they can get married, but as he describes what their lives will be like

with a baby he starts to falter. She says their lives are ruined but goes into the bedroom, saying she is cold. After a moment, he follows her.

Late the next morning, Ben explains that he didn't wake her up for her class because he thought she needed the rest. She says she knows he doesn't want the baby and that she talked with a girl at the restaurant who went to see a doctor when she was pregnant and that it was the easiest thing in the world. When he objects, she says that the baby isn't anything yet and that you can't murder something that doesn't exist. He says if she does it he won't be able to look at her, that if she kills "that thing" inside her she will be killing them both. She says it's like having a wart removed and, as she is about to leave, tells him that the baby isn't his anyway.

The final scene occurs at night. We see Ben sitting on the couch and hear ocean sounds as Tracy comes in, tired, and sits next to him but not close. She tells him that her parents kept giving her animals when she was a child—not just cats and dogs but a raccoon, two ducks, a skunk, and a chicken—and that their house was close to a road and her animals got run over and splattered. Her brothers would pick them up with a shovel, killing those that weren't already dead. She says that giving the animals names made it worse because she loved the animals and took care of them until they were squashed. After a kitten was run over she made her parents promise never to give her any living thing because that was the only way for her to keep from going crazy in a world that killed the things she named and loved and cared for. She admits that she let herself get pregnant because she wanted them to have a baby but that she got scared. She starts tearing off the clothes he bought her and says that she is going back to the ocean the way she came. She goads Ben, telling him that he wants to bash her brains in with a crowbar, but Ben tells her she can go if she wants to go. She starts throwing things at him, a lamp, books, his typewriter, the novel in the refrigerator, crying and stumbling, saying that she murdered their child. She ends up sitting in a pile of rubble on the floor, and Ben tells her that he chooses her. She says she is cold and he puts a blanket over her shoulders, then starts to the kitchen to make her something to eat. She says that it's never going to work, that she is leaving "right now," but neither of them moves as the lights fade to black.

* * * * * *

The last full-length play in the Pendragon series (so far), *November*, takes place in 1980, a few years after Ben's encounter with Tracy. Part of the unit set is a room in a nursing home near Armitage, with a bed for 85-year-old Aunt Liz. Less prominent aspcts of the set are "a

fragmented collection of pieces of farmhouse that form the geography of her mind." Featured in this collection are the upright piano of Aunt Dor, 84, and her rocking chair. The action begins with the sound of a ticking clock and then Aunt Dor playing "a rather insane sounding version" of Chopin's Waltz #7 in C-sharp minor. (Aunt Dor plays from memory, and since she has been deaf since childhood, she hits many wrong notes.) The piano fades out as Aunt Moll approaches Liz's bed, asking if she wants a banana. Aunt Liz occasionally has difficulty hearing. She asks for Ben, confused about where he is, and Aunt Moll tells her several times that Ben is in Connecticut. Aunt Moll asks if Becky has visited Liz, and Dor, who has not left the stage, sits round on her piano bench as if she heard the name and makes a loud raspberry sound. Aunt Liz asks about several people, including Davey Armitage, and Aunt Moll reminds her that he died in 1957. When Aunt Liz asks if Aunt Dor still plays the piano, Aunt Moll says that Dor plays badly because she is deaf. Aunt Liz speaks of their sister Jessie, Becky's mother, and Mrs. Prikosovits (accent on second syllable), 78, wanders in, bewildered, as Aunt Moll crosses to Aunt Dor's farmhouse/piano area.

Mrs. Prikosovits rambles on about being a neighbor of the Palestrinas when Becky was married to Johnny, the baseball pitcher, after her first husband hanged himself and before she married Rooks. She wanders out, still talking to herself, as Becky comes in and Aunt Liz talks of her husband, Rooks, chasing the cat down the alley with a pickup truck. Becky says she has brought some legal papers for Aunt Liz to sign, but Aunt Liz says she will sign the papers after her nap.

Rooks shouts from offstage for Becky and as she leaves Mr. Kafka, 77, wanders in, followed quickly by Nurse Jane, 25, who gives Aunt Liz her pills and urges Mr. Kafka to return to his room as Aunt Moll and Ben approach.

In answer to Aunt Liz's questions, Ben says that his father is fine and that his girl friend, Tracy, is in New York. After Ben and Aunt Moll leave, and while Nurse Jane is tidying up the room, Aunt Liz takes out the papers, saying she can't see without her glasses, and wishing that Dorothy was there to help her. Across the stage, from her rocking chair, Aunt Dor speaks and gestures as if carrying on a normal conversation, but the sound she utters is "the harsh guttural sound that has been her only voice since childhood." Aunt Liz carries on a conversation with her about Ben and Rooks, with Aunt Dor drawing a finger across her throat when Rooks is mentioned. Nurse Jane says hello to Becky who is coming in and Aunt Liz quickly hides the papers

under her pillow and begins talking about Jessie and a trombone player doing it with a bucket. Becky asks about the papers, but Nurse Jane says she hasn't seen them and listens as Aunt Liz continues with her story of the trombone player and the bucket. Becky wonders if Mrs. Prikosovits might have stolen the papers, then says she has to make lunch for her husband. After she leaves, Nurse Jane finds the papers as she is rearranging the pillows and looks through them, telling Aunt Liz that Becky and Rooks want her to sign over everything she owns to them—the farm, the house, and all her bank accounts. Aunt Liz tells Nurse Jane that, after Lewis (her husband) died, Rooks cut down two enormous pine trees that stood in front of her house.

When Aunt Moll comes in, she says that Aunt Liz should not sign anything she doesn't understand. Aunt Liz says that if she were dead, Becky would have the farm and that might make her happy. Aunt Moll says that Rooks plans to put grasshopper oil pumpers on the land and sell all the timber and lease the hill for his friend to put trailers on and tear down the barn and put up an automobile graveyard, covering the farm with junked cars. Calling her sister a fool, Aunt Moll stomps out as Mr. Kafka is coming in, telling Aunt Liz that it's time for lunch. She says lunch is brought to her in her bed, and we hear Mrs. Prikosovits coming down the hallway, calling for Elmo (her dead husband) whom she has confused with Mr. Kafka. He hides under the bed but Mrs. Prikosovirts finds him and tries to pull him from under the bed by his ankles, but he screams for the nurse, saying that Mrs. Prikosovits is hurting his "thing." Becky and Rooks come in to witness the struggle, and Nurse Jane helps Mr. Kafka from under the bed and takes him and Mrs. Prikosovits off for lunch. Becky and Rooks want the signed papers and Rooks is convinced Aunt Liz is just trying to make him angry. He calls Becky's son, Ben, a wacko for almost demolishing Rooks' pickup truck with an ax. Becky starts crying and Nurse Jane tells Rooks and Becky that she has the papers in her office and goes to get them. When she returns, Rooks says Aunt Liz has not signed them, but Nurse Jane says that Liz just took her medication and is too sleepy.

After Rooks and Becky leave, Nurse Jane asks Aunt Liz if she wants to sign the papers, and Aunt Liz says that if she doesn't sign they will take her out of the nursing home, so perhaps she should sign. As Aunt Liz falls asleep, Nurse Jane straightens the covers, puts the papers on the stand by the bed, and turns out the light. Aunt Dor plays, "out of key but gamely," the end of her Chopin waltz, ending the first act.

At the beginning of the second act, as Aunt Liz sleeps, we hear a ticking clock and the sounds of birds. Aunt Dor crosses from her piano

to sit on the edge of Aunt Liz's bed and begins speaking to us, quite normally, about how people who cannot hear or speak are regarded by others as children or idiots. She says she has lived a "mostly forgotten life," learning to be very stubborn about a few things and letting the rest "just go hang." She tells us of the day Ben went off to college and her cat, John Foster Dulles, marched over and shat on the driver's seat of Rooks' new pickup truck and then disappeared forever. She says that she hears the music she plays in her head and her dream is that just once she could play her waltz for Liz and Molly and it would be "perfect, and beautiful and just right." She crosses to her piano and plays, "rather dreadfully," as Ben greets Aunt Liz, telling her that he is going to Idaho, and that her farm is hers to do with as she likes. They talk about what they loved about life on the farm. Ben shouts at her that it is not right for his mother and Rooks to be stealing her farm from her. Becky comes in and Ben kisses Aunt Liz on the cheek as he leaves without speaking to his mother. Becky wonders how Ben could take an ax to Rooks' truck just because he cut down two old pine trees. Then she asks Aunt Liz if she has signed the papers and starts to cry again, saying that Clarence (Rooks) will leave her if the papers aren't signed.

After she goes, Aunt Liz takes out the papers, finds her glasses, and begins reading. Aunt Dor plays "disconsolately" and Mr. Kafka enters and announces that Mrs. Prikosovits has died. He takes out a flask of Jack Daniels whiskey and offers some to Aunt Liz, but Nurse Jane stomps in, telling Mr. Kafka that she may have to tie him to the bedpost. As Nurse Jane chases Mr. Kafka down the hall, Aunt Liz signs "firmly" on three different pages. Nurse Jane runs in, saying that Rooks has just arrived in his pickup truck, and she asks Aunt Liz if she has signed the papers. Seeing that she has, Nurse Jane hesitates, then stuffs the papers into her uniform as Rooks walks in. She suggests to Rooks that perhaps Becky has the papers and Aunt Liz says that she signed the papers for Becky, not for Rooks. Rooks assumes that his wife has the signed papers and jubilantly tells Aunt Liz what he is going to do to her farm to make himself rich—pumping out the oil, stripmining the hill to get the coal, pumping out all the gas, and starting his auto salvage business.

As he leaves, Aunt Dor makes an enormous raspberry sound at him. Nurse Jane takes out the papers and suggests that she give Aunt Liz more medication so she can rest. Aunt Liz tells her that she misses her brain, that it comes and goes. Learning from Aunt Liz that Mrs. Prikosovits has died, Nurse Jane starts to give Aunt Liz her medication but is startled by a "really blood-curdling" scream from Mr. Kafka,

who tells her that he has seen a zombie, that Mrs. Prikosovits is coming down the hall to get him. As Nurse Jane turns, Mrs. Prikosovits startles her into screaming and Mr. Kafka makes a cross with his fingers as Mrs. Prikosovits comes in. Understanding the situation, Nurse Jane leads Mrs. Prikosovits out and Mr. Kafka notices that Aunt Liz is about to take her pills. He tells her not to take them, that they are the reason for her inability to think clearly. He says he hides his and flushes them down the toilet when no one is looking. He tells her that when he first arrived he was like her, in bed all the time like a watermelon. But one day he dropped his pills on the floor and didn't tell anyone and he has not taken any medication since because he felt so much better. He says he doesn't want anyone to forget that he was alive, and Aunt Liz remembers that her sister Jessie said the same thing. Mr. Kafka says that every time Aunt Liz talks about Jessie she smiles, and he explains that he wants Nurse Jane to smile when, as an old lady, she remembers him. He says that he is going into the big visiting room by the parakeet cages and take off all his clothes.

When he goes, Aunt Liz throws her medication under the bed and when Nurse Jane returns she assures her that she has taken her pills. Aunt Liz then shows Aunt Moll the signed papers, but Mrs. Prikosovits runs in to tell Nurse Jane that "Elmo" (Mr. Kafka) is dancing a polka naked with a parakeet cage in front of the visitors and a girls' glee club from the junior college. Nurse Jane storms out, followed by Mrs. Prikovovits, and Aunt Liz starts giggling, saying that if Jessie were there she would have taken off her clothes and joined him. Aunt Moll agrees and starts giggling, too. Aunt Liz asks Aunt Moll to stay with her until Becky and her "baboon husband" return, and the women talk about Thanksgiving coming up, probably with a parade. Aunt Liz says she would like to be in the parade, or at least make a contribution to it. Her contribution will be confetti, she says, as she starts tearing the papers in half, giving part to Aunt Moll. Aunt Liz tells her sister that she has decided what to do with the rest of her life—she is going to "outlive the son of a bitch." And with that, the women giggle like schoolgirls as they tear the papers into confetti. Aunt Dor plays the final 32 bars of the waltz but for the first time she makes no mistakes, "perfect and beautiful." The lights fade as Aunt Liz and Aunt Moll throw confetti at each other, and when the waltz ends "quite perfectly" the lights are out.

INDEX

Monologues

Short(er) Plays: 2 Actors

Short(er) Plays: 3 Actors

Short(er) Plays: 4 Actors

Short(er) Plays: 4+ Actors

Full-Length Plays

Ruffing Plays

Pendragon Monolouges

Pendragon One-Acts

Pendragon Full-Length